Burning
the Box of
Beautiful
Things

Burning the Box of Beautiful Things

THE

DEVELOPMENT

OF A

POSTMODERN

SENSIBILITY

ALEX SEAGO

OXFORD UNIVERSITY PRESS

1995

Oxford University Press, Walton Street, Oxford OX2 6DP

Oxford New York

Athens Auckland Bangkok Bombay
Calcutta Cape Town Dar es Salaam Delhi
Florence Hong Kong Istanbul Karachi
Kuala Lumpur Madras Madrid Melbourne
Mexico City Nairobi Paris Singapore
Taipei Tokyo Toronto

and associated companies in
Berlin Ibadan

Oxford is a trade mark of Oxford University Press

British Library Cataloguing in Publication Data
Data available

Library of Congress Cataloging in Publication Data
Seago, Alex.
Burning the box of beautiful things: Ark magazine and the
development of a postmodern sensibility at the Royal College of Art,
1950–1962 / Alex Seago
Includes bibliographical references and index.
1. Ark (London, England: 1950)—Influence. 2. Royal College of Art
(Great Britain)—Periodicals. 3. Postmodernism—England
I. Title.
NX409. G7R697 1994
700´. 9421´3209045—dc20 93–25909

ISBN 0–19–817221–4
ISBN 0–19–817405–5(Pbk.)

1 3 5 7 9 10 8 6 4 2

Printed in Great Britain
on acid-free paper by
Butler & Tanner Ltd.
Frome, Somerset

Contents

Foreword by Len Deighton vii

Acknowledgements xiii

List of colour plates xv

List of black and white plates xvii

INTRODUCTION
Pop and 'National Postmodernisms' 1

CHAPTER 1
'Years may come, years may go, but the Art School Dance goes on forever':
Art and Design Education and an English Postmodern Sensibility 6

CHAPTER 2
ARK Magazine and Graphic Design at the Royal College of Art: 1950–1963 25

CHAPTER 3
English Good Taste 49
'Englishness' 49
The Festival of Britain: Victoriana and Popular Culture 52
'Good Taste' and Mass Culture 67

CHAPTER 4
Dada, Dodo, and Doo-Dah 77
National Service 77
Performance 82
Tachisme and Situationism 109
Postmodern Cross-overs: Dada, Situationism, TV, and Film 128

Contents

CHAPTER 5

Uptown Pop 138

American and Continental Graphic Design in *ARK* 141

ARK, the RCA, and the ICA 156

CHAPTER 6

Downtown Pop 175

Pop Photography in *ARK* 185

Pop Art and Pop Art-Influenced Graphic Design in *ARK* 189

CHAPTER 7

ARK and an English Postmodern Sensibility 198

Bibliography 214

Notes 219

Index 229

Foreword by Len Deighton

Dr Alex Seago has written an exceptionally fine book that I can recommend to anyone interested in the ups and downs of British artists and designers in the post-war period. His stimulating and perceptive book could perhaps be called: 'the secret birth pangs of London's swinging sixties'. Reading this review of days long past made me remember both the best and the worst of those lively times. Sometime during the 1950s a film reviewer said the hero was two jumps ahead of the police, but three behind the audience. Some of us who were art students during that period knew the feeling well. New York was exploding with graphic ideas—wonderful typography and unsurpassed illustrations by such artists as David Stone Martin and Bob Peak—while British advertising and magazines were controlled by people preoccupied by Victoriana. Continental Europe offered no escape. The Swiss and the Scandinavians showed clean cool elegance in their typography and furniture design but there was none of the self-mocking wit that comes naturally to a native New Yorker.

So when vacation time finally came I put my name down for a London—New York charter flight and sold my piano to the RCA Junior Common Room to get the ninety-nine pounds I needed to pay for it. That summer in America confirmed everything I believed. I visited advertising agencies, met designers and photographers and even worked in a studio. When I returned I found myself something of a freak. Today one would have to have returned from a trip to the moon to know the same intense curiosity to which I was subjected.

One of the many things I'd learned about in New York was the part played by Art Directors. It was their creativity linked with technical know-how which ensured the superb quality of the printing, and it was their layouts which decided such simple ideas as larger-than-life images (a way of giving even the cookery pages sensational impact). In London the art director's task went little beyond applying rubber-stamps to authorise work for despatch to the printer.

At the RCA the role of the art director was not acknowledged, neither was the existence of photography. Before going to art school I had been trained as a photographer and worked on an RAF film unit. While studying I managed to spend some of my vacation time working as an unpaid supernumerary in various London advertising agencies where I found a rebellion—against such things as Victorian-style typefaces—that somewhat mirrored my own feelings. American advertising agencies were coming to London and preaching the disturbing idea that advertising should sell things. For their English competitors this was a most unpopular innovation, and at the Royal College of Art it was enough to confirm their darkest suspicions of American insensitivity. I could find no one on the staff of the RCA who wanted to know anything about the world into which students of the Graphic Design and Illustration Department would one day have to fit. Hearing me call camera-ready material 'art-work', one tutor confided that he found that expression horrible. Students in the Illustration Department did not dare to be seen producing 'slick' work (which meant anything publishers would buy) and certainly not romantic illustration of the sort used in women's magazines. Instead they were given 'tasks' of illustrating the classic works of nineteenth-century writers in styles that had been fashionable some 50 years before. No wonder that so many students reconciled themselves to a career teaching more unemployable students.

Of course there were wonderful opportunities. I made a point of invading all the other departments of the college. Many of the teaching staff were brilliant and even Victoriana was delightful in small doses. I soon discovered that a college education is like shopping in a supermarket; you select what you want from the shelf, pile your buggy as high as possible, go home and concoct a meal. In my third and final year at St Martin's School of Art, Henry Collins, the teacher I most respected there, had advised me to apply for the three-year course at the Royal College of Art. You'll find there all the people you'll be competing against for the remainder of your career, he told me. It was good advice. Then, as now, there was no better postgraduate art college anywhere in the world. The most ambitious students from art schools all over Europe, and far beyond, had been selected for the RCA. Mixing with the top talent was an important part of the education. For myself, the way in which the Painting School shared its accommodation—in a back part of the Victoria & Albert Museum—with the School of Graphic Design and Illustration meant that there were life drawing classes and models sitting all day every day. At the end of my first year I transferred from Graphic Design to Illustration and spent most of my last two years learning to draw. I never regretted this decision. Training in observation is

as vital to writers and detectives as it is to bank managers and film directors. As a basic skill learning to draw is second only to learning to write.

I wound up my time at the RCA with a thesis showing the way in which artists such as Paul Gauguin, Henri Rousseau, Edouard Manet, Edgar Degas and Toulouse-Lautrec all used photographs for reference when painting. This revelation was not received with enthusiasm, and after searching I eventually retrieved my thesis from a waste bin. Having graduated and signed with Artist Partners—an agent for freelance artists—I spent a year flying around the world as an airline steward, doing a few commissioned drawings and filling sketch-books with the sort of banal scribbled impressions of Africa, Japan and Australia that laymen think are artistic.

But three years at the RCA had transformed my life. Most importantly I met Ted Dicks, Stan Riley, Peter Blake, Bruce Lacey and Joe Tilson (with whom I'd come from St Martin's). Together with such Graphic Design students as Raymond Hawkey, Barry Driscoll, and John Norris Wood they were to be my closest and most loyal friends for the rest of my life. John and Barry together with other friends such as Dennis Bailey and Lewin Bassingthwaite were outstanding artists setting a standard of sensitive draftsmanship which I knew I would never equal.

During my time at the College I was particularly lucky in having a shabby labyrinth basement flat in Emperor's Gate. I shared it with Ted Dicks, an outstanding student of the Painting School and an accomplished musician and composer. Being just a stone's throw from the College, the flat became a hang-out for all manner of people. Sometimes it was as crowded as Harrods' Food Hall. We gave dinner parties and congenial members of the staff such as John Minton came along. One day I arrived home to find Liz Moore, a painter from the Academy Schools, was making a cup of tea for Stanley Spencer. He was sitting on the dining room table, his feet not reaching the floor. Another memorable afternoon our local doctor dropped in, bringing the Russian military attaché who had six bottles of duty-free vodka. A noisy party just grew around them. An American soldier named Smithmier wandered in on his first day in England, slept on the sofa, and left ten days later to return to his unit in Germany. Tall, dark, and handsome, his success with female visitors was phenomenal. Even after he was a civilian and back in Memphis, he was still sending appreciative postcards. A visiting American professor of typography, on an exchange to the RCA, came to dinner. He entered, looked around wide-eyed at the squalor, and said: 'You guys sure triumph over your environment.' That accolade went into our vocabulary.

Alex Seago is generous in his review of the student work published in those ancient copies of *ARK* and I admire his skill in putting them into a context to explain the emergence of contemporary 'postmodern' culture. The people who worked on *ARK* saw only the one or two issues with which they were concerned. Of course much energy had to be devoted to arguments and discussions about breaking away from out-dated methods and ideas. There were endless compromises with the content and the style of *ARK*'s cover and contents. A large proportion of the *ARK* I art-directed was devoted to the activities of various departments from jewellery to furniture design. It came out as rather dull stuff but we all felt that *ARK* should show what the RCA did rather than engage in philosophical arguments about the meaning of art. Much of that issue—the cover in particular which should have been stark black and white—was a compromise. Soon I was to find that in the world of design outside the RCA everything was a compromise.

When considering the success of Robin Darwin it is important to remember the lasting damage that William Morris and his Arts and Crafts movement had inflicted upon our designers (Scotland was an exception, the Scots had the mighty Charles Rennie Macintosh to celebrate). At a time when the designers in Vienna, Berlin, Munich and Paris were working in close co-operation with factories and printers, William Morris and his supporters were resolutely opposed to the machine. While Continental factories were producing reasonably priced design fitted to modest incomes, England was a place where only the very rich could afford to buy hand-made artifacts from William Morris and his socialist co-workers. Britain's traditional hostility to scientists and engineers fitted well with the ideas of Morris, and coupled with the artist's low status, kept British design well behind rival products. World War II had demonstrated the sad fact that most British tanks, guns, and aircraft were inferior to those of the other belligerents.

By 1951, the Festival of Britain promised a world furnished with well-designed British goods but British designers had still not come to terms with the methods of the factories, and the Festival was a grave disappointment. The war had been won; Britain's brave role in it was widely admired. Marking Britain's post-war role with the flag-waving whimsy that had given the Lion and Unicorn Pavilion its name, was seen as a very English reaction. But the grimness of wartime austerity could not be rejigged with a few bits of red white and blue ribbon and a thousand versions of the royal coat of arms. Just as the Great Exhibition of 1851 showed the world that Britain had lost the lead that the industrial revolution had granted it, so the 1951 Festival showed that British design had little to offer when compared with the world's finest examples, and for those tempted to believe that

this was no more than a lapse of judgement, Britain's architects were slaving to disfigure its towns with the most abysmally ugly buildings to be found anywhere in the world.

How the tatty mess of 1951 became the exciting mess of the 'swinging sixties' is a miracle yet to be fully explained but Alex Seago gives more than one clue. Certainly the way in which talented designers by-passed middle-men played an important part. Dress designers such as Mary Quant bought retail shops and found a way to sell directly to the public. Many others, such as Biba, found the same solution. The beatles told the music-publishing tycoons what to do with their moons and Junes, and performed their own compositions instead. As *ARK* became more bogged down in obscure art-criticism, publications such as the *Sunday Times Colour Section, Queen* and *Man About Town* took over from what *ARK* had started. The BBC showed disbelievers that the germ of an original idea could survive and flourish even in the furnace heat of self-righteous smugness. BBC Television provided opportunities for the design of titles, set designs, set dressing and costume. But it was the making of short TV commercials that allowed directors to experiment and show their real ability. The Royal College of Art trained some of the best of the new talent and as many directors of TV commercials like Ridley Scott went on to direct feature films London became a world centre of film production. American film companies set up shop in London. When I made a film of Joan Littlewood's quintessentially British stage musical 'Oh What A Lovely War!' no British finance could be found. It was an American company, Paramount, which gave me the money I needed to secure the rights, write the script, engage the crew and make the film.

The swing of the sixties did not become perpetual motion. American film-makers withdrew from Europe (for reasons I have not space to explain). One after another Britain's aircraft, and its motor cars and trucks, could not find customers at home, let alone in world markets. A traveller nowadays will seldom know the pleasant jolt that recognition of British products in foreign shop windows used to provide. But the story is not yet over, and the Royal College of Art is sending highly trained men and women to design jobs in every part of the world. Perhaps one day British manufacturers—or even its politicians—might notice that the strongest and most resilient economies are those where the designers, artists, and engineers enjoy the highest status, i.e. America, Germany and Japan.

Finally there are two minor points I would like to add to Dr Seago's account. First, that although the RCA student body—with its ex-service students keen to earn a living—had no time to spare on politics, anti-Americanism was well-established there. Tweedy gentleman-artists, who resented the thought of

American bombers flying over 'Constable country' found common cause with leftist students who loudly proclaimed that American design meant only Coca-Cola billboards and large cars with too much chromium.

Secondly, I do not recall the association called the Dodo. I say that regretfully, for Alex Seago's description of its activities makes it sound most remarkable.

LEN DEIGHTON, 1994.

Acknowledgements

I wish to thank the following, without whose kind help and advice this book would have been impossible:

Len Deighton, Raymond Hawkey, Bernard Myers, Robyn Denny, Roger Coleman, John Norris Wood, Ted Dicks, Stan Riley, Richard Guyatt, Nigel Chapman, John Blake, Bruce Lacey, Alfred Daniels, Philip Guilmant, Roddy Maude-Roxby, Alan Fletcher, Denis Postle, Richard Smith, Clifford Hatts, Ralph Rumney, Peter Blake, Derek Boshier, Ian MacKenzie-Kerr, Ken Sequin, David Gillespie, Ken Garland, Theo Crosby, Gordon Moore, June Cull, Terry Green, Geoff White, Joe Tilson, David Gentleman, Alan Bartram, Romek Marbur, Brian Duffy, Dennis Bailey, David Collins, Derek Hyatt, Denis Bowen, Colin Sorensen, Michael Foreman, Brian Haynes, Harry Greenaway, Douglas Merritt, Dr Graham Whitham, and Dr Margaret Garlake.

For their kind permission to reproduce illustrations I wish to thank the Royal College of Art, Apple Corps Ltd., Camilla Arthur Representation (Europe), Peter Blake, Derek Boshier, Robyn Denny, Harper's Bazaar, Haymarket Publishing Group Ltd., the Hearst Corporation, Initial Group Ltd., Nick Knight, Sir Anthony Lousada, Roger Mayne, the National Magazine Company Ltd., Jamie Reid, the Joint Shell Mex/BP Advertising Archive, Lord Snowdon, Mrs Mary Spear, the Tate Gallery, Times Newspapers Ltd., Trinifold Management Ltd., Virgin Records Ltd., and Peter Williams. Every effort at my limited means was made to request permission from those responsible, and I extend my apologies to any I may have been unable to trace.

I would also like to give special thanks to Professor Christopher Frayling for his support and to my friends and colleagues Dr Virginia Button, Dr John Dickerson, and Dr Ralph Lillford for their constant help and encouragement. In addition I wish to acknowledge and thank Anne George and all the staff of the Royal College of Art library who guided me through the stacks and archives and were

Acknowledgements

always ready with good-humoured answers to my innumerable queries. I would like to thank Helen Craven for her support during the initial stages of research and my brother, Bob Seago, for his help in preparing the illustrations.

This book is dedicated to my father, who always said I should write about Pop.

ALEX SEAGO

London
July 1994

List of colour plates

Between pages 74 and 75

1 Cover of *ARK* 24 (Autumn 1959) by Denis Postle. Courtesy Denis Postle and RCA Department of Graphic Design and Art Direction.

2 Robyn Denny, *Eden Come Home* (c.1957). Courtesy Robyn Denny.

3 Ruskin Spear, *Homage to Barnett Newman and Alexander Liberman* (1970). Courtesy Mrs Mary Spear.

4 Ruskin Spear, *Portrait of a Young Contemporary* (c.1959). Courtesy Mrs Mary Spear.

5 Advertisement for the Orient Line on back cover of *ARK* 24 (Autumn 1959) by Denis Postle. Courtesy Denis Postle and RCA Department of Graphic Design and Art Direction.

6 Cover for *Never Mind the Bollocks, Here's the Sex Pistols* by Jamie Reid (Virgin Records, 1976). Courtesy Virgin Records and Jamie Reid.

7 Design by David Collins for Toni del Renzio's article 'Shoes, Hair, and Coffee' in *ARK* 20 (Autumn 1957). Courtesy David Collins and RCA Department of Graphic Design and Art Direction.

8 Derek Boshier, *I Wonder what my Heroes Think of the Space Race?* (1962). Courtesy Derek Boshier.

9 Pull-out from the Beatles' *Sergeant Pepper's Lonely Hearts Club Band* (1967) designed by Peter Blake and Jann Howarth. © Apple Corps Ltd

10 Cover of *ARK* 32 (Summer 1962) by Brian Haynes. Courtesy Brian Haynes and RCA Department of Graphic Design and Art Direction.

11 'Get Age' collage by Brian Haynes in *ARK* 32 (Summer 1962). Courtesy Brian Haynes and RCA Department of Graphic Design and Art Direction.

12 'Kit of Images' by Brian Haynes in *ARK* 32 (Summer 1962). Courtesy Brian Haynes and RCA Department of Graphic Design and Art Direction.

13 Cover of *The Who Sell Out* 1967 designed by David King and Roger Law with photographs by David Montgomery. Courtesy Trinifold Management Ltd.

14 Poster designed by Robyn Denny for a lecture at the RCA by Lawrence Alloway on 19 February 1959. Courtesy Robyn Denny and RCA Department of Graphic Design and Art Direction.

List of black and white plates

1 Coronation year exhibition poster (1953) by David Gentleman. Courtesy David Gentleman and RCA Department of Graphic Design and Art Direction. *30*

2 Poster for RCA Film Society (*c*.1959) by Neil Godfrey. Courtesy RCA Department of Graphic Design and Art Direction. *30*

3 Posters for 'The Nature of Pop Art' lecture series by Neville Malkin (1963). Courtesy RCA Department of Graphic Design and Art Direction. *31*

4 Poster for RCA Film Society by Norman Vertigan (*c*.1960). Courtesy RCA Department of Graphic Design and Art Direction. *31*

5 Poster for RCA Jazz Club by John Fenton-Brown (1961). Courtesy RCA Department of Graphic Design and Art Direction. *31*

6 Poster for RCA 'Custer's Last Vest' Dance by Tony Guy (*c*.1959). Courtesy RCA Department of Graphic Design and Art Direction. *31*

7 Title-page of *Sir Gawain and the Green Knight* by Geoffrey Ireland (1956). Courtesy RCA Department of Graphic Design and Art Direction. *32*

8 Title-page of *The Life of John Wilkes*, designer unknown (1956). Courtesy RCA Department of Graphic Design and Art Direction. *32*

9 Cover of *ARK* 1 by Geoffrey Ireland (1950). Courtesy RCA Department of Graphic Design and Art Direction. *33*

10 Advertisement for *ARK* 30 (Winter 1961), designer unknown. Courtesy RCA Department of Graphic Design and Art Direction. *35*

11 Advertisement for Shell-BP from *ARK* 34 (Winter 1963) by Melvyn Gill. Courtesy Joint Shell-Mex and BP Advertising Archive and RCA Department of Graphic Design and Art Direction. *37*

12 Advertisement for Murphy televisions from *ARK* 24 (Autumn 1959) by Denis Postle. Courtesy Denis Postle and RCA Department of Graphic Design and Art Direction. *38*

13 Advertisement for Colman, Prentis, and Varley from *ARK* 26 (Summer 1960) by Colin Murray. Courtesy Colin Murray and RCA Department of Graphic Design and Art Direction. *38*

14 Cover of *ARK* 12 (Autumn 1954) by Patricia Davey. Courtesy RCA Department of Graphic Design and Art Direction. *39*

15 Frontispiece of *ARK* 13 (Spring 1955) by Alan Fletcher. Courtesy Alan Fletcher and RCA Department of Graphic Design and Art Direction. *39*

16 Cover of *ARK* 19 (Spring 1957) by Gordon Moore. Courtesy Gordon Moore and RCA Department of Graphic Design and Art Direction. *41*

17 Layout for *ARK* 22 (Summer 1958) by David Varley. Courtesy RCA Department of Graphic Design and Art Direction. *41*

18 Cover of *ARK* 25 (Spring 1960) by Terry Green. Courtesy Terry Green and RCA Department of Graphic Design and Art Direction. *41*

19 Detail of 'Adam Faith Show' centrefold by Allan Marshall for *ARK* 30 (Winter 1961). Courtesy RCA Department of Graphic Design and Art Direction. *43*

20 Cover of *ARK* 28 (Spring 1961) by Allan Marshall. Courtesy RCA Department of Graphic Design and Art Direction. *43*

21 Cover of *ARK* 33 (Autumn 1962) by Keith Branscombe. Courtesy RCA Department of Graphic Design and Art Direction. *43*

22 Princess Margaret photomontage from *ARK* 34 (Winter 1963) by Michael Foreman. Courtesy Michael Foreman and RCA Department of Graphic Design and Art Direction. *44*

23 Cover of *ARK* 36 (Summer 1964) by Roy Giles and Stephen Hiett. Courtesy RCA Department of Graphic Design and Art Direction. *46*

24 Cover of *About Town* (Summer 1960). Courtesy Haymarket Publishing Group. *46*

25 Layout for 'People of the 60's' article featuring 'Pioneer of Pop Art' Peter Blake, *Sunday Times Colour Section*, (1 February 1962). © Times Newspapers Ltd. *47*

26 Rear view of Lion and the Unicorn Pavilion (1951). Photo courtesy RCA Department of Graphic Design and Art Direction. *53*

27 Entrance to Lion and the Unicorn Pavilion. Photo courtesy RCA Department of Graphic Design and Art Direction. *53*

28 Interior display in Lion and the Unicorn Pavilion. Photo courtesy RCA Department of Graphic Design and Art Direction. *53*

29 Interior display in Lion and the Unicorn Pavilion. Photo courtesy RCA Department of Graphic Design and Art Direction. *53*

30 Poster by Edward Bawden for the film *The Titfield Thunderbolt* (1953). Courtesy Initial Group. *56*

31 Poster for a lecture by Nikolaus Pevsner on 'The Englishness of English Art' (*c*.1953), designer unknown. Courtesy RCA Department of Graphic Design and Art Direction. *56*

32 Photograph of John Minton (*c*.1952) Photographer unknown. Courtesy RCA Department of Graphic Design and Art Direction. *58*

33 Illustration by John Minton for Elizabeth David's *French Country Cooking* (1951). Courtesy Sir Anthony Lousada. *59*

34 Book jacket by John Minton for *The Country Heart* by H. E. Bates. Courtesy Sir
 Anthony Lousada and Michael Joseph Ltd. *60*

35 Advertisement from the Festival of Britain catalogue (1951). Published by HMSO. *61*

36 Cover for *ARK* 4 (Spring 1952) by David Gentleman. Courtesy David Gentleman and
 the RCA Department of Graphic Design and Art Direction. *63*

37 Illustration by Jim Lovegrove for his article 'The Spritsail Sailing Barge' in *ARK* 4
 (Spring 1952). Courtesy RCA Department of Graphic Design and Art Direction. *64*

38 Illustration in *ARK* 7 (Spring 1953) by Peter Midgley. Courtesy RCA Department of
 Graphic Design and Art Direction. *65*

39 Illustration by W. Crawford Snowden for his article 'The Pool of London' in *ARK* 7
 (Spring 1953). Courtesy RCA Department of Graphic Design and Art Direction. *65*

40 Advertisement for Shell (1930). Courtesy Joint Shell-Mex and BP Advertising
 Archive. *73*

41 Advertisement by Paul Nash for Shell (1932). Courtesy Joint Shell-Mex and BP
 Advertising Archive. *73*

42 Advertisement by John Skeaping for Shell (1952). Courtesy Joint Shell-Mex and BP
 Advertising Archive. *73*

43 Poster by David Gentleman for the Royal College of Art Theatre Group's
 performance of *Orphée* and *The Life and Death of Tom Thumb the Great* (1952). Courtesy
 David Gentleman and RCA Department of Graphic Design and Art Direction. *83*

44 Poster by Paul Temple for the Royal College of Art Theatre Group's performance of
 The Beggar's Opera (1953). Courtesy RCA Department of Graphic Design and Art
 Direction. *83*

45 A 'hominoid' robot made by Bruce Lacey (late 1950s). Courtesy Bruce Lacey. *88*

46 The Alberts (early 1960s). Photographer Bruce Lacey. Courtesy Bruce Lacey. *89*

47 The Bonzo Dog Doo-Dah Band (mid-1960s). Photographer Stephen Goldblatt. Private
 collection of Mrs Mary Spear. Courtesy Mrs Mary Spear. *89*

48 *Evening of British Rubbish* poster by John Sewell (1961). Private collection of Bruce
 Lacey. Courtesy Bruce Lacey. *90*

49 Illustration for *ARK* 34 (Winter 1963). Courtesy RCA Department of Graphic Design
 and Art Direction. *90*

50 Cover for *ARK* 23 (Autumn 1958) by David Gillespie. Courtesy David Gillespie and
 RCA Department of Graphic Design and Art Direction. *95*

51 Stained glass window, nave, for Coventry Cathedral by L. Lee, G. Clarke, and K. New
 (1956). Photographer unknown. Courtesy Keith New and
 RCA Department of Graphic Design and Art Direction. *98*

52 Mosaic mural for Abbey Wood School by Robyn Denny (1959).
 Courtesy Robyn Denny. *99*

53 Edward Wright, typographic mural on exhibition building, International Union of
 Architects' Congress, South Bank, London, 1961. Architect: Theo Crosby. *101*

54 *Ev'ry Which Way: A Project for a Film* by Robyn Denny and Richard Smith, *ARK* 24

(Autumn 1959). Courtesy Robyn Denny, Richard Smith, RCA Department of Graphic Design and Art Direction. *102*

55 Poster for the 'Kurt Schwitters' exhibition at the Lords Gallery, October 1958. Private collection Derek Hyatt. Courtesy Derek Hyatt. *103*

56 Peter Blake, *On the Balcony* (1955–7) 121.3 x 90.8 cm. Courtesy the Tate Gallery, London. *106*

57 Barrie Bates, 'Loving Tea Pots' project (*c.*1962). Private collection Brian Haynes. Courtesy Brian Haynes. *108*

58 Poster for RCA Film Society by Barrie Bates (*c.*1962). Courtesy Barrie Bates and RCA Department of Graphic Design and Art Direction. *108*

59 Photograph of Robyn Denny and Richard Smith from *ARK* 20 (Autumn 1957). Courtesy Robyn Denny, Richard Smith, and RCA Department of Graphic Design and Art Direction. *113*

60 Poster for RCA Film Society by Ken Sequin (1962). Courtesy Ken Sequin and RCA Department of Graphic Design and Art Direction. *134*

61 Brigitte Bardot centrefold by Terry Green from *ARK* 25 (Spring 1960). Courtesy Terry Green and RCA Department of Graphic Design and Art Direction. *134*

62 Peter Blake, 'Only Sixteen', *ARK* 25 (Spring 1960). Courtesy Peter Blake and RCA Department of Graphic Design and Art Direction. *135*

63 Poster for the 'Have Image Will Travel!' exhibition at the Oxford University Divinity School, October 1959. Courtesy RCA Department of Graphic Design and Art Direction. *136*

64 Exhibit from the 'Have Image Will Travel!' exhibition. Courtesy RCA Department of Graphic Design and Art Direction. *137*

65 Exhibit from the 'Have Image Will Travel!' exhibition. Courtesy RCA Department of Graphic Design and Art Direction. *137*

66 Layout by Derujinsky for *Harper's Bazaar* (1951) © 1951 courtesy Hearst Corporation/ *Harper's Bazaar*. *142*

67 Cover for *ARK* 10 (Spring 1954) by Len Deighton. Courtesy Len Deighton and RCA Department of Graphic Design and Art Direction. *146*

68 'Hopalong Cassidy' comic insert in *ARK* 10 (Spring 1954). Courtesy RCA Department of Graphic Design and Art Direction. *146*

69 'A Bowler Hat on Broadway' illustrations by Len Deighton in *ARK* 13 (Spring 1955). Courtesy Len Deighton and RCA Department of Graphic Design and Art Direction. *147*

70 Poster for RCA Film Society by John Sewell (*c.*1954). Courtesy RCA Department of Graphic Design and Art Direction. *147*

71 Dust jacket design for Len Deighton's *The Ipcress File* by Raymond Hawkey (1962) Artist's collection. Courtesy Raymond Hawkey. *148*

72 Photograph by Alan Fletcher in *ARK* 19 (Spring 1957). Courtesy Alan Fletcher and RCA Department of Graphic Design and Art Direction. *150*

73 Poster for *ARK* 19 (Spring 1957) by Gordon Moore. Courtesy Gordon Moore and RCA Department of Graphic Design and Art Direction. *150*

74 Cover for *ARK* 20 (Autumn 1957) by A. J. Bisley. Courtesy RCA Department of Graphic Design and Art Direction. *154*

75 Design by David Collins for Richard Smith's article 'Man and He-Man' in *ARK* 20 (Autumn 1957). Courtesy David Collins and RCA Department of Graphic Design and Art Direction. *162*

76 Poster by Peter Smith for a lecture by Colin Cherry (*c*.1959). Courtesy RCA Department of Graphic Design and Art Direction. *169*

77 Cover of Robyn Denny's thesis 'Language, Symbol, Image' (1957). Courtesy Robyn Denny. *173*

78 Peter Blake, *Self Portrait with Badges* (1961) 173 x 122 cm. Courtesy the Tate Gallery, London. *176*

79 'Glances in the Slanting Rain' illustration by Joe Tilson in *ARK* 14 (Summer 1955). Courtesy Joe Tilson and RCA Department of Graphic Design and Art Direction. *180*

80 'Down Past Compton on Frith, Food Makes Wonderful Music' illustration by Len Deighton in *ARK* 10 (Spring 1954). Courtesy Len Deighton and RCA Department of Graphic Design and Art Direction. *180*

81 Photograph of interior of El Sombrero espresso bar in *ARK* 20 (Autumn 1957), photographer unknown. Courtesy RCA Department of Graphic Design and Art Direction. *183*

82 Advertisement for Vince Man's Shop by Gordon Moore in *ARK* 20 (Autumn 1957). Courtesy Gordon Moore and RCA Department of Graphic Design and Art Direction. *184*

83 Roger Mayne, *Southam St.*, photograph in *Uppercase* (1958). Courtesy Roger Mayne. *187*

84 *On the Mat at Lime Grove*, photograph by A. J. Bisley in *ARK* 20 (Autumn 1957). Courtesy RCA Department of Graphic Design and Art Direction. *188*

85 *Beaulieu Jazz Festival 1960*, photograph by Allan Marshall in *ARK* 28 (Spring 1961). Courtesy RCA Department of Graphic Design and Art Direction. *188*

86 Layout from *Twen* (1959). *191*

87 Layout from *Twen* (1960). *190*

88 Layout from *Town* (1960). Courtesy Haymarket Publishing Group *190*

89 'Twist Drunk' picture story by Keith Branscombe in *ARK* 33 (Autumn 1962). Courtesy RCA Department of Graphic Design and Art Direction. *191*

90 Poster for 'British Paintings at the Paris Biennale 1963' featuring Derek Boshier, Peter Phillips, Joe Tilson, David Hockney, and Peter Blake by Stephen Abis (1963). Courtesy Janet Abis and RCA Department of Graphic Design and Art Direction. *192*

91 Layout for Richard Smith's 'New Readers Start Here' by Brian Haynes (featuring cover of the 'Kit of Images' and photograph of *I will Love you* by David Hockney) in *ARK* 32 (Summer 1962). Courtesy Brian Haynes and RCA Department of Graphic Design and Art Direction. *193*

92 'Twist Drunk' by Keith Branscombe in *ARK* 33 (Autumn 1962). Courtesy RCA Department of Graphic Design and Art Direction. *195*

93 *Bowery* photograph by Brian Haynes in *ARK* 32 (Summer 1962). Courtesy Brian Haynes and RCA Department of Graphic Design and Art Direction. *195*

94 Cover of *Queen* (16 Aug. 1961), photographer Peter Williams, art editor Gordon Moore. © National Magazine Co. Ltd. *199*

95 Cover of *Town* (Sept. 1962), photographer Horst Baumann. Courtesy Haymarket Publishing Group *199*

96 'A Clown with Vision' by Emma Yorke: article on David Hockney in *Town* (Sept. 1962). Courtesy Haymarket Publishing Group. *199*

97 Cover of *Sunday Times Magazine* (30 Aug. 1964) featuring RCA industrial design student Vic Roberts © Times Newspapers Ltd. *202*

98 *Sunday Times Magazine* feature on young designers, including Zandra Rhodes, George Ingham, Nick Jensen, Roger Wilkes, and Richard Lord © Times Newspapers Ltd. *202*

99 'Private View' feature on Richard Smith in the *Sunday Times Magazine* (3 Oct. 1965), photograph by Lord Snowdon. Courtesy Lord Snowdon. © Times Newspapers Ltd. *203*

100 *Queen* (21 June 1967). © National Magazine Co. Ltd. *203*

101 Poster for 'Graphics RCA' (1963). Courtesy RCA Department of Graphic and Art Direction. *204*

102 'It Lasts Only a Second but we Know we're Really Alive', surfing feature by Roy Giles and Stephen Hiett in *ARK* 36 (Summer 1964). Courtesy RCA Department of Graphic Design and Art Direction. *209*

103 Introduction to 'New England' photo-essay in *The Face* (August 1986), art direction by Robin Derrick, photography by Nick Knight. © Nick Knight *209*

104 *New England* photograph by Nick Knight, art direction by Robin Derrick in *The Face* (Aug. 1986). © Nick Knight. *210*

105 'A Fine-Artz view of teenage cults' in *ARK* 36 (Summer 1964). Courtesy RCA Department of Graphic Design and Art Direction. *211*

106 'Was Freddy Kreuger a Mod?' photographs by Christian Thompson, *The Face* (Nov. 1988). Courtesy Camilla Arthur Representation Europe. *211*

Introduction

Pop and 'National Postmodernisms'

This book was originally inspired by the desire to understand and discover the origins of postmodern culture in Britain. As many cultural historians are aware, a major obstacle in any study of the postmodern arises when one attempts to achieve a working definition of the term, for although 'postmodernism' is one of the most commonly used words in contemporary academic discourse, it is also one of the most infuriatingly elusive. As the cultural critic Dick Hebdige has pointed out:

Postmodernism—we are told—is neither a homogeneous entity nor a consciously directed 'movement'. It is instead a space, a 'condition', a 'predicament', an *aporia*, an 'unpassable path'—where competing intentions, definitions, and effects, diverse social and intellectual tendencies and lines of force converge and clash. When it becomes possible for people to describe as 'postmodern' the decor of a room, the design of a building, the diagesis of a film, the construction of a record, or a scratch video or a TV commercial . . . the layout of a page in a fashion magazine or a critical journal . . . a general attenuation of feeling, the collective chagrin and morbid projections of a generation of baby boomers confronting disillusioned middle age, the 'predicament' of reflexivity . . . a process of cultural, political or existential fragmentation, the 'decentering of the subject', the 'incredulity towards metanarratives' . . . the decline of the university, the functioning and effect of new miniaturized technologies, broad societal and economic shifts into a 'media', 'consumer' or 'multinational' phase . . . when it becomes possible to describe all these things as 'postmodern' . . . then it's clear we are in the presence of a buzzword.[1]

Clues to discovering the origins of postmodern culture and disentangling the plethora of meanings the term postmodernism has accrued have been provided by the German cultural historian Andreas Huyssen. In an essay appropriately titled 'Mapping the Postmodern', he argues that what is loosely referred to as

postmodernism and 'appears on one level as the latest fad, advertising pitch or hollow spectacle' is, in fact, part of a slowly emerging international cultural transformation, a change in sensibility in which 'there is a noticeable shift in practices and discourse formations which distinguish a postmodern set of assumptions, experiences, and propositions from that of the preceding period'.[2] What needs further exploration, however, is whether this transformation is generating genuinely new aesthetic forms or whether it is simply recycling the techniques and strategies of modernism.

Huyssen explains the emergence of postmodernism as a response to the exhaustion of the modern movement, and, more specifically, as a response to the exhaustion of a specific image of modernism which has to be reconstructed in order to understand postmodernism's problematic relationship to the modernist tradition. Turning to architecture as the most palpable model of the issues at stake, postmodern architecture is interpreted as a response to the exhaustion of modernist utopian ideas which were 'part of an heroic attempt after the Great War to rebuild a war ravaged Europe in the image of the new . . . to make building a vital part of the envisioned renewal of society'. After 1945 modern architecture was 'shipwrecked on its own internal contradictions' and, largely deprived of its former social vision, became increasingly an architecture of power and representation. Rather than representing a promised utopia, modernist housing projects, for example, became symbols of alienation and dehumanization. Rejecting the modernists' denial of the past, postmodernist architects favoured the reintroduction of multivalent symbolic dimensions into architecture, mixing codes and appropriating elements of local vernacular styles and regional traditions into their work. For Huyssen, the publication of *Learning from Las Vegas* (1972) by Robert Venturi *et al.* was the 'most telling moment' of the 'postmodern break' in American architecture and he emphasizes the proximity of Venturi's strategies and solutions to what he refers to as the American 'pop sensibility' of the 1960s:

Time and again the authors use Pop Art's break with the austere canon of High Modernist painting and Pop's *uncritical* espousal of the commercial vernacular of consumer culture as an inspiration for their work . . . Pop in its broadest sense was the context in which a notion of the postmodern first took place . . . from the beginning until today, the most significant trends within postmodernism have challenged modernism's relentless hostility to mass culture.[3]

From the vantage-point of English culture, the observation that the pop and postmodern sensibilities are very closely related, if not actually synonymous,

seems particularly valid. Huyssen points out, however, that for a variety of reasons the idea of a postmodern sensibility would not have made much sense in Continental Europe during the 1960s. In his native West Germany, for example, the 1960s witnessed a major re-evaluation and shift of interest away from one set of moderns to another, away from 'Kafka and Thomas Mann to Brecht, the left expressionists and the political writers of the 1920s, from Heidegger and Jaspers to Adorno and Benjamin'.[4] Unlike the Americans, Germans were not rejecting modernism but searching for alternative cultural traditions within modernity which were then directed against the 'depoliticised version of modernism' which provided the cultural legitimation for the Adenauer restoration:

From the depths of barbarism and the rubble of its cities, West Germany was trying to reclaim a civilised modernity and to find a cultural identity turned to international modernism which would make others forget Germany's past as predator and pariah of the modern world. Given this context, neither the variations on modernism of the 1950s, nor the struggle of the 1960s for alternative democratic and socialist cultural traditions could possibly be construed as *post* modern.[5]

In France, too, Huyssen argues, the 1960s witnessed a return to modernism rather than a step beyond it. Within the context of French intellectual life the term 'structuralism' did not seem to imply a major break with modernism, as it did in the United States. Contemporary French structuralist and poststructuralist criticism can be perceived as being theories of and about modernism. Few French theorists have displayed much real involvement as consumers of an alien pop culture; they are essentially gourmets of the discourses of Continental modernism. Rather than offering a theory of postmodernity and developing coherent analyses of contemporary culture, the French theoreticians of the 1960s and 1970s provided an 'archeology of modernity'—an account of 'modernism at the stage of its exhaustion': 'It is as if the creative powers of modernism had migrated into theory and come to full self-consciousness in the poststructuralist text—the owl of Minerva spreading its wings at the fall of dusk.'[6]

For Huyssen, then, the postmodern cultural break is essentially American. In literature and the visual arts it began in the mid-1950s with the rebellion of a new generation of artists including Rauschenberg, Johns, Burroughs, Kerouac, and Ginsberg against the dominance of Abstract Expressionism and classical literary modernism. The American revolt of the 1960s was not a rejection of modernism *per se* but rather a revolt against a version of modernism which had become domesticated during the 1950s, had become part of the liberal-conservative consensus of the times, and had been turned into a propaganda weapon. American postmodernism, therefore, is a movement *sui generis* which owes its

peculiar characteristics to the cultural history of the United States. Although European-born avant-garde artists such as Marcel Duchamp became the 'godfathers' of the new American sensibility, the historical background against which the movement was staged (the Beat Poets, the Civil Rights Movement, the Bay of Pigs, Vietnam, the hippie counter-culture, etc.) made it specifically American:

Perhaps for the first time in American culture an avantgardist revolt against a tradition of high art and what was perceived as its hegemonic role made political sense. High art had indeed become institutionalized in the burgeoning museum, gallery, concert, record, and paperback culture of the 1950s. Modernism itself had entered the mainstream via mass reproduction and the culture industry . . . The irony in all this is that the first time the United States had something resembling an 'institution art' in a European sense, it was *modernism* itself, a kind of art whose purpose had always been to *resist* institutionalization.[7]

American postmodernism of the 1950s and 1960s was distinguished from other national varieties by its attempt to validate popular culture as a challenge to high art. The beat poetry, jazz, rock music, 'psychedelic' graphic design, and 'multimedia' experimentation characteristic of American postmodernism during this period resulted in a new relationship between high art and mass culture which has become a major source of difference between high modernism and much of the art, music, and literature which has been produced since the late 1960s.

Arguing that the American postmodernism of the 1950s and 1960s can only be understood by analysing the reception of international modernism within the specific context of American cultural history, Huyssen makes a point of central importance to the chapters which follow by stressing that contemporary cultural historians must be very wary of making vague theoretical generalizations which eulogize or ridicule postmodernism *en bloc* as if it were a standardized international movement. The cultural historian, it is implied, should concentrate instead upon detailed analyses of the ways in which an idea of the postmodern developed within specific cultural contexts:

It is important for the cultural historian to analyse . . . *ungleichzeitigkeiten* [turbulent periods] within modernity and . . . relate them to the very specific constellations and contexts of national and regional cultures and histories. The view that the culture of modernity is essentially internationalist . . . is a view tied to a teleology of modern art whose unspoken subtext is the ideology of modernization. It is precisely this teleology of modernization which has become increasingly problematic in our postmodern age.[8]

While 'Mapping the Postmodern' provides some clues to the aspiring

cartographer of the origins of the postmodern in English culture, the specific characteristics of those '*ungleichzeitigkeiten* within modernity' within which one is led to suppose an English postmodernism must have arisen originally are never mentioned. This study, therefore, is an attempt to extend the map of the postmodern by surveying and charting some of the *terra incognita* of post-war English culture.

1

'Years may come, years may go, but the Art School Dance goes on forever': Art and Design Education and an English Postmodern Sensibility[1]

The earliest accounts of the development of what might be recognized as a distinctly English postmodern cultural sensibility began to appear towards the end of the 1960s. Jeff Nuttall's *Bomb Culture*, a rambling, highly idiosyncratic story of the development of the post-war English 'underground', traced the fusion of pop culture and avant-garde art from its origins in the existentialist beatnik havens of Paris and San Francisco through the jazz clubs and coffee bars of London and Liverpool to its widespread diffusion through the channels of 'progressive' rock and hippie counter-culture during the mid-1960s. From Nuttall's perspective the crucial fusion of the hitherto distinct 'art', 'protest', and 'pop' subcultures occurred in the opening years of the 1960s:

Up to [that] point . . . it would be broadly true to say that pop was the prerogative of working class teenagers, protest was the prerogative of middle class students, and art was the prerogative of the lunatic fringe. The pop fans despised protest as being naïve and art as being posh, the protesting students despised pop as being commercial and art as being pretentious, and the artists despised pop for being tasteless and protest for being drab.[2]

Nuttall maintains that one catalyst which helped fuse these subcultural groups was the *Goon Show*, the radio comedy programme which ran throughout the 1950s. For Nuttall the origins of the *Goon Show*'s humour lay in the absurd experience of compulsory National Service in an era dominated by the H-bomb. It brought together hitherto alien traditions and its influence was very widespread. 'The Goon Show was protest. The Goon Show was surrealist and therefore art, the Goon Show was every National Serviceman's defence mechanism, and was therefore pop.'[3] The *Goon Show*'s influence was particularly potent in the London art schools from the mid-1950s onwards and, in Nuttall's opinion, it was from these institutions that a large part of the new 'underground' culture emerged:

Throughout this world the prevailing mood was pure Goon and the prevailing sentiment was anti-bomb. The crowning expression of both the mood and the sentiment was the comedy-trad of two bands, the Temperance Seven and the Alberts. The Temps, who started off with a brilliant freak clarinettist called Joey, finished up in the Top Twenty. The Alberts, far wilder than the Temps, with disturbing elements of genuine lunacy in their make-up, consisted of the Grey Brothers and Bruce Lacey and . . . his magnificent hominoids, sick, urinating, stuttering machines constructed of the debris of the century.[4]

Through personalities such as Screaming Lord Sutch, who 'took some of the Alberts' lunacy into the rock 'n' roll clubs', Dick Lester, the director of the Beatles' films who worked with Bruce Lacey and Spike Milligan of the Goons, the manic theatrical rock singer Arthur Brown, and Pete Townshend of The Who, a *Goon Show*-inspired London art school sensibility became mainstream by the mid-1960s, when 'there were close connections between the popular music world and the previously separate world of art'.[5]

More staid and serious than *Bomb Culture*, Christopher Booker's *The Neophiliacs: A Study of the Revolution in English Life in the Fifties and Sixties* (1969) is a fairly coherent early cultural history of the period. Booker, a leading light in the satire boom of the early 1960s and the first editor of *Private Eye*, discovers the origins of a distinctly English 'cultural revolution' in the Festival of Britain, the trad jazz cult, the Independent Group at the ICA, and the Teddy boy subculture of the early 1950s. For Booker the 'moment' of this fundamental change in English culture occurred in 1955–6. In his analysis the cultural revolution was synonymous with the idea of 'image':

if there was one bond which linked the different aspects of the changes which came over English life since 1956, it was the extent to which so many of them contributed to the presence in society of a new body of eye- and mind-catching imagery—the images of television and advertising, the subtler omnipresence of beat music, the visual imagery of eye-catching clothes, the bright lights of the new supermarkets, the glossy packaging of food.[6]

For Booker an important harbinger of the cultural revolution was the 'This is Tomorrow' exhibition of 1956, which 'largely under the influence of the Independent Group from the ICA . . . caused a stir among the rising generation of art students equivalent to that aroused in the theatre by *Look Back in Anger*'.[7]

Although Booker's work is intuitive and atheoretical, his emphasis on the idea that the 'Neophiliacs' of the 1950s and 1960s were 'in love with' the hollow and, in his opinion, worthless imagery of pop culture allies his writing to the more pessimistic analyses of the 'postmodern condition' which appeared during the 1980s.[8]

As early as 1969, therefore, we can see the critical positions which continue to characterize contemporary debates about postmodernism beginning to coalesce. On the one hand we have Nuttall, who celebrates the collapse of traditional cultural boundaries and emphasizes the new possibilities for cultural intervention which spring up out of the ruins of the old order. On the other we have the far more conservative voice of Booker, recognizing the same phenomena but remaining deeply pessimistic regarding their likely cultural consequences.

Robert Hewison's ambitious trilogy—*Under Siege: Literary Life in London 1939–45* (1977), *In Anger: Culture in the Cold War 1945–60* (1981), and *Too Much: Art and Society in the Sixties 1960–1975* (1986)—attempts a comprehensive cultural history of post-war Britain. Hewison's approach is methodologically conservative, focusing upon the 'relationship between artistic activity and the institutions, both cultural and political, which create the climate in which individual artists and writers have to work'.[9] His main topics are 'British art and literature and the institutional, economic, and social conditions in which they are produced'. As the extensive 'Notes on Sources' which conclude each volume reveal, the raw material for Hewison's brand of cultural history resides in the stacks of university libraries and archives. 'Culture' remains synonymous with the novel, poetry, theatre, painting, and sculpture. 'Pop culture', that is jazz, pop, and rock music, advertising, commercial radio, television, and even film, is virtually ignored. In his analysis of the cultural history of post-war Britain the genesis of what we might describe as a 'postmodern break' can be discovered in the convergence of high culture and pop culture during the 1960s, a decade in which 'what might be loosely defined as "high" culture was considerably modified by the impact of the mass media and the so-called "popular" culture that it reflected'.[10]

In Hewison's analysis Pop Art is seen as an important precursor of the broader interconnections between high and popular culture which would characterize the 1960s. Pop Art was 'the herald of the celebratory side of the sixties, the side that welcomed material affluence and the cultural and social changes that it brought'.[11] Although Pop Art was a specifically British movement, the artefacts it was fascinated by were mainly American since these represented 'the most industrialised forms of mass culture'. This American material offered the early Pop painters alternatives to what Hewison describes as the 'Mandarin' values of the British 'intellectual aristocracy' of the 1950s:

Thanks to the war and its consequences, Mandarin values dominated the early 1950s. Having abandoned the mild socialism that had given Bloomsbury a radical edge up to 1945, the intellectual aristocracy fell back on a system of values that was more appropriate to the function they performed and the caste from which they came. These values were

truly aristocratic in origin, in that they were conservative by tradition, pastoral as opposed to industrial, and most detectable when it came to nuances of class.[12]

The atmosphere within which these literary mandarin values developed is described by Hewison as 'reactionary' since its effect was to reassert the importance of hierarchy and tradition, a mood that was perfectly in tune with a succession of Conservative Party election victories and the warm response to the Coronation of Elizabeth II in 1953. The arts were central to the mandarin way of life, for although relatively few were involved in creating art, many were employed in disseminating it and the values it expressed:

The existence of an avant garde was tolerated, even promoted, though this was most evident in painting, where the function of an avant garde was most institutionalized. The wartime avant garde had produced a picturesque, English-rooted neo-Romanticism . . . suited to the prevalent nostalgic hankering after an idealized earlier period, before modernism and before world wars, when cultural and social values seemed retrospectively more secure.[13]

Hewison's explanation of why artists and art critics should have played such a prominent role in challenging these mandarin values is particularly interesting, for he argues that, whereas other cultural fields such as literature and the theatre tended to be dominated by graduates of Oxford and Cambridge, the visual arts retained their own peculiar system of recruitment—the art schools. Whereas a public school/Oxbridge background tended to produce individuals who were 'conformist, socially conscious and repressed' while skilled in 'the manipulation of institutions', the post-war art school was

a haven for imaginative people otherwise neglected by the educational system . . . the relative freedom of art schools encouraged experiments with style. For working class students they were an escape route from the factory, for middle class students they were the entry to bohemia.[14]

Whereas the arts departments of British universities during the 1950s and early 1960s were bastions of the anti-American cultural criticism which characterized that period, students in the more classless, socially marginal art schools tended to be less encumbered by these prejudices.

In Hewison's analysis, the Independent Group at the ICA were the first to challenge the traditional mandarin view of the arts as a pyramid with the fine arts at the top and mass culture at the bottom. He points to Lawrence Alloway's essay 'The Long Front of Culture' (1959), which argued that mass production and general affluence had changed the terms in which culture could be evaluated and proposed a new 'long front of culture' to challenge traditional hierarchies of

value and subject-matter. As another example of the Independent Group's challenge to the cultural stance of university-based cultural critics Hewison cites Richard Hamilton's address to the 1960 National Union of Teachers' Conference on 'Popular Culture and Personal Responsibility', which stood in stark contrast to the Leavisite jeremiads of the other speakers by arguing that mass production and the mass media did not necessarily imply cultural uniformity. On the contrary, Hamilton argued, the new pop culture opened up a far greater number of individual cultural choices than those which had been available under a pre-industrial craft economy.

A similar description of the 'postmodern break' in British culture is offered by Bryan Appleyard. In his *The Pleasures of Peace: Art and Imagination in Postwar Britain* (1989) he argues that the Pop Art and pro-Pop cultural criticism of the Independent Group 'hardened and updated the role of the artist' in Britain. The 'true Pop tone of voice' was tough, lacking 'the humane anguish of the earlier generation or, indeed, any metaphysical pretensions'.[15] For Appleyard the cultural significance of the Independent Group lay 'in its reversal of the visual preoccupations of twentieth century painting'.[16] He argues that whereas in Britain before the war 'painterly mainstream modernism in the shadow of Picasso and Matisse had been the orthodoxy',[17] Pop represented a postmodern rejection of 'the emphasis on form and the painted surface' by adopting

a dead pan or ironic pose. It did not wish to assault . . . the nervous system, but rather it aimed to provoke the suave pleasures of the intellect and the senses to unite us with the city and its technology. Its fragmentary imagery was placed before us as significant information, which the new urban self could interpret as it pleased. If Richard Hamilton was the synthesiser of this idea, Eduardo Paolozzi was its cataloguer.[18]

Appleyard sees Pop Art as directed at a 'new audience . . . who would respond to the idea of an art based on the familiar ephemera of urban life' and in his analysis the success of the pop idea finally became clear in the popular cultural manifestations of the 1960s because:

At the heart of Pop was a denial of the old distinctions between high and low art. Its glorification of 'B' movies and magazine iconography was a deliberate sneer at the former hierarchies of significance. The oil, bronze and stone images of fine art were revealed as comically powerless when confronted by the visual feast provided by technology and mass communications.[19]

For Appleyard, as for Hewison, the art schools were a prime site for this cultural transformation which began in the visual arts. To exemplify the ways in which art students pioneered this new English cultural sensibility he discusses R. B. Kitaj's influence on David Hockney at the Royal College of Art in the early

1960s. Appleyard explains that Hockney's frustration with Abstract Expressionism was solved by following Kitaj's advice to 'paint what you like', which enabled the younger painter to escape from 'an arid, puritanical modernism into a landscape of fun and naughtiness':

He was freed from intellectual and critical programmes . . . this inclusiveness of all experience, however banal, had obvious affinities with Pop, but it was an easier, more open, less austere programme than that evolved by Hamilton and the Smithsons . . . by writing in paintings Hockney was achieving a new kind of artistic space for himself . . . which stressed a directness of communication, a kind of innocence in contrast to the sophisticated justifications of abstraction.[20]

According to Appleyard, it was this new, more accessible art which, combined with his gold lamé jackets and dyed blond hair, made Hockney a hero of pop culture alongside 'the Beatles, fashion models, and all the familiar paraphernalia of the 1960s'. Hockney and the other RCA Pop painters' 'liberal and inclusive . . . bright, celebratory, and optimistic work' represented a thorough rejection of the 'oversophistication' of the late modernist avant-garde.[21]

Unlike the cultural historians for whom 'culture' is synonymous with 'the arts', Bernice Martin's *Sociology of Contemporary Cultural Change* (1981) adopts a more rigorous model of culture and cultural change derived from the sociological theories of Emile Durkheim, Max Weber, and the interpretative phenomenology of Peter Berger. She argues that the cultural transformations Western societies have experienced since the Second World War are 'a continued working out of the principles of Romanticism which rooted themselves in North American and Western European culture at the outset of the modern age'.[22] This cultural transformation began 'as a sort of a cultural revolution among a small minority of crusading radicals' but has ended by altering 'the assumptions and habitual practices which form the cultural bedrock of the daily lives of ordinary people'.[23] The main agency which has promoted this change has been 'an international movement involving the arts and the politics of a cosmopolitan intelligentsia'.[24]

At the heart of this cosmopolitan radical movement, Martin argues, lay the counter-culture of the 1960s, which 'served as a dramatic embodiment of certain Romantic values which in subsequent decades became intimately woven with the fabric of our culture'. As a result 'what was shocking in 1968 is often too commonplace today to require comment'.[25]

In Martin's analysis a romantic drive towards boundary violation lay at the root of the profound cultural shifts of the 1960s: 'a single-minded, often fanatical onslaught on boundaries and structures, a crusade to release . . . the infinite

expressive chaos into the everyday world.'[26] The avant-garde of this subversive movement was the 1960s counter-culture whose most salient trait was 'liminality', or 'the symbolism of anti-structure'. In Martin's view, two main factors contributed to the incorporation of counter-cultural values into the mainstream of social life. The first was the fact that the social group which acted as the main carrier of these romantic values was a cultural élite located close to the status, if not the power, centre of industrial society: the upper middle classes in the expressive professions, particularly in the arts, the mass media, and higher education. The second was that by the early 1970s commerce was finding that hints of romantic expressiveness and authenticity helped sales and strengthened corporate images.

Unsurprisingly, Martin regards the British art schools of the late 1950s and 1960s as fertile breeding grounds for counter-cultural expressive romanticism, for it was in these 'riotous meccas of anti-structure' that the attitudes which infiltrated mainstream culture in subsequent decades were encouraged and nurtured. In Martin's analysis the first symptom of this virus in Britain was Pop Art:

the direct inheritor of the tradition of Dada and Surrealism. Pop Art offers a whole new anti-structure package: the breaking of taboos, the elevation of camp, the rejection of fixed form, the dislike of boundaries, rules, certainties of any kind, anarchic, mind-blowing humour, the use of violent motifs, of banality, of despised commercial images, materials and techniques, an investment in contradiction, fluidity and ambiguity.[27]

Having developed amongst the avant-garde art intelligentsia and their students in the art schools, Pop Art's subversive techniques filtered into the realm of popular culture via the channels of rock music and youth culture. For Martin this seepage from the academy into the mainstream was 'what was really new' about the 1960s and was a consequence first 'of the acceleration of cycles of stylistic change' and secondly of 'the determined violation of taboos against mixing vulgar commercialism with high art'.[28]

For Martin, therefore, Britain has been particularly susceptible to this seepage of anti-structural liminality from the counter-culture into the mainstream partly because of the curious character of its educational system. Writing as a conservative cultural critic in the pre-Thatcherite era, she claims that in England 'for a century at least . . . it has been more gentlemanly to be useless than useful: the expressive carries more kudos than the instrumental . . . the lower down one lies in the stratification system the more difficult it is to justify one's existence in purely expressive terms'.[29]

For Martin and those who share her views,[30] therefore, the 'postmodern break'

symbolized by Pop Art is evaluated negatively as being synonymous with anomie and a decline in aesthetic standards. For critics emerging from the 'Cultural Studies' tradition which developed at the University of Birmingham's Centre for Contemporary Cultural Studies during the 1970s, however, there was a distinct tendency to evaluate pop culture (as opposed to Pop Art, in which they showed no interest) positively.

In their book *The Popular Arts* (1964) Stuart Hall and Paddy Whannel were the first university-based British critics to distinguish between mainstream and marginal tendencies within popular culture and to suggest that the artefacts of the new mass media-based pop culture were being appropriated by working-class youth in socially significant ways to develop subcultures of 'resistance' to their conventional roles within capitalist society. This rather romantic view of popular culture being used as 'resistance' by working-class youth was the distinctive characteristic of the analyses of the styles of youth subcultures by young CCCS-trained critics including Paul Willis, Dick Hebdige, Angela McRobbie, Tony Jefferson, Iain Chambers, and John Clarke which appeared in *Resistance through Rituals: Youth Subcultures in Postwar Britain* (1975). Although the original CCCS approach to subculture and style paid scant attention to the relationship between art and design education and popular culture, preferring to focus instead upon the rituals of proletarian youth, it is particularly relevant as the 'Cultural Studies' approach to the analysis of pop culture provided a point of departure for several major analyses of the relationship between art and design education and cultural change in Britain.

The earliest of these studies, Howard Horne's 'Hippies: A Study in the Sociology of Knowledge' (1982), begins with a thoroughgoing critique of the CCCS approach and demonstrates its inapplicability to the analysis of the historical origins and cultural location of the British hippie counter-culture of the late 1960s. Horne argues that the hippie counter-culture had nothing in common with working-class youth subcultures such as Teddy boys, mods, rockers, and skinheads analysed by the CCCS theorists, but was instead 'a modernized instance of bohemianism, an attempt to formulate the ground rules of an aesthetic revolution and present a cultural critique according to the problems and solutions of artistic practice'.[31] He analyses the development of the hippie bohemian ideology by focusing upon the development of British art education and emphasizing the methods whereby these institutions 'kept the Romantic bohemian ideology alive and pertinent'.[32] The hippie counter-culture, Horne stresses, must be understood in relation to the institutional setting of the British art school, where the ideology of romantic bohemianism (epitomized for Horne by the statements of the students who occupied Hornsey College of Art in May

13

1968) re-emerged during the late 1960s as a solution to the conflicting cultural and artistic ideologies inherent in English art education:

> From being a setting of . . . mechanical purpose and ideological discipline in the nineteenth century organization of artistic training, the art school of the late 1960s had become an institution more than ready to embrace the idea of and the tensions of youth and expressive cultural opportunity being intertwined. In terms of ideologies of work, leisure, and style, the art school was the natural location for the attempted realization of this claimed unity.[33]

According to Horne, the philosophies of the major English art educational institutions (the RCA, the Slade, and the Royal Academy Schools) were, by the late 1950s, sharply polarized between the demands of a belief in an autonomous, albeit marginal, fine art practice and a modern, progressive push to feed the culturally relevant aspects of the visual arts. In the lower levels of the art education hierarchy, however, the situation was more turbulent, especially after the radical reorganization of art and design education which followed the publication of the Coldstream Report. The introduction of Bauhaus-inspired 'Basic Design' courses marked a shift in many of these art schools away from a general ambience of romantic conceptions of art towards the 'more sterile attitudes' of Pop and Conceptualism. Horne places the blame for this squarely at the feet of Victor Pasmore, Richard Hamilton, *et al.*, whose abandonment of traditional methods in favour of encouraging 'basic analytical power' is interpreted as a belated attempt to catch up with the experimental, formally questioning approaches of modernism. The originators of the Basic Design philosophy believed that before students could realistically practise art, all previously held beliefs about method, meaning, skill, and creativity had to be dismissed. In Richard Hamilton's words, there had to be 'a clearing of the slate'. As the new degree-equivalent Dip. A.D. qualification, with its academic entry requirements and compulsory courses in General Studies, began to replace the more vocationally oriented and specialized National Diploma of Design (NDD), Basic Design became institutionalized within British art education.

According to Horne the events at Hornsey College of Art in 1968 were partly an expression of discontent against these reforms which took the form of 'a restatement of the spirit of romantic bohemianism: an attempt not only to relocate and redefine the cultural position of artistic practice, but to redefine, in turn, the problems and solutions of wider cultural and political life around artistic aesthetic ideals'.[34] For Horne, therefore, the British 'underground' hippie counter-culture of the 1960s cannot be understood except as an updated version of bohemianism:

In their language, their ideology of work and leisure, their heroes and their attempts to redefine the aesthetics of politics in the pursuit of the aesthetic redefinition of culture . . . hippies were both bohemians and artists . . . in the magazines and the music of the 1960s the romance of the artistic life was articulated and eulogised . . . it was here in graphics and music . . . that the counterculture's own institutional base worked through the imagery of the artistic, Fine Art romantic tradition.[35]

Simon Frith and Howard Horne's *Art into Pop* (1987) reworks and refines Horne's thesis with direct reference to pop music, arguing that 'art school connections explain the extraordinary international impact of British music since the Beatles'.[36] The authors explain that the only way to account for the curious link between art and design education and British pop music is 'to put musicians themselves at the centre of the pop process', an approach which challenges the 'populist version of structuralism' promoted by CCCS-trained critics like Dick Hebdige and Paul Willis, who find positive meaning in mass culture not in its making but in its use—that is, mass culture is reclaimed for art via the concept of *bricolage*-based style. While the CCCS approach represented by Hebdige sees creativity, self-expression, and protest entering pop culture at the moment of consumption, Frith and Horne argue that more attention should be paid to the conditions of the production of pop culture.

For Frith and Horne, pop music has provided a 'solution' to a tension between creativity and commerce experienced particularly acutely by art students. Their position is that British pop music has been made 'through struggles and arguments that can only be understood with reference to art school connections', debates which have been conditioned by 150 years of argument about the cultural use and function of art and design:

The modern British art school has evolved through a repeated series of attempts to gear its practice to trade and industry to which the schools themselves have responded with a dogged insistence on spontaneity, on artistic autonomy, on the need for independence, on the power of the arbitrary gesture. Art as free practice versus art as a response to external demand: the state and the art market define the problem, the art school modernizes, individualizes, adds nuance to the solution.[37]

A key to understanding the unique character of British pop music can be found in the 'peculiar attitude to commercial success' which has resulted from the art schools' emphasis on creativity and artistic distance:

Art school students are marginal, in class terms, because art, particularly fine art, is marginal in cultural terms. Constant attempts to reduce the marginality of art education, to make art and design more 'responsive' and 'vocational' by gearing them towards industry and commerce have confronted the ideology of 'being an artist', the Romantic

vision which is deeply embedded in the art school experience. Even as pop stars, art students celebrate the critical edge marginality allows, turning it into a sales technique, a source of celebrity.[38]

Art into Pop focuses on the methods by which art school students of the 1960s attempted to solve the contradictions between expressive romanticism and vocational utilitarianism by 'creating their own version of aesthetic revolt, working bohemian style into a general reappraisal of media form and image'. The most obvious manifestations of this romantic bohemian revolt could be seen in the graphics of the psychedelic rock posters and underground magazines and heard in the music of 'progressive' rock bands of the era such as Cream or Pink Floyd:

For the hippies, play had to be Now . . . This is why the late 1960s bohemian counterculture put the full weight of its creative energies into the institutional reorganization of the media, why the aesthetic strategies of cultural change involved posters, printing, publishing, bookshops, music, film and video. In these areas work could be transformed with 'substitute play' . . . media practice was modernized art practice . . . and the area in which this creative stance was worked through most thoroughly, which transmitted Romantic ideology most effectively into popular culture, was music.[39]

In Frith and Horne's view, therefore, the genesis of the British art school-based 'postmodern sensibility' can be traced back to the cross-fertilization between romantic ideology and popular culture during the 1960s. During this era art school-based musicians made an attempt to define their work as being different from mainstream commercial pop music by laying claim to special visionary knowledge, the models of which were to be found in poetry and painting. As the new breed of British rock musicians began to identify themselves with romantic art heroes such as Van Gogh and avant-garde art movements such as Surrealism they affected a self-conscious bohemian style and began to regard their music as a quasi-mystical form of self-expression. By the mid-1970s the original rhetoricians of punk were beginning to emerge from art schools, forging a link between Conceptual art and popular culture. For Frith and Horne, the 1970s punk pose of radical chic aesthetics and the politics of creative subversion carried the message of a 'do-it-yourself' creativity which was very similar to the hippie counter-culture:

What both hippy counterculture and punk bohemia did, then, was direct the concerns of artistic practice into pop and rock. Art school romanticism was translated into the terms of popular culture . . . The nervous tension of both hippy and punk Bohemias arose not

directly from their untenable positions, but from the usual contradictions of avant garde art: how to balance public success against private truth.[40]

In sharp contrast to Bernice Martin's conservative critique of contemporary culture, Frith and Horne are optimistic about the postmodern 'collapse of high culture/low culture distinctions' represented by the art school-based British hippie and punk movements. They argue that art students' involvement with the pop process 'makes possible postmodern politics', which 'gives artists new opportunities for cultural intervention'. For Frith and Horne 'the apparently narrow issue of the relation of rock and art schools' is a useful way to focus the much broader problems of the relationships of 'art and commerce, high and low culture . . . what we've been describing as the postmodern condition'.[41]

To understand Frith and Horne's position more clearly it is useful to turn to Colin Campbell's *The Romantic Ethic and the Spirit of Modern Consumerism* (1987), which argues that romanticism was deeply implicated in the birth of modern consumerism and that it has continued in the two centuries or so since that time to 'overcome the forces of traditionalism and provide a renewed impetus in the dynamic of consumerism'.[42] Campbell emphasizes the necessary link between Romanticism and consumerism by focusing upon the close association between Romanticism 'especially in its social form of Bohemianism' and a dynamic upsurge in cultural consumerism in Paris during the 1890s and California during the 1960s, arguing that it is possible to discern a close correspondence between outbursts of bohemianism and periods of creative consumer boom:

One can observe such connections in the 1890s, the 1920s, and the 1960s, the 'Naughty Nineties', the 'Jazz Age' and the 'Swinging Sixties', all revealing essentially the same characteristic features. Each period witnessed a 'moral revolution', in which 'a new spirit of pleasure' emerged to challenge what was identified as a restrictive puritanism—a spirit most evident in the educated young who sought pleasure and self expression through alcohol, drugs, sex and art, whilst an intense moral idealism went hand in hand with an unrestrained commercialism.[43]

Frith and Horne posit similar links between consumerism and romanticism. In their opinion romanticism has 'always been a necessary component of the bourgeois world view, a crucial aspect of commodity aesthetics'.[44] They argue that designers are relevant to contemporary capitalism because they are able to apply romantic tenets to the market-place, to understand the desire of consumers to change their lives through the purchase of commodities. To be a successful designer one will probably have developed the sensibility of a precocious, expert consumer, one who understands that for many people individuality is guaranteed by taste, creativity by consumption:

Today the discourse of advertising is itself constituted by the rhetoric of the imagination, rebellion, creativity and free expression that was once primarily associated with the figure of the artist. To become the quintessential artistic subject you do not have to paint your masterpiece, but only consume the Right Stuff.[45]

For British art students the universality of romantic ideology had two immediate consequences. On the one hand creative authority came to be increasingly expressed through original consumption, a superior 'knowing' pose, and on the other, art students from the 1960s onwards became experts in the *idea* of creativity. As Frith and Horne point out, this can be interpreted as a direct consequence of the success of the Coldstream Report's intention to develop a 'fine art attitude' amongst all art and design students. A direct result of inculcating a romantic fine art sensibility into several generations of British art and design students is that 'the "death of the author" in high culture means the cult of the author in mass culture . . . just as the success of the mass market—everyone is the same—depends on each person's individual impulse to be different'.[46]

Frith and Horne were not the first to recognize the importance of art and design students' understanding of the hidden mechanisms of consumerism. As early as 1957 RCA student artist Richard Smith was pointing out that aesthetic decisions made in the act of consumption were every bit as interesting as those made by fine artists in the seclusion of their studios.[47] Terry Atkinson and the 'Fine Artz Associates' expressed similar opinions in their analyses of mod subculture in 1964.[48] Similarly, in 1968, William Varley explained the differences between the attitudes and dress of 'the typical teenager' and the 'art student' in terms of differing attitudes towards consumption: 'Although they share the same concern with pop fashion and might look very alike, they differ profoundly, because the art student is an aware "expert" teenager, his approach is much more serious . . . behind the mod gear is the iconographer of cultural anthropology.'[49]

If pop in its broadest sense was the context in which a notion of the postmodern first took shape, it seems accurate to claim that much of the earliest work which identified and analysed the emergence of a distinctly British postmodern sensibility has been produced by scholars working in the area of design history. Although the roots of this scholarship can be traced back to the mid-1950s and the iconoclastic critical writing of Reyner Banham, Lawrence Alloway, and Toni del Renzio, Penny Sparke's 'Theory and Design in the Age of Pop' (1975) was the first scholarly work in Britain to assess the 'postmodern break' of pop as a distinct movement within the history of design rather than within the history of art.[50] Sparke was also one of the first scholars to recognize the historical significance of Reyner Banham's and Lawrence Alloway's

celebration of technology and defence of 'anti-functionalist' pop design. Her pioneering research helped to inspire a number of extremely detailed scholarly works which appeared during the 1980s concentrating on the Independent Group. The 1990 ICA retrospective 'The Independent Group: Postwar Britain and the Aesthetics of Plenty' owed a great deal to this extensive body of scholarship, particularly to the research of Anne Massey and Graham Whitham.[51]

While Sparke provided the earliest British analysis of Pop design, Christopher Williams's 'A Survey of the Relationship between Pop Art, Pop Music and Pop Films in Britain from 1956–76' (1976) was the first detailed exploration into the nature of the relationship between British art and design education and cultural change during the 'Age of Pop'. Arguing that 'the final fusion of Pop Art and Pop Music has been taking place most significantly during the 1970s', Williams's work outlined the central characteristics of a particularly English version of postmodern culture by stressing the crucial role played by British art and design education in distinguishing British pop from its American counterparts:

It would appear that the eclecticism of British pop had its own unique qualities that have often distinguished it from the American pop arts. In America ideas have always been much more separately conceived and developed . . . whereas British pop has developed through a much more marked exchange of ideas due primarily to the Independent Group (in the early stages) and an art college system which has provided teachers whose personalities and images became particularly significant.[52]

Williams also points out that the 'tone' of British pop differed from the American. A 'particularly British' pop trait was eclecticism, the reliance upon chance and random juxtapositions of sounds and images. This distinctly British 'free and easy' approach to pop could often produce 'uniquely interesting images and sounds as if by accident'.[53] Whereas the Americans tended to produce 'direct images of the immediate environment', the nature of British work was whimsical and autobiographical. Williams argues that the key technique underlying British pop, whether musical or visual, was the fluid eclecticism of collage: 'Fluid eclecticism is the key to British pop . . . the binding factors have been a sense of the evocative and an amoral approach, both of which were crucial to the diffusion of a camp sensibility.'[54] In addition to collage, British pop could be distinguished from the American variety by its humour, theatricality, and by its essentially celebratory nature:

Humour . . . has always been a fundamental aspect of British pop. Pop's development has owed a great deal to the dislike of the serious, pompous and pedantic. The Independent Group felt the need to rob art of the 'high-mindedness' that characterised much 'official'

painting of the early fifties, hence their irreverent approach to the fine art/pop art dichotomy and the artists' willingness to give their work a light-hearted edge.[55]

Williams argues that the 'easy-going, freewheeling approach' which characterized most British pop was rooted in the atmosphere in the English art schools of the 1950s and 1960s which fostered particular attitudes either as an extension of or as a move away from particular lines of teaching viewing art education as discovery and exploration rather than as a means of imparting a set body of knowledge and a range of skills. This was especially true of the Basic Design courses run by Victor Pasmore and Richard Hamilton at Newcastle, William Turnbull at the Central, Alan Davie, Tom Hudson, and Harry Thubron at Leeds, Roy Ascott at Ealing, and Arthur Ballard at Liverpool. In Williams's opinion, art schools were important generators of the pop sensibility because

The prevailing spirit was much looser than the more traditionally objective kind of university teaching . . . naturally the system attracted inventive, eccentric and increasingly working class students who easily latched on to the loose art school structure with its indefinable 'goals' and more liberal thinking.[56]

The postgraduate research of Sparke and Williams during the mid-1970s appears to have inspired two books on pop design published during the late 1980s. The first of these, Nigel Whiteley's *Pop Design: Modernism to Mod* (1987), has become the definitive work on the pop design phenomenon. Whiteley divides the 1952–72 period into Early (1952–62), High (1962–6), Late, and Post Pop (1966–72) eras, identifying within these periods three main categories of pop activity: 'intellectual pop', 'conscious pop', and 'unselfconscious pop'.

According to Whiteley, intellectual pop began in 1952 and is virtually synonymous with the activities of the Independent Group. He argues that the virtue of the IG's intellectualizing lay in their attempts to understand and analyse the social and cultural conditions of the new, post-war mass media age at a time when virtually every other cultural critic in Britain remained virulently opposed to pop culture. Conscious pop is a term Whiteley uses to describe the artefacts and images of pop such as clothes, record covers, and furniture that were commercially produced for the youth market. Most of these designers, he argues, were actively and emotionally immersed in pop culture and most of them had been to art school and had acquired either a professional training in fashion or graphics, or a liberal fine art education. He points out that, unlike conventional professional designers (especially those influenced by modernist principles), who tended to adhere to a close link between design theory and practice, the pop designers of the 1960s were largely atheoretical and rarely aware of the IG's

intellectual pop. Unselfconscious pop is defined as the 'do-it-yourself' variety of pop endeavour created by people who were simply responding to the trends of the time. Much, but not all, British pop music of the period under discussion falls into this category.

Whiteley's survey of the High Pop era of pop design (1962–6) also places particular emphasis on the central role played by the British art and design education system: 'The role of the art college in the development of Pop was crucial. It was not necessarily what the colleges taught—although in areas such as fashion design this should not be underestimated—but the *atmosphere* in which they taught.'[57] With the replacement of the old NDD qualification by the new 'degree-equivalent' Dip. A.D. during the High Pop years in many colleges 'there was no longer a consensus, let alone an observable criterion' about what was good or worthwhile work. Whiteley argues that the only shared belief was that art colleges saw their role as providing conditions conducive to innovative and creative work of any kind. This meant that

all sorts of individuals—students and staff—were attracted to art colleges . . . art colleges became an appealing alternative within higher and further education. During the 1960s British art colleges acquired a reputation for being the most experimental public-funded institutions in the world. They became the focal points for those who sought change, excitement and an alternative culture. Far more than their teaching (at times in spite of it) their atmosphere produced the painters, fashion designers, poster artists and even the pop musicians who became the heroes and heroines of the High Pop years.[58]

Christopher Williams's approach to the analysis of interrelationships between Pop Art, pop music, and pop films was refined and developed by the design historian John A. Walker in *Crossovers: Art into Pop; Pop into Art* (1987). Like Frith and Horne, Walker stresses the fact that it is the aesthetic aspect of a product like pop music, its 'use value', which renders it desirable to the consumer. *Crossovers* focuses on specific examples of links between fine art and pop music in Britain, detailing the ways in which artistic values have served, coexisted with, opposed, and resisted the demands of the music business. In common with other scholars, Walker locates the intellectual origins of these issues within the debates of the Independent Group in the early 1950s. He points out that by the late 1980s the mass culture/high culture cross-overs Alloway, Banham, *et al.* celebrated had become so commonplace that they went virtually unnoticed, a fact which

lends support to Walter Benjamin's view that while artistic experiments are rejected by the masses as 'incomprehensible' when encountered as part of avant garde art, they are accepted and appreciated when seen as part of mass culture. The incredible technical and

formal inventiveness of pop videos, for example, which build upon the innovations of the Surrealist, abstract and other experimental film makers of the first half of the twentieth century have been enjoyed by millions throughout the world.[59]

Like Frith and Horne, Walker regards the interactions between pop music and fine art as a key to understanding the origins of British postmodernism:

In truth, modern art's shock value has virtually evaporated, indeed modern art is, arguably, the approved, official culture of western nations. The characteristics of shock, social criticism, political opposition, utopianism, aesthetic radicalism and difficulty once crucial to certain avant garde movements have been taken up by young musicians working within the sphere of rock or pop music.[60]

Walker's explanation of the central role played by art and design students in the development of British pop music and pop culture is straightforward and lucid. The cross-overs between pop and art are explained as being a direct consequence of students from working-class and lower middle-class backgrounds encountering the experimental syllabuses introduced into art schools during the 1960s and developing strategies to reconcile their desire for artistic autonomy with the pressures of a capitalist economy:

The 1960s must be considered the heyday of the British art school. Resources increased and courses were upgraded so that degree-equivalent qualifications were awarded. At that time there were fifty six minor and twenty nine major art and design colleges . . . Many children from working class and lower middle class homes also gained access to higher education for the first time . . . for [these students] who were intelligent and manually skilful but antagonistic towards academic subjects, the art school was the ideal choice. They brought the optimism and energy of youth and the irreverence towards authority typical of their class; they also brought street wisdom and an easy familiarity with American rock music and mass culture.[61]

For Walker, as for Frith and Horne, the most significant site for the development of pop within the British art schools was in the fine art courses because in the wake of the Coldstream reforms these were often

unstructured and non-theoretical. Fine Art students are not taught a fixed body of knowledge, though they may be given some help in terms of methods and skills. Students are encouraged to explore, to improvise, to experiment . . . Art students do not spend long hours researching in libraries or attending lectures and seminars, their activities in the studio resemble manual labour rather than academic study. They work directly with tools in a messy, noisy, chaotic physical environment. Practice is more important to students than theory . . . on the whole individualism rules.[62]

During the 1960s, Walker argues, art schools served 'as a metaphor for an enclave

of freedom in an otherwise controlled and repressive society'; they were a space where lower-class youth could escape the implications of their social situation and live out a 'fantasy of cultural freedom'. Although that freedom might have been real enough during the three years of art college when students had only to please themselves, their friends, and perhaps their tutors, the real crunch came after graduation when the romantic ideas of the artist as the free individual and anti-establishment outsider clashed head on with the demands of the cold, hard world. As Walker points out, luckily for many art students, the tenets of romanticism were by no means antipathetic to all aspects of the capitalist economy. Art students expert in the idea of creativity perfectly suited the requirements of a music business faced with the problem of creating demand from desire:

Learning to be an artist means learning to play on a sense of difference, becoming a Pop star means peddling that difference to the masses. What we have here is not art *versus* commerce but commerce *as* art . . . music offers art students a wonderful solution to their more pressing material problems; rock is a way to be creative and to make money—to work for one's living by living in one's work.[63]

Moreover, from the early 1960s the prospects of financial success for art students in the music world were far greater than in the art world. Pop culture offered the promise of fame, glamour, and adulation—a stark contast to the silence and solitude of the painter or sculptor's studio.

Whether they are positive or negative in their assessment of the development of postmodern culture in England, all of the works reviewed in this chapter identify the English art school of the 1950s and 1960s as an important breeding ground for the postmodern sensibility, but whereas the majority of these works are theoretical and speculative, this volume is an attempt to employ the tools of archive research and interviews to trace the origins of an English postmodern sensibility in London art schools, focusing particularly upon the development of a distinct *mentalité* among a generation of students who attended the Royal College of Art between 1950 and 1963.

It is important to emphasize the difference between a study which seeks to trace the evolution of a particular sensibility and one which discusses the meaning of a specific idea. A discussion of every aspect of contemporary interpretations of the term 'postmodern' (a term first used in the 1950s in England by Nikolaus Pevsner with reference to aspects of architecture but which did not enter general academic parlance until the mid-1970s) would of course involve writing at least one additional book. However, the central elements of postmodernism—the erosion of traditional distinctions between high culture and

the market-place, the challenge to modernist claims of unilinear historical development, the belief that mass consumerism constitutes a major break with the social and technological conditions of the first half of the twentieth century— were all in existence long before the term postmodernism gained common currency within the academy.

One of the main points of this study is that it was art and design students who were among the first to be aware of and to articulate the social implications of postmodern culture, before any fundamental cultural 'paradigm shift' had been acknowledged by a significant number of critics and despite the fact that the framing definition of postmodernism was not yet in existence. These students had never heard of the term 'postmodernism', but by the mid-1950s a distinct postmodern sensibility was developing rapidly. In an attempt to discover the 'little narratives' which led to the development of this sensibility, we will now turn our attention to some aspects of the post-war history of the Royal College of Art.

ARK Magazine and Graphic Design at the Royal College of Art: 1950–1963

2

In the first chapter of *The Neophiliacs* Christopher Booker argues that the 'cultural revolution' in British life during the 1950s and 1960s was synonymous with the development of the idea of 'image', represented by the 'eye- and mind-catching images' of television, advertising, fashion, the interior design of shops, and the glossy packaging of consumer goods. If the rise of image consciousness was one of the most obvious symptoms of the revolution in English culture during the 1950s and 1960s, then the School of Graphic Design at the Royal College of Art bore a good deal of responsibility for that cultural transformation. In order to begin to trace the development of a postmodern sensibility at the RCA it is important to understand the theory and practice of graphic design at the RCA during the 1950s and early 1960s.

The evolution of the term 'graphic design' was the product of peculiarly English prejudices. Although the foundations of the subject had been pioneered throughout the 1920s and 1930s in the Soviet Union, Holland, Germany, and the United States, English art education remained innocent of these developments until after the War. The first true graphic design course in this country was founded by Jesse Collins at the Central School of Arts and Crafts in 1945, but the term 'graphic design' itself was first used in Britain by Richard Guyatt.

Guyatt was appointed Professor of Publicity Design at the RCA in 1948. The new post was part of Robin Darwin's radical restructuring of the College which re-emphasized the role of the design schools in the wake of their relative neglect in favour of fine art during the pre-war and wartime regimes of William Rothenstein and Percy Jowett. Darwin's aim was to establish the Royal College firmly at the pinnacle of the British art school system, working at a university level but closely integrated to the aims of industry. The thirteen separate schools and departments he established dealt not only with industrial design but also with the fine arts, which remained, in Darwin's eyes, the inspirational core of all design activity within the RCA. The School of Graphic Design, the largest in the

College, was to occupy a unique position in Darwin's reforms because it had its feet firmly planted in both industrial design and the fine arts. The School of Graphic Design was, therefore, the hub of a new sensibility in which the traditional boundaries which had distinguished the fine arts from industrial design began to blur and merge:

Inherent in the reorganization of the College was the tenet that the fine arts are the inspiration of the applied arts. Hence the importance, within the School of Graphic Design, of the Printmaking Department which deals with graphic media as a fine art. It is through the fine arts, the 'useless arts', that the 'useful' arts of design are invigorated, in much the same way as researchers in 'pure' science affect the work of 'applied' science.[1]

Shortly after Darwin's appointment as Principal of the RCA an article appeared in *The Times* applauding the new Principal's pragmatic, pro-design reforms while deploring the vulgarity of the term 'Publicity Design'. The term appeared to be tainted by its associations with advertising or 'commercial art' which, in the eyes of some, appeared to be a vulgar trade practised by fine artists who had failed to make the grade, or, worse still, by *louche* lower-class types with no formal art education at all. Guyatt vividly recalls the stigma:

Commercial art had a very bad name in the 1940s and early 1950s . . . I didn't want to call the School 'The School of Commercial Art', although that's what people appointed me for, really. You see what was happening within the College during my time was that the fine art students were the absolute bloods, they were the aristocrats, they set the pace, people followed them. I subscribed to that in my own philosophy. I think the fine arts are the pinnacle . . . I came up with the term Graphic Design, which was accepted, but no one knew what the hell it meant. It all stemmed from that.[2]

In his inaugural lecture entitled 'Head, Heart and Hand' delivered at the Royal Society of Arts in November 1950, Guyatt outlined the aims of his new school and the theories upon which its teaching would be based. Set against the newly stated purpose of the College as a whole, the young professor's Ruskinian views on the nature of art as applied to commercial design were of particular significance, for in his lecture he contended that a great work of art, be it a painting, a design, or a piece of craftsmanship, is a blending of emotion, intellect, and skill. All three faculties, Guyatt argued, were employed by each artist, with the painter learning from his heart, the designer from his head, and the craftsman from his hand. In his School, Professor Guyatt hoped, students would learn to combine the three:

I hope that in my School young designers will learn, with their heads, the reason for their designs—their functions as designers, the scope and possibility in their chosen profession;

that in their hearts this knowledge will be quickened by the excitement of designing, the delight in the search for harmony; and finally, that their hands will learn the skill to do justice to their inspiration and enable them to carry out their work as professionals.[3]

As the new School of Graphic Design grew and established itself during the 1950s and early 1960s three main departments developed. The backbone of the School was the Design Department, which was based on the disciplines of lettering and typography. The Design Department ran courses in publicity design, book production, and bookbinding. It was allied to other departments via overlapping subject areas. For example, the illustration course linked it to the Engraving Department (renamed Print-making in 1961), which taught etching, lithography, silk screen techniques, and wood engraving as fine arts. Guyatt's aim was to impress on all students the interrelationship between all branches of Graphic Design with the purpose of making all RCA graduates 'complete designers'.

For Guyatt becoming a 'complete RCA designer' implied the development of refined aesthetic sensibilities and the understanding of the differences between 'Good' and 'Bad' taste:

If the idea behind a poster or a press advertisement is cheap and silly, then the expression of it in pictorial form is bound to be cheap and silly . . . Obviously one cannot teach design at the debased level. To learn about design one must first of all understand what is 'good' in good design. This means developing one's taste . . . Ability in a young designer grows by this assimilation of good taste coupled with the effort of recreating it in new and personal forms—in understanding and then trying to create good designs.[4]

These sentiments were closely linked to Robin Darwin's insistence that the new breed of RCA designer during the era of his leadership (the 'Era of the Phoenix' as opposed to the previous era of the 'Dodo') needed not only the applied designers' skills of business methods and modern production processes, but also the 'amused and well tempered mind' of a gentleman which would enable him (usually him) to feel at home in the company of a cultivated élite: 'You won't get good designs from the sort of person who is content to occupy a small back room: a man who won't mix because his interests are too narrow to allow him to, a man who is prepared and, by the same token, only desires to eat, as it were, in the servants' hall.'[5]

Darwin and Guyatt's aesthetic convictions helped explain why throughout the early 1950s the School of Graphic Design retained a strong bias towards the fine arts end of the graphic design spectrum rather than towards the development of skills more immediately relevant to contemporary developments in mass media. Photography, for example, was virtually ignored until 1956, when Geoffrey

Ireland (who was better known as a calligrapher) was appointed as the first Tutor in Charge of Photography. Television Design did not make an appearance on the curriculum until a course was established by George Haslam in 1959 and a separate Department of Film and Television had to wait until 1962, almost ten years after the BBC resumed post-war broadcasts. One of the many ironies of Darwin's period as Principal was that he presided over innovations for which he had very little personal enthusiasm. As Richard Guyatt remembers, Darwin remained extremely wary of the social and cultural consequences of mass communications:

Robin Darwin was very English, very much the eighteenth-century clubman . . . If you had a good rapport with him he'd let you do virtually anything. He didn't sit on your back at all as long as you delivered the goods. He backed you like mad . . . The only thing he wasn't good at, in my experience, was starting the Department of Film and Television. He was very anti-film . . . one of Robin's criticism when I suggested that we start a Film School was: 'But Dick, think of the *kinds of people* we'll have in the Common Room!'[6]

A major feature of Darwin's reforms was his insistence that all staff members should be professional designers rather than professional teachers. As Guyatt has explained, Darwin held the teaching profession in very low esteem and was eager to shed the College's pre-war reputation as a training school for art teachers:

Robin Darwin's idea was that teaching should be done by professionals and not by teachers. We were expected to have our own private practices, which we all did . . . You see, art teachers had a pretty low standing then. They were considered to be people who couldn't make the grade. Before 1948 the College was a standing joke amongst the design community because it was a sort of ingrowing toenail full of people who couldn't make the grade teaching others to do just that! Robin's great aim was to break that circle, to create real professionals.[7]

The idea was to employ the exacting standards and bustling atmosphere of professional practice and to banish forever the moribund cosiness with which the College had become associated during the pre-war era. Once prospective students succeeded in passing the RCA's entry requirements, they were encouraged to reassess themselves as artists during the first year of their three-year course by being subjected to exacting standards of criticism while being exposed to new techniques. By the end of the 1950s, first-year graphic designers entering the RCA were expected to confront formal problems of spatial relationships in two and three dimensions. These exercises were complemented by regular periods of life drawing, colour theory, lettering, photography (after 1956), and a course in typography which included practical typesetting. Students were also expected to attend General Studies lectures, which started with

philosophy in the first year and culminated by the third year in a study of the history and theory of art, architecture, and design. The first-year examination reviewed students' work and was used to determine the area of graphic design in which the student would specialize and take the Diploma at the end of the third year. In contrast to the general first-year course, the second- and third-year courses specialized in the various branches of graphic design, including fine print-making and illustration, book production, general advertising design, and, by 1959, a third-year course in television design.

Keeping in line with Darwin's emphasis on professionalism, training courses for graphic designers were primarily practical rather than theoretical, with opportunities for practice abounding in a Design Department which was responsible for designing and printing all official college literature. Alongside these official requirements the Design Department provided the publicity for student societies including the Drama Society, the Film Club, and the Jazz Club (Plates 1–6). In addition to these internal commissions the School of Graphic Design was in direct contact with industry and throughout the period under discussion it handled a wide variety of external commissions which were usually carried out by advanced students working under supervision. External commissions executed between 1950 and 1959 under F. H. K. Henrion's supervision provide good examples of this policy.[8] In 1959 Richard Guyatt explained that:

Only by constantly engaging in this practical process can a student learn how to give expression to his ideas freshly through a growing understanding of the discipline of his medium. And the facilities of the School, with its printing shops with five full time printers . . . its bindery, its photographic studio, enable the second and third year courses to be put on a severely practical level of production . . . This puts the students in the fire of professional competition and brings them face to face with the slippery problem of working for a client.[9]

The Lion and the Unicorn Press and the magazine *ARK* lay somewhere between the demands of internal and external commissions. They were useful pedagogic aids which doubled as valuable sources of public relations for the College. Both the Lion and the Unicorn Press and *ARK* exemplified Richard Guyatt's aim to integrate head, heart, and hand, for in their work on the press or for the magazine, illustrators, typographers, poster artists, and commercial artists were supposed to co-operate in the creation of one object while having the opportunity to understand each other's problems and the means to overcome them.

The Lion and the Unicorn Press was established in 1953 (Plates 7–8). In the RCA *Annual Report* of that year Professor Guyatt stated that the backbone of the work of the School of Graphic Design should be typography and that this was best

1 Coronation year
exhibition poster (1953)
by David Gentleman

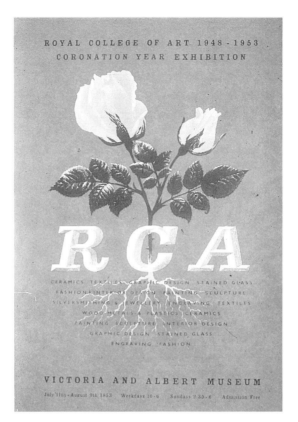

2 Poster for RCA Film
Society (*c*.1959) by Neil
Godfrey

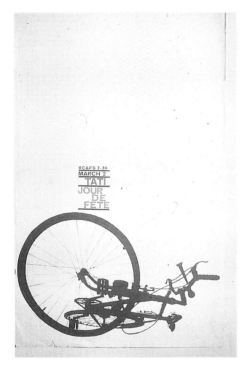

3 Posters for 'The Nature of Pop Art' lecture
series by Neville Malkin (1963)

4 Poster for RCA Film Society by Norman
Vertigan (*c*.1960)

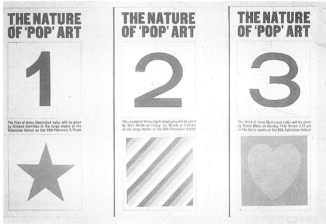

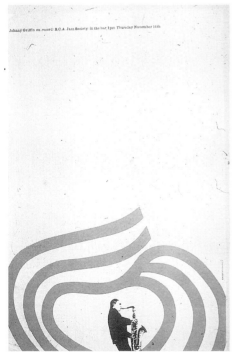

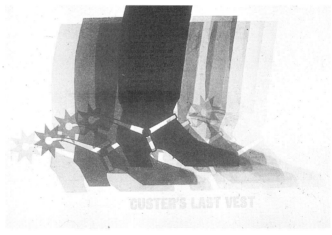

5 Poster for RCA Jazz Club by John Fenton-
Brown (1961)

6 Poster for RCA 'Custer's Last Vest' Dance by
Tony Guy (*c*.1959)

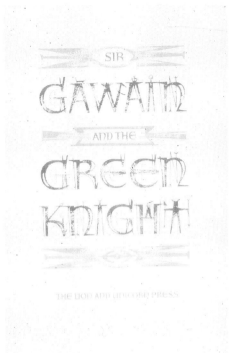

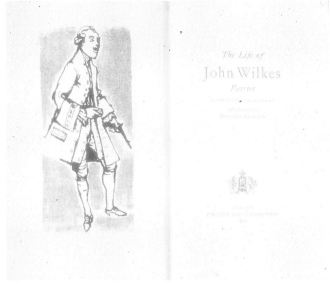

7 Title-page of *Sir Gawain and the Green Knight* by Geoffrey Ireland (1956)

8 Title-page of *The Life of John Wilkes*, designer unknown (1956)

learned through a series of book production exercises. Named after the Festival of Britain's Lion and the Unicorn Pavilion, the Lion and the Unicorn Press was established with the aim of producing finely printed, bound, and illustrated books:

> The Lion and the Unicorn Press aim to publish each year a few volumes in limited editions . . . that will reach the highest standards of book production in typographic design, illustration and binding . . . the aim is to carry on the tradition of the many private presses which, until recently, have flourished in this country and have contributed so greatly to the reputation for intelligent experiment enjoyed by English printing.[10]

The Lion and the Unicorn Press epitomized the principles outlined in Guyatt's 'Head, Heart and Hand' lecture. Between 1953 and 1978 the Press produced a series of books for connoisseurs which demonstrated the traditional English craftsmanship and skill of both students and staff—including work by Richard Guyatt, John Brinkley, John Lewis, John Nash, Edward Bawden, Edward Ardizzone, Reynolds Stone, and Edwin La Dell.

 ARK was founded in 1950 on the initiative of Jack Stafford, a student in the School of Woods, Metals, and Plastics who sank a considerable amount of his

own money into the first two issues (Plate 9). The purpose of *ARK* was much vaguer than that of the Lion and the Unicorn Press. In his first editorial Stafford stated that:

The elusive but necessary relationships between the arts and the social context are the real objects of our enquiry through the pages of *ARK* and our policy will be to set a subject, give our answers as students of the arts and ask a selection of those who will see the same subject from other and different viewpoints. We shall serve this mixture up to you with the firm belief that it is best to be serious without being solemn.[11]

In a fairly loose sense *ARK*'s 'object of enquiry' remained 'the elusive but necessary relationships between the arts and the social context' throughout its twenty-five-year history, one of the main reasons why it still remains a valuable archive for the cultural historian.

Another distinguishing characteristic of *ARK* was that it was never a typical student magazine. To begin with it remained relatively expensive. In 1950 it cost half a crown, the cost of four pints of beer or several meals in the student cafeteria—the equivalent of about £4 today. Secondly, although many contributors were students or members of staff, many of *ARK*'s writers were what Jack Stafford called 'representatives of the cold, hard world . . . chosen for their open-mindedness towards contemporary trends in the arts'.[12] By the latter half of the 1950s a distinct editorial bias towards articles written by the latter

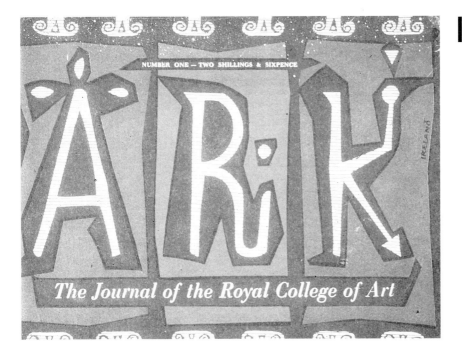

9 Cover of *ARK* 1 by Geoffrey Ireland (1950)

category of contributor created considerable discontent amongst sections of the RCA student body. Both John Hodges (editor of *ARK*s 15–17) and Roger Coleman (editor of *ARK*s 18–20) were faced with hostile deputations of students unhappy about the fact that *ARK* appeared to be ignoring their work in favour of contributions from 'trendy' outsiders. Striking the correct balance between publicizing students' work and ideas and keeping *ARK* in touch with contemporary developments in the world outside College was a constant editorial dilemma, as the novelist Len Deighton, art editor of *ARK* 10, remembers:

No one knew what the hell *ARK* was for. When I took over the art editorship at the end of 1953 I said, 'What's it all about? Is it a college magazine? Is it something to sell the College to manufacturers and employers?' No one knew. It was typically English. No one could decide. In England the whole way of living is predicated upon never defining anything, because that way no one can get it right or wrong.[13]

Despite this vagueness of purpose, or perhaps even because of it, *ARK* was an immediate success. From the start it attracted good reviews in the press.[14] As Bernard Myers, one of *ARK*'s pioneering contributors, has remarked, the journal's favourable initial reception owed a great deal to the austere cultural climate of the time, when 'there was nothing to do but read'.[15] The late 1940s and early 1950s were the heyday of the 'Little Magazines' and the layouts of the early *ARK*s were strongly influenced by *Penguin New Writing*, edited by John Lehmann, the publisher and leading member of the London literati who offered paternal advice to young illustrators in the first issue of the magazine.

For a college magazine *ARK*'s circulation was considerable. By the end of 1950 circulation was already over 2,000, peaking at 3,000 by 1963. Most copies were sold by subscription, but in London it was on sale to the general public in the main art bookshops including Zwemmer's and Better Books. By the mid-1950s the magazine had built up a large subscription circulation which included the libraries of virtually every art college in Britain. It was in these libraries that *ARK* had perhaps its largest impact, as the graphic designer Ken Garland, who was a student at the Central School in the early 1950s, recalls: 'Whether they liked *ARK* or not students at other art schools looked at it with great envy because it was a magazine put together by students with ads designed by students for real clients. It had a real professional feel to it. It even had a professional business manager.'[16] *ARK* also built an international reputation. By 1952 it had subscribers, largely in art schools and universities, throughout Western Europe and in the United States, Canada, South Africa, Australia, and New Zealand (Plate 10). According to the 'Minutes of RCA College Council' of 1951–2, *ARK* was also received by

subscribers in thirty-two countries including Mexico, Egypt, and India and was read regularly in France, West Germany, Switzerland, and in the art schools of the four countries of Scandinavia. *ARK*'s impact upon its international readership should not be underestimated: during the 1950s and early 1960s it was the subject of articles in several influential international graphic design journals including the Swiss magazine *Graphis* and the German journal of international advertising art *Gebrauchsgraphik*.[17] As one influential teacher of graphic design who was a student in Cuba and the United States during the late 1950s and early 1960s has explained:

ARK was enormously influential both for myself and my contemporaries. In the early 1960s it seemed to us to be the visual equivalent of the music of the Beatles and seemed to provide an insight into what was happening in 'Swinging London'. We used to seize every issue with eager anticipation.[18]

By 1951 it had become obvious that Jack Stafford's gamble had paid off. From issue 3 onwards, Darwin decreed that *ARK* would receive financial help from the College to

relieve students from as much tiresome administrative and accounting detail as possible and to make the work of art direction and layout of each succeeding issue an official element in the curriculum of training in the School of Graphic Design while leaving editorial policy exclusively in the hands of students as hitherto.[19]

10 Advertisement for *ARK* 30 (Winter 1961), designer unknown

ARK was given its own office on the top floor of the new students' union building at 21 Cromwell Road. The editorial side of the magazine remained entirely in the hands of students. Most editors were recruited from the Painting School (often recommended to Richard Guyatt on the strength of their General Studies essays) and were given a full sabbatical fourth year to prepare three issues. The art direction and advertising were overseen by the School of Graphic Design with advertising managers succeeding art editors in assuming responsibility for the layout of at least one issue. By 1954 this team was bolstered by Nicholas Jacobs, *ARK*'s long-serving (and often long-suffering) full-time business and circulation manager who remained with the magazine throughout the 1950s and 1960s. This innovative editorial structure, which usually involved a painter/editor co-operating with graphic designer/art editors facilitated the overall blurring of boundaries and crossings-over of influences between fine art and design which characterized much of the work of the RCA during the late 1950s and early 1960s.

Although *ARK* received some financial help from the College and sometimes needed to be bailed out by its mother institution, it aimed to be as self-sufficient

as possible, financing itself with revenue from over-the-counter bookshop sales, subscriptions, and, most importantly, advertising revenue.

The history of *ARK*'s advertisements during the 1950s provides an interesting insight into the cultural history of the period. This is partly because the advertisements reveal a great deal about the ways in which Darwin's links with the Establishment could be used to support College ventures, partly because of what the advertisements reveal about the changing status of the advertising industry among graphics students, and partly because of the changing designs of the advertisements themselves. The job of the advertising manager was to sell advertising space to companies and to find students to design the advertisements in the space that had been sold. In the early 1950s the majority of companies who were persuaded to buy advertising space seem to have preferred to supply their own advertisements, which are very difficult to distinguish stylistically from the few advertisements designed by students, but by the end of the decade the occasional non-student advertisement looks absurdly archaic when compared to those designed by young graphic designers.

The financial health of *ARK* was heavily dependent upon the support of about twenty firms, most of which had direct or indirect links with the College. These included: Wedgwood Pottery (Darwin was the great great-grandson of Josiah Wedgwood), the Orient Line (Sir Colin Anderson, its owner, was a member of College Council), Shell (Jack Beddington, who had been in charge of Shell's advertising campaigns during the 1930s, was also a member of College Council), Cowell's (the firm responsible for printing *ARK* and managed by John Lewis, who was on the staff of the School of Graphic Design), Murphy (the radio and TV company run by Edward Powell, a close friend of Gordon Russell, Chairman of the CoID and prominent member of College Council. The cabinets of Murphy's radios and televisions had been designed since the late 1930s by Gordon Russell and his brother R. D. 'Dick' Russell, Professor of the School of Woods, Metals, and Plastics). Other advertisers included the artists' materials suppliers Winsor and Newton, Reeves, Rowney's, and the art booksellers Zwemmer's and Better Books, the drink manufacturers Schweppes and Gilbey's (whose pre-war advertisements and packaging had been designed by Milner Grey, a founder of the Design Research Unit), and an ever increasing number of advertisements from advertising agencies eager to recruit young talent from the RCA including Colman, Prentis, and Varley (Deputy Chairman Jack Beddington, Art Director Arpad Elpher), Crawfords (Art Director Ashley Havingden), and Erwin Wasey (whose Director of Visual Planning, F. H. K. Henrion, taught in the School of Graphic Design 1950–9) (Plates 11–13).

ARK's relationship with the advertising agencies was beneficial and reciprocal.

As the 1950s developed into a decade of booming consumerism, the agencies' 'talent spotters', led by Arpad Elpher of Colman, Prentis, and Varley, were constantly on the look-out for talented graphic designers graduating from the RCA. As *ARK* was the most prestigious and widely read art school magazine in Britain the money spent on buying advertising space in the magazine proved to be an excellent investment.

In 1956 *ARK* changed from its old album shape to a more conventional A4 magazine format which gave the art editors far more scope for experimentation

11 Advertisement for Shell-BP from *ARK* 34 (Winter 1963) by Melvyn Gill

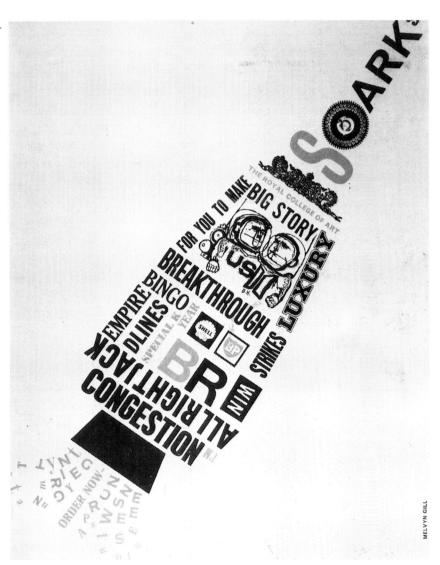

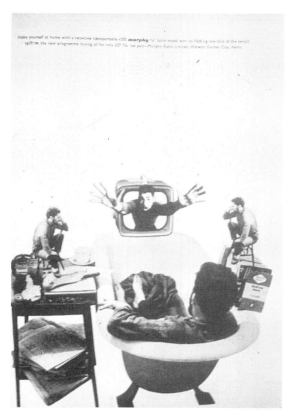

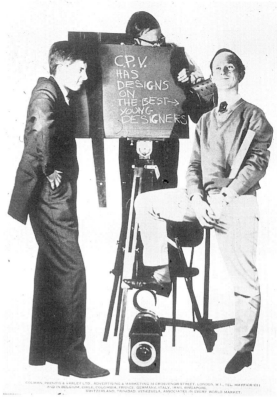

12 Advertisement for Murphy televisions from *ARK* 24 (Autumn 1959) by Denis Postle

13 Advertisement for Colman, Prentis, and Varley from *ARK* 26 (Summer 1960) by Colin Murray

with different types of paper, innovative layouts, centrefolds, and half-tone photographs. As successive editors vied to outdo one another with ever more exotic issues, the magazine soon inherited a substantial overdraft. It was first rescued in 1957 by Jack Beddington, who organized an appeal within the advertising agencies to arrange deeds of covenant to save the magazine.

As subsequent chapters reveal, *ARK* proved to be a very sensitive indicator of the changes which transformed the Royal College during the Darwin era. During the early 1950s its contents and editorials were often rather earnest and literary, celebrating the Coronation, the College's contribution to the Festival of Britain, the Council of Industrial Design, English folk culture, and crafts. The album format was conducive to produce quite conservative layouts, featuring 'tasteful' illustrations and advertisements and a distinct penchant for the archaic Victorian typefaces much favoured by Guyatt and his colleagues John Lewis and John Brinkley. The editorial staff of these early *ARK*s included John Blake, who went on to edit *Design* magazine, and Raymond Hawkey, the graphic designer responsible for changing the layout of several British newspapers during the

1960s.[20] Although Hawkey had caused something of a scandal by including an unretouched photograph of a nude life model in *ARK* 7 (Spring 1953), the first issue really to 'rock the boat' and challenge the aesthetic preferences of the RCA 'Establishment' was *ARK* 10 (Spring 1954), edited by Ros Dease and art edited by Len Deighton. Not only did Deighton manage to irritate Guyatt and Darwin by introducing a good deal of photography into the magazine, he also deliberately offended their canons of good taste by including a Hopalong Cassidy comic strip printed on low-quality newsprint. *ARK* 13 (Spring 1955), edited by Anthony Atkinson and art edited by Alan Fletcher, challenged the decorative typefaces favoured by its predecessors by introducing a stark sanserif cover and frontispiece (Plates 14–15). Fletcher invited Herbert Spencer to contribute an article on 'Recent Developments in Typography', which introduced the work of the masters of Continental modernist typography such as Willem Sandberg, Max Huber, and Pierre Faucheux to *ARK*'s readership for the first time.

By late 1955–early 1956, under John Hodges's editorship, *ARK* was beginning to jettison the parochial concerns of its predecessors. *ARK*s 16 and 17 (Spring and Summer 1956) contain articles on aspects of pop culture by the Independent Group stalwarts Reyner Banham (on futuristic Italian motorcycle styling) and Lawrence Alloway (on science fiction). Growing student interests in Dada and Surrealism begin to surface in articles by Richard Smith (on ideograms) and John Hodges (on collage, featuring work by Roger Coleman, Peter Blake, Robyn Denny, and Richard Smith).

With the change to an A4 format in the autumn of 1956 both the contents and the layouts of *ARK* changed substantially. Under the editorship of Roger

14 Cover of *ARK* 12 (Autumn 1954) by Patricia Davey

15 Frontispiece of *ARK* 13 (Spring 1955) by Alan Fletcher

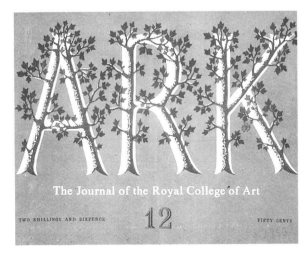

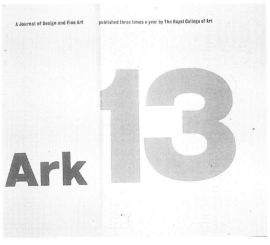

Coleman (Autumn 1956–Summer 1957) the magazine became a mouthpiece for the intellectual pop of the Independent Group (Plate 16), featuring articles by Lawrence Alloway, Toni del Renzio, Frank Cordell, Peter and Alison Smithson, and John McHale. Coleman's art editors, Gordon Moore, Alan Bartram, and David Collins, radically altered the layout of the magazine, incorporating a vivid, Duchamp-inspired cover, grainy black and white photographic centrefolds, Sandberg-inspired pages of brown wrapping paper divided into grids, and multicoloured transparent overlays.

After Coleman left the College in the summer of 1957 to continue his involvement with the Institute of Contemporary Arts' Exhibitions Committee and to write for *Design* magazine, the editorship of *ARK* was taken over by Derek Hyatt, who edited issues 21, 22, and 23 (Spring–Autumn 1958). Feeling that *ARK* had paid more than enough attention to pop Americana, Hyatt focused on romanticism and landscape painting, Eastern art (with a particularly distinguished layout by art editor David Varley), Dadaism, and Art Autre, featuring articles on Schwitters and Dubuffet (Plate 17). Issue 23 also contained the first article to appear in Britain about Frank Auerbach, recently graduated from the Painting School.

The Dada theme continued in *ARK*s 24 and 25 (Spring–Summer 1959) edited by Roddy Maude-Roxby and art edited by Denis Postle and Terry Green. Senior members of staff were particularly incensed by Denis Postle's carefully hand-ripped lurid day-glo cover and by Terry Green's random typographical errors superimposed upon a cover photo of Brigitte Bardot inspired by Roger Vadim's cult 1956 film *And God Created Woman* (Plate 18). The essential aesthetic distinctions between 'Good' and 'Bad' taste which Richard Guyatt had emphasized in his 'Head, Heart and Hand' lecture seemed to be under siege by now.

When Ken Baynes took over the editorship of *ARK* 26 in the spring of 1960 the magazine assumed a less anarchic and more sober tone. Articles with titles such as 'London and the Arcadian Dream' and 'Environment for Intolerance' reflected the architectural and environmental concerns of its editor, a committed socialist who organized the RCA Anti-Ugly Society devoted to lampooning hideous architecture and design. By the time *ARK* 28 appeared in the spring of 1961, the year of the famous 'Young Contemporaries' exhibition, it was becoming apparent that Baynes's interests were at odds with the pop enthusiasms of his art editor Allan Marshall, who included a gatefold of the pop idol Adam Faith, a photo-essay of the 1960 Beaulieu jazz festival, and an action shot for the cover of a leather-clad rocker 'doing the ton' on a custom Triton motorcycle (Plates 19–20).

The contrast between the contributions of intellectually inclined editors and

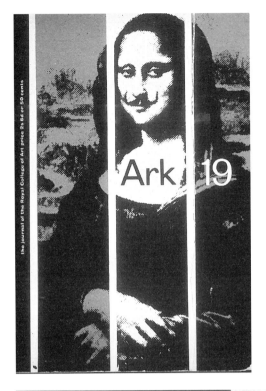

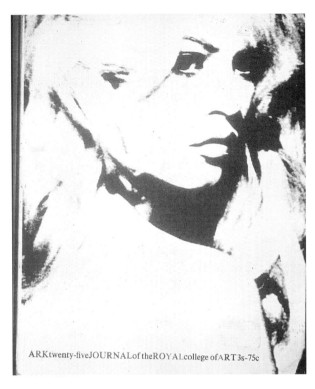

16 Cover of *ARK* 19 (Spring 1957) by Gordon Moore

17 Layout for *ARK* 22 (Summer 1958) by David Varley

18 Cover of *ARK* 25 (Spring 1960) by Terry Green

the pop image-makers from the School of Graphic Design continued during Stephen Cohn's editorship. *ARK* 30 (Winter 1961) is devoted to a discussion of the then new Basic Design courses with Ken Baynes casting grave doubts upon the cultural value of Pop Art and abstraction and Denis Bowen, who had just assumed control of the Basic Design course for the new Department of Engineering Design (later Industrial Design (Engineering)), arguing forcibly in favour of 'hot rod tachism, drip dry action, pop optics, and space constructions'.[21]

ARK 31 (Spring 1962), the first of three issues edited by Bill James, features a sumptuous gold cover and a layout designed to resemble a prayer-book, complete with lace bookmark designed by art editor Annette Wakefield. *ARK* 32 (Summer 1962) is one of the best-known issues of the magazine, as it contained an article by Richard Smith about a young painting student by the name of David Hockney, whose 'range is perhaps as narrow as the lapels on his jacket but within his terms he has made a highly successful personalized statement'.[22] *ARK* 32 also introduces the reader to the work of Derek Boshier and Peter Phillips, who, alongside Pauline Boty and Peter Blake, were about to feature in Ken Russell's film about the Royal College Pop painters *Pop Goes the Easel* (1962). Art editor Brian Haynes's Pop Art-influenced graphics include a pull-out 'free gift', a Pop Art 'Kit of Images', and a cover design featuring a fairground slot machine, the Joker from the Batman comic strip, and cod-Edwardian cut-out moustaches. *ARK* 33 (Winter 1963) continues in the 'Swinging London' vein with references to a top ten hit by pop singer Cliff Richard (Plate 21): 'This ARK is mainly about young people . . . we hope that whatever views you have about the younger generation, you will enjoy this somewhat oblique exposée of the Young Ones.'[23] *ARK* 33 is pure pop, featuring a grainy black and white photo-essay by Keith Branscombe of a 'Twist Cruise' across the Channel, a youth culture feature article on the rockers who roared along London's arterial roads, and Eric Mottram writing on Kerouac, Ginsberg, and the 'Beat Generation'.

All this was a far cry from the polite restraint of earlier *ARK*s and Robin Darwin was obviously not entirely happy with the new direction the magazine was taking. In fact he was not at all fond of the new breed of student which was beginning to filter into the College from provincial art schools. Writing in 1960 he observed that:

Ten or eleven years ago students were older than they are now, the sequence of their education had been interrupted by war or national service; they had known experiences and discharged responsibilities far outside the orbit of their interests, and returning to them they were primarily concerned with the rediscovery of themselves as individuals. As artists they were less self confident, but in other ways they were more mature. By the

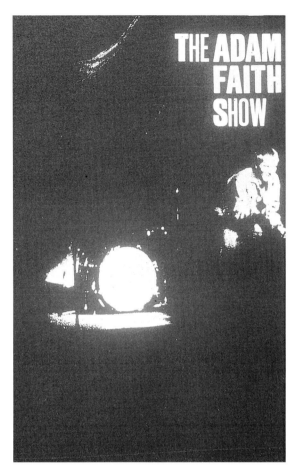

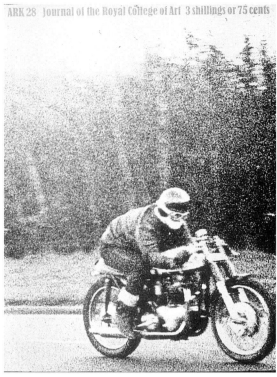

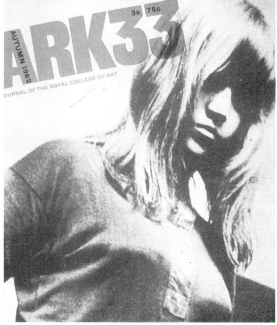

19 Detail of 'Adam Faith Show'
centrefold by Allan Marshall for *ARK* 30
(Winter 1961)

20 Cover of *ARK* 28 (Spring 1961) by
Allan Marshall

21 Cover of *ARK* 33 (Autumn 1962) by
Keith Branscombe

same tokens perhaps they were less experimental in their ideas. The student of today is less easy to teach because the chips on his shoulders, which in some instances are virtually professional epaulettes, make him less ready to learn . . . this no doubt reflects the catching philosophy of the 'beat' generation.[24]

His worst fears were to be confirmed when he turned the pages of *ARK* 34 (Winter 1963), edited by Gerald Nason and Michael Bartlett and art edited by Michael Foreman and Melvyn Gill (Plate 22). Consisting of an entirely visual collage of violent and semi-pornographic images, including a montage of Princess Margaret in a bikini surrounded by Britannias brandishing 'Vote True Blue. Vote Conservative' placards, this *ARK* finally stretched the tolerance of the RCA Establishment to the limit. *ARK* 34 was censored and the entire print run

22 Princess Margaret photomontage from *ARK* 34 (Winter 1963) by Michael Foreman

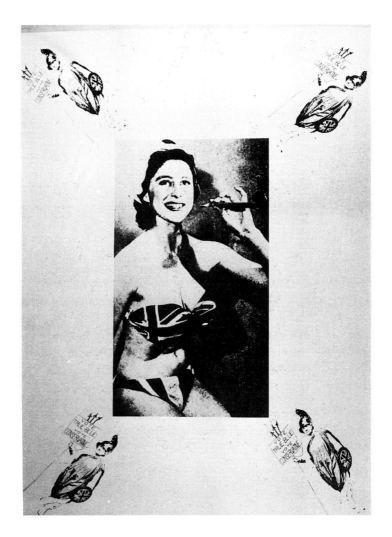

was ordered to be pulped. The Minutes of the May 1963 Financial and General Purposes Subcommittee reported that:

For some reason little was known by the School of Graphic Design of ARK 34, and our only intelligence was that, though sailing near the wind at points, it was in fact likely to be a good seller. It was not until the end of March that Professor Guyatt saw the magazine, and came to the conclusion that ARK 34, if not actually libellous and pornographic in parts, was most distasteful. The Principal, on seeing it, took the same view . . . It is clear that the College must consider the future of ARK. There is no doubt that ARK has contributed greatly to the College's reputation in Graphic Design all over the world, and it has proved a most lively and vivacious magazine which has set the pace to some extent in this country. However the continual losses which nearly every issue incurs (met up to now by funds from an appeal made to the advertising agencies in 1957) has, apart altogether from the fate of ARK 34, led to a good deal of re-thinking being done about the organization of ARK.[25]

After the débâcle of *ARK* 34 the magazine was subjected to closer scrutiny by the staff of the School of Graphic Design and seems to have lost much of its spontaneity and liveliness as a result. *ARK*s 35 and 36 (Spring–Summer 1964) featured some prophetic work by four young ex-painters from the Slade School of Fine Arts (John Bowstead, Bernard Jennings, Roger Jeffs, and Terry Atkinson) who called themselves 'Fine Artz Associates' (Plate 23). In *ARK* 35 they challenged the credibility of Royal College Pop Art ('the masses have begun to see through the confidence trick'[26]) and in *ARK* 36 they made the prophetic observation that 'the clues of tomorrow's culture lie in the [youth] cults of today'.[27]

 It was symptomatic of *ARK*'s growing malaise that the most interesting material which appeared during 1964 was contributed by students who were deadly rivals of the RCA Pop painters.[28] The real problem, however, was that *ARK*'s vitality was being sapped by the new breed of highly professional commercial glossy magazines including *Queen* (bought by Jocelyn Stevens in February 1957 and by 1961 featuring Mark Boxer as art director, Anthony Armstrong-Jones and John Hedgecoe as photographers, and ex-*ARK* man Gordon Moore as art editor), *Man about Town* (later shortened to *About Town*, then to *Town*) (owned by Michael Heseltine and Clive Labovitch, edited by Nicholas Tomalin, and art edited by Tom Wolsey) (Plate 24), and the new Sunday colour supplements pioneered by the *Sunday Times Colour Section* (1962) and the *Sunday Telegraph* and *Observer* colour magazines of 1963 and 1965. In an article he wrote for the catalogue to the 'Graphics RCA' exhibition of 1963, Mark Boxer (by then editor of the *Sunday Times Colour Section* and himself an ex-editor of the

Cambridge University student magazine *Granta*) tacitly acknowledged the pioneering role played by *ARK* during its halcyon days:

ARK belongs to the amateur tradition of magazine journalism. Often wilful, sometimes seriously naïve, occasionally ridiculous, it is at its best one of the most hopeful performances on the English visual scene . . . The last issue (No. 32 Summer 1962) seems to me quite outstanding, a controlled and distinguished number. It has all the magazine qualities. Firstly it's about something. Secondly the art editor respects and values his text. Thirdly it has great pace and variety. Fourthly it has exuberance and at the same time great style. The reason for this must surely not be unconnected with the Painting School. The Pop Art movement owes a great deal to graphics. But in its turn it has enriched graphics and *ARK* in particular . . . The pop-graphic movement may be instant nostalgia, but this is the very guts of visual magazines.[29]

23 Cover of *ARK* 36 (Summer 1964) by Roy Giles and Stephen Hiett

Boxer exploited the techniques he admired in *ARK* to great effect in the *Sunday Times Colour Section*, the first issue of which featured Peter Blake (Plate 25), who had first been the subject of a critical article by Roger Coleman in *ARK* 18

 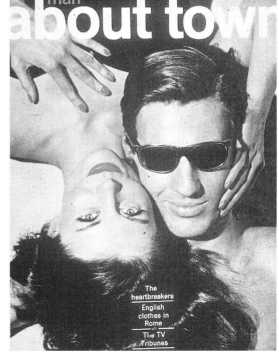

24 Cover of *About Town* (Summer 1960)

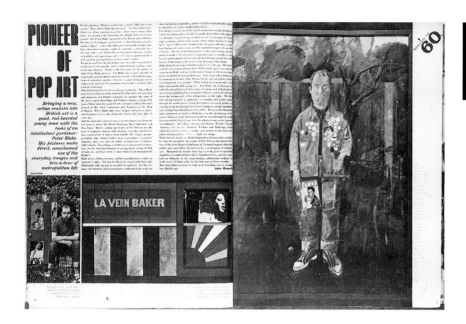

25 /Layout for 'People of the 60's' article featuring 'Pioneer of Pop Art' Peter Blake, *Sunday Times Colour Section*, (1 February 1962)

(November 1956). Employing several of *ARK*'s ex-editors and contributors (including Gordon Moore, Brian Haynes, and Romek Marbur) the various Sunday colour supplements refined *ARK*'s original fusion of fine art, innovative graphic design, and cleverly designed, witty advertisements to produce some of the earliest examples of mass circulation postmodern media in Britain.

By mid-1964 it had become obvious to Michael Myers, the editor of *ARK 35*, that the magazine had been eclipsed and was unable to compete with the mainstream media:

The main criticism of ARK, which seems to me to be particularly valid . . . is that it has no recognisable sense of direction, that it meanders aimlessly across the graphics scene, falling prey to any passing visual trend which happens to come along, that it tries to be something which, owing to the peculiarities of ARK's chemistry it can never be; and that is like other magazines. It is when ARK is comparable to another magazine (any magazine) that it is bad, because it cannot help but come off second best to whichever magazine it happens to be compared with . . . Mark Boxer says of ARK that 'it has all the magazine qualities'. I have no doubt Mr. Boxer's intentions were of the very best kind, but what was conceived as a compliment is in fact, a slap in the face . . . If ARK tried to out-queen *Queen* or to out-town *Town* or even to out-spectator *The Spectator*, the result would be ridiculous and pathetic.[30]

Although *ARK* continued to be published until 1976, its 'moment' had gone. By the mid-1960s student energies were being channelled elsewhere and it was becoming difficult to find editors. Two members of staff, John Hedgecoe and

Alistair Grant, had to volunteer to edit *ARK* to keep it going. *ARK* 50 (Spring 1972) was the last issue of the regular print run and, despite the fact that a few 'neo-*ARK*s' appeared during the next four years, to all intents and purposes the magazine was dead. *ARK*'s 'moment' had been 1950–63, the early years of English pop. The chapters which follow trace the emergence of an English pop-oriented postmodern sensibility during those years through the pages of *ARK* and in the words of the magazine's editors, art editors, and contributors.

English Good Taste

The pages of *ARK* between 1950 and 1963 are of particular interest to the cultural historian for what they reveal about the emergence of a particularly English, art school-based, postmodern sensibility. For, owing partly to the nature of Darwin's reforms, and partly to the contrast between the RCA Establishment's cultural preferences and those of many RCA students, the RCA provided a particularly volatile crucible within which the various cultural discourses of the 1950s and early 1960s were fused and synthesized. In order to understand the origins and development of the emerging *mentalité* reflected by *ARK* it is necessary to broaden the base of this analysis to include a reconstruction of the cultural milieu which *ARK* both reflected and challenged, for, as Theo Crosby has remarked, *ARK*'s primary value as a cultural archive lies in what it reflects of 1950s art school culture. Although *ARK* was a lively magazine it was seldom genuinely avant-garde:

ARK was seldom a pioneering magazine in any sense because it was a student magazine . . . It was always coming along behind somehow, but it wasn't really to be expected that students would be on top of the situation and know exactly what was going on. Occasionally you'd get a really bright editor who had a real nose for what was going on, but the moment he really knew about it he'd left the College. Three years isn't really enough to get in touch . . . but *ARK* is still really interesting because it reflects the cultural scene of the time.[1]

'Englishness'

Robin Vere Darwin, great-grandson of Charles Darwin, educated at Eton, Cambridge, and the Slade, was the epitome of an English gentleman with impeccable Establishment credentials. After five years (1933–8) as art master at Eton, he served during the Second World War as an officer in the Camouflage

Directorate, where he met many of his fellow officer artists and designers who would join his staff after his appointment as Principal of the RCA in 1947. A senior administrator drawn from the ranks of the ruling class, Darwin's style and opinions differed from those of the principals of other leading English art schools (such as William Johnstone of Camberwell and the Central), who were often much more interested in the pedagogical problems of art and design teaching and conformed more closely to the role of what Americans would term 'art educators'. In fact, as Christopher Frayling has pointed out, Darwin displayed relatively little interest in or concern for other institutions in the English art education system. In his eyes Cambridge University was the paragon of English educational institutions and represented the ideal to which the RCA should aspire:

When I was a small boy I had, as I think, the good fortune to be brought up at Cambridge . . . As I came back on a winter's evening from children's parties through the great court of Trinity or through Kings, the windows of the chapel would still be glowing from candles lit for Evensong, with the lights twinkling in the Fellows' rooms from all sides. The power that has kept them shining day in, and day out, for six centuries or more, depends upon the deep impulse which makes mature men come together in one place and associate with one another in learning and research, and in the common pursuit of ideas more important than themselves . . . This is the spirit which hallows all universities and gives to them their timeless traditions, and I believe something of this spirit has begun to move within the Royal College of Art.[2]

From the very beginning Darwin's reforms had a distinctly patrician character. The Senior Common Room was reorganized to resemble a cross between an officers' mess and a Cambridge Senior Common Room in which the Painters' Table substituted as a High Table. Pomp and ritual abounded, suits and ties (preferably Old Etonian) became obligatory for staff, fine wines were served by a retainer in white gloves, and the Principal's favourite chair was 'out of bounds' to others.

As Richard Guyatt has pointed out, although this process often seemed absurd ('Everyone thought starting a Senior Common Room was absolutely hilarious. He used to sit around saying, "I must think up a good tradition!" But he half joked at himself, really.'[3]), there was a strong logic behind Darwin's gentrification programme. In order to transform what had become a discredited institution for training art teachers into the glittering pinnacle of the British art and design educational pyramid, Darwin had to attract 'top people' to the RCA. His success in achieving this goal brought great benefits to successive generations of young

RCA-trained designers, as Nigel Chapman, a Canadian student in the School of Woods, Metals, and Plastics 1952–4 (and later RCA Professor of Vehicle Design), recalls:

For a young product designer like myself in the mid-1950s it was desperately hard to make a breakthrough into industry. I designed clocks and at that time the clock industry was very heavily dominated by Smiths. Their design department was pretty well controlled by their sales department. It was what had sold before and the idea of making a breakthrough into something new was a very difficult concept for them. It was a really heartbreaking, soul-destroying process to try to persuade manufacturers of the importance of innovative design . . . Darwin's approach was very successful indeed because he linked managing directors of the companies to the design practitioners who taught at the RCA. The managing directors would then use particular groups of RCA designers on certain projects. If you didn't have that magic link it was a very different story . . . The whole place enabled those crucial links to develop—the Senior Common Room, Top Brass, Old Etonian ties, the Establishment. Darwin made friends with all these great industrialists and brought them to the College. It was all *so* English![4]

The essential 'Englishness' of the Royal College under Darwin's regime became a focus of admiration for some and ridicule for others. Although his style was in perfect harmony with the prevailing cultural atmosphere of England during the era of the Festival of Britain and the Coronation, his Establishment connections always made him the butt of ridicule for the satirists of the Student Common Room. As Clifford Hatts, who attended the College between 1946 and 1948 (and returned to teach in the School of Graphic Design 1955–7 before leaving for the BBC, where he was to become Head of the Design Group), has pointed out:

When Darwin arrived in 1947 he saw the RCA as the equivalent of an Oxbridge college. You could see him inventing it all the time. He invented a beadle and dressed him up in livery with a long lance. At graduation he had fanfares and trumpets and put us all in caps and gowns and had a big procession just like a university. Whether 'class' in the accepted sense of the word is what he was after, I'm not sure, but he certainly had this idea of what I call 'Royal College of Art Royal'. For example, in the SCR, which he created, there was fine food and fine vintages and he would go down to the châteaux every summer with friends to bring back the wines. He was a connoisseur. Very *English*.[5]

The ARKs of the early 1950s share these characteristics and tend to reflect rather than challenge the tastes and opinions of the RCA 'Establishment'. This was no coincidence as during 1950–1 many staff and students were working on the same project—the Lion and the Unicorn Pavilion for the Festival of Britain.

The Festival of Britain: Victoriana and Popular Culture

Darwin was always quick to spot projects which would bestow kudos upon his institution and the Lion and the Unicorn Pavilion was the first of a series of high-profile commissions in which he encouraged the staff and students to involve themselves. Although, as it has been pointed out,[6] Darwin later became convinced that the commission for the Lion and the Unicorn Pavilion had been given directly to the RCA, in fact the commission to design the interior and exterior of the Pavilion had originally been granted by Sir Hugh Casson to the team of R. D. Russell and Robert Goodden, a reflection of that fact that members of staff were expected to run their own private practices. Goodden approached Darwin to ask his permission to embark on the project to which Darwin consented, on condition that the project was executed 'well enough for the College to gain a reputation from it'.[7]

Russell and Goodden collaborated with Richard Guyatt on the overall design of the interior of the prefabricated hall with its fifty-foot span and elegantly curved roof (Plates 26–7). John Brinkley designed the lettering and typographical display. Edward Bawden designed a large mural entitled *Country Life*, Abram Games designed the famous Festival emblem, the Festival fourpenny stamp, and (with Will Bradley) the Festival catalogue, Roger Powell was responsible for the binding of the New Oxford Lectern Bible on show in the Pavilion. F. H. K. Henrion executed the overall design of both the 'Agriculture' and the 'Country' Pavilions. The Painting School's contributions included Carel Weight's *English Landscape* mural in the Country Pavilion and John Minton's *Land Exploration* mural in the Dome of Discovery. Edwin La Dell from the Engraving Department designed five panels for the 'New Schools' section on the South Bank and supervised a set of twenty lithographs sponsored by the Arts Council. Carel Weight, John Minton, Ruskin Spear, Rodrigo Moynihan, and John Nash all contributed paintings to the Arts Council's Festival exhibition 'Sixty Paintings'.

The interior of the Lion and the Unicorn Pavilion, designed by Richard Guyatt, was particularly representative of the tastes of the staff of the School of Graphic Design. As Richard Guyatt explains:

An idea of 'Englishness' was at the backbone of the Lion and the Unicorn Pavilion. When we were first given the brief for the Pavilion the title was 'The Communication of Ideas' and we couldn't really do it, we fell down on it, it was just too grand. It was Hugh Casson who suggested that we call it the Lion and the Unicorn and we tried to incorporate the tradition of the Lion, the leonine tradition, and the whimsy of the Unicorn. It spun off from that. An interesting aspect of that period was that people like myself who were illustrators and designers had to turn to exhibition design because of the paper shortage. It meant that many designers went into display work.[8]

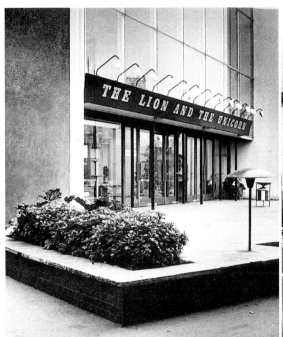

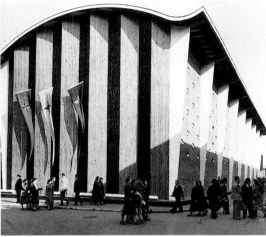

We are such stuff as dreams are made on, and our little life is rounded with a sleep

▌26 Rear view of Lion and the Unicorn Pavilion (1951)

▌27 Entrance to Lion and the Unicorn Pavilion

▌28 Interior display in Lion and the Unicorn Pavilion

▌29 Interior display in Lion and the Unicorn Pavilion

The whimsical, nostalgic vision of Englishness which characterized the Lion and the Unicorn Pavilion (Plates 28–9) was reflected in the *ARK*s of the early 1950s. The cultural history of this nostalgic vision of Englishness in the field of British graphic design can be traced back to a reaction against the typographic revolution pioneered by Emery Walker and William Morris at the turn of the century. By the late 1920s their work, coupled with the innovations of Eric Gill, had combined with the influence of Continental Bauhaus-trained typographers such as Jan Tschichold to rid the printed page of as much superfluous ornament as possible. During the 1930s there was a general trend for advanced types to be designed according to carefully defined procedures and letters were not supposed to depart from their 'correct' forms. Clarity and readability became the axioms for every progressive typographer.

In England, however, these innovations were by no means universally accepted. A typographical reaction developed led by Andrew Tuer and Will Bradley (the co-designer of the Festival catalogue with Abram Games), who continued to use the archaic typefaces such as 'Egyptian Expanded', 'Doric Italic', 'Thorne and Figgins Shaded', 'Bold Latin', and 'Thorowgood Italic' which were still widely used in provincial print shops despite being despised by sophisticated cosmopolitan designers. Shortly before the outbreak of the Second World War there was a concerted reaction against the austerity of foreign, modern typeforms and a significant revival of interest in 'Old Fashioned' English typefaces. The revival was most obvious in advertising and poster design, but it also began to influence book and magazine design.

Apart from Tuer and Bradley, the Victorian revival in graphic design was pioneered by Robert Harling, James Shand, and John Betjeman, whose book *Ghastly Good Taste* (1935) brought the Victorian revival into the public eye for the first time. In 1936 Harling and Shand started the magazine *Typography*, which specialized in using exotic archaic typefaces and which featured articles about the ways in which these old-fashioned types had been used in nineteenth-century ecclesiastical printing, Victorian children's alphabets, and Victorian architectural lettering. Interest in the 'Victorian look' also distinguished the 'Shell Guides' of the 1930s which Betjeman was editing. These best-selling guides helped fuse the image of Victorian typeforms with a popular conception of 'Englishness'. Gordon Cullen, Chairman of the Festival Lettering Advisory Panel, also designed the *Architectural Review*, which, alongside the magazine *Alphabet and Image* and the work of the Curwen Press, helped promote the Victorian revival in post-war Britain.

The Victorian revival paralleled a growing interest in pattern and decoration in all aspects of design during the late 1930s. Edward Bawden, who rejoined the staff

of the RCA in 1938 (having been a star student alongside Eric Ravilious during the mid-1920s) and was a leading member of the staff of the School of Graphic Design throughout the 1950s, was very influential in leading this movement back to decoration. Nicolette Grey's *Nineteenth Century Ornamented Types and Title Pages*, which was published by Faber in 1938 (and reprinted in 1951 under the title *Nineteenth Century Ornamented Typefaces*), became the source-book for a movement which was only temporarily halted by the outbreak of the War.

In the minds of many English people after the War, the term 'modernism' had become even more inextricably associated with the Continent and its political embroilments. A people sickened and wearied by war were eager consumers of images which helped them reaffirm their sense of cultural identity and national heritage. There was an enormous surge in the popularity of writers who focused on folk arts, country life, and 'local colour' of all kinds. The 'Britain in Pictures' series, published by Collins and edited by W. J. Turner, ran to over 100 volumes. Images of 'Englishness' made these slim volumes extremely popular during and immediately after the War. So successful was the 'Britain in Pictures' series that it even received priority paper supplies because it was considered to be integral to the war effort and national recovery.

With Paris no longer the centre of art it once had been and New York still relatively unknown as far as painting was concerned, the English in the 1940s and early 1950s embraced a vision of Englishness that became synonymous with Victorian design and images of country life.[9] As the graphic designer Raymond Hawkey (who art edited *ARK* during the early 1950s) points out, 'You can see those folsky influences in all those early *ARK*s. A yearning for the old order that we had fought to defend and now wanted back with a vengeance.'[10]

The films of Ealing Studios during the late 1940s and early 1950s provide more evidence of these preoccupations and link them directly with the RCA. Michael Balcon, a director of Ealing Studios, was a member of College Council, and posters for films such as *Hue and Cry* (1947), *The Titfield Thunderbolt* (1953) (both directed by Charles Crichton) (Plate 30), *The Loves of Joanna Godden* (1947) (directed by Charles Frend), *Eureka Stockade*, and *Where No Vultures Fly* (1951) (directed by Harry Watt) were designed by Edward Bawden and John Minton.

At the time of the Festival of Britain fuel was added to the flames of the Victorian revival from an unexpected source. The eminent architectural critic Nikolaus Pevsner, who had been an arch-protagonist of modernism during the 1930s, appeared to perform something of a critical volte-face, for the author of *Pioneers of the Modern Movement* published *High Victorian Design* in 1951, stating the case for a re-evaluation of Victoriana (Plate 31). When dealing with an intellectual of Pevsner's calibre it is important to evaluate the nuances of his

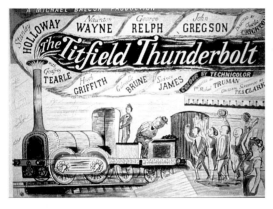

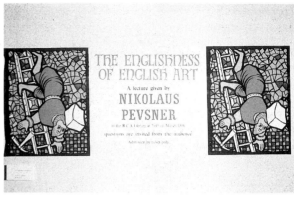

30 Poster by Edward Bawden for the film *The Titfield Thunderbolt* (1953)

31 Poster for a lecture by Nikolaus Pevsner on 'The Englishness of English Art' (*c*.1953), designer unknown

critical positions correctly. Like Harling, Shand, and Betjeman, Pevsner appeared to be proposing that Victorian design offered relief from the austerity of modernism, but what he was actually arguing has to be understood in the context of the cultural history of the early 1950s.

The year 1951, that of the Festival of Britain, was also the centenary of the Great Exhibition of 1851. *High Victorian Design* was a re-evaluation, after years of neglect or vilification, of the designs which appeared in the Great Exhibition. Pevsner was attracted to the energy and dynamism of High Victorian design, from which he thought contemporary designers could learn a great deal. Supporting Henry Cole rather than William Morris, he applauded the Victorians' thirst for information, faith in commerce and industry, inventiveness, and technical daring, but was not at all keen on the uncritical stylistic plagiarism he dubbed 'historicism'. He referred to historicism as

an alarming recent phenomenon . . . one of the least attractive developments of recent architecture . . . the imitation of, or inspiration by . . . styles which have never previously been revived. Of course, all reviving of styles of the past is a sign of weakness, because in revivals all independent thinking and feeling matters less than the choice of patterns.[11]

After the War the *Architectural Review* had emerged as the leading advocate of the Victorian revival in architecture and graphic design. Pevsner was one of the editors of the *Architectural Review*, which had in the basement of its building a lovingly reconstructed brass and mahogany Victorian pub, The Bride of Denmark. Pevsner did not regard the pub as an example of the historicism he so abhorred because:

I would say that this pub is a 'folly' in the true sense of the word and that the result of it, in the campaign in the *Architectural Review* for a new attitude towards the building of pubs, was certainly not an attitude towards the building of Victorian pubs, but towards

modern pubs with as much as possible of the atmosphere of the Victorian pub recovered, in opposition to the cheerless and soulless Neo-Georgian or otherwise denuded pub.[12]

In other words, Pevsner was keen to reinstate the energy and vigour of Victorianism without slavishly imitating its designs. He was no fan of bland postmodern pastiche. This is even more obvious in his attitude towards the Victorian revivalism of the *Architectural Review*'s typefaces. Like Harling and Shand, he recognized and appreciated the energy, humour, and adaptability of Victorian typefaces but he would never have supported the reactionaries who advocated a wholesale shift away from modernism and back to Victorian design: 'The *Architectural Review* does not recommend cooking *a la Victorienne* but rather spicing with Victorian ingredients. It is, you might say, a question of display faces, not of Victorian *mise en page*; that is Victorian materials are used in undeniably twentieth century layouts.'[13]

A similar attitude characterized much of the design policy of the Festival of Britain, especially when the work demanded an evocation of 'national characteristics'. Charles Hasler, Chairman of the Festival's Typographic Panel (and Tutor in Typography at Goldsmiths College throughout the 1950s) chose Victorian typefaces to produce a display letter 'which is British in feeling, of good "typographic colour" and is . . . capable of being used architecturally without loss of character'. For, according to Hasler,

Nothing could be more British in feeling than the display types created by the early nineteenth century typefounders . . . our researches have led us to reexamine the Egyptian types cut by Figgins, Thorne and Austin between 1815 and 1825. It is very largely on these that the basic Roman and Italic in the present series are modelled.[14]

The Victorian revival in architecture and graphic design was intimately linked to the Neo-Romantic movement in painting and illustration. One of the shining stars of this movement was John Minton (Plate 32), a central figure in the history of the early *ARK*s and a tutor in the Painting School from 1946 until his untimely death in 1957. The artist Robyn Denny vividly recalls his reputation:

After the war there was an interest in visionary romanticism amongst artists like Minton, Colquhoun, and McBryde . . . Minton was very brilliant. He burned very brightly. He was perceptive and erudite as a critic and as a teacher. I was very impressed by him even before I went to College. He was a star, he had charisma like a star, and he was very, very famous . . . There was a sort of yearning at that time for an indigenous British art and Minton seemed to characterize it. Every time you picked up a little literary magazine— *New Writing, Horizon*, or whatever, there were these pictures of bright-eyed, visionary young British painters—mainly John Minton, it seemed.[15]

32 Photograph of John
Minton (*c*.1952)

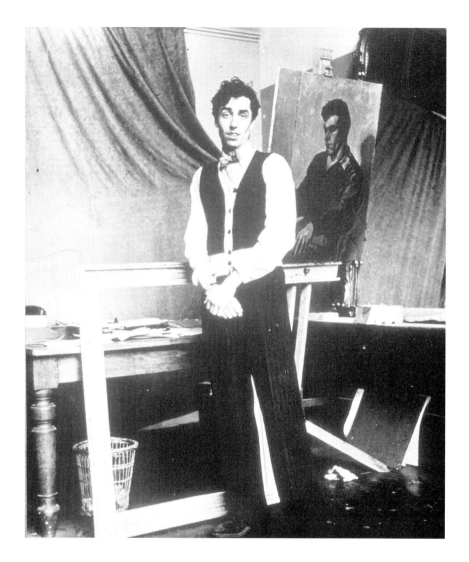

The themes of Minton's painting were essentially nostalgic, for example 'the figurative pursuit of a poignant, idealised representation of youth' which included post-Blitz, East End townscapes ('The masculine, empty shell of Britain's declining industrial base . . . shrinking into picturesqueness'[16]), bucolic English landscapes, and exotic, sensuous Mediterranean imagery. Like his RCA colleague Edward Bawden, Minton could turn his hand to either painting or illustration. His illustrations were very well known (such as those for Elizabeth David's *French Country Cooking* (1951) (Plate 33), for example), and like Bawden, Edward Ardizzone, and John Piper he designed posters for Ealing Studios' films.

Minton's influence on his contemporaries in both painting and graphics at the RCA was enormous. Many ex-students from the Painting School and the School of Graphic Design interviewed in the course of this study have been at pains to stress that he was by far the best teacher they ever had. The painter Peter Blake, for example, remembers that:

He was my tutor during my first year at College. He was always a great friend to the students. He was a marvellous guy. I remember my interview at the College when I was 17. I'd had a really bad cycling accident and I'd really cut my face up and knocked all my teeth out. I did the interview soon after that. I was very scared and I had no teeth. I must have looked like a monster and I was faced with this inquisition of Robert Buhler, Ruskin Spear, and Carel Weight, all nice men, but quite old, and at one end of the table sat Johnny Minton separate from them . . . He was the nice policeman. He was always like that . . . a very nice man, a big influence. He'd actually sit down and teach you how to do things.[17]

While the graphic designer Dennis Bailey recalls:

When I joined the College from Worthing Art School in 1950 they put all the illustrators into the Painting School for the first year, which was marvellous for me . . . The painters got lumbered with us, I suppose, and Johnny Minton taught us. He was a very good tutor.

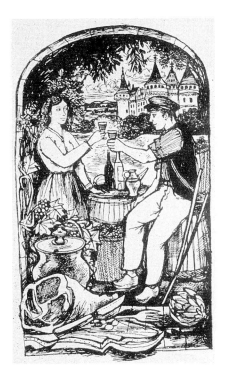 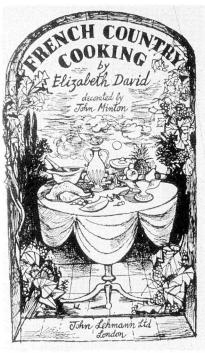

33 Illustration by John Minton for Elizabeth David's *French Country Cooking* (1951)

He told me a lot of home truths. I started with ideas that I was the reincarnation of Cézanne, but he soon brought me back down to earth! He was one of those rare people who can criticize constructively. He could instruct and enthuse you at the same time.[18]

Apart from being a much-loved teacher and friend, Minton exuded a certain style which characterized the Royal College during the early to mid-1950s. He was wealthy, handsome, charming, cultivated, bohemian, and very racy. He lived life with panache, in the fast lane. In many ways he symbolized the spirit of the romantic fine artist and seemed to justify the Painting School's status at the pinnacle of the RCA's hierarchy of taste. As Richard Guyatt remembers:

He was very, very charming. He always complained that he couldn't draw! He was a rather sad figure in a way, too, but he was part of a terrific gaggle . . . Lucian Freud, Francis Bacon, the Soho crowd. They were all up in the Senior Common Room and the drinking used to go on until four in the afternoon . . . Very racy, flat out . . . They were very impressive people in a strange way, quite terrifying really![19]

Another aspect of romanticism and nostalgia which characterized both the Festival of Britain and the contents of the early *ARKs* was the revival of interest in nineteenth-century popular culture and every variety of folk art. The popular culture craze began in earnest around 1946 with the publication of Noel Carrington's *Popular English Art* and *English Popular and Traditional Art* by Margaret Lambert and Enid Marx. These books were followed by several others published during the late 1940s including Noel Carrington's *Life in an English Village* and H. E. Bates's *The Country Heart* (Plate 34), which were illustrated by Bawden and Minton respectively. Several of the leading lights in the popular

34 Book jacket by John Minton for *The Country Heart* by H. E. Bates

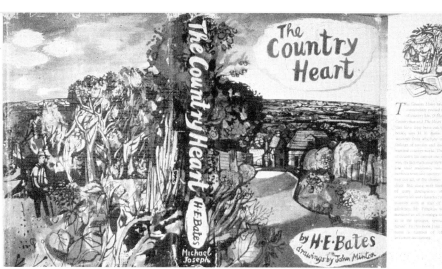

culture revival had RCA connections. Enid Marx, whose *English Popular and Traditional Art* was reprinted in 1951, had been an RCA student in the 1920s. Barbara Jones, who collaborated with Tom Ingram to organize the 'Black Eyes and Lemonade' exhibition at the Whitechapel Gallery in 1951, had been an RCA student during the 1930s.

The popular arts enthusiasts of the late 1940s and 1950s could be categorized into two distinct tendencies. Some, like Carrington and Marx, tended to agree with John Betjeman that very little worthwhile 'authentic' popular culture had survived the war. Others, including Barbara Jones, Tom Ingram, and several of the RCA students who wrote for *ARK* between 1950 and 1955, were less conservative. In her book *The Unsophisticated Arts* (1951) Jones argued that although the modern popular arts were cruder, harder, and brasher than the pre-industrial folk arts they could be just as humorous and energetic. Since the late 1940s she had been contributing articles to the *Architectural Review* with titles like 'Roundabouts: The Demountable Baroque', arguing that manifestations of traditional popular arts such as fairgrounds retained their vitality and exuberance because they were working-class institutions:

The essential quality of unashamed heartiness remains and the flabby hand of the gentlemanly designer has not been loosed in the field of fairground design. May that same quality which gives us the writing on costers' barrows, on the cut price store labels and on the windows of cheap 'Dining Rooms' continue in the decoration of fairground machines and may the slick American industrial designer be restricted to static streamlining and the architectural re-styler to his pale blue and gilt church furnishings.[20]

Like the funfair at the Battersea Pleasure Gardens featuring Rowland Emmett's Far Tottering and Oyster Creek Railway, the 'Black Eyes and Lemonade' exhibition associated Englishness with whimsicality, eccentricity, and nostalgia. As Charles Plouviez has commented, in many ways the Festival of Britain marked the beginning of the theme park style of 'Heritage Culture' so characteristic of late twentieth-century Britain (Plate 35):

It might be said to mark the beginning of our 'English disease'—the moment at which we stopped trying to lead the world as an industrial power and started being the world's entertainers, coaxing tourists to laugh at our eccentricities, marvel at our traditions and wallow in our nostalgia.[21]

'Black Eyes and Lemonade' featured items such as a model paddleboat made of glass beads, a three-foot high scale model of St Paul's Cathedral made entirely of icing sugar, papier mâché chairs, ships in glass bottles, ships' figureheads, and scrimshaw work executed by sailors on long whaling voyages. George

35 Advertisement from the Festival of Britain catalogue (1951)

McEarnean, a West End pavement artist, had his pitch set up in the corner of the Gallery below a *naif* painting of Lord Kitchener in his coffin. There was a section dedicated to barge decoration where entire cabins were reconstructed, painted, and decorated with fairy landscapes and flower patterns. There was a Hobbies Section which featured a model of Dunstable Priory Church made of $3,862\frac{1}{2}$ matches, Staffordshire china figures of 'The Queen of Prussia', 'A Bear Grasping a French Soldier', and a pair of milk jugs in the shape of black cows. The Souvenir Section was devoted to artefacts such as mugs showing the view from Hastings railway station, those made to commemorate Queen Victoria's Silver, Golden, and Diamond Jubilees, and kitsch ashtrays which enabled you to stub your cigarette on the noses of royalty. The scene was brought right up to date with the inclusion of a fireplace made to look like an Airedale dog, a Talking Lemon extolling the virtues of Idris Lemon Squash, and a selection of Bassetts Liquorice Allsorts isolated under a spotlight.[22]

The 'Black Eyes and Lemonade' exhibition was followed in 1952 by the influential exhibition of 'Victorian and Edwardian Decorative Arts' at the Victoria and Albert Museum, a display of 960 exhibits which helped greatly to stimulate the post-war revival of interest in art nouveau and the Arts and Crafts movement.

The Festival in general and the Lion and the Unicorn Pavilion in particular were regarded by the staff of the Royal College as great triumphs. *ARK* 4 (1952), edited by John Blake (later to become editor of *Design* magazine), features a cover by David Gentleman (a star student in the School of Graphic Design who became a full-time member of staff between 1952 and 1955) in true Festival style (Plate 36), featuring 'Egyptian' lettering and fairground imagery. Despite constant hostility from the Tory press and rumbles of discontent about what the critic Michael Frayn described as the 'herbivorous' characteristics of its organizers, the Festival in general and the Lion and the Unicorn Pavilion in particular were celebrated whole-heartedly. According to Sir Gerald Barry, one of the Festival's organizers, the attributes of the Lion and the Unicorn Pavilion were:

First novelty; the change for the mind and the eye in coming upon something unexpected . . . the relaxation of laughter. Second, the intrinsic beauty and style of most of the individual exhibits. Third, and by far the most important as I see it, the opportunity afforded a team of architects and artists to see a whole job through from top to bottom, start to finish. They not only designed the building and its decoration, they not only chose the articles to be exhibited . . . they were largely responsible for devising the theme itself, in outline and detail.[23]

Continuing the spirit of the Festival *ARK* 4 initiated a series of articles on popular culture which characterized *ARK* for years to come. The first of these, Jim Lovegrove's 'The Spritsail Sailing Barge', upholds the virtues of English

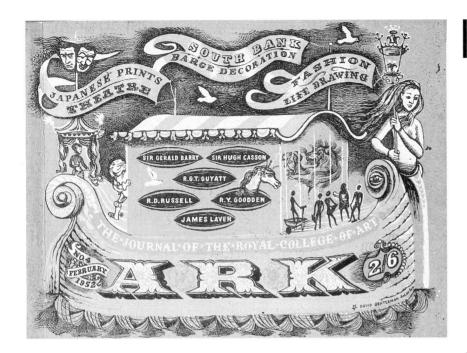

Jim Lovegrove's 'The Spritsail Sailing Barge', upholds the virtues of English popular culture displayed at the Festival and contrasts it to the etiolated sophistication of Continental modernism:

The formidable limits imposed by austere efficiency, functionalism, the fashion for modernity . . . all these lost their terrors for the designers of the Festival who were told to do as they pleased and . . . it is not surprising that many of their felicitations were remarkably like those of their grandfathers.[24]

In his text and illustrations (Plate 37), Lovegrove, a keen sailor and owner of a Thames sailing barge, celebrates

The Spritsail sailing barge of 1850 called the 'Thames' with its cabin finished in bird's eye maple, mahogany and gleaming brass . . . with its rich and pleasant smell mingling sweetly with the tang of the bitumen coating on the shroud lanyards and of the servings and ratlines soaked in Stockholm tar, swept aside occasionally by a breath of smoke from the chimney, or a whiff of roast joint and plain duff simmering and sizzling in the forecastle oven.[25]

In the early *ARK*s 'English' illustrations and articles can be found in abundance. *ARK* 7, which appeared in the Coronation year of 1953, for example, is entirely dedicated to the sea. Justifying the nautical tone of the issue, the editor, David Weeks, explains that:

37 Illustration by Jim
Lovegrove for his article
'The Spritsail Sailing
Barge' in *ARK* 4 (Spring
1952)

The sea has been a major factor in the development of these islands both as a defence and a highway. This dual and conflicting character has shaped our national culture and heritage . . . To survive we had to have a navy and a navy meant ships, wooden ships built with the oak of our forests . . . the craft of shipbuilding developed woodcarving and eventually produced the magnificent figureheads of the 18th and 19th centuries, while at home our potters were celebrating naval victories with souvenir designs.[26]

The magazine contains articles about a heroic old disabled lifeboatman from Aldeburgh (Plate 38), home of Benjamin Britten's annual Festival of Music and the Arts, nautical illustrations, and an article about the romance of the London docks entitled 'The Pool of London' (a film of the same name was produced by Ealing Studios that year) (Plate 39). A series of articles by David Weeks and David Gentleman contrasts the eternal verities of the coasts of Cornwall and Brittany to the effete, inauthentic preoccupations of the city:

In France as in Britain, local culture and independence are fighting a battle against the encroaching forces of mediocrity, mass produced habits and applied opinions. In some places this must of necessity be a losing battle, but in a region such as Brittany there exists an influence strong enough to counteract these forces. The influence is the Sea—out of its richness, beauty and mystery it gave the Bretons independence, clarity of vision and poetry; the three essentials from which life may develop.[27]

38 Illustration in *ARK* 7 by Peter Midgley (Spring 1953)

39 Illustration by W. Crawford Snowden for his article 'The Pool of London' in *ARK* 7 (Spring 1953)

ARK 5 (1952) contains an article by the editor John Blake which praises 'country life' in a nationalistic vein:

The great tradition of landscape in this country is deeply rooted in our national temper . . . Despite fluctuations in style and taste and the periodic influx of ideas from abroad, the fundamental spirit remains the same, for it is the intense consciousness of nature which lies at the heart of English painting. Whether it be the sun rising through the mist over Norham Castle or the fresh dripping trees of Dedham Vale, there is a mood, a common theme which is different from that of all other European painting. So strong is this concern for nature that the tide of conflict and revolution in the arts that swept Europe in the first thirty years or so of the twentieth century left us comparatively high and dry.[28]

The article is complemented by a series of landscape illustrations by Robert Buhler, Robert Blayney, Derrick Greaves, Carel Weight, Dennis Bailey, Edward Middleditch, and David Gentleman.

There is also plenty of space given over to 'Black Eyes and Lemonade'-style popular culture including articles on Victorian locomotive design, Victorian toy theatres, and tattooing. For example, in 'Pictures on the Skin' (*ARK* 13 (1955)), Bernard Myers laments the fact that:

the fast implacable career of the machine has dealt the artist and craftsman some pretty hard knocks. Mechanical progress has left a path littered with artist casualties who could not get out of the way quickly enough . . . But one art, a folk art with origins that smell of magic, of initiation rites, visual proof of physical trials and endurance, the permanent badge of the jealous identity of the fighter, adventurer and traveller, survives in the civilised, rational world—tattooing.[29]

Another popular arts *aficionado* was illustration student Colin Sorensen (now Keeper Emeritus of the Museum of London), who contributed several articles on the architectural merits of Victorian railway termini and the architecture of East End music halls, arguing passionately in favour of their preservation from demolition:

Every Londoner has, I suppose, one particular station which plays or has played an especial part in his or her life. Each of them has its own personality . . . if you like stations for their own sakes, as I do, you will have your list of favourite items . . . It may include the ripple of the wooden valence under the rainbow curved facade at Fenchurch Street (rumoured to be doomed), beneath the vast west wall of which the juvenile legions of the film *Hue and Cry* fought; perhaps . . . you may include the Doric portico at Euston with the two huge and impressive halls beyond, or maybe the view of St. Pancras and King's Cross from the Pentonville Road . . . Marylebone in the west gently sleeps, haunted it seems by ghosts in Norfolk jackets wheeling bicycles fitted with burnished carbide lamps, off for a late Victorian day in leafy Bucks.[30]

The early *ARK*s contain a score of articles in this vein on every aspect of popular culture in which folk songs, folk culture, folk arts, Victorian music hall design, and *naif* art are celebrated as representing the 'authenticity' and 'honesty' of the 'ordinary bloke'. Rosalind Dease, editor of *ARK*s 9 and 10, for example, lodged with the Buckett family in Brougham Street, Battersea. Mrs Buckett was the tea lady in the Painting School and her husband was a self-taught painter.

My friends and I regard it as a slice of luck for me that I live *en menage* with the Bucketts. They can hardly be aware of the strain I undergo in trying with an expensive art training, to compete with Mr. Buckett . . . He has given me an excellent recipe for trees in which 'you first draws your branches, then you puts in your dark green, then you puts in your

light'. I think this recipe Cennino Cennini might well have written in his treatise on painting . . . Mr. Buckett also makes dulcimers, windvanes 'to please the kids', collects yodelling records, reads thrillers and makes gadgets all over the house.[31]

Although the early *ARK*s are dominated by nostalgia, ruralism, whimsy, and romance there is another theme which runs through them, involving a debate about taste. Owing to the magazine's eclectic contents and mercurial editorship this debate is by no means coherent, but there is a series of articles between 1950 and 1955 which throw light on to the cultural politics of the early to mid-1950s. Like the articles on popular culture and the Festival, these articles on taste and aesthetics have to be 'teased out' in relation to the cultural politics of the RCA at that time.

'Good Taste' and Mass Culture

In 1945 Robin Darwin had been appointed Training Officer for the newly formed Council of Industrial Design. His job had been to review the Council's role in the education of young designers, and in his 'Report on the Training of Industrial Designers', which appeared in the *CoID Annual Report* for 1946–7, he observed that in the inter-war period art schools had become far too remote from the world of industry. Taking their lead from the example of William Morris and the Arts and Crafts movement, the art schools had become oriented in the direction of handicrafts and fine arts and in so doing had earned the reputation amongst members of the business community for being impractical 'artsy-crafty' institutions.[32]

In the immediate post-war period Darwin attempted to throw the whole weight of the RCA, College Council, and the CoID behind specialized and professional instruction in all branches of industrial design to give the College a direct bearing on the national economy. Gordon Russell, who was appointed Director of the CoID in 1948, at the same time Darwin was appointed Principal of the RCA, was a prominent member of College Council. Both Darwin and Russell hoped that the work of the RCA would provide an 'essential buttress' to the work of the CoID and leave the old 'arts and crafts' approach of the pre-war years far behind.

In an Open Letter to Gordon Russell's brother R. D. Russell, Professor of Woods, Metals, and Plastics, which appeared in *ARK* 2 (February 1951), Darwin expressed his support for the CoID and his eagerness to jettison the legacy of the Arts and Crafts movement:

William Morris' ideas were all confused with the 'dignity of labour' and so on. The whole thing got mixed up with the world's yearning after 'integrity' which will one day be seen,

perhaps, as the distinguishing characteristic of this century, leading to Divorce Law Reform, general education, women's suffrage, a reverence for the Windsor chair and Lord knows how many other results of questionable value. Honesty in most contexts is all very well, but surely in art it is neither here nor there.[33]

Although this looks as if it might be a moment which ushers in 'unethical' postmodern design, it is probably more accurate to understand Darwin's position in the context of a man eager to rid himself of the pre-war baggage (and implicit socialist politics) of the DIA's emphasis on the moral role of the designer. The left-wing theories of the design community were probably a major factor contributing to their isolation from the businessmen Darwin was eager to entertain in the Senior Common Room. Gordon Russell would probably have raised an eyebrow at Darwin's letter to his brother. In his autobiography *Designer's Trade* he defends the selection policy of the Design Centre in terms of 'honesty':

I have no wish to be a design dictator . . . Our job was to persuade [manufacturers] that a standard existed and that it was worth their while to up-grade their production so as to attain it. It is sometimes said that there is no such thing as good or bad design, that it has no real measurable standards, that it is, in fact, just a matter of personal taste. But it is readily accepted that there is a standard of, say, honesty, or driving, or housing, so why not one of design?[34]

For Russell and the CoID 'Good Design' was synonymous with a combination of 'good materials and workmanship, fitness for purpose and pleasure in use'.[35] These attributes could apply equally well to traditional or modern designs although Britain's reputation for traditional design 'could not have been won had earlier generations not had the courage to experiment and add their fresh ideas to the national heritage, therefore . . . the bias of the Council's propaganda has always been towards encouraging fresh thought and design in both the old craft-based and the new technical industries'.[36] For Russell, Paul Reilly, and their supporters the epitome of Good Design was to be found in the Scandinavian countries, where design seemed to combine traditional craft skills with the integrity of modernism and a more 'sympathetic', less 'austere' aesthetic than that represented by the Germanic International Style. Scandinavian design appeared to reconcile the aesthetic heritage of William Morris and the Arts and Crafts movement with the spirit of the modern age. Gordon Russell's own designs epitomized this combination. His furniture was soundly constructed of traditional materials yet it was capable of mass production. In its synthesis of the virtues of tradition with the necessities of the modern world it seemed to represent Good Design for the People.

During the War Russell had been Chairman of the Utility Furniture Committee, preparing designs for an entire range of items to which manufacturers were compelled to conform. The main thing some young designers disliked about Russell was that, like most other modernists, he had a tendency to adopt an élitist and moralizing tone when justifying his designs and the work of the CoID. They were aiming 'to give the people . . . something better than they might be expected to demand'.[37]

After the War the CoID and *Design* magazine promoted the principles of 'Good Design' and battled ceaselessly against 'Tudorbethan' and 'jazz modern' styling, which they regarded as uneducated, crude, vulgar, and escapist bad taste. However the CoID was not opposed to most folk art. As Gordon Russell wrote:

The exhibition 'Black Eyes and Lemonade' at the Whitechapel Art Gallery showed ornamental articles, some of astonishing beauty and some trash. All were things ordinary people have bought not because they are really necessary but because they have some element of delight, of that fairy-tale world which all of us, however grown up, like to retreat to at times . . . We are all entitled to our foibles. At heart most of us like vulgarity, the vulgarity of the circus playbill and the cut-glass-and-mahogany pub. It is the unashamed exuberance of the ordinary bloke, not to be confused with the sodden vulgarity of soul which we can count on seeing in Messrs ——'s windows in any biggish town.[38]

Kitsch was the enemy, not 'authentic' popular culture. The *ARK*s of the early 1950s also testify to this sentiment. Articles on aspects of folk culture are interspersed with reviews of the 'contemporary' designs enthusiastically supported by students in the School of Woods, Metals, and Plastics. As Nigel Chapman, who contributed an article on contemporary clock design to *ARK* 11 (1954), explains:

All of us in the School of Woods, Metals, and Plastics were *very* pro-CoID because in those days we had very few friends indeed . . . the CoID saw that article on clocks I did for *ARK* and gave me tremendous help. They promoted me, fixed up an appointment for me to see J. M. Richards at the *Architectural Review*, and he published the article too . . . The CoID seem a bit strait-laced in retrospect, I suppose, but for young product designers like myself at that time they were great . . . We were simply desperate to make a breakthrough into industry.[39]

John Blake, another student in the School of Woods, Metals, and Plastics and editor of *ARK*s 3 to 5 before graduating to the editorship of *Design*, explains that at the time he too was

overwhelmed by Paul Reilly's vision. It was wonderful. He wanted to contest what he called the 'backwoodsman' mentality . . . the old-fashioned, knobbly-legged stuff. The

Scandinavian design was clean, elegant, modern . . . I was particularly impressed by Ernest Race's 'Antelope' and 'Gazelle' chairs, which were displayed for the first time at the Festival. They were marvellous.[40]

Such whole-hearted support for the Gordon Russell–Robin Darwin axis was by no means universal, however. There is strong evidence in *ARK* that a minority of students found the CoID line patronizing. In an article entitled 'In Defence of Common Vulgarity' (*ARK* 6 (November 1952)) Joseph Burrows betrays a characteristically ironic, 'postmodern' sensibility in his presentation of the case for kitsch 'bad taste':

Our monotonous routine of daily existence is coloured by the egg-timer from SWALLOW FALLS, the teapot cottage and the marmalade jar with its insistent morning greeting of 'I CUM FROM LOOE'. Light green and elaborate tins shouting TEA, SUGAR AND COFFEE. The calendar, bronze Indian ashtrays and elephant bells inlaid with red and green enamel . . . Doormats in coconut fibre with stencilled designs, teddy-bear hot water bottles, shopping bags in raffia. Black-tiled Scotty dog electric fires . . . A pink plastic radio, the ever-open mouth which provides continual background noise to all our activities, pumped into our living rooms from dawn to dusk, flooding everywhere and pouring out of the open windows into the neighbours' back garden . . . It seems inevitable that in this age of social mass organisation, of town planning, of holiday camps, of compulsory National Service . . . that OUR home, regimented and conformed outside though it may be, should inside express absolutely OUR personality.[41]

Burrows's celebration of the 'inauthentic' in *ARK* is the first evidence of the pop shape of things to come.

For most students and virtually all of the staff during the early 1950s, however, mass culture was the enemy. In the School of Graphic Design it was generally perceived that the harbinger of vulgarity and the 'levelling down process' was photography. The first issue of *ARK* in 1950 was dedicated to book illustration and was 'overshadowed by the widespread feeling that the book illustrator, retreating before the photographic half-tone, is being confined to the more limited editions of the bookjacket'.[42] In 'Doing the Book of the Film, or How I Ruined my Life', the final article in the first issue of the magazine, John Minton wittily describes an unhappy commercial liaison between himself and 'Finglehofer, Spottiswoode and Gunthorpe', the firm which has commissioned him to design 'the book of the film':

There takes place what the S.I.A. likes to call 'the Designer–Client Relationship', which consists of the client telling the designer that he's all for art . . . and that he's Doing You a Big Favour ('We want to Help you Young Chaps'), that he's got a Mission and so forth. 'But we don't want anything *too* extreme', he says. 'Here it comes,' I think, 'here we go again . . .'[43]

The hapless illustrator draws the film's star, one Wanda Topscore, 'looking out of the window, looking into a window, looking into space and looking out of space'. He hates doing it. It drives him crazy. 'I grow thinner, I cut my friends in the street. I mutter at tea parties. I take to secret drinking;' but eventually, six months later, when the book appears, his painstakingly executed illustrations have been usurped by a photograph: 'There is my dust jacket or rather there is a photo of Wanda Topscore with a few clouds behind. I drew the clouds, yes, the clouds were actually mine . . . three of them. And the illustrations? Well, I found a tailpiece, but the rest seemed to be photographs.'[44] The sensitive illustrator is, alas, a doomed anachronism in the crass, vulgar world of commercial mass culture: 'Yes, there's money in the Hunk Organization, but look at me now, white haired and bitter, sitting in the Gargoyle night after night thinking of what might have been.'[45]

Throughout the early to mid-1950s most members of staff and the majority of students in the School of Graphic Design saw themselves as defenders of Good Taste against the incursions of the forces of mass culture. Whole-hearted involvement in the advertising industry (with the exception of executing the occasional tasteful poster for Shell, Ealing Studios, Fortnum & Mason, or college societies) was regarded as something to be avoided. The advertising industry in general seemed to threaten to reduce the status of the graphic designers to that of commercial artists. 'Advertising', ex-illustration student Len Deighton remembers, 'was a dirty word', while his friend Raymond Hawkey recalls that 'it was *very infra dig* indeed'. Deighton and Hawkey's contemporary Dennis Bailey remembers that the staff of the School of Graphic Design encouraged students to find a suitable patron to commission work from them rather than stoop to actually working for an advertising agency full time. The ideal situation for the illustrator was regarded as being that of a self-employed 'gentleman illustrator' rather than a professional commercial artist. Bailey recalls his attitudes to the commercial world thus:

I left College in 1953 seeing myself as an illustrator rather than a graphic designer. When I graduated I had an exhibition of my paintings at the Studio Club with my friend Lewin Bassingthwaite . . . I thought I'd get a job part-time teaching and although I didn't want to be an artist in a garret I thought it would be something like that. You just knew there was no money to be made from illustration but you liked doing it, so if you got the occasional drawing in the *Radio Times* or *Lilliput* maybe an advertising agency would ask you to do some work occasionally. The College encouraged you to cultivate patrons and the main one was Jack Beddington.[46]

Beddington was a member of College Council and in a sense he represented the Ideal Employer, for he was a man who managed to reconcile the vulgarities

of commercial art with the life and style of an English gentleman. An elegant and cultivated man, Beddington described himself as a 'gifted amateur', an outlook which derived from a sophisticated and wealthy family background with august literary and musical connections. At Balliol he was fashionably academically undistinguished, and after the First World War, in need of a job, he went to work for Shell in China. Back in London in 1928 he became a member of Shell's Advertising Committee. He knew 'nothing at all about advertising', but turned down every design he saw on 'the grounds that they were hideous'. His chief responded by making him publicity manager at the time Shell was merging with BP. BP owned the Regent Advertising Service, of which Beddington became Chairman. Shell-Mex and BP's advertising was transferred to Regent Advertising and Beddington found himself in the position of being his own client.

Beddington's method of choosing artists to design advertisements was particularly endearing to an English gentleman like Darwin, for Beddington simply spent his relaxed lunch hours strolling round West End art galleries and, when he saw a work which appealed to him, would commission the artist to design an advertisement for Shell. In the eyes of Robin Darwin or Richard Guyatt, Beddington's 'impeccable' taste enabled him to commission young and unknown artists who were later able to command substantial fees. During the late 1920s and 1930s these had included Graham Sutherland, John Piper, John and Paul Nash, Edward Bawden, Cedric Morris, McKnight Kauffer, Edward Ardizzone, Edwin La Dell, John Skeaping, and Richard Guyatt. Unlike the art directors of most advertising agencies, Beddington never told his artists how to design the advertisements 'but gave them a subject and the size and left them to it'.

Beddington had little in common with the stereotypical brash, thrusting, Madison Avenue advertising executives who began to settle in London from the mid-1950s onwards in the wake of the dismantling of governmental wartime controls. In 1937 only four American advertising agencies had offices outside the United States whereas by 1960 the number had risen to thirty-six. In London the American agencies sometimes set up their own offices from scratch, but usually they bought out existing British agencies, bringing with them new techniques derived from market research and the psychological study of human motivation.[47]

Beddington represented a bastion of English tastefulness opposed to the hard sell techniques of the American agencies which began to mushroom in London during the mid-1950s. Only Beddington, for example, could have hired a high Tory and implacable anti-modernist, the poet John Betjeman, to edit the 'Shell Guides' which were then illustrated by John Piper, the foremost exponent of a

PRESERVATION OF THE COUNTRYSIDE

WEST WYCOMBE—RECENTLY PURCHASED BY THE ROYAL SOCIETY OF ARTS

THE PROPRIETORS OF SHELL
DO NOT ADVERTISE THEIR
PETROL IN PLACES LIKE THIS

EVERYWHERE YOU GO

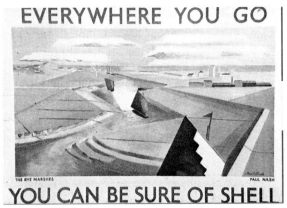

THE RYE MARSHES PAUL NASH

YOU CAN BE SURE OF SHELL

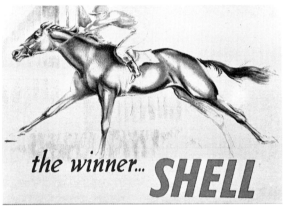

the winner... SHELL

pastoral vision of 'Englishness'. The witty captions and pretty illustrations of Shell's suave advertisements were restrained and never 'vulgar'. Beddington's policy of commissioning paintings and illustrations from known and unknown artists of distinction helped confound the deepest prejudices of the anti-advertising lobby and did much to boost Shell's public image. One of the most famous Shell advertisments, for example, consisted of an exquisite picture of the English countryside with the caption 'Shell Do Not Advertise in Places Like This' inscribed beneath (Plates 40–2). By the end of the 1950s, however, the British advertising business had changed beyond recognition. Writing in the hectic days of the early 1960s, a rather wistful ad man by the name of Nigel Birch looked back to the good old days of Beddington's regime when

the copy writer could . . . stroll into the office and compose a slogan consisting of three witty words or a batch of fragrant phrases, before retiring, unexhausted to his flat at 5.30

40 Advertisement for Shell (1930)

41 Advertisement by Paul Nash for Shell (1932)

42 Advertisement by John Skeaping for Shell (1952)

to get on with his novel. The entry of marketing into the advertising agencies today has largely coincided with the exits of various distinguished pen-men, transit passengers who passed through the advertising world but once and earned a pleasant living by doing some copy-writing while getting ready to write their best-selling novel, film or play. It's difficult sometimes not to feel a bit nostalgic about those old ornaments of the advertising business still living somewhere in Schweppesshire.[48]

In the eyes of the College Establishment, Beddington represented the ideal patron for the RCA-trained illustrator. As Nikolaus Pevsner once said: 'You could apply the term Lorenzo very aptly to Jack Beddington.'[49]

Some of the students were not so enthusiastic, however. Dennis Bailey remembers being 'discovered' by Beddington, labouring night and day to produce illustrations acceptable for an advertisement, having them rejected, and producing more only to be told by his debonair patron that the figures in the illustrations

looked like some chaps who'd been picked up for importuning in the lavatories in Piccadilly underground station. I stormed out into Mount Street almost in tears and thought, 'God Almighty, there must be some other way to earn a living! Do I really have to listen to this crappy, patronizing, pompous nonsense?'[50]

Raymond Hawkey, a student in the School of Graphic Design and art editor of *ARK* 5 (1952), was not so keen on what Beddington stood for either. In 'Advertising: A Skeleton in Whose Cupboard?', Hawkey aimed his guns directly at the great patron in an attempt to strip away the gentlemanly pretence which seemed to veil the true nature of Beddington's trade:

The similarity between the methods employed by the modern political propagandist & the modern advertiser is disturbing. Both methods make use of half truths and deliberate falsehoods as a means of influencing opinion and appeal to the emotions rather than the intellect. Both rely on telling the audience what it wishes to believe—that the solution to its particular political, professional, domestic or sexual problem is relatively easy, inexpensive and guaranteed.[51]

As Beddington had run the Films Division of the Ministry of Information during the War, Hawkey's salvo probably found its mark. Beddington seems rather unconvincing when he replies that 'there is practically no similarity between a political propagandist and a modern advertiser. You cannot sell ideas by the same methods as you use to sell articles.'[52] In reply to Beddington's assertion that all the wartime propagandists who turned to advertising in peacetime proved to be absolutely hopeless at it, Hawkey remarks that 'Surely this is an odd statement, especially when one remembers that Misha Black, Milner Grey, Beverley Pick,

1 Cover of *ARK* 24
(Autumn 1959) by Denis
Postle.

2 Robyn Denny, *Eden Come Home*
(*c*.1957).

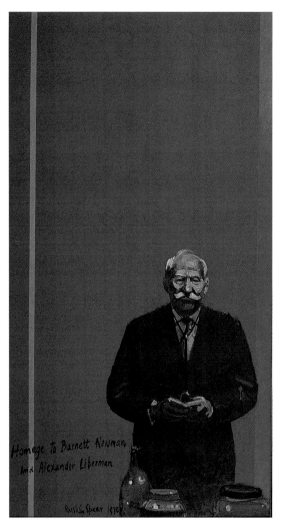

3 Ruskin Spear, *Homage to Barnett Newman and Alexander Liberman* (1970).

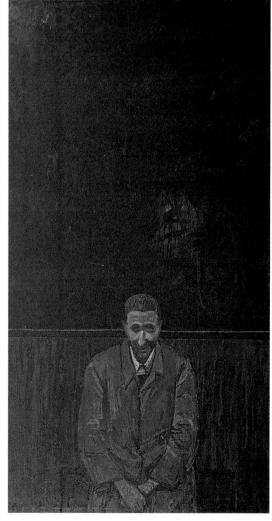

4 Ruskin Spear, *Portrait of a Young Contemporary* (c.1959).

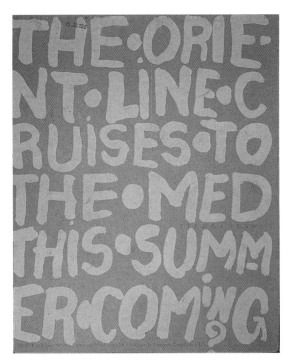

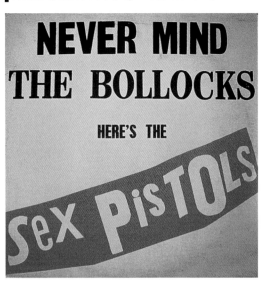

6 Cover for *Never Mind the Bollocks, Here's the Sex Pistols* by Jamie Reid (Virgin Records, 1976).

5 Advertisement for the Orient Line on back cover of *ARK* 24 (Autumn 1959) by Denis Postle.

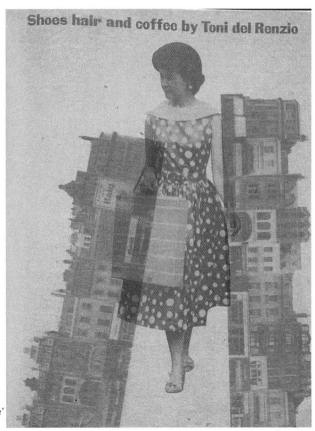

7 Design by David Collins for Toni del Renzio's article 'Shoes, Hair, and Coffee' in *ARK* 20 (Autumn 1957).

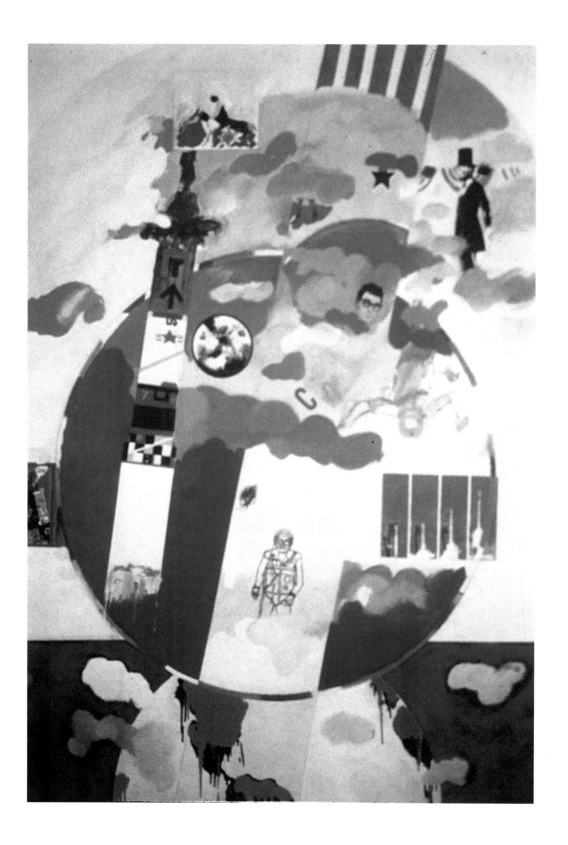

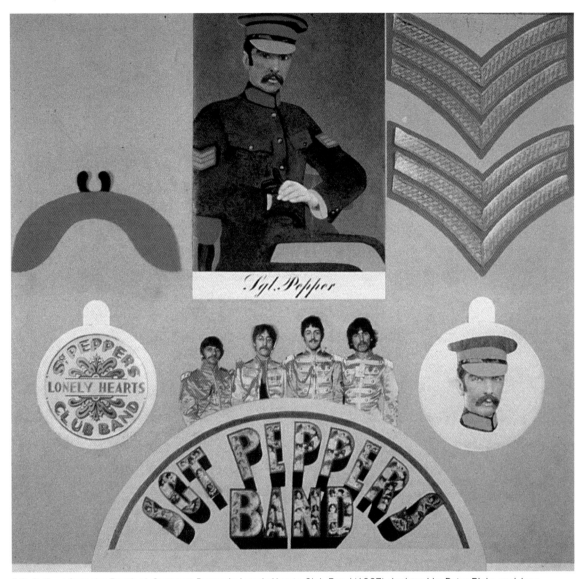

9 Pull-out from the Beatles' *Sergeant Pepper's Lonely Hearts Club Band* (1967) designed by Peter Blake and Jann Haworth. © Apple Corps Ltd

8 Derek Boshier, *I Wonder what my Heroes Think of the Space Race?* (1962).

10 Cover of *ARK* 32
(Summer 1962) by Brian
Haynes.

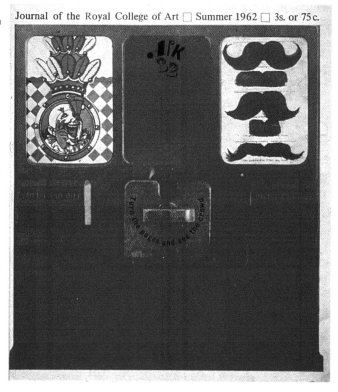

11 'Get Age' collage by
Brian Haynes in *ARK* 32
(Summer 1962).

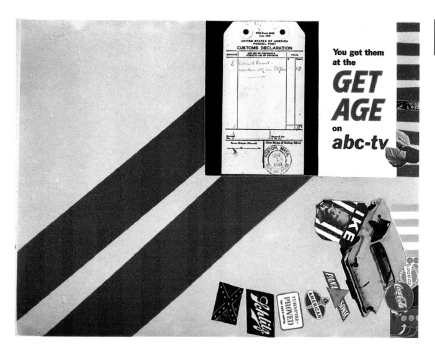

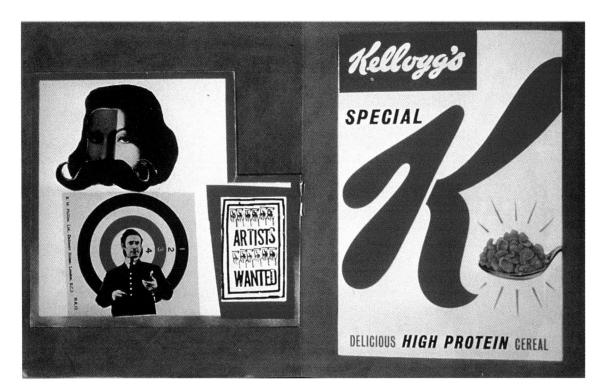

12 'Kit of Images' by Brian Haynes in *ARK* 32 (Summer 1962).

13 Cover of *The Who Sell Out* (1967) designed by David King and Roger Law with photographs by David Montgomery.

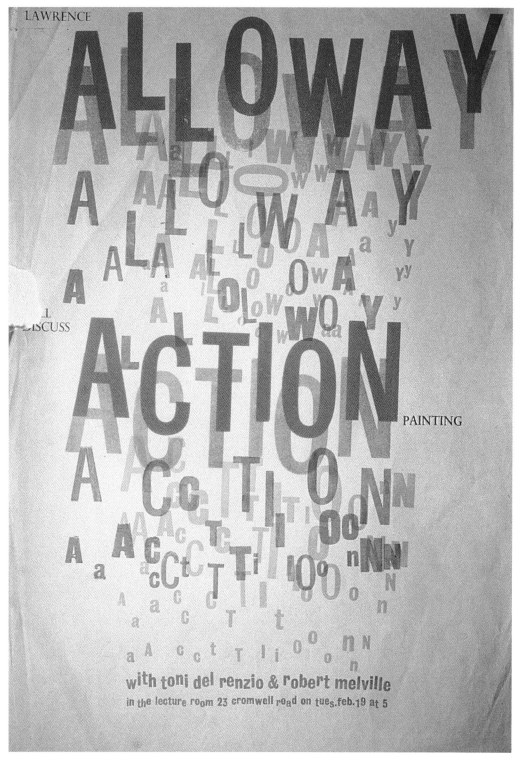

Lesley Room, James Holland, and Mr. Beddington himself worked in the propaganda machine.'[53]

The following issue of *ARK* contained another attack which was focused directly at members of College Council and the aims of Darwin's reforms in general:

It is now fashionable for the modern designer to deride William Morris and to swear allegiance to industrialism with an enthusiasm as wholehearted as it is suspect. The heretic of the moment is the romantic individualist who frankly admits his detestation of organised technology . . . A strange perversion arising from the modern designer's awareness of history is manifested in the desperate search for originality at all costs. The deduction that only the new has value.[54]

Statements like these were obviously sources of considerable irritation to members of College Council. In *ARK* 8 (July 1953) Gordon Russell led the Establishment's counter-attack:

The prewar attitude encouraged the artist to look nostalgically to the past instead of bravely to the future. The Arts and Crafts movement did not realise that hand and machine work were complementary. To them it was hand or nothing, so that many able designers came to think that all machine work must, of necessity, be ugly and nothing could be done about it. The chasm seemed to widen. To the manufacturer the artist was an impractical dreamer, to the artist the manufacturer was a philistine.[55]

He reminded 'those students who criticise members of College Council' that

those manufacturers, all of them very busy men, who have given up their time to sit on the Council of the College . . . have performed a notable service . . . Loose talk by students about the rapacity of manufacturers will cease as the partnership between industry and College grows . . . Students do not always remember that such institutions were not primarily set up as political hot houses.[56]

In reality, despite Russell's insinuations, the RCA in the early to mid-1950s seems to have been generally apathetic politically. There is, for example, no mention whatsoever in *ARK* of international events of the significance of the Suez crisis or the Soviet invasion of Hungary. RCA students, it seems, were concerned with art and design to the exclusion of virtually everything else. The discontent which *does* begin to resonate increasingly through the pages of *ARK* during the 1953–5 period tends to be directed squarely against the parochialism and drabness of the British art and design scene rather than any institution or political party. Commenting on the ambience of that period, Alan Fletcher (a student in the School of Graphic Design 1953–6) comments:

> It's difficult to describe how awful life was then. How grey it was! There was nowhere to go. The main excitement was when a place opened where you could get a decent cup of coffee, called El Mocambo in Knightsbridge . . . there was actually nowhere else to go. So on Saturdays the art schools all had dances with bands. St Martin's one Saturday, Camberwell the next . . . We always used to go and spend our Saturday nights there. There really was nothing else to do.[57]

The fashion photographer Brian Duffy, Alan Fletcher's friend and contemporary, confirms these observations: 'I wouldn't say London was boring at that time. It was much worse than boring. It was BORING! It was AWFUL! . . . El Mocambo was so *glamorous* when it came along. I can't tell you how glamorous it was.'[58]

ARK 12 (Autumn 1954) captures this feeling of frustration and longing for new stimuli in an article entitled 'Londres la nuit' by Cyril Ray, a *Sunday Times* columnist, who describes the dreadful mediocrity of night life in contemporary London and the poor impression it left on foreign visitors to the capital:

Along Fleet Street to Leicester Square and the champagne supper that was to be the highlight of our tour. Five tables were occupied in the restaurant that was to be that evening's high spot and there was plenty of room for the floor show—four girls in top hats and long fishnet stockings. There was a table proudly laid out for the night life party and we had not one but *two* triangular sandwiches containing the meat from old, cold chicken legs and margarine. There was not one but *two* bottles of wine between the nine of us . . . I tried hard not to catch my Spanish neighbour's eye but there was no denying him. 'For seven pesetas', he said 'which is 1s/6d, in the Molino in Barcelona . . . I can see one hundred and fifty girls, most of them beautiful and all of them *young*. In my country,' he said, raising his voice, 'in my country the beer is COLD, this . . . this is like *consomme*.'[59]

Apart from whiling away Saturdays in El Mocambo or dissipating oneself in the search for elusive sex at the art school dance, one strategy for coping with the drabness of London during the 1950s was to involve oneself in amateur dramatics. The role of theatre in the cultural changes which transformed the RCA during the 1950s has seldom been mentioned, but the particular fascination for performance throughout the 1950s and early 1960s provides a vital key to understanding the development of a distinctly English postmodern sensibility.

Dada, Dodo, and Doo-Dah

4

National Service

Between 1945 and 1960 a large percentage of male students were entering the College after active wartime military service or two years of National Service. Few writers have placed much emphasis upon this link between military service and art education but it provides a vital clue to understanding why art schools became important catalysts of cultural change during the 1950s.

Until 1950 it was possible to leave the Services and be awarded an ex-servicemen's grant under the Further Education and Training scheme in order to study virtually any subject one wished. Like the grants provided under the GI Bill of Rights in the USA, the purpose of these FET grants was to help repair careers and skills disrupted or neglected during the War. In 1949, when it was rumoured that the Labour government was intending to terminate these grants in the near future, there was a rush of ex-servicemen into art education. By the early years of the 1950s a huge percentage of art students were ex-servicemen from a very wide range of social backgrounds. Their presence in the art schools radically altered the rather genteel atmosphere and tightly structured curricula which had prevailed in many of these institutions before the War. In the RCA Schools of Painting and Graphic Design in particular, a direct result of this influx of ex-servicemen was a new kind of iconoclastic, 'student-led' experimentation which developed as the influence of the teaching staff over the students declined.

Many of the ex-servicemen who attended the RCA during the late 1940s and early 1950s were hostile to Darwin's attempts to transform the College into a quasi-university. As Clifford Hatts, who attended the RCA during the late 1940s, recalls, 'we were ex-servicemen in our late twenties who were not in the mood to take any nonsense from anyone' and although 'Darwin's arrival in 1948 was welcomed in so far as he would bring about the innovations and changes

required to revitalize a moribund and somewhat Victorian institution' there was a strong tendency to debunk and ridicule the new regime:

We had a very interesting table in the canteen at the College in the late forties. There was Cliff Wilkinson who had been an officer in charge of signals on a big battleship, Mike Kelly who had flown with Bomber Command, Jack Chalker, who had been a POW in Changi Prison, Derek Fowler, the portrait painter, who had been a Staff Captain in India, and myself, a Sergeant-Major Mechanic . . . Darwin didn't get an easy ride from us! There were legendary stories about big fellows who'd been in the infantry who were up in the Painting School smoking and the tutors trying to get them to stop and them saying, 'Are you talking to *me*, Pal?' We were *very* bolshie. You see a lot of us had seen a real war for four or five years. They had come to the College to paint. They were men, not little students. Big chaps who had fought their way across the Northern Approaches on a battleship in the depths of winter didn't take kindly to being told not to smoke by a painting tutor![1]

Darwin's determination to close the Students' Common Room on Queen's Gate, a drill hall constructed during the Crimean War which he described as a 'pigsty', became the focus of considerable dissent for Cliff Hatts's generation. By tradition the 'Hut' was out of bounds to staff and beyond the reach of the 'Authorities' in the social sense. Denis Bowen (RCA Painting School 1947–50) remembers that after six years of active service in the Navy he and his friends were in no mood to be told what to do by Darwin: 'He knew he had a lot of trouble from us, he wanted to "inspect" *our* Common Room. We simply told him to get lost.'[2]

Satire was adopted as the favourite strategy for resistance. It was a tradition in those days for RCA students to mount end of term burlesques and in 1948 it was decided that the 'Convocation Burlesque' would be a thoroughgoing lampoon of Robin Darwin's new 'Dynamic and Thrusting' mode of operation. A 'treatment' was written by Clifford Hatts, Barry Wilkinson, and Peter Newington caricaturing Robin Darwin as a Victorian Principal of the RCA, a 'monster' who threatened to demolish the Common Room. A 16mm. film was shot and back projected during the performance while the live action proceeded on stage, including a rapier duel between the Minister of Education and Darwin which was seen simultaneously on stage and screen. The title of the film became known as 'Elluva Twist' (because David Lean's *Oliver Twist* was the hit film of 1948).[3]

An article in *ARK* 10 (Spring 1954) typifies the attitudes of many of the ex-soldiers, sailors, and airmen who attended art school during the late 1940s and early 1950s. Entitled 'The Survivor' it was written and illustrated by Ronald Searle, who, like several RCA students of the 1940s and early 1950s, had been a

POW and had experienced the horrors of a Japanese prison camp deep in the Siamese jungle,

where I spent a year rock breaking and began drawing, I think for the first time, because I had something to say (a lot of it unprintable—in several senses.) After a year of that and eighteen months in prison further down, I'd made up my mind that I'd be a freelance somehow or other, if I ever got back, just-to-say-what-I-wanted-for-the-hell-of-it.[4]

Ex-servicemen not afraid 'to say what they wanted just for the hell of it' did not hesitate to ridicule anything they regarded as anachronistic, snobbish, or patronizing. They tended to see their time at the College as an opportunity to improve their career chances and they took very little notice of members of staff who appeared to be impeding their goals.[5] Their attitudes were perpetuated and accentuated by the ex-National Servicemen who entered the RCA in their wake. The 1950s generation of RCA students differed from those who came after them in several key respects. To begin with most of them were considerably older than students of the 1960s and were likely to be in their mid- to late twenties or early thirties. Secondly, relatively few of these students had come to the College directly from their first art school. Most of them were already experienced, mature adults. It is instructive to listen to the ways in which the experience of National Service affected their attitudes:

I got into the College in 1950, but in those days you had to do National Service first, so from 1951 to 1953 I did National Service. As time goes by I realize National Service was a key experience. June 12th was the day I went in. You never, ever forget it. You were 18. In most cases it was the first time you'd been away from home and people of 18 then were a very *young* 18. Suddenly you were in a barrack room with men of 30—hard cases from Glasgow and the first homosexuals you'd ever run into, just a total mix of people— Geordies, members of the aristocracy, too, people you'd never come into contact with before . . . National Service had a really big effect because you'd met so many people by the time you went to College that you'd had an education in life. (Peter Blake, RCA Painting School, 1953–6)[6]

The generation preceding mine had actually fought in the War. My generation was in National Service. I was in the Navy in 1949 . . . I became a conscientious objector after I left the Navy, so my next spell was in the Royal Naval Detention Barracks in Portsmouth because I'd refused to do my Reserve Training . . . So by the time we got to College we'd knocked around a bit, we'd actually been out in the world. We didn't simply go straight from College to a job . . . I was married by the time I got to the RCA, I'd been in the Navy, I'd been in naval prison, I'd been teaching, I'd been at art school in Paris, I'd been self-supporting, living on my own. I was an independent person. I had developed independent views. I questioned everything. I wouldn't accept received opinions. (Robyn Denny, RCA Painting School, 1954–7)[7]

I was very lucky to have done my National Service before I went to the RCA. The experience knocked the terrible art snobbery I'd had at Twickenham Art School right out of me . . . I was a real art snob. I thought if you weren't an artist or you didn't know about art you weren't worth talking to. That attitude got you nowhere fast in the RAF! . . . We were shipped around to camps all over the country, there were fighting competitions every night. It really opened my eyes to the world. (Terry Green, RCA School of Graphic Design, 1957–60)[8]

The ex-wartime service and ex-National Service generations were drawn from a wide range of social classes and tended to be far more outspoken and more rebellious than their predecessors. For many of them, especially those from working-class backgrounds, art school represented the one chance for social mobility and it was seized with both hands. As Len Deighton points out:

If you look at immigrants into New York City at the turn of the century, they couldn't go into areas with strong unions, like the Teamsters, they couldn't go into things where language barriers were high, so they went into visual things—movie-making, the dress business, entertainment, music. The social revolution in England after the Second World War was a similar thing . . . The only cracks in the edifice that were going to provide us with opportunities were advertising, film, show-business.[9]

Len Deighton's friend and RCA contemporary Joe Tilson (ex-carpenter, ex-RAF, RCA Painting School 1952–5) also stresses the unique combination of ingredients which characterized his generation of students:

What happened at the RCA then will probably never happen again. It was very much a class thing. Len Deighton, Peter Blake, and I all came from working-class backgrounds from the London area. We were the kinds of people who would never have gone to art school before the War. Len and I went to St Martin's with the help of the ex-servicemen's grant that existed until about 1950. We even got demob suits![10]

Like Clifford Hatts's contemporaries during the late 1940s, many of these students were intolerant of the College's social pretensions and many of them, graphics and painting students in particular, had very little time for what they regarded as irrelevant, archaic syllabuses and the occasional pompous or patronizing member of staff. As Len Deighton recalls:

We all knew New York was the new centre of art by the mid-1950s. The problem at the College was that all the instructors were still thinking in terms of the 1930s while the students were living in the 1950s. Staff members would seriously refer to Paris as the centre of painting! It wasn't the centre of anything by then. People would be coming round actually giving us lessons in illustrating books! Illustrated books were a Victorian preoccupation. All the instructors were living in a world that had gone! . . . Talking from a graphics point of view, the students fell into two distinct categories. They weren't at war

with one another, but some had come to College because of what the College had represented during the Rothenstein era—genteel fine art. Other people, including myself, thought: 'At last, here are three years in which I can paint and draw!' They didn't give a damn about Darwin or the College. It could have been a prefab hut in the middle of Clapham Common for all they cared.[11]

Although some of the students who contributed to *ARK* between 1950 and 1960 managed to avoid National Service owing to gender, luck, guile, or ill health, the majority were touched by the experience in some way. The background of shared military experience reinforced the separation between 'officers' (staff and the Senior Common Room) and 'men' (students and the Student Common Room), a separation which was made quite bizarre by the fact that many of the 'men' had held a higher wartime rank than many of the 'officers'! This curious paradox combined with equally bizarre wartime experiences. Denis Bowen, for example, recalls the tall story of a fellow painting student, an ex-RAF mechanic who 'was fixing the tail end of a plane when suddenly it took off and he was left hanging on to it as it flew all over the Western Desert. Of course that was the kind of incident we included in our end of term revues!'[12]

Similarly, Ted Dicks, an ex-National Serviceman and a student in the Painting School during the early 1950s, remembers that

art school was still regarded as rehabilitative therapy at that time. We had people in the Painting School with severe shell-shock. We had one bloke who was literally twitching and who would collapse if someone dropped a drawing board or something. It was very strange. I was really staggered.[13]

Richard Guyatt recalls that Darwin's suggestion for a replacement editor for *ARK* after the departure of Jack Stafford, the first editor, was a similar psychological casualty:

Robin said he thought there was a student in the Sculpture School who had run the Eighth Army newspaper in Italy. He said he was a colonel and would make a jolly good editor . . . This man came to my studio and he was very much the cheeky chappie with a moustache and a spotted cravat, almost a caricature of a colonel, really. As the interview went on I thought this was rummer and rummer. He was really *very* strange. I later discovered that he was a complete alcoholic—tight as a coot. He drank at least a bottle of gin a day. Yes, there was that type of student. A man in his mid-thirties with long wartime experience behind him.[14]

Given the ex-active service and National Service experience of so many RCA students, it is not difficult to understand why the *Goon Show*, which began BBC broadcasts in November 1952, gained a devoted following at the RCA and other

art schools, for the scripts of Harry Secombe, Peter Sellers, Michael Bentine, and Spike Milligan seemed to reflect the surreal absurdity and insanity of war and military service perfectly. The *Goon Show* was a major influence on the RCA student reviews of the 1950s and their tone owed a good deal to the anti-Establishment 'bolshieness' nurtured on the parade ground and in the NAAFI.

Performance

Even before the War the Royal College of Art had a reputation for theatrical performances of a high quality, but during the late 1940s and 1950s the quality of drama at the College reached new heights with the students' union presenting at least three ambitious theatrical productions a year. The small pre-war unit which had specialized in Theatre Design within the old Design School had been closed by Darwin in 1948 and was taken over by the students themselves. This is an early example of the kind of 'student-led education' which began to characterize parts of the RCA throughout the 1950s and it resulted in several students specializing in design for the professional theatre, film, and television. So although an official Department of Television Design within the School of Graphic Design did not materialize until 1962, for over a decade students at the RCA had been devising their own training in set design via their involvement in RCA theatre productions.

Plays staged in the old Queen's Gate Common Room included a five-hour version of Ibsen's *Peer Gynt* as well as *Hassan*, *The Taming of the Shrew*, and a production of *The Tempest* which involved demolishing the entire back wall of the 'Hut' to create an extremely elaborate set. Productions in the new Cromwell Road Common Room opened with a double bill featuring Cocteau's *Orphée* and Fielding's *Tom Thumb* (Plates 43–4) followed by a revival of Gay's *Beggar's Opera* directed by Bernard Myers with sets by David Gentleman. These were serious major performances executed in a professional manner with students and ex-students combining to form their own semi-professional company—London Artists' Theatre Productions—which also staged plays in the Toynbee Hall.

Many RCA performances received regular reviews in the national press and were often praised for the quality of their acting and especially for the originality and skill of their set designs. The School of Graphic Design produced much of the publicity while students and staff from every school in the College acted and designed the costumes and the sets. Throughout this period there was a direct link between the Royal College Drama Society and the Royal Court Theatre with several students and members of staff, including John Minton and Rodrigo Moynihan, actively involved in directing and designing productions for both the

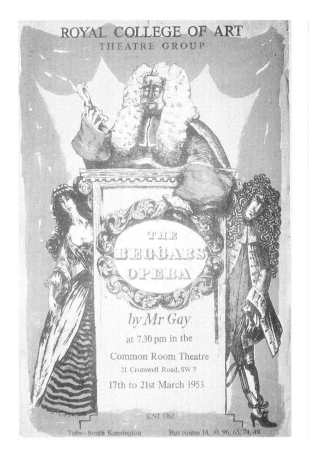

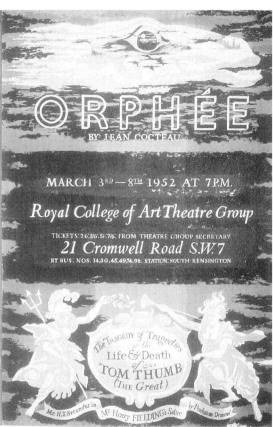

RCA and the Royal Court. The high quality, wit, and originality of the College's theatrical productions were enhanced by the exceptional facilities of the new Students' Common Room at 21 Cromwell Road, which boasted a very large auditorium, professional light and sound equipment, and an elaborate movable stage.

The RCA's reputation for high-quality drama during the late 1940s and 1950s owed a good deal to the post-war demand for exhibition and set designers. Hugh Casson (who became Professor of Interior Design in 1952) and Misha Black (who was appointed Professor of Industrial Design in 1959) had served on the Design Panel for the Festival of Britain and recruited several promising RCA graduates to work on the Festival, including Clifford Hatts, who had been a leading light in drama and amateur film-making at the College during the late 1940s. After working on the Festival and for a brief period as a free-lance designer, Hatts was recruited by Dick Levin, Head of Design at the BBC, who had suffered a serious loss of his most talented designers to ITV in 1954–5. By 1957 Hatts was working

43 Poster by David Gentleman for the Royal College of Art Theatre Group's performance of *Orphée and The Life and Death of Tom Thumb the Great* (1952)

44 Poster by Paul Temple for the Royal College of Art Theatre Group's performance of *The Beggar's Opera* (1953)

83

full time for the BBC as a set designer, eventually being promoted to the general managership of the entire BBC Design Group by 1972. Although his work on the Festival of Britain originally drew Hatts to the attention of Dick Levin, the skills brought to bear as a set designer at the BBC were originally nurtured as a performer and a set designer in the Queen's Gate 'Hut'. Recognizing this interesting cross-over in the School of Graphic Design from illustration and typography to exhibition design for the Festival of Britain to television design for the BBC, Roger Coleman, editor of *ARK*s 18–20 (1956–7), featured an article by Hatts entitled 'Designing for Television' in *ARK* 19 (Spring 1957). As Hatts comments,

Roger was interested in early pop culture and TV was early pop culture which needed designers. It was started by engineers, and it grew like a great tree, it seemed unstoppable. Everything got overtaken, the engineers got overtaken, the technicians got overtaken, and the audience mushroomed as we headed towards the 1960s. I loved it. I worked on major operas. I worked on the Billy Cotton Band Show. I worked on everything from music hall to light entertainment to the *Quatermass and the Pit* . . . all of that was good, new culture, and it was marvellously interesting.[15]

When he became Head of Design at the BBC Hatts hired several talented young designers directly from the School of Interior Design, including Bernard Lodge and Julia Trevelyan Oman.

By 1956 there were direct links between Hugh Casson's School of Interior Design and some of the ideas of the ICA's Independent Group via the influence of Richard Hamilton. Hamilton's wartime experience as a jig and tool draughtsman and model maker fed directly into his interest in set and exhibition design. ('By the early 1950s I began to feel that exhibitions were art forms in their own right.'[16]) There is a direct link here with the increasing concern with scale and environment in abstract painting during the mid- to late 1950s. Three exhibitions of the late 1950s, Richard Hamilton and Victor Pasmore's 'An Exhibit' and 'Exhibit 2' (June 1957 and 1959), and Ralph Rumney, Richard Smith, and Robyn Denny's 'Place' (September 1959), were concerned with transgressing the boundaries between painting, exhibition design, and set design in order to explore the dynamics of the 'man-made environment'.

Apart from Cliff Hatts another RCA-trained graphic designer with interests in performance and film recruited for the BBC by Dick Levin was John Sewell, who in 1954 became the first full-time art school-trained graphic designer to work in British television. Sewell arrived at the RCA from Hornsey College of Art strongly influenced by Dadaism and American styles of illustration. Like Hatts, Sewell had a penchant for satire and performance and alongside his ex-Hornsey

friend Bruce Lacey channelled much of his energy at the RCA into film-making and theatre.

In addition to serious dramatic productions, the Students' Union staged revues at the end of each term. Many of these were characterized by a combination of iconoclasm, surreal imagery, anarchic wit, and general zaniness. As Ted Dicks recalls:

When I look back at that period the things I remember are the revues we staged. They were very popular. Len Deighton, John Sewell, and I arranged for tables to be put out so people could drink beer like in the RAF NAAFI. It was very similar to theatre in the round, an art students' celebration, it helped break the mould of theatre at that time . . . For example one of the things we did was an Edwardian drinking evening. Len got a concession from Courage breweries and because most of the students were ex-National Service you had a tremendous amount of talent. You only had to announce what you wanted to do and you had this tremendous array of people putting up lining paper and transforming the hall . . . It was quite remarkable, the staff were staggered. The whole of the ballroom of 21 Cromwell Road was transformed into an Edwardian film set![17]

During the early to mid-1950s the inspiration for these performances often sprang from the wild imagination of the *ad hoc* Dodo Society, named 'as a sly mickey-take out of one of Darwin's more pompous speeches in which he referred to the College before he took over as being as dead as a dodo whereas now it was like a phoenix emerging from the ashes'.[18] All Dodos were known by the names of birds and included Len Deighton (Owl), John Sewell (Raven), and Ted Dicks (Mocking Bird). They were organized and inspired by the comic genius of their Chairman, Bruce Lacey (Cuckoo).[19]

Dodos were dedicated to the promotion of 'unusual events', a home-grown English version of Dadaism and Surrealism, early 'happenings' staged in a 'light and fantastic spirit'. The first of these was The Dodo Cocktail Party, held in the Sculpture School in June 1954. Originally suggested by John Skeaping, Professor of Sculpture, it provided an opportunity to test new Dodos:

Present members will dress in some curious or undressed way. Drinks will be served by nude models . . . There will be pots and lavatory pans instead of ordinary seats. Broken and disgusting crockery for drinks. Drinks to be red and white wine and beer PLUS an undrinkable punch, cold tea in old whisky bottles and imitation wine . . . Food to include cabbages, squeaking buns, spaghetti to look like worms, inner tube sandwiches . . . Exploding cigarettes and horse manure pipe tobacco for pipe smokers . . . Music will be first class chamber music . . . There will be an animal loose in the room, preferably an old horse . . . There will probably be a staged suicide and a line

will be drawn across the middle of the room and any member passing this must remove his trousers . . . The decor will be designed by John Minton.[20]

Other Dodo-inspired events between 1954 and 1955 included a circus (featuring Bruce Lacey tightrope walking, sawing a lady in half, knife throwing, and performing trapeze acts and magical illusions), and an elaborate Edwardian Drinking Evening in full costume featuring a traditional jazz marching band and specially designed Edwardian stage sets. These events, which often displayed the skills perfected whiling away the boredom of barrack room life, were huge successes and drew crowds from far and wide. The Edwardian Drinking Evening, for example, attracted a queue of students from other London art schools which stretched 400 yards from 21 Cromwell Road to South Kensington underground station.

Bruce Lacey, the founder of the Dodos, epitomized the anarchic spirit of the ex-National Service generation which helped nurture the performance art of the 'underground' alternative culture of the 1960s. Like fellow Goon collaborators Michael Bentine and Spike Milligan, Lacey's crazed, subversive humour was also deadly serious. In common with the works of the original Dadaists, it was born out of a hatred of war, cruelty, and bourgeois pomposity.

Although he has been ignored or relegated to a footnote in most of the literature, Bruce Lacey played a central role in the changes in English culture which took place during the 1950s and the 1960s. As he was a seminal figure in the development of an art school-based English postmodern sensibility, his curriculum vitae deserves some attention. Lacey was born in 1927, in Catford, South London, the son of a painter and decorator who was an avid collector of Victorian and Edwardian bric-à-brac. Some of Lacey's earliest memories are of the jugglers, acrobats, trapeze artists, mime artists, and comedians his father used to take him to see at the local Catford Variety Theatre every Saturday night. 'I am', he says, 'a direct descendant of the music hall/vaudeville tradition.'[21]

Leaving school at 15, he found his first job in a local explosives factory, gaining the knowledge that he would put to good use in his stage acts and his special effects for the *Goon Show* team when they appeared on television during the late 1950s (for example, the invention of Footo, the Wonder Foot Exploder, for Spike Milligan). In 1943 he began working as a bank clerk and built a full-scale aircraft simulator in his bedroom while all the time adding to his bizarre collection of objects from junk shops. Rejected by the RAF as a pilot on medical grounds, his National Service was spent as an electrical mechanic in the Navy. It was here that he picked up many of the electrical engineering skills which helped him to construct the manic 'hominoid' robots for which he became famous in the 1950s

and 1960s in his performances with The Alberts. He was invalided out of the Navy with TB in 1947 and in 1948 entered Hornsey College of Art in North London as a painting student.

After graduating from Hornsey in 1951, he was awarded the prestigious Knapping Prize and was accepted by the Royal College, where, for a short time at least, he painted in the then fashionable style of Royal College Realists such as John Bratby, Jack Smith, Derrick Greaves, and Edward Middleditch. With the exception of John Minton, who was characteristically enthusiastic and who encouraged him to pursue his idiosyncratic talents, Lacey heartily loathed the staff of the Painting School, whom he describes as 'either snide, snobbish, or out of date'.[22] So irritated was he at the constant carping of his mentors that he was driven to climbing the long iron ladder that used to rest against the wall of the Painting School 'to escape their criticisms by painting in the loft, where I met John Bratby who was similarly exiled'.[23]

By 1952 most of Lacey's time was being devoted to performance and magic lantern shows which enabled him to exploit the huge collection of bizarre objects he had been collecting since childhood and which he catalogues in *ARK* 10; these included:

1 Elephant's Tooth
1 Elephant's Toe Nail
8 Magic Lanterns
2 Whales' Ear Drums
1 Boy's Head [Wax Skin, Glass Eyes, Full Size]

. . . When I was five I collected bullets, shell noses, incendiary bombs and shrapnel and had masses; the police came, so I dispersed them. When I was fourteen I started collecting swords and daggers . . . pistols, muskets and shields. Then Burmese carving and a mad rush of Buddahs . . . all things Eastern followed—embroidery, statues, carving, tapestries, drums, idols, shoes. I burned incense and walked barefoot—the place stank . . . I bought African records and performed war dances in the dark, I was drunk with Africa and visited the Imperial Institute frequently . . . Then in 1951 I bought my first magic lantern and a few slides . . . It was here that I first felt the pant of the fanatic. With a red mist before my eyes and a limited income, I hunted and purchased until now I am proud to say that I possess no less than eight magic lanterns and over one thousand slides.[24]

The graphic designer Ken Garland, who attended several of Lacey's magic lantern shows at the College during the early 1950s, recalls the impact of Lacey's surreal collage of images:

Bruce used to hold lantern slide lectures at the Royal College which would start off as being reasonably respectable and then they would descend within a matter of seconds

into the most fantastic horror. We'd be absolutely squirming with delight. He used collage and montage. He'd put two slides up one after the other which made an utter mockery out of everything you held sacred—religion, politics, culture—everything was up for grabs.[25]

In 1954 Lacey won a Silver Medal and an Abbey Minor Travelling Scholarship from the RCA and visited North Africa, the Middle East, Greece, and Italy, from where he reported to *ARK* on the gruesome burial customs of the Capuchin monks. After returning from his travels, Lacey abandoned painting and became increasingly involved in cabaret performances and film and television work. His first films *Head in Shadow* and *AGIB and AGAB* (1954) were made with fellow Dodo Society member and ex-Hornsey student John Sewell. Throughout the late 1950s Lacey appeared alongside ex-Goons Peter Sellers, Spike Milligan, and Michael Bentine in television programmes including *A Show Called Fred*, *Son of Fred*, *Yes, it's the Cathode Ray Tube Show*, and *It's a Square World*. He also helped devise, and performed in, the influential early pop films directed by Dick Lester including *The Running, Jumping, Standing Still Film* (1957), *It's Trad Dad* (1961), *The Knack* (1963), and alongside the Beatles as The Lawnmower Man in *Help!* (1965).

By the end of the 1950s 'Professor' Lacey had refined the cabaret acts he had developed at the RCA early in the decade and teamed up with the Grey Brothers (and later Jill Bruce) to form The Alberts, a crazed cod-Edwardian jazz and performance group featuring Lacey's maniacal hominoid robots (Plate 45). Jeff Nuttall describes The Alberts' impact on his contemporaries:

The Alberts [had] disturbing elements of genuine lunacy in their make-up . . . consisted of the Grey Brothers and Bruce Lacey . . . The Grey Brothers owned an extensive collection of Edwardian clothes and redundant wind instruments, all of which Dougie and Tony could play with disarming skill. They appeared on all the anti-bomb demonstrations . . . Dougie in Norfolk jacket and plus-fours, or white ducks and a yachting cap, his cornet and his lecherous greyhounds both on golden chains. When they performed at Colyer's, ravers staggered back from the blinding explosives flashing from the bells of their instruments and the sight of Dougie's magnificent genitals hanging in splendour as he sat in kilt and tam-o'shanter with pheasant plume, blowing the guts out of Dollie Grey, while Professor Lacey accompanied on the amplified penny-farthing bicycle.[26]

The Alberts became the prototype for a generation of Royal College jazz and performance groups (Plate 46), beginning with the nostalgic Temperance Seven (formed in 1956 by a group of RCA students including art director Brian Innes, exhibition designer Philip Harrison, television designer Cephus Howard, and painter 'Whispering' Paul McDowell), continuing with the Bonzo Dog Doo-Dah

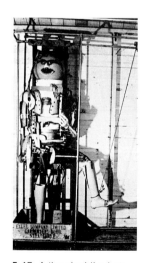

45 A 'hominoid' robot made by Bruce Lacey (late 1950s)

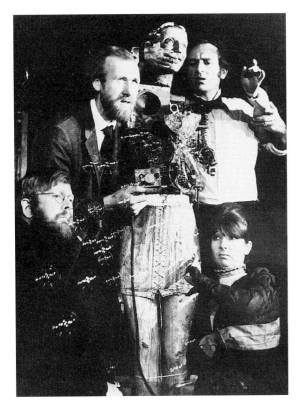

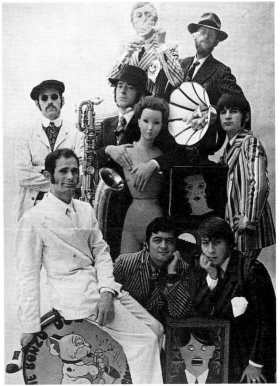

(originally Dada) Band (1964–5) (Plate 47), featuring Roger 'Ruskin' Spear (son of the painter and RCA painting tutor) and RCA student Neil Innes, and continuing today in the performances of Vivian Stanshall and Bob Kerr's Whoopee Band, who both continue to exploit the theatrical devices and the English 'cod-Edwardian' strategy originated by Lacey and the Dodo Society in the early 1950s.

Cabaret performances at the newly opened satire club The Establishment in Soho in 1962 developed into *An Evening of British Rubbish* at the Comedy Theatre the following year. The poster for *British Rubbish* was designed by John Sewell, who was also designing posters and interiors for Tony Godwin's Better Books on the Charing Cross Road. The *épater les bourgeois* style of the *Evening of British Rubbish* poster with its defiled Union Jack caused outrage when it appeared in 1961 and the tickets agencies refused to display it (Plate 48). The pornographic/violent contents of *ARK* 34 (November 1963), designed by Michael Foreman and Melvyn Gill (Plate 49), were direct descendants of the RCA performance tradition pioneered by Lacey, Sewell, the Dodo Society, and *Evening*

46 The Alberts (early 1960s)

47 The Bonzo Dog Doo-Dah Band (mid-1960s)

48 *Evening of British Rubbish* poster by John Sewell (1961)

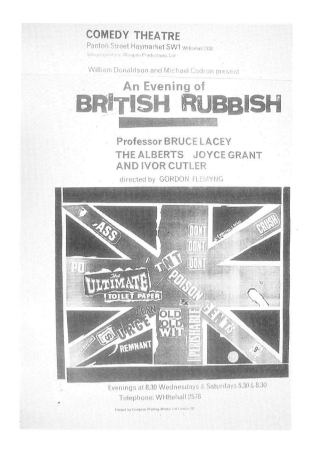

49 Illustration for *ARK* 34 (Winter 1963)

of British Rubbish. The similarities with aspects of the art school-originated British punk movement of the mid-1970s are very obvious.

'Discovered' at The Establishment by the notorious American comedian Lenny Bruce, *An Evening of British Rubbish* transferred (disastrously) to the United States. Returning from New York in 1964, Lacey reimmersed himself in happenings such as the 'Amazing Demonstration of Aeronautical Skill' (1965), an attempt to circumnavigate the globe in a home-made heavier-than-air-machine, launched on Hampstead Heath to the accompaniment of The Alberts, and the outrageous and offensive *sTigma* project installed in the basement of Better Books in February 1965 and designed by (among others) Nuttall, Lacey, and John Latham. Nuttall describes the scene:

The entrance to *sTigma* was through three valve-doorways lined with old copies of *The Economist*. The last you could just squeeze through, but not back, no return. The corridor this led to was lined with hideous bloody heads, photos of war atrocities, Victorian pornographic cards, tangles of stained underwear, sanitary towels, french letters, anatomical diagrams; the passage narrowed into complete darkness—tin, glass, wet bread, plastic, sponge rubber, then a zig-zag corridor of polythene through which you could glimpse your goal, a group of figures. They were gathered around a dentist's chair which had itself been turned into a figure, with sponge-rubber breasts and a shaven head. On the seat of the chair was a . . . bed pan lined with hair and cod's roe. Detergent bubbles spluttered from beneath the slabs of roe, which remained spluttering and stinking for four weeks.[27]

Lacey continued to be a central figure in the British underground/alternative arts scene throughout the 1960s, participating in much-publicized events such as the International Poets' Convention at the Albert Hall in 1964 and the Angry Arts Week at the Roundhouse in 1966. More recently his work has addressed 'New Age' concerns such as man's relationship with natural forces and the natural world. His work has always epitomized a Dadaist, counter-cultural strain which characterized the development of the British postmodern sensibility. Although he was not directly influenced by the leaders of the Dadaist movement ('I hadn't heard of it during the fifties. I was influenced by vaudeville and the circus I had seen when I was a kid in Catford'), Lacey pioneered a particularly English form of subversive performance art, more Dodo than Dada, characterized by constructions, environments, robots, and automata in the spirit of the Surrealist object which were cynical and humorous reactions to the sacredness of Fine Art—'The objects I make are hate-objects, fear-objects, and love-objects. They are my totems and my fetishes.'[28]

91

Collage

By the mid-1950s the home-grown theatrical assaults upon the 'Englishness' and 'Good Taste' of the Senior Common Room were being supplemented by the influence of the experiments of the pre-war Continental avant-garde which began to make its first impact at the RCA in the Schools of Painting and Graphic Design.

In the pages of *ARK* some of the earliest signs of boredom with genteel 'Englishness' appeared in issue 13 (Spring 1955), art edited by graphic design student Alan Fletcher. Fletcher had come to the Royal College in 1953 direct from Jesse Collins's Department of Graphic Design at the Central School, where he had been taught by Anthony Froshaug and Edward Wright, two of the leading exponents of modernist typography and graphic design in Britain. The contrast between the layouts of *ARK* 12 (Autumn 1954) and *ARK* 13 (March 1955) reflects the reaction against 'Englishness' which was beginning to take place by the mid-1950s. As Fletcher recalls:

A big gap between students and staff was beginning to emerge in painting and graphic design at that time. I went to the RCA from the Central which at that time was the really avant-garde school. I was there with Terence Conran, Colin Forbes, and Derek Birdsall . . . I went to the College because I couldn't find a job when I left the Central. I got a grant, so I went. But they used to *lock up* the sanserif type! They wouldn't let you use it, they considered it too modern . . . I wouldn't say the College was exactly behind the times, but it certainly wasn't up in front. They were still locked into Victoriana, old typefaces, steel engravings, wood blocks . . . In the three years I was there there was a real design transition. There were some pretty bolshie students around. There was a big upheaval going on. You see, the students were much more in touch with what was going on than the staff. We taught each other, really.[29]

From 1955 onwards the interests of the students and staff of the Central School began to appear in the pages of *ARK*. *ARK* 16 (Spring 1956) contains an article on motorcycle styling by Reyner Banham, a leading participant in the first series of Independent Group discussions during 1952–3 and lecturer in art history at the Central School. *ARK* 17 (Summer 1956) contains photographs by Nigel Henderson, a member of the Independent Group and Instructor in Creative Photography at the Central 1951–4. For a few RCA graphic designers and painters during the 1954–6 period two major influences which flowed from the studios of the Central were interests in collage and ideograms. These influences proved particularly influential in the development of an English postmodern sensibility, for, as it has often been pointed out, collage was perhaps the single most important medium pop borrowed from the modernist avant-garde.[30]

Many of the pioneer post-war British *collagistes* were associated with the Independent Group and held part-time teaching positions at the Central School, including Eduardo Paolozzi, Nigel Henderson, and Richard Hamilton. Unlike most British art schools in the late 1940s and early 1950s, which remained largely immune to the influence of the Continental avant-garde, Camberwell School of Art and the Central School of Art, under the leadership of William Johnstone (who had trained under André Lhôte and at the Académie de la Grande Chaumière in Paris during the 1920s), remained open and receptive to the influences of avant-garde Continental painting, sculpture, and graphic design. Until about 1955 the RCA lagged well behind the Central in terms of innovation, despite the fact that (much to William Johnstone's chagrin) many of Darwin's most famous recruits, including John Minton, Rodrigo Moynihan, and Ruskin Spear, had been lured from the teaching staff of the Central School in 1948.

Theo Crosby's comment that *ARK* 'was always coming along behind somehow'[31] during the 1950s is well illustrated by its belated discovery of the possibilities of collage. Collage crops up for the first time in *ARK* at the relatively late date of 1956. The tone of the article, written by the editor of *ARK* 17, John Hodges, reveals something of the cultural implications of collage and a good deal about just how alien collage appeared to many students at the RCA even as late as the summer of 1956:

The year 1912 is recorded as that in which Braque and Picasso first raised collage to the level of a serious art form in Western art. The actual practice of sticking ready-made materials together is ages old. Poems written onto a collage design of papers date from the tenth century in Japan . . . The materials of collage are all around and offer a wealth of contrast . . . Some reluctance to take collage seriously is bound up with a reluctance, as it were, to see art less seriously. Collage can have a quality of humour or irony all its own, as in much of the work of Kurt Schwitters, the most poetic of collage artists, who wrote in 1920: 'I play off sense against nonsense, I prefer nonsense, but that is a purely personal affair. I am sorry for the nonsense because up to now it has so seldom been artistically moulded, that is why I love nonsense.'[32]

Illustrated with lithographed collages by Roger Coleman, Richard Smith, Robyn Denny, and Peter Blake, painters whose work is of central importance for understanding the development of a postmodern sensibility at the RCA, the relatively late date of publication of Hodges's 'Collage' article helps to emphasize the intellectual innocence and isolation of the majority of RCA students from the activities of London's avant-garde during the early to mid-1950s. As early as 1951 the 'Growth and Form' exhibition at the ICA had used the collage technique to present a multimedia show incorporating non-art imagery. The 'Parallel of Life

and Art' exhibition held at the ICA in September and October 1953, organized by
Nigel Henderson, Eduardo Paolozzi, and the Smithsons, used the collage
technique to juxtapose images in the creation of a non-hierarchical,
unconventional display. In October 1954 the 'Collages and Objects' exhibition
organized by Lawrence Alloway was shown at the ICA, featuring collages of
established artists such as Ernst, Picasso, and Magritte alongside work by
Paolozzi, McHale, Henderson, and Turnbull. 'Man, Machine and Motion',
another ICA exhibition exploiting the collage technique, had been on display in
July 1955, and two months after *ARK* 17 appeared in June 1956 the 'This is
Tomorrow' exhibition opened at the Whitechapel Gallery, featuring collages not
only within the exhibits themselves, but also in Edward Wright's superb design of
the exhibition catalogue, which featured what is perhaps the most famous of all
British collages of the 1950s, Richard Hamilton's *Just what is it that Makes Today's
Homes so Different, so Appealing?*

Between 1955 and 1957 the isolation of the RCA from London's avant-garde
was becoming less pronounced as several influential ex-Central School tutors and
Independent Group figures began to teach part time at the College. In the
autumn of 1955 Edward Wright (who had been teaching his experimental
typography workshop at the Central School since 1950) joined the staff of
Guyatt's School of Graphic Design. In 1956 Eduardo Paolozzi, who had been
teaching in the Textile Department at the Central since 1952, began working
with students in the RCA School of Ceramics and with first-year students in the
School of Graphic Design. Richard Hamilton, who taught Basic Design at the
Central in the early 1950s before developing the Basic Design course with Victor
Pasmore at King's College, University of Durham, at Newcastle upon Tyne,
became a part-time tutor in Sir Hugh Casson's School of Interior Design at the
beginning of 1957.

Although it is difficult to assess the extent of the influence of these new tutors,
the fact that the layouts and contents of *ARK* change radically from late 1956
onwards can be explained partly as a result of their teaching. In some cases the
influence was direct, as for example in the combined influence of Edward
Wright's typographical experiments and Eduardo Paolozzi's experimental mask-
making exercises upon David Gillespie, the art editor of *ARK* 23 (Autumn 1958),
who designed the cover of his issue to resemble a Dadaist typographic mask
(Plate 50), or in the photographs by Terry Green and Denis Postle in *ARK* 24
(Spring 1959), which feature Paolozzi's masks and sculptures. Edward Wright in
particular had a major influence upon the style of *ARK* in 1959–60, as Terry
Green, art editor of *ARK* 25 (and today a leading television producer), recalls:

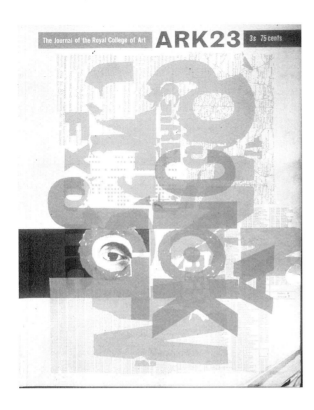

50 Cover for *ARK* 23
(Autumn 1958) by
David Gillespie

Edward Wright was the guy who brought Dada and Surrealism into the College—that's what *ARK*s 24 and 25 are all about. He made a really big impression on Denis Postle, Mike Kidd, and I. We were all in the Graphics School but we really wanted to be painters and we spent a lot of time in the Painting School with Dick Smith and Peter Blake. That was during our first year in 1956 and then along came Edward Wright and that's what made us decide to stay in Graphic Design. Then I decided to join the Television School with George Haslam in my last year.[33]

In the Painting School the influence of Paolozzi, Wright, or Hamilton was less direct, but their abstract experiments with meaning and form inspired by Dada and Surrealism combined with other influences to challenge an orthodoxy which was becoming stale in the eyes of several of the more rebellious students.

During the late 1940s and early 1950s the Painting School at the RCA was a bastion of Neo-Romantic and Euston Road painting. Although the styles favoured by various members of staff differed considerably, from Minton's interpretations of French painting to Ruskin Spear's enthusiasm for character and low-life subjects derived from Sickert, until Rodrigo Moynihan converted to

abstraction in the late 1950s very little non-figurative work was produced. The first well-known 'school' of painters to emerge from the College after the war were the Royal College Realists: John Bratby, Derrick Greaves, Edward Middleditch, and Jack Smith—all of whom were figurative painters influenced by the technique, which had been passed down from the Euston Road School via Sickert and Ruskin Spear, of using a coloured ground, often of dark brownish hue, to unify a composition. The Realists' work tended to be serious and rather sombre, existential in philosophical outlook, and focused upon austere interiors and scenes from everyday life in post-war London. As John Minton, who was friendly with the Realists, wrote in *ARK* 13 (Spring 1955):

Doom being in, and Hope being out, the search amongst the cosmic dustbins is on, the atomic theme is unravelled; the existentialist railway station to which there is no more arrival and from which there is no more departure . . . *Is it valid? Does it relate? Is it socially significant?*[34]

Like the pre-war members of the anti-Fascist Artists' International Association, the Royal College Realists were committed left-wingers suspicious of the imperial ambitions of the United States and opposed to the 'élitism' of abstract art. The often quite bitter conflict between the Realists and the abstract painters would continue throughout the 1950s and on into the early 1960s. *ARK* 30 (Winter 1961) contains an outspoken clash between Denis Bowen, who was at that time in charge of a highly innovative and controversial Basic Design course for first-year students in the Department of Industrial Design (Engineering) (which he brought to the RCA from the Central School), and an ex-*ARK* editor, the designer Ken Baynes, a supporter of the Realists. Bowen responds to uncomprehending 'What is it?' questioners of abstract art by quoting Louis Armstrong's definition of jazz:

'Man, when you got to ask what it is, you'll never know!' Similar 'What is it?' questioners of modern art also make one feel the inadequacy of aesthetic reaction to the impact & meaning of 'now' in this great age of technical achievement . . . Electronic seeing has given a new meaning of image and object and direct action techniques, automatic structurising, and programmed constructivism are now normal means of creating aesthetic realities—art and technology are combined. Hot rod tachism, drip dry action, pop optics and space constructions are all operative art forms & commentaries with long abstract tentacles which reach into the technological arena.[35]

Baynes, on the other hand, deplores much contemporary abstraction as being élitist and essentially trivial 'art about art':

Much modern art is the making of objects which have no practical use but their own harmony or disharmony; painters and sculptors have in many cases rejected story telling

to become aestheticians, manipulators of elegance, colour or texture for its own sake. It is claimed that abstract art is as much about humanity as is figurative art, and in the ultimate sense this is true. Abstract art is produced by men and therefore reflects their sensibility and their quality. Architecture and design are both abstract in the restricted sense of non-figurative. But architecture and design are tied to the human scale by USE, which painting is not . . . Art cannot decently escape a humanist preoccupation . . . it has to do with places and appearance, love and affection, anger and despair, joy and sadness, most of which incidentally find their most direct expression through the means of the human figure. The rest is decoration . . . it has lost the essential particularity of art and is just a mood.[36]

Bowen, who was largely responsible for establishing the New Vision Centre Gallery on Seymour Place in April 1956 for the specific purpose of showing international non-figurative work, remembers the contrast between the Realists' professed political radicalism and their rather parochial aesthetic conservatism:

They were left wing but *conservative* left wing. They were very anti-abstract art. I remember having a huge fight with John Berger when the New Vision Centre Gallery opened. He hated abstract art and told me I ought to be painting 'workers'. I said: 'If they've been at work all day, the last thing they'll want to see is workers!' I had a fight on my hands from the beginning, from the Beaux Arts Gallery and that lot. They were all very anti-Darwin, but they were promoting themselves as revolutionary thinkers while hob-nobbing with the Establishment at the same time, my left-wing ideas were coming from a very different place![37]

For the more radical members of the mid to late-1950s generation of RCA painters, collage provided just one of the means for what Robyn Denny has called 'busting out'—breaking away from the brownish fog of the Royal College Realists and the Euston Road or Neo-Romantic preferences of the RCA Painting School's staff:

You've got to be careful when you're talking about this period. It's always assumed that Abstract Expressionism at the Tate in 1956 changed the world. Well of course we were influenced by that exhibition, but it was an event waiting to happen. British painting had become very provincial again after the War. It had to bust out again and all sorts of phenomena out there were contributing to the sense that the mould had to be broken . . . Basically we were looking beyond British parochialism, over to the Continent and beyond to a wider landscape. We were simply looking everywhere for sustenance, for new ideas.[38]

Denny's comments are supported by examples of his work at the RCA between 1954 and 1957, when the strategies he employed in his search for new visual formulas were almost exclusively derived from the Continent. *ARK* 16 (1956), for

example, contains an article he wrote and illustrated which re-examines 'Mosaic'. This ancient craft exerted a strong appeal because the original mosaic artists in the early Christian churches succeeded in doing 'far more than merely decorating areas of flat wall. They produced an entirely new and unique spatial effect' which synchronized the architecture of the church and the mosaic to create a 'visual impact so powerful that . . . it must have left the spectator spellbound and astounded'.[39]

The techniques of arranging stones displayed in mosaics seemed to provide one solution to Denny's feeling of dissatisfaction with the traditional methods and materials of painting. The interest in collage was partly responsible for turning his eyes and those of other students in the Painting School towards work being executed in the Design Schools. The outstanding work being carried out in the Department of Stained Glass was particularly important in this respect. *ARK*

51 Stained glass window, nave, for Coventry Cathedral by L. Lee, G. Clarke, and K. New (1956)

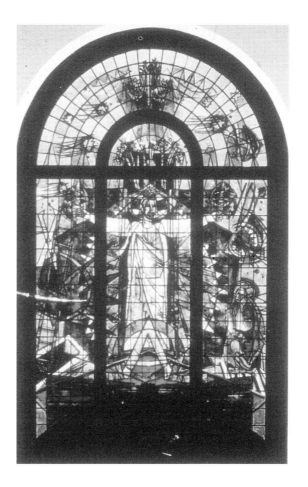

16 (Spring 1956) opens with an article on 'Coventry Cathedral Stained Glass' by Keith New (Plate 51), who along with Geoffrey Clarke and Lawrence Lee, the Head of the Stained Glass Department, was responsible for carrying out the commission to design the vast (70′ by 8′) stained glass windows for Coventry Cathedral on behalf of the College. As Derek Hyatt, editor of *ARKs* 21–3 (Winter 1957–Autumn 1958), recalls:

52 Mosaic mural for Abbey Wood School by Robyn Denny (1959)

The Stained Glass Department was much more modern at that time than anything that was happening in the Painting School. That was collage and mosaic together—long before Abstract Expressionism or Pop Art hit the College—it was punchy, very strong structurally, and very colourful when compared to the painting that was being done at that time, which tended to be sombre and dark brown.[40]

The communicative aspect of abstraction as displayed in mosaic and stained glass appealed to Denny partly because the examples of mosaic and stained glass helped counter the Realist argument that abstract art was hopelessly élitist because it was removed from everyday life and reality. Mosaic seemed to provide a solution because it provided a link between painting and modern architecture. Mosaics were abstract without being incomprehensible to the non-specialist. They could provide a public art fulfilling 'an urgent psychological need for some sort of decorative relief' on the stark walls of the modern buildings which were springing up all over London:

The material with which the mosaic artist works is as real, as alive as that used by the builder . . . and the form as conditioned by the medium is of a nature that is sympathetic to the language of contemporary architectural design . . . engineering makes possible huge facades which can be perforated, notched, raised on stilts, glazed and textured with a variety of surfaces, and mosaic is perhaps the only completely satisfactory material for this latter purpose. It is a material which, if used well, could contribute to the reconciliation between architecture and the fine arts.[41]

The interest in combining mosaic and modern architecture led to Denny being commissioned to design two public murals in 1959. The first, an abstract typographical mosaic, was for the Abbey Wood Primary School in North London (Plate 52), while the other, a painted mural, was commissioned by Austin Reed's of Regent Street, who wanted a trendy evocation of fashionable London. After some hesitation they accepted Denny's solution, 'a metropolitan landscape by the St Raphael advert out of Stuart Davis', an abstract pop collage of urban imagery. These murals exemplify the cross-overs between abstract art, graphic design, advertising, and architecture which were a direct legacy of the collage aesthetic.

Very similar processes can be seen in the evolution of Richard Smith's work, for just as Denny's interest in abstract reliefs of stones and plaster had their origins in the early experiments of Cubism and Dada, Smith's writing in *ARK* 16 reveals a fascination with the experiments of the pre-war Continental avant-garde. His article on 'Ideograms' in *ARK* 16 was partly based on his RCA thesis and features reproduction of Marinetti's *Les Mots en liberté futuristes* (1919), Apollinaire's representational poem *'Il pleut'*, abstract script by Paul Klee, and a poem by e. e. cummings.

Can the poem go beyond the word? An ideogram becomes a painting. The calligraphic quality of some modern painting seems to owe much to Chinese and Japanese ideograms. The paintings of Soulanges have been described by Robert Melville as 'doom-laden letters from a personal alphabet' and of course Paul Klee experimented with many scripts . . . Saul Steinberg does the same . . . In Japan there is a school of progressive calligraphy that is not bound by the ideograms of everyday communication. They create ideograms through which they can express something outside the meanings of the conventional ideograms that have been in use for centuries. They create a language not for direct communication but to communicate by suggestion and inference their 'Weltanschauung'. The integration of subtlety of form with subtlety of language adds a new dimension to poetry.[42]

Smith's interest in words as pictorial objects had been a source of fascination for many years amongst the staff and students in the Graphic Design Department of the Central School, where since the early 1950s Edward Wright had been running an experimental typography class, in which students were encouraged to use type creatively in the spirit of great Continental typographers such as H. N. Werkman, W. J. H. B. Sandberg, Piet Zwart, and Theo van Doesburg. Wright, who was trained as an architect but devoted most of his attention to painting and experimental typography, was born in Ecuador, spoke fluent French and Spanish, travelled to Paris frequently, and was deeply rooted in the Continental avant-garde tradition. His unique, quirky creativity had a profound influence on the contents and layouts of *ARK* and it is no coincidence that his brief period at the College from 1956 to 1959 is also the period in which the layouts of the magazine are at their most interesting, original, and avant-garde. His article in *ARK* 19 (Spring 1957) 'Chad, Kilroy, the Cannibal's Footprint and the Mona Lisa' provides a good example of his Dadaist inclinations and 'Non-Aristotelian' method of collaging images together across a 'long front' of culture which would be seen again later that year in his beautifully designed catalogue for the 'This is Tomorrow' exhibition. The article itself originated as part of the plan for an exhibition at the ICA to be called 'Signs and Symbols', which was an attempt to place art within a general framework of communications research:[43]

Chad and Kilroy were used as symbols of defiance as the footprint in Defoe's novel was used against Crusoe. An act of defiance against a symbol can also occur. That happened on the Third of December last year when Hugo Unzaga Villegas threw a stone at the Mona Lisa. Leonardo's painting of the Gioconda is still capable of provoking vandalism or denunciation . . . In 1921 *L'Esprit Nouveau* put the question 'Should we burn the Louvre?' to its readers . . . The shortest answer, from Solé de Sojo, was: 'No, in spite of the Gioconda'. Marcel Duchamp had already signed a photograph of the Mona Lisa to which he added a moustache and the letters *L.H.O.O.Q.* giving it an impudic double meaning and making this a dada-ist 'anti-masterpiece' object. Léger also put the Mona Lisa 'in her place' when he incorporated her with postcardish matter-of-factness into a composition together with a bunch of keys and other objects.[44]

There are distinct similarities between Wright's cross-overs between typography, architecture, and abstract art (as in his huge typographical mural for the 'Technology and Architecture' pavilion for the International Union of Architects' Congress on the South Bank in 1961 (Plate 53)) and the interests of the Royal College abstract painters during the late 1950s and early 1960s. *ARK* 24, for example, contains a collage entitled *Ev'ry Which Way: A Project for a Film* (Plate 54), which was the result of a phone call to Richard Smith from the film director John Schlesinger. Schlesinger explained that he 'wanted to do a film which related the imagery of our urban environment to the world of art',[45] and asked Smith and Denny to collaborate. The artists replied with a collage-script-proposal:

We were trying to do something *else*. You see, English painting was very pastoral, in the landscape tradition, and what we were trying to say was that the urban environment was our landscape. We weren't making a mimetic copy of it, what we were trying to do was absorb the spirit of it and trying to turn that spirit into an art form. This couldn't have happened had we not been consumers of the city. It wasn't going to be a realistic film. It was non-objective.[46]

Denny and Smith had just returned from Sardinia in the summer of 1959 when they received Schlesinger's call. Photographs of the pair of them with shaved

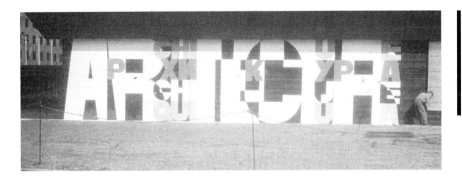

53 Edward Wright, typographic mural on exhibition building, International Union of Architects' Congress, South Bank, London, 1961. Architect: Theo Crosby

54 *Ev'ry Which Way: A Project for a Film*, by Robyn Denny and Richard Smith, *ARK* 24 (Autumn 1959)

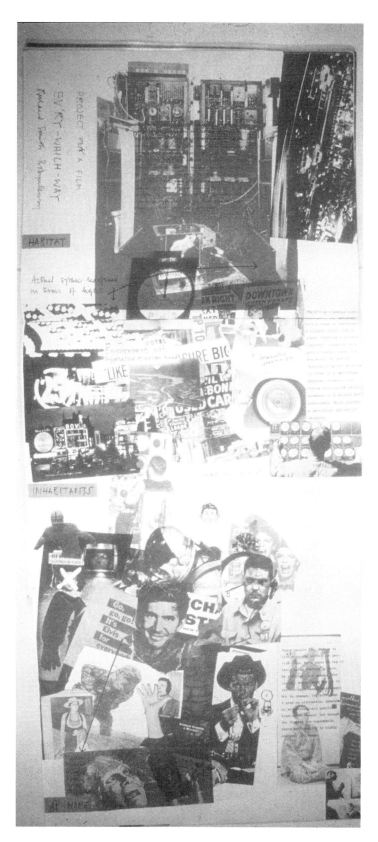

heads appear in the bottom left-hand corner of the fold-out proposal which is a collage of urban imagery from both sides of the Atlantic, incorporating scenes from Broadway, one of Denny's collection of Piccadilly Circus postcards ('I had a huge collection, over 200 of them . . . I took Piccadilly Circus to be the symbol of an urban hub.'[47]), a photograph of a wall in San Francisco saturated in advertising which Denny had used on the cover of his RCA thesis 'Language, Symbol and Image: An Essay on Communication', pin-ups of movie stars, sports personalities, high-tech. lab interiors, and reproductions of the artists' *tachiste* paintings. Although the proposal appealed to Roddy Maude-Roxby and Denis Postle, the editor and art editor of the Dadaist *ARK* 24, Schlesinger was of a more conventional frame of mind and decided to choose a more familiar 'English' artist instead:

He lost his nerve . . . in the end he made a film about an English romantic lady who stood on Land's End with her hair blowing in the wind . . . But we wanted to say that we were abstract artists and we were determined to say that. Even if we were landscape artists it was the landscape of the city that we were interested in.[48]

While many of Smith and Denny's ideas derived from the urban-consumer/high-technology obsessions of the Independent Group, this was not the only source of inspiration for the *collagistes* of the RCA Painting School. To celebrate the tenth anniversary of his death, Kurt Schwitters's collages and assemblages were on view in London at the Lords Gallery in October and November 1958 (Plate 55). Derek Hyatt has stressed the importance of Kurt Schwitters's collages and assemblages in determining the choice of contents and layouts in his *ARK*s of the late 1950s. *ARK* 23 even contained a special Schwitters pull-out supplement featuring photographs of collages and assemblages from the Lords Gallery exhibition:

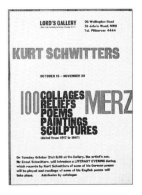

55 Poster for the 'Kurt Schwitters' exhibition at the Lords Gallery, October 1958

I went to see the 'Kurt Schwitters in England' exhibition in 1958 and met Schwitters's son Ernst. I was very interested in collage myself. As a result of that in *ARK* 23 we introduced a little inset which was from the Schwitters catalogue . . . The more we know about Schwitters today—his work in the Lake District, *Merzbau*, etc.—the more we realize that he was interested in how landscape imagery could be related to collage, which is usually thought of as an urban medium . . . I felt Schwitters held an important key, even from the first viewing.[49]

An article by Hyatt in *ARK* 23 entitled 'Kurt Schwitters, Paul Nash and Mrs. Nevelson' is a transcript of a letter written to an admirer of Paul Nash and provides an interesting insight into Hyatt's intuitive feeling that the work Schwitters produced in the Lake District during the late 1940s could provide the

key to a new and exciting approach to the characteristically English pursuit of landscape painting:

I met Mr. Ernest [*sic*] Schwitters . . . I listen to the background of Da Da Zürich, the bitter political slant, the instigating of MERTZ [*sic*] activity, 'the destructive element of Da Da' . . . but before me were gentle built works with an Englishness. The link (for me) was Paul Nash. The colours, materials and shapes, the tenderness and the geometry had many affinities with Nash . . . Patrick Heron wrote of Nash 'laying out the whole thing as one builds the model of a village, constructing it solely in his mind and then finally looking at it from a certain chosen angle, rather high up, and then making what he saw fit into a pictorial design'. The Schwitter's [*sic*] collage constructions could well have been such models! . . . Both Nash and Schwitters were concerned with bringing together apparently aloof, unrelated objects. Nash persuades us against reason by the sheer eloquence of his 'distinguished dreams'. Schwitters convinces us by his blunt honesty. Mr. E. Schwitters told me of his father's conception of a form of creation which would unite many forms of art and non-art into one. Where sculpture, architecture, painting, and relief would combine. MERZBAU. K.S. was building his third when he died at Ambleside in 1948.[50]

Although cultural historians have usually associated the Dada influence with the urban-consumer preoccupations of young artists rejecting the English landscape tradition, Schwitters's use of collage was much more sensitive and subtle than the work of the Independent Group *collagistes* because he often worked with natural materials to evoke the atmosphere of the countryside. Hyatt's writing is a reminder that Dadaist preoccupations of the London avant-garde during the late 1950s could also enhance landscape painting. There is considerable irony in the fact that Schwitters's influence began to feed into the RCA painters during the late 1950s, because, as Christopher Frayling points out, when the RCA was evacuated to Ambleside during the war the painting students were living within a stone's throw of the great artist and had no idea who he was!

Kurt Schwitters was living at 2, Gale Crescent . . . about half a mile away from the Queens Hotel, while he worked on his third *Merzbau* 'combining art and non-art' at a stone walled barn in Cylinders Farm, Langdale . . . When he was no longer strong enough to climb up to Gale Crescent he moved to 4, Millans Park . . . where he was even closer to the Royal College of Art. The extraordinary thing is that no contact seems to have been made between Kurt Schwitters and the members of the 'potato loft university' during the months they were at Ambleside. According to Leslie Duxbury [the print maker]: 'We didn't know who the hell he was . . . he'd scarcely been heard of by the residents, and certainly not by the majority of RCA students'.[51]

When viewed from the other side of the Channel, it must have seemed that by the mid- to late 1950s students in painting and graphics at the RCA were at last

beginning to catch up with the preoccupations of the pre-war Continental avant-garde. The development of an interest in collage was to have profound repercussions on the development of Pop Art and Pop Art-influenced graphics at the RCA, where, it seems correct to say, Schwitters's work was more influential in the mid-1950s than the collages of the Independent Group. The first generation of Royal College Pop painters, particularly Peter Blake and Joe Tilson, were strongly influenced by Schwitters's collage technique, which Blake, for example, was to use to brilliant effect both in his painting and in his commercial graphic design. Blake first became aware of the collage technique while sharing a flat-cum-studio in Notting Hill with Richard Smith when they were both students in the Painting School 1954–5 (Plate 56). As Blake recalls:

Dick Smith and I shared a flat for a year. He had a friend called Jasia Reichardt whose uncle and aunt were great friends with Kurt Schwitters. Dick told me all about collages. He actually taught me what a collage was . . . we both did collages that year and things just bounced off. Maybe some of the pop element in Dick's work came from the fact that we both shared a flat. He was certainly mainly an Abstract Expressionist or a *tachiste*, but the fact that I was in the other room making the early Pop pictures like *On the Balcony* meant that there must have been a two-way link. We read the same magazines, we shared the same interests.[52]

The medium of collage is of profound importance to understanding the development of an English postmodern sensibility because it invites the transgression and violation of boundaries of taste, genre, and class. Students who attended the RCA during the late 1950s and early 1960s were attracted to collage for several reasons. First, the physical layout of the RCA's departments made it very difficult to avoid influences from other spheres of art and design. This was particularly true in the case of painting and graphics. The two schools were next door to one another in the same corridor and students shared many of the same facilities. The graphic designer Gordon Moore, art editor of *ARK* 19 (Spring 1957), has pointed out that:

The graphics school and the painting school were very close together, so we'd run into Peter Blake and Robyn Denny and Dick Smith all the time. We'd all stand around in the corridor drinking tea. We'd get together to do posters for the Film Society . . . the trips to America were beginning then and the walls of the graphics studio were plastered with Americana.[53]

Alan Fletcher has also stressed the importance of the physical proximity of the Painting School and the School of Graphic Design in the evolution of a new sensibility at the College:

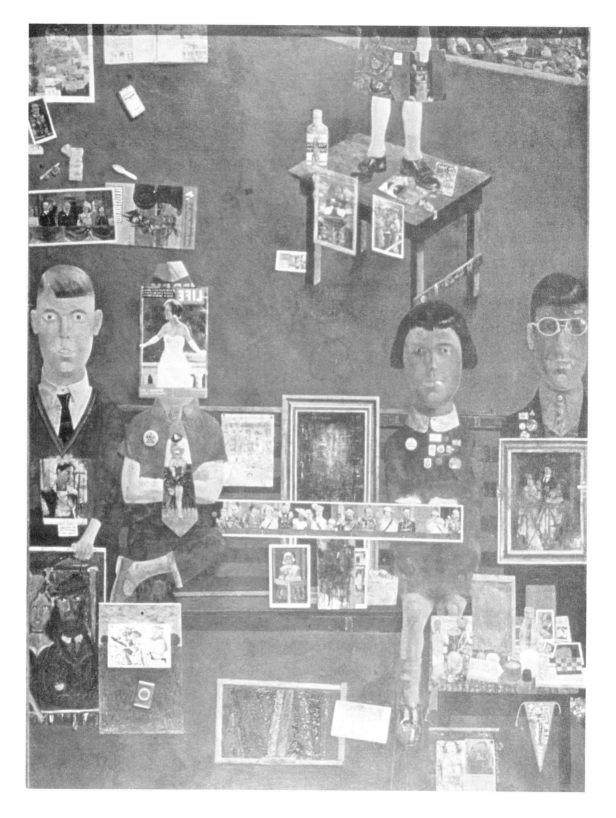

They were close to one another and curiously enough the cross-over came in the litho room, because we all used to meet in there. There was Joe Tilson doing his stencil paintings with stencilled letters and Peter Blake used to be in there too . . . That's how I became friends with Dick Smith, Joe Tilson, and Pete Blake and we've been friends ever since.[54]

Robyn Denny has pointed out that these cross-overs between the Painting School and the School of Graphic Design helped distinguish the work of the RCA from other schools in which painters had less contact with design-based disciplines:

We were in the same building and in the same corridor. There were quite a few departments in the College I never went into. I hardly ever went into the Sculpture School, funnily enough, because it was over on Queen's Gate. So we were much closer to Graphics than to what might perhaps seem a more directly related department like Sculpture.[55]

 A second reason why collage became an important medium at the RCA was that cross-overs between fine art and design were actively encouraged by Darwin and the staff. As Richard Guyatt explained in the catalogue of the 'Graphics RCA' exhibition in 1963: 'Inherent in the reorganization of the College is the tenet that the fine arts are the inspiration of the applied arts.'[56] Although Darwin and Guyatt had originally intended the direction of influence to be from the fine arts to design rather than vice versa, by the end of the 1950s the traffic between the 'useful' and the 'useless' arts was flowing in two directions. Brian Haynes, art editor of *ARK* 32 (Summer 1962), stresses the importance of this 'two-way traffic' in nurturing the pop sensibility at the RCA:

The first real cross-overs happened with the Film Club posters because the corridor we worked in contained print makers, graphics people, and painters. We were always running up and down the corridor the whole time, borrowing things off each other. But you see there were lots of other cross-overs happening, too. I had a lot of friends in the School of Industrial Design, which was in the new Darwin building by then. We were some of the first people to say, 'Hang on, if I want a picture framed why don't I zoom over to the Furniture School?' Now you weren't supposed to do that. The same thing happened in the Industrial Design School. We had friends up there, so if we wanted to do a bit of spot welding or metal bashing we went up there. For example, we had a graphics project on the theme of 'Love'. So some people went off to the Ceramics School and designed a ceramic piece of liver in the shape of a heart on a butcher's slab. Barrie Bates went over to Industrial Design and designed teapots with intertwined spouts and heart-shaped tea caddies. You see graphics people had a job to do which painters didn't have. So we began to think—'You know those "loving tea pots" would make a really good ad for Ty-Phoo tea.'[57]

56 Peter Blake, *On the Balcony* (1955–7) 121·3 x 90·8cm

In Haynes's opinion the eclecticism displayed in graphics projects like the 'loving teapots' or the *Tin Star* film poster (both by Barrie Bates, later known as Billy Apple (Plates 57–8)) was central to the change in sensibility at the RCA during the late 1950s and early 1960s, for RCA collage not only involved a cross-over of imagery between fine art and design, it also involved a cross-over of techniques which students taught one another:

There was a core of images. The painters took them and would go off and be painterly. The graphics people would make them into posters, the sculptors saw the graphics people going up to ceramics and making heart-shaped liver on butchers' slabs and they started doing pop sculpture, the fashion designers took pop images and worked them into their designs . . . the people who went far later had flexible minds and iconoclastic attitudes . . . The staff had very little influence on us at all. In fact they got in the way.[58]

Although there appears to have been little active hostility to the use of collage on the part of the staff in the Schools of Painting and Graphic Design, their response to Abstract Expressionism and *tachisme* was almost universally hostile.

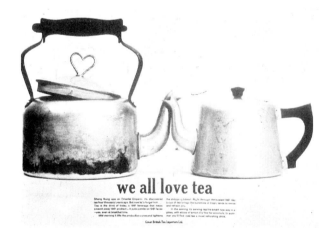

we all love tea

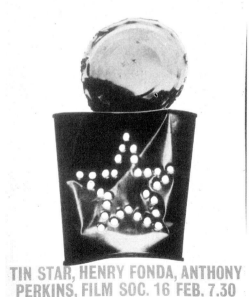

TIN STAR, HENRY FONDA, ANTHONY PERKINS, FILM SOC. 16 FEB. 7.30

▌57 Barrie Bates, 'Loving Tea Pots' project (*c.*1962)
▌58 Poster for RCA Film Society by Barrie Bates (*c.*1962)

Tachisme and Situationism

Andreas Huyssen has argued that it is difficult to speak of a distinct postmodern movement developing in either France or Germany during the 1950s or 1960s because most artists and intellectuals were busy reassessing their pre-war modernist heritage.[59] The English modernist heritage in the visual arts was relatively modest by comparison, therefore any rebellion against the post-war English orthodoxy was forced to look abroad to foreign avant-gardes for inspiration. Interviews with ex-RCA students associated with *ARK* and an examination of the contents of the magazine reveal that the techniques of the European and American avant-gardes were interpreted by RCA students through the 'filter' of post-war English culture and adapted to challenge the 'Good Taste' and 'common sense' of the College (and, by implication, the English) Establishment.

The scandalized English response to *tachiste* painting has to be understood in terms of England's relative isolation from the post-war Continental avant-garde. *Tachiste* painting was greeted in England with almost universal hostility and incomprehension, which gave the technique particularly subversive potential in an English cultural context. As Robyn Denny has pointed out, English culture was and remains very unsympathetic to any form of abstraction:

Our generation at the College, Dick Smith and I in particular, were reacting to an extent against the Realist painters, people like Derrick Greaves, Jack Smith, and John Bratby, so we were against Realism. I suppose the Royal College Pop artists were reacting against what we were doing by being very figurative and anti-intellectual. Although I'm not sure that artistic ideas do develop out of negative reactions to what happened previously . . . I think that the abstract tradition in British art is very short-lived. We are a *narrative* culture. We tend to talk in pictures. Our culture tends to describe itself in a narrative structure. For a non-narrative system to sustain itself for long is very hard in England. Basically the development of Pop Art was a return to the status quo.[60]

It is also important to evaluate the cultural significance of British *tachisme* within the context of contemporary British abstract painting. Before the arrival of Abstract Expressionism in the Tate Gallery shows of 1956 and 1959, British abstract art had been identified with two main groups of painters. The first were the British Constructivists, led by Victor Pasmore, who had been deeply influenced by the Picasso and Matisse exhibition at the Victoria and Albert Museum in 1945, the first chance English artists had to view Continental modernism since the war. Since 1950 Pasmore had been making abstract reliefs developed by means of free constructions of pure forms. Kenneth Martin, Mary

Martin, and Anthony Hill formed a small but influential group deeply influenced by Pasmore's approach to abstraction.

The other, much larger, group of abstract artists was the St Ives School centred around Ben Nicholson and Barbara Hepworth. Artists like Roger Hilton, Peter Lanyon, and Terry Frost (who had been taught by Pasmore at Camberwell School of Art in the late 1940s) developed an English style of abstract painting strongly influenced by the landscapes and seascapes of Cornwall. Patrick Heron, who moved to St Ives in 1956, was one of the first British artists to respond positively to the energy and scale of the American Abstract Expressionist works first displayed in England at the 1956 Tate exhibition. Already his work was tending towards the abstract, but from 1957 he began to produce his large 'Horizontal Stripe Paintings' from which all vestiges of reference to external reality were eliminated in favour of the powerful influence of the effects of light on landscape and seascape.

The first post-war exhibition in Britain devoted entirely to non-figurative art took place at the AIA Galleries in May 1951 and included work by both the St Ives painters and the Constructivists. This show was followed by a series of three weekend shows held at Adrian Heath's Fitzroy Street studio in 1952–3. The third exhibition included work by Eduardo Paolozzi and Nigel Henderson and was 'written up' in *Art News and Review* by Toni del Renzio. From 1952–3 onwards the Independent Group, with which Paolozzi, Henderson, and del Renzio were associated, maintained close links with the Constructivist wing of British abstraction, a collusion much in evidence in the 'This is Tomorrow' exhibition of 1956.

In 1953 a number of young abstract painters who felt excluded and ignored by the Independent Group and the Constructivists but who had little in common with the St Ives group broke away from the ICA to form the Free Painters. This group, which included Denis Bowen, Frank Avray Wilson, and Halima Nalecz, were interested in contemporary developments in Paris, particularly in a movement known as Art Informel. As the attitudes of 'Informal Art' underlie the contents and layouts of *ARK*s 24 and 25 (Spring–Summer 1959) it is worth explaining the movement in some detail. In her history of the New Vision Centre, the gallery which became the showcase for the Free Painters, Margaret Garlake has written that

At its broadest, informal art subsumes *matière* painting (where the physical properties of the medium are of predominant importance); gestural painting; works in which the marks on the canvas have a metamorphic function and tachisme. Tachisme refers strictly to small patches of colour, but the nature and meaning of these are dependent on the character of the action—or gesture—with which they are applied and the quality of their

paint surface, with its inherent power of implying imagery. It is an art where there is no preconception of an end product before it is achieved. The entire content of the work emerges in the course of applying the pigment. The movements of the artist's body—his physical engagement with the act of painting—determine the meaning and appearance of the work. A work thus records an event, in which marks are made on canvas and its significance lies here, rather than in visually expounding an idea.[61]

The Parisian critic Michel Tapié had coined the term 'Art Autre' to describe the informal art of the leaders of this movement—Dubuffet, Mathieu, Wols, and Michaux—whose work ranged from brutal figurative graffiti, through automatic drawing, to spontaneous 'action' painting. There were obvious parallels with New York Abstract Expressionism and in 1953 Michel Tapié's exhibition 'Opposing Forces' at the ICA provided the first opportunity to compare Sam Francis and Jackson Pollock with their French counterparts. Although both New York Abstract Expressionism and Parisian Informalism had their roots in the Surrealist experiments with automatism, the ideological implications of the two schools differed radically. Whereas Abstract Expressionism was adopted by the American art establishment as an acceptable manifestation of American freedom and democracy, Informalism retained subversive connotations. In its exaltation of spontaneity and crudity against refinement and harmony, 'Art Autre' stood as a direct heir to the Dadaist–Surrealist tradition of subversive anti-art.

The ICA provided a showcase and a discussion centre for French Informalism and American Abstract Expressionism throughout the early 1950s and the vital role of the Independent Group in promoting these styles in Britain has been very thoroughly documented.[62] Links between the ICA and the RCA before 1956 were rather tenuous, however. As Joe Tilson (RCA Painting School 1952–5) has pointed out:

The collage we used came from Schwitters and Picasso. That's who we were getting it from . . . I think the Independent Group's role in the development of pop has been rather overdone. Very few of us went to their meetings, which were quite exclusive. They were much older than us to begin with and their meetings often seemed rather boring to us.[63]

The first RCA student to have direct experience of *tachisme* and action painting was Robyn Denny, who had attended the Académie de la Grande Chaumière in Paris after leaving the Navy in 1950:

I went to Paris after I left the Navy in 1950 and attended the Académie de la Grande Chaumière, where there were lots of American students studying under the GI Bill. The Cultural Affairs Officer of the American Embassy used to call on them from time to time to make sure that they were doing their work and they would take the mickey out of this guy by doing crazy things . . . They'd put up ladders and scaffolding and drop paint from

them onto the canvas below and he didn't know what to make of it. They were doing it for a laugh, but they were doing the same kind of thing that Bill Green would be doing later and the fact was, of course, that Jackson Pollock was doing it very seriously in New York in 1950.[64]

When he arrived at the RCA from St Martin's School of Art in 1954, Denny incorporated *tachiste* techniques into his own work in an attempt to shrug off the influence of Neo-Romanticism, the Euston Road School, and the Royal College Realists. Together with his friend Richard Smith, Denny became the first RCA student to produce uncompromising *tachiste* canvases. Although Denny, Smith, and Roger Coleman (all RCA Painting School 1954–7) attended ICA exhibitions of the work of Dubuffet and Mark Tobey (1955) and Mathieu (1956), most of their exposure to French Informalism and American Abstract Expressionism before and after 1956, the year which opened with the famous 'Modern Art in the United States' exhibition, came either from the pages of the sophisticated French art magazines *L'Art d'aujourd'hui* (founded in 1949) and *Cimaise* (founded in 1953) or from copies of the Stedelijk Museum catalogues designed by the modern Dutch master of graphic design W. J. H. B. Sandberg. It is interesting to bear in mind, therefore, that for many RCA students exposure to avant-garde European and American art was not primarily experienced from visiting galleries but through the graphic filter of magazine layouts, which were far more modern and elegant than anything available in England at that time. In fact Roger Coleman, editor of *ARK*s 18–20 (Autumn 1956–Autumn 1957), and his art editors Gordon Moore, Alan Bartram, and David Collins were attempting to produce English equivalents of these Continental magazines influenced by the work of European graphic designers such as Max Huber, Armin Hofmann, and Josef Müller-Brockmann. As the graphic designer David Collins, who co-art edited *ARK* 20 with typographer Alan Bartram, has explained: 'The thing that influenced me was Dutch, Swiss, and Italian design, without a doubt. Most of the work I did for *ARK* was the working out of those Continental influences.'[65]

During their first two years at the RCA the development of Denny and Smith's work owed more to their influence upon one another than to any direct influence from exhibitions or discussions held at the ICA. Isolated from fellow students and either ignored or ridiculed by the staff of the Painting School they insulated themselves by developing a tough, witty, combative stance aiming 'to provoke the tutors . . . at every point'.[66] To begin with Denny and Smith's main ally within the Painting School was their contemporary Roger Coleman. Although Coleman's personal style of painting and illustration was figurative and fairly conservative, he was excited by contemporary developments in abstract art and bored with the grey parochialism of much of the contemporary English art

scene: 'Although I like abstract painting immensely I'm not really capable of doing it and I think that writing about it was a way of participating and I found it very exciting . . . I wasn't able to express the excitement in any other way.'[67] Coleman became the editor of *ARK* in the autumn of 1956, selected by Richard Guyatt on the strength of his thesis on abstract art. While his predecessor John Hodges had begun to steer the magazine away from its 'English' preoccupations with subjects such as canal barge decoration and Victorian toy theatres, Coleman's first editorial was an uncompromising statement of a radical change of editorial policy:

A 'strong' editorial policy as I see it can mean only one thing; that the publication shall have something to say and fulfil its duty and comment as well as present. For my selection of articles I make no apologies, from the bewildering number of possibilities that are open to an editor he has to make a personal choice . . . If his choice has any punch then it has to be things he dislikes or things he likes or things he feels should be said. I have expressly avoided getting together material that will please everyone . . . nothing ever stays in the memory that pleases indiscriminately, it is better to be criticized than tolerated.[68]

As soon as Coleman assumed the editorship of *ARK* both the tone and the layout of the magazine changed and its contents began to reflect contemporary debates in the art world. *ARK* 18 (Autumn 1956), for example, contains articles by the Constructivist artist Anthony Hill on 'The Constructionist Idea and Architecture', referring to work recently displayed in the 'This is Tomorrow' exhibition, an article by the critic Robert Melville on 'Action Painting: New York, Paris, London', featuring photographs of the *tachiste* Georges Mathieu, Alan Davie's *Blue Triangle Enters*, Mark Rothko's *No. 10 (1950)*, and Jackson Pollock's *No. 1 (1948)*. By autumn 1957 Coleman was providing the critical back-up for the RCA *tachistes* by reviewing the work of his friends Richard Smith and Robyn Denny (Plate 59):

Richard Smith seems to me to be one of the most successful of the younger English painters who have turned their gaze from Paris to New York. He is better than most, not because his paintings resemble Rothko's or De Kooning's more closely than his contemporaries, but because he is thoroughly committed to the world of values that action painting represents. Alison and Peter Smithson have suggested that Brutalism should be considered ethically rather than stylistically. The same I think could apply to action painting . . . Unfortunately it is only too easy to transform even something as uncompromising as an action painting into a picturesque academic *tache*, and we English above all peoples possess a truly remarkable propensity for being able to turn something vital and uncircumscribed into a neat and innocuous system.[69]

59 Photograph of Robyn Denny and Richard Smith from *ARK* 20 (Autumn 1957)

Coleman's influence was largely responsible for transforming *ARK* from a

parochial little magazine produced as a training exercise for student graphic designers into an energetic and elegantly designed journal in touch with contemporary developments in art and design. The refreshing energy of *ARK* 18 quickly came to the attention of the critic Lawrence Alloway, whose influence was to have profound effects not only upon the contents of several *ARK*s during the late 1950s, but also upon the subsequent development of abstract painting at the RCA.

Born in 1926, Alloway studied art history in London University's evening school programme. Earning his living as a part-time lecturer at the Tate and National Galleries, a reviewer for *Art News and Review*, and as British correspondent for the New York magazine *Art News*, Alloway was a *habitué* of the ICA, where from 1952 onwards he became a regular lecturer and contributor to discussions and was elected to the Exhibitions Committee in September 1953. In 1954 Alloway published his first book, *Nine Abstract Artists*, a review of the 'Work and Theory' of the British Constructivist group of abstract artists, including Robert Adams, Terry Frost, Adrian Heath, Anthony Hill, Roger Hilton, Kenneth and Mary Martin, Victor Pasmore, and William Scott. The book led to an exhibition, also entitled 'Nine Abstract Artists', which promoted the Constructivists as the 'cutting edge' of the contemporary avant-garde. This was the first of a number of exhibitions organized in London by Alloway during the late 1950s and early 1960s in which he used his skill as a theorist and a critic to promote particular styles of art and groups of artists as representing the most advanced state of the British avant-garde. In both the United States and Britain during the 1950s the role played by theorists like Alloway in making or breaking art and artists became increasingly important.

Alloway's position of power and influence on the London art scene was greatly enhanced in July 1955 when he was appointed Assistant Director of the ICA. The appointment was the culmination of his involvement in the ICA's 'Aesthetic Problems of Contemporary Art' and 'Books and the Modern Movement' lecture series of 1953–4, his lectures, contributions to discussions, and organization of exhibitions, including the influential 'Collages and Objects' exhibition of October–November 1954, designed by John McHale and featuring work by McHale, Eduardo Paolozzi, and William Turnbull.[70] Towards the end of 1954 and the beginning of 1955 Alloway and McHale reconvened the second session of Independent Group meetings, shifting the emphasis of the loosely organized discussion group towards Americana and pop culture. Much of the contents of *ARK*s 19 and 20 (Spring–Summer 1957) reflects these discussions, for Roger Coleman provided Alloway with the means to promote the ideas and interests of

the Independent Group to a younger generation at the Royal College after the IG ceased to meet. As Coleman has said:

I think Alloway saw *ARK* as an opportunity and a platform to promote abstraction and there weren't any others . . . The College supplied an audience. When I was involved with the ICA later [from February 1957 onwards] it was often terribly difficult to get people along to fill up a programme. So here were another group of people who could be tapped to keep the programme going.[71]

To use his own terminology, Alloway's interests always spanned the 'long front of culture'. While he was an erudite scholar of the history of art and architecture he was also a connoisseur of Hollywood B movies and science fiction novelettes. His six contributions to *ARK* between 1956 and 1959 reflect his anti-hierarchical cultural attitudes and are roughly equally divided between pop culture and critical writing about Continental avant-garde painting. On the pop culture side, *ARK* 17 (Summer 1956) contains 'Technology and Sex in Science Fiction: A Note on Cover Art', *ARK* 19 (Spring 1957) contains his famous 'Personal Statement' in which he argues against 'the iron curtain of traditional aesthetics which separated absolutely art from non-art' and in favour of an analysis of 'the general field of visual communications [in which] the unique function of each form of communication and new range of similarities between them is just beginning to be charted'.[72] *ARK* 20 (Summer 1957) contains 'Communications Comedy and the Small World', an analysis, heavily influenced by the writing of media theorist Marshall McLuhan, of the 'saturation of an environment with communication devices' in the world of contemporary film and television.

Alloway's art criticism in *ARK* included 'Marks and Signs' for *ARK* 22 (Summer 1958), an article about mark-making and calligraphy in contemporary art in which he analyses the role of sign language in contemporary gestural painting:

In Europe, painting and writing are separated so that a visual sense and literacy have become specialized and, as in Britain, often antagonistic functions. In opposition to this tendency such artists as Klee, Miró, Baumeister (late), Kandinsky, started to play with signs, developing a pseudo-archeological picture which had the provocative appearance of alluring, but untranslated, tablets from other cultures. Such signs are an index of modern artists' awareness of other cultures . . . this is not simply primitivism (the replenishment of cultural vitality by hormone treatments from exotics) but a product of the crowded channels of twentieth century visual communications. We know from the flood of illustrated books and exhibitions that, unlike when you are travelling, 'you don't have to know the language'; that signs, whether we have the key or not, can be loaded with loot, evocative and undecipherable.[73]

Reviewing the work of contemporary gestural artists such as Capogrossi,

Alcopley, Kline, and Mathieu, Alloway quotes Mark Tobey's remark that 'England collapses, turns Chinese with English and American thoughts', arguing that solutions to 'the topical requirements of Western art and aesthetics' were to be found in the calligraphy and sign systems of the East. The article challenged Alloway's critics (such as RCA librarian and broadcaster Basil Taylor) who accused him of being completely seduced by America.

Alloway's cosmopolitan yet anti-hierarchical perspective struck a resonant chord amongst RCA students. His influence had a profound effect upon the development of *ARK* as its student editors turned away from English culture for new sources of inspiration. As the actor and director Roddy Maude-Roxby, editor of *ARK*s 24 and 25 (1959–60), has commented: 'Alloway helped us greatly in our attempt to make *ARK* more international and be aware of what was happening elsewhere. What we wanted most of all was to be in tune with what was happening on the Continent and particularly in America.'[74]

ARK 24 (Spring 1959), for example, contains Alloway's 'Commentary on the Technical Manifesto given at the 1st International Congress of Proportion at the IXth Triennale, Milan, 1947', an analysis of the 'Spazialismo Manifesto' of Italian artist Lucio Fontana, who 'believes [like so many of the avant-garde] in the disappearance of easel painting'. Fontana's punctured, ripped, striated, and suspended 'Spatial Concepts' are reproduced in *ARK* 24 and echoed in the luminous, punctured day-glo cover designed by Denis Postle and featuring a work signed by Fontana (Colour Plate **1**). Alloway's article on Fontana had a dramatic influence upon the next issue of the magazine. Inspired by the cosmopolitanism of *ARK* 24, Terry Green and Mike Kidd (art editor and advertising editor of *ARK* 25) travelled to Italy via Germany, where they tried, unsuccessfully, to secure an interview with Elvis Presley for *ARK*. Unable to find Fontana at home in Milan, they travelled on to Rome, where they contacted the artists Burri and Scialoja, returning with pages from Scialoja's notebooks and photographs of the artist at work. Alloway contributed an accompanying article on contemporary Italian avant-garde art which appeared in *ARK* 25. These contributions were backed up by the several lectures Alloway delivered at the RCA between 1956 and 1960, including a lecture on action painting with Robert Melville and Toni del Renzio in February 1959, publicized for the College by a poster designed by ex-student Robyn Denny (Colour Plate **14**).

Alloway's interests in the most extreme and subversive elements in the Continental avant-garde brought him into contact with Asger Jorn and Ralph Rumney of the Situationist International, formed in July 1957 in Cosio d'Arroscia, Italy, as a coalition between three fringe Dadaistic–anarchistic movements in an attempt to construct 'spheres of social life which were not

occupied or dominated by capitalism'.[75] The Danish *tachiste* painter Asger Jorn's 'Movement for an Imaginist Bauhaus' was committed to apply the technology of design to non-functional ends. The Lettrist International, founded in 1946 by Romanian 'letter poet' Isidore Isou and dominated since the mid-1950s by Guy Debord, was dedicated to the subversion of language and culture and a variety of Dadaistic anti-art activities. The Psychogeographic Society, formed by Ralph Rumney, exploited the techniques of 'psychographology' and the *derive* (drift) through the urban landscape (often under the influence of alcohol or drugs) following only the subconscious 'pull' of the architecture the drifter encountered. 'Psychographology' involved mapping the patterns of the *derive* in an attempt to lay the blueprint of new utopian urban environments. Central to the strategies of the Situationist International was the creation of 'situations', spectacular and subversive events which, it was believed, would strip away the enslaving yet seductive veils of consumer society, heighten consciousness, and pave the road to revolution.

Situationism was the product of two distinct European traditions, revolutionary anarchism and Dada-Surrealism. In the relatively apolitical climate of the London art scene during the late 1950s it was the latter tendency which had the most impact. There were fairly close links between some of the interests of the Situationists and those of the Independent Group, particularly the shared interest in the urban environment, mass media spectacles, and the emphasis upon creative play which members of both groups derived from their familiarity with works such as John Huizinga's *Homo Ludens* (1944). Believing that it was only a matter of time before technology eliminated the drudgery of work, Huizinga argued that in the future leisure-based societies would enable people to achieve full potential through play. Accordingly, the concept of leisure had to be redefined as the central element in everyday life rather than as time left over after work; the issue of time for play had become a serious matter in contemporary culture.[76]

Lawrence Alloway, who maintained links with the quasi-Situationist COBRA (Cophenhagen / Brussels / Amsterdam) group of artists, was particularly interested in the ideas of ex-COBRA member Asger Jorn while Reyner Banham saw connections between his own Futurist-inspired technological optimism and the theories of the psychogeographers. In a 1959 issue of *Cambridge Opinion*, for example, Banham published an article entitled 'City as Scrambled Egg' in which he expressed his hostility to traditional town planners who 'demand that our cities must be compact', celebrated the 'motorised communications city' as a 'scrambled egg with all its elements irrevocably stirred', and suggested that Situationist psychogeography provided the key to understanding 'the forces

which cause jazz-men, wig-makers, sports-car enthusiasts or sculptors to collect in one area'.[77]

Alloway and Ralph Rumney provided the key links between the Situationist International, the London art scene, and *ARK*. Roddy Maude-Roxby first encountered Rumney in Venice and discovered that the conceptual strategies and techniques of the Situationists such as the psychogeographical *derive* bore close similarities to the performances which Maude-Roxby was refining and developing through his involvement with The Temperance Seven, RCA revues, and experimental performance work for the Royal Court Theatre. *ARK*s 24–6 (Spring 1959–Summer 1960) contain 'The Leaning Tower of Venice', a captioned photographic document of Rumney's *derive* through the backstreets of Venice with his American 'beat' poet friend Alan Ansen.

Psychogeography is the study of the exact effects of geographic environment, controlled or otherwise, on the affective behaviour of individuals. (G. E. Debord) . . . The photos in this study were taken along points along the black line on the map, which is an ideal trajectory through the zones of main psychogeographic interest . . . 200lb. 'A'—well-known author of 'Heroin—an Ode', orients fast in N. Adriatic honeymoon town built on 118 islets joined by 364 bridges. 'A' is aware of photographer and is showing off. Nevertheless environment is clearly affecting his play-pattern.[78]

Rumney was one of the first of many members of the Situationist International to be expelled from the organization by its main spokesman Guy Debord. He had been one of the first young British artists to leave the country to live on the Continent after the War, but he returned to London in 1959 and began to take an active part in the new London art scene increasingly dominated by the personality of Lawrence Alloway. Between 1955 and 1960 Alloway was largely responsible for first promoting and then demoting Constructivism as the primary representative of the British avant-garde, replacing it first by *tachisme* and secondly by 'hard edge' abstraction.

The 'This is Tomorrow' exhibition which was on display at the Whitechapel Gallery from 6 August to 8 September 1956 featured Constructivist artists exhibiting in environmental groups alongside work with a distinct pop quality. In his foreword to the 'This is Tomorrow' catalogue Alloway described the exhibition as an attempt to demonstrate the possible collaboration of painters, sculptors, and architects in an integrated art. The environmental preoccupations of 'This is Tomorrow' were enhanced in the eyes of several RCA students by the impact of the 'Modern Art in the United States' exhibition which had been shown in January 1956 at the Tate Gallery and in which the work of the American Abstract Expressionists had been on display in the final room. The

sheer scale, confidence, and vigour of the Tate show made a deep impression on the small group of Royal College students struggling to escape the legacy of 'Kitchen Sink' Realism. As Roger Coleman recalls:

In 1956 there were lots of things happening. There was the big exhibition of American art at the Tate, with Grant Wood, Thomas Hart Benton, Ben Shahn, Andrew Wyeth, and then a selection of the Abstract Expressionists—Rothko, deKooning, Kline, and Pollock . . . There was a mixture of reactions. Dick Smith was very deeply impressed and so was Robyn Denny. I was fascinated, but to a lesser extent.[79]

Although the impact of the American show at the Tate has probably been overstated by cultural historians and art critics, it seems to have given the self-confidence of the RCA abstract painters a boost. In the aftermath of that exhibition Smith and Denny began to pursue their gestural experiments at the RCA with more energy and on a larger scale than previously while a younger generation of RCA painting students including Alan Green (RCA 1955–8), William Green (RCA 1955–8), Michael Chalk (RCA 1955–8), and Stuart Brisley (RCA 1956–9) started to pursue informal abstraction with vigour and self-confidence.

In January 1957 'Statements: A Review of British Abstract Art in 1956' opened at the ICA. The show included work not only by St Ives-based Constructivists and landscape-inspired abstractionists but also by British abstract painters who were clearly influenced by American Abstract Expressionism and French Informalism, including Sandra Blow (who would be appointed tutor in the RCA Painting School in 1961), Rodrigo Moynihan (a spectacular convert to abstraction in 1956), and Independent Group 'insider' Magda Cordell. In the catalogue notes Alloway emphasized that the source of inspiration for abstraction was changing and he suggested that Paris was being replaced by New York as a major source of inspiration for British abstract painting. The momentum of change was carried on later that year when 'Metavisual, Tachiste, Abstract' opened at the Redfern Gallery in April. Organized by Partick Heron, who, like Alloway, was a British correspondent for the New York magazine *Arts*, the exhibition was an indiscriminate mix of artists inspired by Art Autre, *tachisme*, and Abstract Expressionism. The term 'Action Painting' was used in the catalogue to describe the work on show, further enhancing the perception that New York, rather than Paris, was the new centre of the art world. In December 1957 'Dimensions', organized by Alloway and Toni del Renzio, opened at the O'Hana Gallery. This exhibition, which set out to codify current trends in British abstract painting, privileged informal abstraction above Constructivism and implied, by showing three Informalist canvases for every Constructivist piece, that *tachisme* had now

become the dominant tendency within avant-garde practice. According to Alloway's introduction to the exhibition, 1956 'was the year that everyone got into the *act* of painting'.[80]

In the wake of 'This is Tomorrow' and 'Modern Art in the United States', therefore, the London art scene was thrown into turmoil. As Margaret Garlake has pointed out, in late 1956–7 most non-constructivist British abstract art was being described indiscriminately and imprecisely by critics as *tachiste*, action painting, or abstract 'impressionism', with the result that the two main sources of Informalism, Continental Art Autre and New York Abstract Expressionism, became conflated.[81] The complex critical manœuvres of 1956–60, largely orchestrated by Alloway, involved a jostling for position between landscape-inspired abstraction, Constructivism, and the Parisian and New York wings of Informalism for the dominant position within the British avant-garde. The 'winning team' required not only a strong image but also an ability to manipulate the media through the creation of appropriate 'situations' and persuasive, articulate spokesmen. It was partly to forge a link between the RCA and the ICA and partly to help secure the triumph of the New York-oriented abstractionists that Alloway recruited Coleman from *ARK* to the Exhibitions Committee of the ICA in February 1957, while Coleman was still a student at the College and shortly before the publication of *ARK* 19. Throughout 1957 Coleman's friends Denny and Smith were exhibiting their work in the exhibitions listed above, with Denny exhibiting in 'Metavisual, Tachiste, Abstract' and both painters showing in 'Dimensions'. From late 1957 to early 1958, however, both Denny's and Smith's work began to display influences which owed far more to the United States than to Europe, indicating that although both painters had been painting in the Parisian manner they were now beginning to think 'New York'.

Interest in American Abstract Expressionism at the RCA was enhanced by the influence of Stefan Munsing, the Cultural Attaché of the American Embassy. Not only did the library of the American Embassy on Grosvenor Square provide a major source of American art magazines but also Munsing, who was friendly with Alloway, provided considerable support for young British artists interested in the new American painting. In September 1959 Munsing opened 'Place', an environmental exhibition at the ICA featuring the work of Denny, Smith, and Rumney and designed by Roger Coleman. The idea for 'Place' grew out of a combination of interests which included the environmental impact of painting, the idea of exhibition design as an art form in itself, and Situationist interests in the *derive* and the theory of games. Designed by Roger Coleman to resemble a maze, the installation of very large (7′ by 6′) abstract paintings was described by Coleman as:

24 canvases . . . fixed back to back to make 12 double-sided pictures which were on the gallery floor at 45° to the walls and 90° to each other, and in addition 10 paintings (Smith 3, Denny 3, Rumney 4) . . . fixed to the end walls and each other to project into the gallery. This gave four directions in which the pictures faced, three of which were taken, one by each painter, with the fourth side shared.[82]

In the 'Guide' to 'Place' Coleman explained the background to the undertaking and the influences which brought it about including the mass media ('not as a source of imagery but a source of ideas that act as stimuli and as orientation'), the sheer scale of the new American painting (seen once more in London in February 1959 in 'The New American Painting' exhibition at the Tate Gallery, a show which, unlike the 1956 'Modern Art in the United States' show, was entirely devoted to American abstract work), and games theory ('the painting/spectator relationship as games situation').[83]

 Despite the fact that 'Place' received terrible reviews (for example, Eric Newton, a supporter of the Neo-Romantic School of painting writing in the *Observer*, incorrectly referred to it as 'Peace' and called it 'the silliest exhibition I have ever seen in my life'), characteristically Lawrence Alloway was the one critic who understood its significance as an attempt to capture 'a subjective sense of the city, as a known place, defined by games, by crowds, by fashion'.[84]

 By 1959 there was a close working relationship between Alloway, Coleman, Smith, and Denny, as Denis Bowen (who observed the rapidly changing scene from the position of a staunchly European-oriented *tachiste*) recalls:

Those boys were the first people to really wave the flag for abstract work at the RCA, one of the reasons they went far was because they immediately got into the ball game of self-promotion through *ARK* and they were friendly with Alloway—Britain's ace hyper. He was very intelligent and always on the ball. He built a team. Alloway and Coleman did the write-ups, backing one another up—it was a really professional job and later on he got Robert Freeman down from Cambridge to help him too.[85]

The two 'Situation' exhibitions, held at the RBA Galleries in 1960 and in the Marlborough Gallery in 1961, were virtuoso displays of Alloway and Coleman's flair for promotion. In the wake of the 'New American Painting' exhibition at the Tate Gallery in February–March 1959, and the 'West Coast Hard Edge' and 'Morris Louis' exhibitions of March–May 1960, there was an increased demand for exhibition space in which to show very large-scale environmentally oriented art. The 'Situation' series, which was originally intended to be an annual 'situation/event/spectacle' was organized by a committee which comprised Alloway and Coleman plus six of the twenty painters who showed in the exhibition, including Robyn Denny as Honorary Secretary. Organized as a

showcase for abstract artists who either had no gallery to represent them or who were unable to show their large paintings in the galleries they had, the paintings shown in the first 'Situation' show were roughly divided between *tachisme* and those paintings Roger Coleman described in his catalogue preface as 'cartographically simple but perceptually complex'.[86] In the following year's 'Situation' these 'hard edge' paintings (Alloway had coined the term early in 1959) usurped the *tachiste* works, confirming the final decisive shift of the London avant-garde's interest from Paris to New York, a move further confirmed by the fact that two of the contributors, Harold Cohen and Richard Smith (who had travelled to New York on a Harkness Fellowship in 1959), were now living and working in the United States.

The rapid change of pace and increase in hard-nosed professionalism which characterized the London art scene during the mid- to late 1950s had dramatic repercussions within the RCA's Painting School and in the pages and layouts of *ARK*. With the possible exception of Rodrigo Moynihan, who converted to abstraction in the wake of the 'Modern Art in the United States' exhibition of 1956, the staff of the Painting School were either indifferent to the growing influence of *tachisme*, Abstract Expressionism, and hard edge abstraction or positively hostile to it. Roger Coleman recalls that 'there was a tremendous amount of hostility from the staff in the Painting School during that period. Ruskin Spear I remember was particularly hostile.'[87]

It is not difficult to understand the sources of their resentment. Everything which young painters like Denny and Smith represented seemed to challenge the most cherished attitudes and values of the Painting School. Although their American influences have probably been overemphasized at the expense of Parisian Informalism, Smith and Denny were the first Royal College painters to attempt to tackle what being a British artist meant in a new era of American artistic ascendancy. To the older generation they seemed to have been seduced or hoodwinked by Alloway and the Americans. John Minton, for example, both disliked and misunderstood their work. Although Denny is at pains to stress Minton's brilliance as a teacher and erudition as a critic, the Painting School's first *tachistes* managed to rile Minton, who was regarded as the most tolerant and permissive of tutors.

Minton cared about students' work, he was very generous, open and direct. Very open and generous with himself, which is a nice characteristic, especially for a teacher. He used to do Sketch Club in which students would make an exhibition of their current work and invite someone to come in and make a crit. of it. There was a Sketch Club one day and Minton was the critic . . . He used to 'psyche himself up' by drinking a lot and then he'd become more and more drunk and brilliant, waving his arms around and delivering a very

interesting, telling kind of criticism. At one point he picked out two pictures for a particularly damning attack. One was a large abstract painting of mine and one was by Dick Smith. He really went to town on these.[88]

At this criticism, held in December of 1956, Minton was particularly infuriated by a *tachiste* painting exhibited by Richard Smith and a burned and scorched black and gold painting of Denny's. There was a political storm brewing in Suez at the time and, as the Prime Minister Anthony Eden was away convalescing from illness in Jamaica, Minton concluded his tirade against *tachisme* with a topical reference by declaring: 'You could call this painting *anything*! Why don't you call it "Eden Come Home"?' Denny took Minton's advice and used the title for another scorched-canvas abstract picture (Colour Plate **2**). Shortly after Minton's passionate salvo against abstraction, Denny, Richard Smith, and Roddy Maude-Roxby composed a tough counterblast to Minton's criticisms of their work entitled 'A Stiffy on Whose Easel? An Open Letter to John Minton':

While welcoming your criticisms . . . we want to make clear our attitude towards painting, and our present situation (or predicament as you would prefer) which we feel you have misunderstood because of what you describe as your increasing sense of isolation from our generation. We are not disillusioned with the world. There is no God that has failed us. To your generation the thirties meant the Spanish Civil War; to us it means Astaire and Rogers. For you 'today' suggests Angry Young Men, rebels without causes; we believe in the dynamism of the times where painting being inseparable from the whole is an exciting problem linked now more than ever with the whole world problem of communication and makes its essential contribution to the total which is knowledge. Our culture heroes are not Colin Wilson and John Osborne, rather Floyd Paterson [world heavyweight boxing champion] and Col. Pete Everest [the first man to break the sound barrier; both American] are more likely candidates for the title. Painting is an activity you can accomplish alone, but being cut off does not itself create an ivory tower. Our tower is no more cut off from the world than those in Manhattan.[89]

It seems clear that contemporary abstract painting as represented by the student work of Smith and Denny made Minton feel threatened. As Frances Spalding has pointed out in her biography of the artist, an exhibition of Minton's painting held at the Lefevre Gallery earlier in 1956 had received rather lukewarm reviews and the emphasis of these younger painters on American culture only served to underline how *passé* his dedication to certain European traditions had become. The techniques and attitudes of Denny and Smith were utterly opposed to everything Minton represented. Pro-American and urban, they were in the vanguard of a new breed of hard-nosed anti-romantics. Eager to establish themselves as tough, professional artists they were gunning against the figuration

and 'cute' tasteful illustration which Minton seemed to epitomize.[90] As Robyn Denny has commented: 'He felt angry about developments in abstract painting . . . His credibility was under threat . . . I suspect that Minton found in Abstract Expressionism the kind of tough macho quality his own work lacked and I think he felt threatened by it.'[91]

Minton was not alone in his dislike and mistrust of abstraction, Ruskin Spear was also particularly hostile to the new trends and especially towards the growing influence of America and the New York art scene. He would vent his spleen some years later in his sarcastic *Homage to Barnett Newman and Alexander Liberman* (Colour Plate **3**), a giant (7′ by 8′) fusillade fired against the new American painting and sculpture. Commenting on the painting later in his life, Ruskin Spear remembered how angry American painting made him feel:

The whole thing aggravated me and I painted it out of aggravation. The obvious banality of second-rate abstract painting gave me the idea of standing the self-satisfied painter against one of his ludicrous canvases. I'm afraid the *Homage* was very much tongue in cheek . . . Curiously, poor old Newman died soon after I completed the painting and I was warmly complimented by one or two of the protagonists of the great man for my alacrity in producing such a speedy tribute![92]

Both the layouts and the contents of the *ARK*s of the late 1950s, especially those edited by Roger Coleman, Derek Hyatt, and Roddy Maude-Roxby, reflect the widening generation gap between the staff and students anxious to explore new horizons and challenge an increasingly parochial version of 'Englishness'. In his Report to College Council which appeared shortly after the publication of the 'Situationist' *ARK* 24 in 1959, Robin Darwin attempted to account for the 'generation gap' and the attitudes of what he termed the new College 'Beat Generation':

The students of today are on the whole much more extraordinarily dressed and a lot dirtier and this no doubt reflects the catching philosophy of the 'beat' generation . . . This revolt, for such I take to be its essence and inspiration, against a managerial revolution which offers the possibilities of material welfare and mass extinction with equal generosity, and which denies increasingly the opportunity for the ordinary person to express a choice between these alternatives and still less to prepare a third, is a powerful stimulant to the young. They see things generously and in simple terms . . . the more imaginative among them have come to reject all material preoccupations, easements, and satisfactions as diminishing their stifled ideals; they reject attachment of any kind, and every convention is so tainted that even love is suspect . . . yet considered more or less in the abstract there is something engaging and admirable in this attitude and one cannot

help thinking of another age in which a revolt against luxury and profligacy scorched Europe under the magic hand of St. Francis of Assisi.[93]

Introduced into the College by Denny and Smith and promoted through *ARK* by Roger Coleman, Lawrence Alloway, and Robert Melville, 'action painting' combined with varieties of home-grown Situationism and performance-based Dadaism to become the main vehicles of expression for the RCA 'Beat Generation' in the period between 1956 and the emergence of RCA Pop Art in the 'Young Contemporaries' exhibition of February 1961. Although the links between Alloway, Coleman, Smith, and Denny have been documented in detail, it is worth pointing out that after the 'ICA crowd' (as they were known by their contemporaries) graduated in the summer of 1957, the direct influence of Dover Street over the life of the RCA declined somewhat. Between 1957 and 1959, while Denny, Smith, and Coleman were immersing themselves in the sophisticated manœuvrings of an art world increasingly dominated by New York, the rising star of Informalism at the RCA was William Green.

Far less interested in the Byzantine politics of the avant-garde than Alloway and less 'cool' than Coleman, Denny, or Smith, William Green provides an early example of those cross-overs between fine art, performance, and pop which lay at the core of the new art school-based cultural sensibility. Green was very interested in the work of the New York Abstract Expressionists, especially Jackson Pollock. Other influences came from German expressionism and from the performance element in the work of Georges Mathieu.

Throughout the 1950s and early 1960s Mathieu visited the capitals of the world executing his huge *tachiste* 'Battle Paintings' in public while dressed in appropriate military period costume. His huge *Battle of Hastings*, for example, was painted before an invited audience (including a BBC TV crew) during his one-man show at the ICA in July 1956. Not only was Mathieu's combination of *tachisme* and theatrical event a perfect example of an early 'happening' and a 'situation' arranged for the media, it also meshed sweetly with the RCA's tradition of subversive anti-Establishment reviews. Like Mathieu's painting performances, some of William Green's action paintings were planned as 'events' to be executed before an audience who watched as Green assaulted the canvas with cans of paint, buckets of bitumen, handfuls of sand, knives, fire, and, most notoriously, a bicycle. One of Green's *tachiste* events, performed in late 1957, became the subject of the first film of the then stills photographer Ken Russell, who ran a studio near the RCA Fashion School in Ennismore Gardens, South Kensington. Roddy Maude-Roxby, who helped arrange the filming, recalls that

Carel Weight, the RCA's Professor of Painting, was extremely worried about the political implications of the proceedings:

One of William's techniques was to burn boards and for Ken Russell's film he really took it to the limit . . . he brought in a bicycle and skidded it around and it was suddenly seen in every magazine, including *Paris-Match*. I can remember when we were doing those paintings Carel Weight saying: 'You absolutely must not bring the press in!', which we were planning to do. 'Because', he said, 'if you do questions will be asked in the House!' By which he meant that the government would clamp down on what was happening in the art schools. And he was right of course, it happened, it was one of the ways that they attacked art education.[94]

Because Ken Russell did not possess a British union card he showed the film all over the Continent and the notoriety it generated made Green one of the best-known young British artists of the 1950s, as Robyn Denny recalls:

No one was more famous for fifteen minutes than Bill Green, he became part of the folklore . . . The press were always turning up. He became 'the most famous English artist' for a while. I remember being with Ralph Rumney in the Piazza San Marco in Venice and I heard Ralph shout, 'Come and see this!' He'd bought a copy of the *Daily Mirror* at the news-stand and there was a strip cartoon of someone bicycling across a painting. It had already entered the popular vernacular.[95]

William Green's painting events fascinated Roddy Maude-Roxby who, apart from editing *ARK*, was also organizing theatrical events in the students' union and at the Royal Court Theatre. *ARK* 24 contains 'Recording the Painter's Movement', an article by Warren Lamb of the Laban Centre which 'notates' Green's movements in the act of painting as if he were performing a dance. In *Errol Flynn: An Operation*, a series of photostats incorporating images of string, chains, and tubes of paint, Green assumed the role of an artist-surgeon, 'chronicling' a medical dissection of the Hollywood film star ('Skin, tissue, and sublayered veins, flesh properties, and organic strata penetrated to c minus level'). 'The Errol Flynn Exhibition' opened at Denis Bowen's New Vision Centre Gallery on 7 December 1959 and, as Bowen recalls, provided London with one of its first 'happenings':

The Errol Flynn Show got the NVCG a lot of media coverage because by coincidence Errol Flynn died a few days prior to the exhibition. We opened on the Monday and on the Tuesday Errol Flynn's sister came in! . . . Due to the strength of the nitric acid William had used in making the new works, large areas of the hardboard had been completely burned through and most of the works he had prepared were now totally unsuitable for exhibiting . . . William painted two hardboard panels with bitumen paint, and laid a thick sheet of cellophane across them. That's all we had, two pictures for the Errol Flynn Show.

The bitumen was still wet and it started to drip on the floor, so I got a tin bucket out of the back and the painting slowly dripped into that throughout the show . . . at the opening of the show a girl turned to William, who drove a beautiful old Packard Straight Eight, and said, 'What a lovely car!' William said, 'Do you want a ride?' She said, 'Yes!' and they both pushed off—out of the opening of his own show![96]

While the performance and event art which was developed during the 1960s by artists like Gustav Metzger, John Latham, Stuart Brisley, and Gilbert and George has received considerable attention from critics and cultural historians, the pioneering work of Bruce Lacey and William Green in this field has been virtually ignored. It would seem that this neglect can be explained partly by the hostility of both artists towards contemporary developments in the critic–gallery–dealer system. William Green exhibited alongside Richard Smith and Peter Blake in 'Five Young Painters', the first exhibition Roger Coleman organized at the ICA in January 1958, and also in the second 'Situation' show in 1961. Like Smith and Denny, he for a time became part of the Alloway–Coleman–ICA axis. As Roddy Maude-Roxby recalls, Green took his work seriously and developed an ambivalent reaction to the media, which seemed determined to treat him as a freak. As Green has commented, 'I enjoyed the notoriety, but I wanted the work to be taken seriously.'[97] Through the Drian Gallery he was offered an exhibition in Stuttgart, but he was unable to accept because he needed the financial security of a teaching job. Rather than achieving fame and fortune in the art world, Green began teaching Basic Design with Denis Bowen at Harrow College of Art in 1961. Later that year he was offered a teaching post at Ealing College of Art, where he stayed for several years, introducing his personal brand of *brut* expressionism to a younger generation of art students, including the future rock star Pete Townshend, who would incorporate elements of Green's techniques into his stage act later in the decade.

Naturally enough Green's brand of *tachisme* proved perplexing to some of his mentors at the RCA, who were undecided whether or not to award him a first class diploma. The fact that he was awarded a First probably had a good deal to do with his fame (it was well known that John Cage had expressed an interest in his work, for example) and the fact that he had already displayed his competence in a recognized style and in traditional skills such as life drawing. As Green recalls: 'When I first arrived at the RCA my paintings were in a German expressionist style and Roger de Grey wanted me to include some of my earlier life drawings in my Diploma show. For the most part, though, the staff were helpful and left me to my own devices.'[98] One member of staff who *was* irritated by William Green was John Bratby, brought back to teach at the College by Carel Weight in 1959. There is a certain irony in this clash between Bratby, who in his

day had been the most *outré* of the Royal College Realists, and Green, whom Bratby describes with barely concealed derision in his autobiographical novel *Breakdown* (1960) as

a young man of twenty-six . . . in a jazzy, dirty white American shirt covered by a huge dirty white pullover with the name of an American university football team plastered over the front in huge red capitals . . . enthusing over the 'tensions in the work of Jackson Pollock . . . an expression of this age—directly in tune with the universal subconscious of the Beat Generation of the USA, the only generation that is up to date.'[99]

Postmodern Cross-overs: Dada, Situationism, TV, and Film

In her biography of John Minton, Frances Spalding notes that shortly after taking a leave of absence from the RCA in April 1956 to recover from the combined effects of alcoholism and depression exacerbated by difficulties in his personal and professional life, the artist was interviewed by a reporter from the *Daily Express*. In the newspaper article, entitled 'A Painter Gives Up', Minton complained about what he regarded as the meaninglessness of contemporary art and insisted that 'Painting is outdated . . . the cinema, the theatre, possibly television, are the mediums [*sic*] in which painters must express themselves.'[100] Although Minton's opinions were obviously deeply influenced by his personal dilemma, it was an insightful statement. For a particularly crucial 'moment' in the development of an English postmodern sensibility occurred at the RCA during the late 1950s as Dadaist and Situationist strategies began to cross over from new trends in painting into graphic design and from graphics into design for film and television. The careers of David Gillespie, Denis Postle, and Terry Green, art editors of *ARK*s 23, 24, and 25 (1958–9), provide illustrations of the origins of this cultural development. All three entered the RCA as students in the School of Graphic Design and partially as a result of their involvement in *ARK* all three joined George Haslam's course in Television and Film Design during the year of its inception in 1959–60.

David Gillespie joined the RCA's School of Graphic Design in 1957 from Croydon School of Art, where he had trained as a book illustrator under Dennis Bailey, who had himself contributed articles and illustrations to *ARK* during the early 1950s. Like many RCA students during this pre-Coldstream Report era, Gillespie was admitted to the College on the strength of his portfolio and possessed virtually no formal academic qualifications. Consequently he found the rather self-conscious intellectualism of the RCA–ICA axis as represented by Alloway and Coleman both intimidating and perplexing:

I joined the College as an illustrator because it was the easiest thing I could think of for getting in. I was too frightened to go into fine art, into painting or anything like that because at that time people were so incredibly intellectual . . . You got left miles behind unless you knew about the work of fifty painters and could talk about them knowledgeably. That was very difficult for me. I didn't have any O or A levels. What terrified me about working for *ARK* was my spelling. I just looked after the visual side.[101]

'Looking after the visual side' of *ARK* enabled Gillespie to escape 'the general run of the mill' of book illustration. Influenced by Edward Wright's Dadaist typographical experiments, by the performances of The Alberts and The Temperance Seven as well as by the 'events' staged by the 'Anti-Ugly Society' (who sallied forth *en masse* from 21 Cromwell Road led by The Temperance Seven to applaud or barrack selected buildings in the South Kensington or Knightsbridge area), Gillespie turned his attention from the rather staid area of book illustration to George Haslam's new course (it would not become a separate department until 1962) in Film and Television Design. During his final year at the RCA Gillespie's particular *métier* became the design of television scenery from expanded polystyrene:

I just discovered this new expanded polystyrene stuff and it was absolutely perfect for scenery. The only trouble was that it was incredibly inflammable. Anyway, we filled the College with the stuff, forty-foot blocks of it. I carved entire grottoes, castles, God knows what else and the polystyrene granules were blowing all over the place . . . I first started doing that for an exhibition of the work of George Haslam's Television School.[102]

When the show ended Gillespie persuaded the Registrar to rent a garage in Jay Mews to store the polystyrene, from which he established his own company, Rocks Ltd., which hired the polystyrene to newly established Independent Television studios in Teddington. Not only was the company outstandingly successful, but it also helped Gillespie break into the world of commercial television design, where his Dadaist inclinations could be very profitably exploited:

When the TV School was set up by George Haslam in 1959 he took a painter, someone from Stained Glass, some people from Interior Design and Graphics and we were all instantly offered jobs because there was such a shortage of competent TV designers then . . . I left the TV School in 1960 and went straight into ITV. It was absolutely incredible. I was thrown in at the deep end. Within six months I was designing hour-long shows like the Peggy Lee Show. I went straight into Light Entertainment whereas the intellectual people went into Drama and Talks. It was marvellous for me, because television was still black and white in those days and it had to be visually exciting. You had to do lots of interesting shapes to make the sets stand out on this little 10" grey screen . . . In a year or

two I was earning an absolute fortune. I had a Mark 7 Jaguar and I lived in an enormous house and I was only 23. I used to get arrested by the police because I looked such a terrible scruff and they thought I'd stolen the Jag![103]

It transpired that Gillespie's experience on *ARK* was an extremely useful preparation for the lucrative world of television design. As art editor of the magazine he was given virtual *carte blanche* to design the magazine as he wished ('providing it wasn't too outrageous we could get on with it') and in the new world of television design there were 'no rules'. 'It was great. You were given a budget. You met the director of the programme and you just got on with it. Just like *ARK*, really.'[104]

 With the savings he amassed from his work as an ITV set designer, Gillespie set up his own company specializing in the creation of fibreglass sculptures, scenery, and models for television sets. Upon the introduction of colour television, scenery requirements for television changed radically, so Gillespie branched out into shopfitting, specializing in fantasy interiors for boutiques, restaurants, and pubs: 'We went into shopfitting in the sixties. I did lots of the boutique interiors down the King's Road, all the trendy pubs . . . we were trying to get some fantasy and excitement into shopping.'[105]

 Gillespie's transition, via RCA-Dadaist events and the art editorship of *ARK*, from traditional book illustration to commercial television design and the creation of 'fantasy interiors' for boutiques during the 1960s and 1970s, provides an illustration of the role played by art schools in the creation of an English postmodern sensibility. Gillespie's example challenges the generalizations of commentators such as Walker, Frith, and Horne[106] who, by focusing upon events in British art schools during the 1960s, lay great emphasis on the romanticism of art students while ignoring the ways in which the 1950s generation of art students adapted modernist avant-garde strategies for use in mainstream mass media with the deliberate intention of making money and building careers. In contrast to Frith and Horne's stereotype of the anti-materialistic beatnik or hippie bohemian art student, Gillespie emphasizes that:

Everyone I was at College with wanted to chuck out that romantic nonsense idea that you don't make money out of art and design. We wanted a really good standard of living and we wanted big cars and we wanted to get married and to have children. We wanted to have executive life-styles and to make a lot of money out of our talents.[107]

The career of Denis Postle, David Gillespie's successor as art editor for *ARK*, provides another example of the ways in which the techniques and strategies of the fine art avant-garde filtered into the world of television and film. Another working-class RCA student, Postle arrived at the RCA from Sunderland School of

Art, very well versed in the traditional English craft skills appreciated by Richard Guyatt, John Brinkley, John Lewis, and other members of staff in the School of Graphic Design. As in Gillespie's case, Postle's perspectives were completely altered by contact with the London art school scene:

From my point of view [the RCA] was an extraordinarily fruitful experience, because I'd come from a very provincial background, from Sunderland. There was a whole gang of us down from Sunderland at that time, a sort of subculture from Sunderland College of Art, which because of its excellent training in traditional craft skills was quite amazingly successful at getting people into the College . . . we came down pretty green, but by the end of the first year some of us had our feet under the table a bit. I came to the College very competent in typography but not particularly ambitious to pursue a career in that field . . . so I got into two things—one was running the Film Society, the other was *ARK*, both gave you a good deal of independence. One thing I noticed about *ARK* was that virtually everyone who had been art editor of the magazine had a large degree of independence from the College—you had a phone, an office, and the freedom to do what you liked . . . It gave you the freedom to try this or that and not have to do what you didn't feel like doing, that was a considerable virtue.[108]

For Postle, the important thing about *ARK* was the process of art editing the magazine; both he and *ARK*'s editor Roddy Maude-Roxby shared an interest in performance, collage, and the disruption of conventional narrative structure by exploiting the aesthetic effects of chance encounters: 'It was an intuitive, naïve politics, our view was to break away from "aboutism". I wanted to make *ARK* a thing, an object, not "about" something . . . an experience, an event.'[109] The techniques for achieving this assault upon the common-sense English narrative were derived partly from Paolozzi's collages and sculptures, partly from jazz and rock 'n' roll, but mainly from films such as Jacques Tati's *Mr Hulot's Holiday*, *The Wild One* starring Marlon Brando (which received one of its first screenings in Britain at the RCA Film Club in 1958) (Plate 60), and Guy Debord's notorious underground film *Hurlements en faveur de Sade*, which Ralph Rumney had brought to the ICA from Paris early in 1959. *Hurlements* was an extremely long but absolutely blank film with nothing at all shown on the screen, the soundtrack being interrupted occasionally with odds and ends of French prose spoken in a deadpan voice followed by a final silence of twenty-four minutes when the only sound was the turning of the reel. When the lights finally went up at the ICA after its first screening the protest from those who had bought tickets for the preposterous hoax was so loud that it reached the next audience queuing on the stairs. Those who came out of the auditorium tried to persuade their friends on the stairs to go home rather than wasting their time and money, but the atmosphere had become so charged with excitement that their advice had the

opposite effect. The graphic equivalent to *Hurlements en faveur de Sade* can be seen in Postle's layout for *ARK* 24, which includes the use of livid day-glo, fragmented nonsensical structure, and use of deliberately *brut* childish lettering for the obligatory College Council-funded Orient Line advertisement on the back cover (Colour Plate **5**), a tactic which would be revived in the mid-1970s by Jamie Reid's punk graphics for the Sex Pistols (Colour Plate **6**). Postle explains that the design was a deliberate attempt to offend the 'Good Taste' of the Establishment, especially the ideals of the Lion and the Unicorn Press:

I had learned old-style book production really well at Sunderland and it provided a good basis to kick against and to jump off into other things from . . . The Lion and the Unicorn Press was regarded with hoots of derision by all of us as pointlessly and hopelessly anachronistic and ludicrous. One of the famous jokes about the staff in the School of Graphic Design amongst students at that time was that they had a box of ephemera labelled 'Beautiful Things'. We planned to find it and burn it in public. It was a key thing. That fey kind of beauty was regarded with great suspicion at the time . . . *ARK* 24 was intentionally subversive in a kind of late teenage way which is a pretty permanent phenomenon. But it was much more than that. It was technically innovative and original too. The day-glo cover was produced within twelve months of the first day-glo inks emerging. It's faded a bit now, but when it first came out it was really, really offensive. The opposite of 'Good Taste' in fact![110]

Apart from deliberately crude, random typography and the exploitation of 'vulgar' commercial innovations such as day-glo inks, an alternative strategy for cultural subversion was the use of pop culture in a direct, appreciative, and unintellectual fashion. Because he understood the wiring system of the student union, Postle became the student union's resident disc jockey 1958–9:

The dances became really extraordinary. We played Elvis, Cliff Richard, Buddy Holly, The Everly Brothers . . . music made explicitly for dancing. The culture was based entirely upon dancing and it was complemented by some extremely wild behaviour and very bizarre clothing. Those dances and those clothes were distinguishing aspects of RCA culture at that time.[111]

The accuracy of Postle's reminiscences seems to be confirmed by contemporary minutes to RCA College Council, which reported that:

During last summer term a number of complaints were made to the College by people living in the neighbourhood of 21, Cromwell Road about noise, rowdiness, and disturbances emanating from the Junior Common Room when students' dances were held. On investigation it was discovered that the police had also received a number of complaints by telephone on dance nights, and that on one occasion plain clothes policemen from Hammersmith Police Station had attended a dance in the JCR.[112]

After art editing *ARK* Postle transferred to George Haslam's course in Television and Film Design and later joined Granada TV as a Production Trainee. By the late 1960s, after working on BBC and ITV arts documentaries, features, and commercials, he established a film company, Tattooist International, devoted to making experimental films. The strategies of the 'underground' films produced by Tattooist International bore close similarities to the Situationist *ARK*s:

They were films about the audience. About coming down off the screen and getting into the audience's head. Seriously trying to get the audience to leave. Telling them nothing is going to happen . . . they'd really irritate people (although at that time we hadn't caught on that this wasn't really such a good idea!). One of the statements that ended one of the films was: 'You came looking for art, but you didn't bring any with you.' Sometimes we showed it in places where we'd get the most wonderful reactions—I remember in one place someone started drawing on the screen. He had brought art with him, that was excellent . . . There was an absolute continuity between those films and *ARK*.[113]

For a brief period in the 1960s Postle was joined at Tattooist by Terry Green, Postle's successor as *ARK*'s art editor. The last to be edited by Roddy Maude-Roxby, *ARK* 25 continued the Dadaist–Situationist tone of its predecessor, including the second part of Ralph Rumney's 'Leaning Tower of Venice', a dialogue between Rumney and Alan Ansen on the Beat Generation, an article on the Italian *tachiste* Scialoja by Lawrence Alloway, a short play by Ann Jellicoe (author of *The Knack*, made into a film by Dick Lester in 1963), and various articles on contemporary abstract painting. The cover of *ARK* 25 features a grainy black and white photo (repeated inside on a spectacular fold-out centrefold) of a still of Brigitte Bardot in Roger Vadim's *And God Created Woman* (Plate 61), a film which became something of an RCA cult (a Bardot clip is also included in Ken Russell's famous 1962 film about RCA Pop Art *Pop Goes the Easel*). Complete with its deliberately random typographical errors the cover proved especially galling to Richard Guyatt. As Terry Green recalls:

The cover of *ARK* 25 really drove Richard Guyatt up the wall because there's a couple of incorrect typefaces in there—quite deliberate of course. There were terrible rows about that, because the cover was set at College whereas the rest was printed at Cowell's printing works in Ipswich. We got away with it in the end. We convinced him we were interested in chance, randomness.[114]

The imagery of *ARK* 25 was the first directly to reflect the new mood of the Royal College Pop Art of David Hockney (RCA 1959–62), Derek Boshier (RCA 1959–62), Pauline Boty (RCA 1959–62), Allen Jones (RCA 1959–60), Peter Phillips (RCA 1959–62), and Patrick Caulfield (RCA 1960–3) in its concerted attempt to break away from the intellectual pop which had become associated with the

61 Brigitte Bardot
centrefold by Terry Green
from *ARK* 25 (Spring
1960)

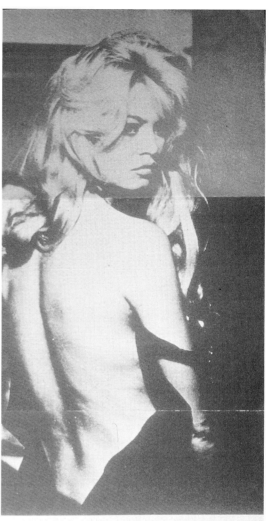

60 Poster for RCA Film
Society by Ken Sequin
(1962)

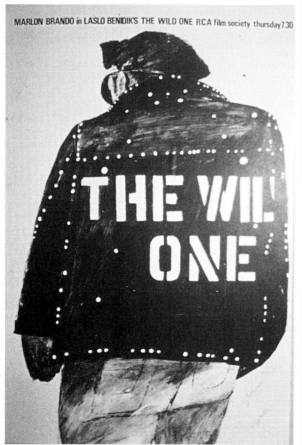

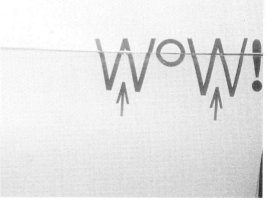

Independent Group, Alloway, and the Denny–Smith–Coleman generation. As
Terry Green recalls: 'There was a very posey thing around at that time which had
to do with artists being intellectuals. We didn't like that. That's why we put
Brigitte Bardot on the cover. At that time she represented the new
permissiveness.'[115] Another homage to contemporary pop culture is Peter Blake's
'Only Sixteen: In Ark's Tender Breathtaking Love Stories All your Dreams Come
True' (Plate 62), a ironic parody of contemporary *Teen Romance* comics.

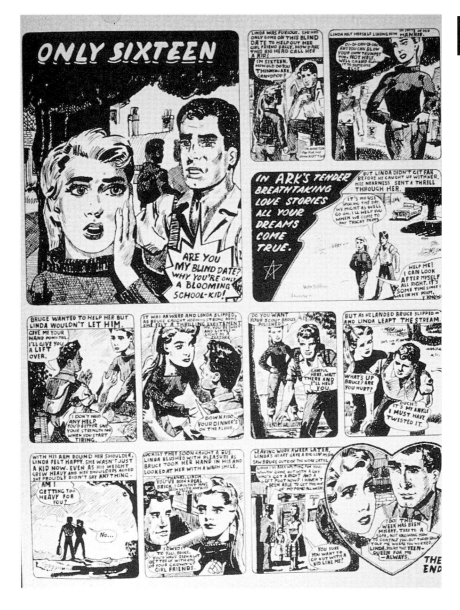

62 Peter Blake, 'Only
Sixteen', *ARK* 25 (Spring
1960)

The most spectacular manifestation of *ARK*'s Situationism occurred in the autumn of 1960 when Green, Postle, and *ARK*'s advertising manager Mike Kidd were telephoned by the Oxford University Design Society and asked to mount an *ARK* exhibition in the Oxford University Divinity School. The Oxford students' request was made shortly after the publication of *Cambridge Opinion*, 17, edited by Robert Freeman (who, like Roger Coleman, was 'recruited' to the ICA by Lawrence Alloway), which contained articles by John McHale, Reyner Banham, and, most notably, Lawrence Alloway's seminal article 'The Long Front of Culture'. In February 1960 a group of Cambridge University students (James Mellor, Raymond Wilson, George Coral, and Tim Wallis) had exhibited their paintings at Denis Bowen's New Vision Centre Gallery under the title of the 'Cambridge Group'. As Terry Green recalls, the Oxford students obviously felt that they were being upstaged by their Cambridge rivals:

The Oxford Student Union phoned us up and said, 'You won't believe this but the main bookshop at Oxford has nothing more modern than Klee!' They asked us to do an exhibition including some of Peter Blake's paintings. We included a huge blow-up of that Brigitte Bardot picture that's in *ARK* 25. The exhibition was held in the medieval Divinity School alongside statues of Sir Walter Raleigh. That really upset a lot of people. In fact there were nearly fisticuffs with a group of outraged Oxford students![116]

63 Poster for the 'Have Image Will Travel!' exhibition at the Oxford University Divinity School, October 1959

Unlike 'This is Tomorrow', 'An Exhibit', or 'Place', 'Have Image Will Travel!' (Plate 63), the *ARK* exhibition at Oxford (October 1960) had no theoretical *raison d'être*, it was simply a celebration of contemporary pop culture with a strong dash of Dadaism, rendered all the more potent because it was displayed in the heart of Establishment culture (Plates 64–5). Like Gillespie and Postle, Terry Green, Mike Kidd, and their friend Ridley Scott joined George Haslam's Television and Film course. After being awarded the Royal College's Gold Medal, Green joined Thames TV at Teddington as an art director in set design. Discovering that he wanted to be a director, like Ridley Scott, he turned to making commercials:

It was the quick route to directing if you had a graphics background and it was a fairly easy route, but then, of course, it becomes a rack which you can't get off because you get categorized as a 'Commercials Director'. Ridley Scott helped change that, but at that time to do commercials was no qualification to do films or TV drama . . . I was lucky, because of my background in George Haslam's course I'd served my apprenticeship at Thames as a TV art director and I was eventually recommended for TV drama.[117]

Since working on *ARK* and graduating from George Haslam's television and film course, Green has spent his entire career designing, editing, producing, and directing film and television. During the 1960s he helped design several programmes which have since become synonymous with the style of that

▍64 Exhibit from the 'Have Image Will Travel!' exhibition
▍65 Exhibit from the 'Have Image Will Travel!' exhibition

decade, including *The Avengers*, *Thank Your Lucky Stars*, and *Armchair Theatre*. More recently he has produced successful television programmes including *Minder*.

This chapter has charted aspects of the development of an English postmodern sensibility during the 1950s by focusing upon the development of art school culture within the specific context of the Royal College of Art. Although we have focused upon the development of specific subcultures within the RCA during the 1950s, so far we have paid relatively little attention to other external cultural factors which influenced RCA students during this period. The following chapter will attempt to recreate something of the milieu of London art school culture of the mid- to late 1950s and early 1960s, focusing in particular on the ways in which these cultural influences are reflected in the pages of *ARK*.

5 Uptown Pop

In the previous chapter we traced the origins of postmodern sensibility at the RCA back to a particular confluence of cultural and historical factors. It was argued that, after the social and political watershed of the War, a generation of *déclassé* mature students, many of whom were ex-servicemen, entered the RCA ambitious to begin or resume careers disrupted by the War or National Service. Difficult to teach or discipline because of their age and experience, this generation had a tendency to lampoon and satirize anything and anyone they regarded as pompous or reactionary. Although the cult of 'Englishness' displayed in the Lion and the Unicorn Pavilion of the Festival of Britain was appreciated by many RCA students of the early 1950s, by the mid-1950s these nostalgic symbols of national identity were becoming associated with the culture of a supine, reactionary Establishment.

Because of the RCA's tradition of amateur drama and its depth of talent in the field of theatre design, many of the early challenges to the Establishment took the form of satirical revues and vaudeville-inspired performances in the spirit of the *Goon Show*. By 1955–6, however, these theatrical performances were supplemented by the rediscovery of the strategies of the modernist avant-garde. At first these influences were primarily European but later, especially after the Tate Gallery exhibition of American art in January 1956, the focus began to shift towards contemporary developments in the United States.

Seen in England for the first time either in exhibitions held at the ICA, the New Vision Centre Gallery, and a few commercial galleries or in the pages of magazines imported from the Continent or the United States, varieties of Dadaism and American Abstract Expressionism combined with the home-grown tradition of satire and eccentric performance to lend the art school culture of the RCA's 'Beat Generation' a characteristically subversive edge. This development can be most clearly seen in issues of *ARK* produced between 1959 and 1960, in

which Situationist-inspired contents and resolutely 'anti-tasteful' layouts were intended to irritate, confuse, or enrage the Establishment.

Because several of the ingredients which constituted this aesthetic rebellion were drawn from modernist avant-garde sources, the term 'postmodern' requires some qualification here, for whereas the aesthetic rebellion of the Independent Group at the ICA can be interpreted as being directed in part against a particular version of 1930s modernism favoured by an older ICA generation, the art school culture of the 1950s generation of RCA students tended to be characterized by salvoes aimed primarily at the 'English' tastes and patrician mannerisms of the staff. As few of Darwin's professors were enthusiastic modernists,[1] the main targets of the more rebellious students tended to be Victorian revivalism, Euston Road, and Neo-Romantic painting. Although there was a fusion of interests between the older generation of Independent Group members (born during the 1920s) and a younger generation of RCA students (born during the 1930s and early 1940s), it was the latter generation's unintellectual espousal of street-level pop culture which distinguished the art school culture reflected in *ARK* between 1959 and 1963 from the more ironic, theoretically sophisticated approach of the IG and their RCA-based acolytes.

The 'postmodern sensibility' which this book is attempting to trace is, therefore, a paradoxical, chaotic, and contradictory phenomenon. As Joe Tilson has commented:

It's easy to get this period terribly wrong. There are two quite distinct things you have to trace. The first is the interest in Americana and American culture generally. The second is when it's used, how it's used, and who it's used by. The first thing is easy . . . most of us grew up with that culture, it was Peter Blake's, Richard Smith's, and Robyn Denny's basic cultural background as it was mine. We all grew up watching Betty Grable movies and listening to Benny Goodman and modern jazz. But that's not the same thing as getting it into your art. Peter Blake managed to introduce it in the form of comic strip, but Robyn Denny never got it into his art and he was one of the principal protagonists of Americana at the College . . . It edges into Dick Smith's work, but not very significantly.[2]

It was the sophistication, energy, and sheer impact of American culture, from its painting to its graphic design to its music, which impressed art students rather than the critical debates which surrounded its influence. As Tilson points out, during the mid-1950s the impact of Americana (American pop culture) and of American Abstract Expressionism (American high culture) was often conflated and confused as part of an image of a fantasy America:

Americana influenced Peter Blake, Robyn Denny, Dick Smith, Len Deighton, and I, but you're also talking about Abstract Expressionist painting which had got nothing to do

with pop culture. It's very important to differentiate between the two because although we were all into Americana, that pop side of it was really picked up by Peter Blake, who was also interested in the work of Ben Shahn and Saul Steinberg, but Peter was never interested in Pollock, Rothko, or De Kooning, he was just into street-level Americana. Denny, Smith, and William Turnbull on the other hand were immensely influenced by the sheer physical presence of American abstract painting, which was often the total opposite of the American Pop Art which followed. At that time there was a huge gulf between those 'Situation' painters and the rest of us, myself included, who were interested in Americana but who were excluded from that show.[3]

Apart from understanding the evolution of the peculiarly English version of Dadaism which was traced in the last chapter and which fed into the worlds of television and film via ex-RCA students such as Bruce Lacey, John Sewell, David Gillespie, Denis Postle, Ridley Scott, and Terry Green, it is also important to disentangle the complex ways in which American culture influenced the RCA student generation of the 1950s and early 1960s. Tilson provides a key to solving this puzzle when he points out that 'All Pop tends to get lumped together, but it's much more complex than that. I've always said that there was an Uptown and a Downtown Pop.'[4] Although Tilson is referring primarily to painting ('In England Richard Hamilton and Dick Smith were Uptown, Peter Blake was Downtown . . . Gold Flake packets and soft porn mags in the corner shop'), the uptown/downtown distinction provides a useful model for dissecting the American influence at the RCA during the 1950s and early 1960s as it manifests itself in *ARK*.

Lawrence Alloway's seminal essay, 'Pop Art since 1949', first published in the *Listener* in December 1962, uses references which bear a similarity to Tilson's uptown/downtown model. Describing the 'first phase of English Pop Art', Alloway explains how the Independent Group took popular culture out of the realm of 'escapism', 'sheer entertainment', and 'relaxation' and began to 'treat it with the seriousness of art'. As sophisticated consumers, most members of the Independent Group favoured uptown pop for, as Alloway says, 'Hollywood, Detroit, Madison Avenue were, in terms of our interests, producing the best popular culture.'[5] The taste for uptown pop was also shared by Richard Smith and Roger Coleman, the main protagonists of Alloway's second phase of English Pop at the RCA. Praising *ARK*s 18–20, Alloway describes Coleman's three numbers of the magazine as 'serious and lively, instead of only lively, as subsequent issues became under other art editors'.[6] Alloway's third phase of English Pop, 'which emerged decisively at the Young Contemporaries Exhibition of 1961', however, was (with the important exception of R. B. Kitaj) far less intellectual than its predecessors. The 'downtown' street-level pop imagery

which characterized the student work of Peter Phillips and Derek Boshier was interpreted in an unintellectual, even anti-intellectual, fashion. Alloway quotes Phillips in this respect: 'My awareness of machines, advertising, and mass communications is not probably in the same sense as the older generation that's been without these factors . . . I've lived with them ever since I can remember, so it's natural to use them without thinking.'[7] Because of its subjective 'fan' quality, its return to figuration, and its lack of critical intellectual substance, Alloway found the third phase of English Pop Art less interesting than the previous two, concluding his 1962 essay with the comment that contemporary English Pop Art did not possess 'the density and rigour of New York Pop Art'.[8]

Although Alloway's essay provides a valuable insight into trends in painting, he displays little interest in graphic design. A study of *ARK* during the 1950s and early 1960s adds an extra dimension to the uptown/downtown model by considering the complex relationship between Pop Art, graphic design, and pop culture.

American and Continental Graphic Design in *ARK*

Alan Fletcher has pointed out that during his three years (1953–6) in the Royal College of Art's School of Graphic Design 'there was a major design transition going on . . . a big upheaval'.[9] The first evidence of this change can be seen in *ARK* 5 (Summer 1952), edited by John Blake and art edited by Raymond Hawkey. *ARK* 5 contains 'Advertising: A Skeleton in the Consumers' Cupboard', Hawkey's broadside against Jack Beddington, Deputy Chairman of Colman, Prentis, and Varley, an Honorary Fellow of the SIA, and a member of College Council. Hawkey's attack on Beddington was not born of personal animosity but out of a frustration with everything that Beddington represented—the cult of the English gentleman and amateur, and, above all, the parochialism and insularity of most contemporary British graphic design. Hawkey explains that he was not actually opposed to advertising *per se*: 'What I disliked was bad advertising. One has to remember that at the time there were a vast number of advertisements around that simply wouldn't be allowed today. Firms like Horlicks making claims about the perils of "Night Starvation". It was very crass indeed.'[10] Hawkey's article represented a rebellion against the status quo of graphic design at the RCA, for although he appreciated and admired the traditional crafts of lettering, book illustration, and steel and wood block engraving of which members of staff such as Bawden, Brinkley, La Dell, and Lewis were leading exponents, he was quick to see that the students were innocent of the best developments in contemporary graphic design. Hawkey was one of the first RCA students to turn his attention

away from the English approach to illustration and concentrate on contemporary developments in American graphic design. His approach was to have a major influence on the development of British graphic design later in the decade:

I remember buying one of the first *Art Directors' Annual of Advertising and Editorial Art*, published by the Art Directors' Club of New York. It came as an absolute revelation. Even today you see a lot of work in magazines that looks as if it could have come from those chic, elegant annuals . . . In America at that time, the late 1940s, early 1950s, they were already using very sophisticated modern photography whereas the emphasis in England was very much on the drawing, producing illustrations which often had a fake wood block quality.[11]

Whereas the staff of the School of Graphic Design during the 1950s tended to look down upon photography as a second-rate pursuit, the work of American master photographers such as Richard Avedon, Irving Penn, and Horst P. Horst, commissioned by art directors such as Alexander Liberman of *Vogue* or Alexey Brodovitch of *Harper's Bazaar*, seemed to make a complete mockery of the idea that photography was somehow 'inferior' to illustration (Plate 66). What was more, the illustrations of David Stone Martin, Ben Shahn, and Saul Steinberg on display in the *Art Directors' Annual* seemed to be in tune with the pace of the modern world, in stark contrast to the bucolic romanticism of their English counterparts.

66 Layout by Derujinsky for *Harper's Bazaar* (1951)

It was the sheer professionalism of American graphic design which Hawkey admired. For a young British illustrator it represented an escape route from the penury of part-time teaching, occasional work for *Lilliput* or the *Radio Times*, or perhaps the odd advertising commission from a well-connected patron like Beddington. Unlike in Britain, where commercial art was still considered to be rather *infra dig*, graphic design in the United States appeared to have considerable social status and was a self-confident, tough, and lucrative business. Influenced by American *Vogue* and the New York *Art Directors' Annual*, Hawkey began to plan his future as a commercial graphic designer rather than as an illustrator who occasionally turned his hand to commercial work. In contrast to the more traditional orientation of contemporaries such as David Gentleman and Dennis Bailey, Hawkey regarded his compulsory first year with 'the bloods' in the Painting School as an imposition rather than a privilege:

I got into the College as an illustrator from Plymouth School of Art and in those days illustrators were required to spend their first year in the Painting School. I hated it so much that I applied for a transfer to Graphic Design . . . I had a run in with Ruskin Spear . . . I couldn't get on with the old Chelsea Arts Club style of beer-swilling bohemians . . . Richard Guyatt was very irritated, but he looked at my work and I did get a transfer to Graphic Design. So for me the Painting School had no bearing at all on what I subsequently went on to do.[12]

ARK 5 (Summer 1952) reflected Hawkey's stance. It not only contains the broadside against Jack Beddington, but it is also the first *ARK* to contain photographs, in the style of Avedon and Penn's work for Liberman and Brodovitch.

Hawkey's experience as *ARK*'s art editor enabled him to win a *Vogue* talent contest in 1953, the same year as he was awarded his ARCA. He went to work for Conde Nast where he quickly became Art Director in charge of the Promotion Department and, by 1954, Art Editor of British *Vogue*, where his interest in American graphics stood him in good stead:

The interest in American graphics was very useful, because, as it turned out, they didn't really know exactly what they wanted when they hired me, but because my interests reflected what their American art director Alexander Liberman had been doing for many years (a great deal better than I was doing it, I might add!) the accent of my work was right and the more one's confidence and experience developed, the better one became. But it did very much derive from the American school of graphic design.[13]

In 1957 Hawkey was commissioned to design the prototype of a magazine Hulton's were planning that was to be modelled on the innovative American

illustrated magazine *Fortune*, but the publishers went out of business before the project could be completed. Lord Beaverbrook had been interested in the Hulton project and in 1958 hired Hawkey as a consultant to Beaverbrook Newspapers. It was a small step from there to becoming design director for the *Daily Express*, under the editorship of Arthur Christiansen, a post he held from 1959 to 1964 before moving to the *Observer*.

What the *Express* wanted was 'the introduction into the paper of a magazine flavour, polished, sophisticated, modern', and an interest and understanding of American graphic design techniques helped Hawkey transform the paper's image. On the *Express* he worked with Michael Rand (who later became art editor of the *Sunday Times Colour Magazine*) to develop original, attractive graphics which acted as both advertisements and co-ordinating headlines to give a symbolic feel to the page. In 1964, a year after Michael Rand left the *Express* for the *Sunday Times*, Hawkey joined the *Observer* as presentation director. After restyling the paper he turned his attention to the colour magazine, which during its first year of existence had been art edited by another RCA graphics student and *ARK* contributor, Romek Marbur.

Hawkey's admiration for American graphic design was shared by his friend Len Deighton. Deighton also entered the RCA in the early 1950s as an illustrator but found the 'gentlemanly' world of contemporary book publishing unappealing. Like Hawkey, Deighton was ambitious to pursue a career in the lucrative world of mass circulation magazines and advertising agencies. As he recalls:

American advertising at that time was fantastic, especially the photography. When I went to the College there was no one in the Graphic Design School who knew what a camera was. None of the staff and none of the students. I'd been a photographer in the RAF and I'd been earning my living as a free-lance photographer all the time I was at St Martin's School of Art, so I was very much in favour of photography. I didn't feel photography was something we needed to worry about. Some people were very neurotic about it. They called me 'the photographer' and they didn't mean it as a compliment, either, they meant it as the most pejorative thing they could think of and the reason it was pejorative was that they were frightened . . . I had lots of friends from the RAF who worked in advertising agencies so I knew what was happening out there in the real world. In my year in the Graphics School I don't think there was one person who'd ever been inside an ad agency. When I mentioned it to the staff they said: 'Well, I hope we never see the day when any of you are working for an advertising agency!' That was the prevailing attitude.[14]

Deighton's layouts as art editor for *ARK* 10 (Spring 1954) drove his point home. The cover, a photograph of a hand drawing a hand, was intended to emphasize

the point that although photography was not necessarily 'superior' to illustration, it was certainly about time that staff and students of the RCA woke up to the creative potential of photography rather than simply ignoring or dismissing it (Plate 67).[15] Equally iconoclastic and offensive to the traditionalists was an article appropriately entitled 'Unpopular Art' which compared American comics to old English chap-books and was deliberately printed on low-quality newsprint (Plate 68). This Hopalong Cassidy comic ('reproduced in *ARK* by special permission of the publishers') is the first example of the pop aesthetic to appear in *ARK*, for, as Deighton explains, 'I was interested in putting in a comics section like in an American newspaper, a little newspaper insert, to give the magazine an expendable quality . . . something to be read once and then thrown away.'[16]

Deighton's emulation of the work of the Americans Ben Shahn and David Stone Martin is revealed in the style of his illustrations for two articles he contributed to *ARK* in 1954–5, 'Abroad in London: Down Past Compton on Frith, Food Makes Wonderful Music' and 'Impressions of New York: A Bowler Hat on Broadway' (Plate 69). Similar influences can be seen in the student work of his contemporary John Sewell (Plate 70).

Hawkey and Deighton's association continued throughout the 1950s and 1960s. Deighton contributed his cartoon cookery strips to the *Daily Express* while Hawkey designed the book-jackets for Deighton's best-selling spy novels from *The Ipcress File* (1962) onwards (Plate 71). Hawkey's innovative use of photography for these book-jackets helped to transform British book design as virtually all British book-jackets had featured drawings before that time. Ironically enough, this was precisely the development which had been feared by several of *ARK*'s early contributors. In his editorial to *ARK* 1 (October 1950), for example, Jack Stafford had written:

The first issue of *ARK* is overshadowed by the widespread feeling that the book illustrator, retreating before the photographic half-tone, is being confined to the more limited editions of the bookjacket . . . The bookjacket is an expendable item unless artificially preserved and even then it never receives the same care and appreciation devoted to a well illustrated text . . . We hope to show some of the versatility of the line block in this issue.[17]

Pessimism about the incursions of photography and hostility towards American trends in graphic design were aspects of a more general anti-American sentiment which permeated British society during the 1950s.[18] In his editorial in *ARK* 2 (February 1951), Jack Stafford identified the American threat to British culture and stressed the need for designers to be on their guard against it:

67 Cover for *ARK* 10
(Spring 1954) by Len
Deighton

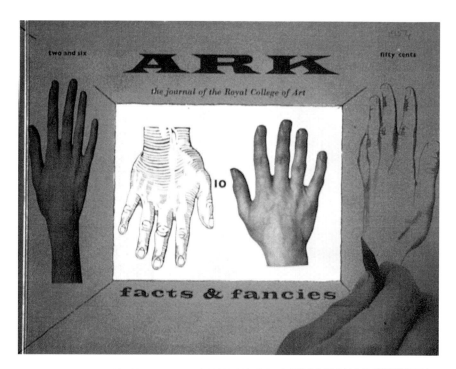

68 'Hopalong Cassidy'
comic insert in *ARK* 10
(Spring 1954)

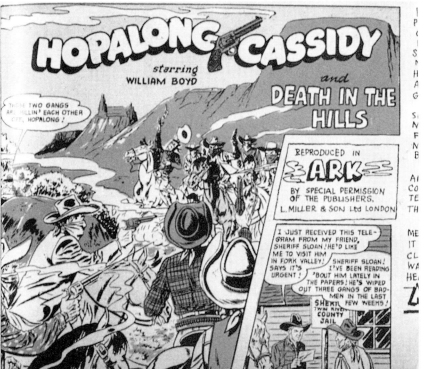

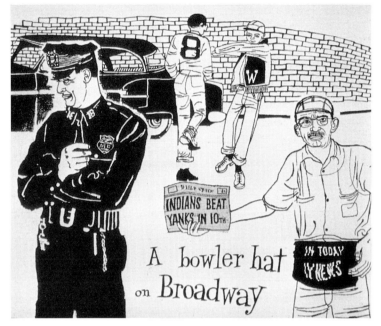

Mark Hellinger's
THE NAKED CITY
Thursday 29 January 7 pm
A documentary thriller by Jules Dassin in actual New York streets, with Barry Fitzgerald & Howard Duff
also Mr. Magoo in BAREFACED FLATFOOT, *and* AI-YE *an experimental film.*
Royal College of Art Film Society, 21 Cromwell Rd Kensington SW7

A recent survey by an American university disclosed that out of 170 million Americans, 77 million do not read one book in a year. NOT ONE BOOK A YEAR . . . need we ask ourselves if they see a contemporary painting or ballet, hear any contemporary music or drama? In this country, too, we see the symptoms, and especially amongst our own generation: a life of the flicks and the pools and the palais . . . When the intellectual distance from even one's own generation is of this order subtle values are lost. In this vacuum one can only shout roughly or keep quiet.[19]

Stafford's editorial serves as a reminder that in the eyes of many RCA students of the early 1950s American culture and American design in particular was synonymous with the 'streamlining', 'borax', and 'jazz modernism' so detested by both the DIA and the CoID. Replying to Darwin's impatience with the Morrisite idea of 'honesty' in design in *ARK* 2 ('Honesty in most contexts is all very well, but surely in design it is neither here nor there . . .'), R. D. 'Dick' Russell, Professor of Woods, Metals, and Plastics, warned the Principal of the implications of his statement:

There is a rather frightening story about the design policy of a huge American radio corporation in the 1930s . . . When the cabinet designs came in, each was made into a full size model and a display of four hundred design prototypes was arranged. The great moment had arrived and the wife of the Corporation's President, a woman with the best of taste who had been to Italy and so forth, was invited to place the designs in order of

69 'A Bowler Hat on Broadway' illustrations by Len Deighton in *ARK* 13 (Spring 1955)

70 Poster for RCA Film Society by John Sewell (*c*.1954)

147

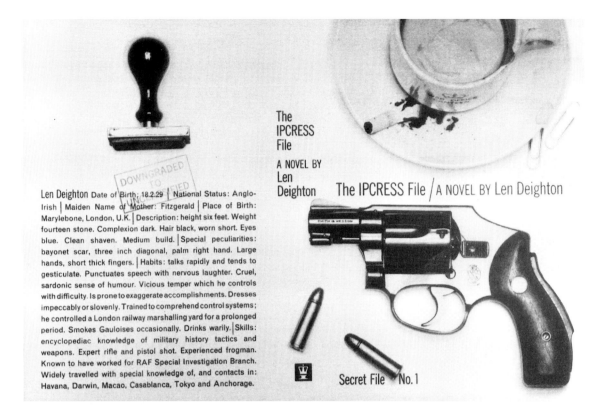

The
IPCRESS
File

A NOVEL BY
Len
Deighton

The IPCRESS File / A NOVEL BY Len Deighton

DOWNGRADED TO UNCLASSIFIED

Len Deighton Date of Birth: 18.2.29 | National Status: Anglo-Irish | Maiden Name of Mother: Fitzgerald | Place of Birth: Marylebone, London, U.K. | Description: height six feet. Weight fourteen stone. Complexion dark. Hair black, worn short. Eyes blue. Clean shaven. Medium build. | Special peculiarities: bayonet scar, three inch diagonal, palm right hand. Large hands, short thick fingers. | Habits: talks rapidly and tends to gesticulate. Punctuates speech with nervous laughter. Cruel, sardonic sense of humour. Vicious temper which he controls with difficulty. Is prone to exaggerate accomplishments. Dresses impeccably or slovenly. Trained to comprehend control systems; he controlled a London railway marshalling yard for a prolonged period. Smokes Gauloises occasionally. Drinks warily. | Skills: encyclopediac knowledge of military history tactics and weapons. Expert rifle and pistol shot. Experienced frogman. Known to have worked for RAF Special Investigation Branch. Widely travelled with special knowledge of, and contacts in: Havana, Darwin, Macao, Casablanca, Tokyo and Anchorage.

Secret File No. 1

71 Dust jacket design for Len Deighton's *The Ipcress File* by Raymond Hawkey (1962)

merit, this she did with great care, choosing for each model the sixteen best designs . . . then the unplaced four were put into production, for the public would not, of course, tolerate any trace of good taste![20]

Although Robin Darwin's personal tastes were conservative, epitomizing the 'Englishness' which many students of the 1950s and early 1960s lampooned, he played a leading role in encouraging students to adopt a pragmatic, professional 'American' attitude to design. Despite his attempt to reform the RCA along the lines of a Cambridge college, he did not regard the American education system as inferior and was quick to understand the advantages of the American system of design education. In 1953 he paid a visit to Yale University and wrote:

Perhaps if one were to attempt to distinguish in the very simplest terms between the American system of training and our own, one would say that whereas the former puts the emphasis on teaching people to think, we try to teach them to feel. Intuitions trained and sharpened by experience may produce the greatest art, but if the creative force is not very strong and the intuitions have not sufficient intellectual backing, the result is not only bad art but a disillusioned and prejudiced artist. On the other hand, an average but well conditioned intelligence with aesthetic sights which are not set too high, may

produce a more self contented and acceptable member of society. Of course, he will not produce great art or anything like it, but he may be responsible for much good industrial design. There is little doubt that the standard of American design is a good deal higher than it is in this country; it may seldom reach our best but it never sinks to the broad strata of our worst. It would for example be quite impossible to assemble each year in the States so vast and grisly a collection of banality and bad taste as is to be seen in this country in the Ideal Home Exhibition.[21]

What appealed to Darwin about American education was its immediate relevance to society and the needs of the American economy. American students impressed him as being more pragmatic and less idealistic than their British contemporaries:

It would, I think, be difficult to find what is fairly common over here—the student who is so concerned to preserve his virtue in a wicked world that he will turn his back on it if necessary, and after seven or eight years of training to be an artist, will become a railway porter or a garage hand rather than compromise himself.[22]

Darwin returned from the United States eager to develop permanent links between the Royal College and Yale. In 1955 Richard Guyatt became the first professor to visit Yale's School of Architecture and Design and in 1956 Alan Fletcher, one of the most gifted students in his year in the School of Graphic Design, was awarded an FBI Travelling Scholarship to become the first Yale/RCA Exchange Student.

Fletcher had come to the College in 1953 from the Central School. As art editor of *ARK* 13 (Spring 1955) he introduced modernist typography into the magazine and included an article by Herbert Spencer, an ex-tutor at the Central and editor of the influential journal *Typographica*, on 'Recent Developments in Typography' which introduced the work of the modern European masters of graphic design such as Huber, Faucheux, Hofer, and Sandberg into *ARK* for the first time.

Strongly influenced by the modernist curriculum of Jesse Collins's Graphic Design Department at the the Central School and especially by the teaching of Anthony Froshaug, Edward Wright, and Herbert Spencer, Fletcher was aware of the limitations of the RCA approach to graphic design and jumped at the chance to study in the United States:

I'd always wanted to go to America. It was all grey here but the States was Doris Day, bright lights, big cars. It seemed like Mars to us and when I got there I couldn't believe it, it was great . . . At Yale I was taught by amazing guys—Paul Rand, Leo Lionni, Saul Bass, Lou Dorfsman—really big cheeses. On the British side you had Henrion, Games, Lewis, Unger, Brinkley. It was a total generation gap not so much of age but of *attitude*.[23]

There was none of the English predilection for romanticism and nostalgia in American graphics. At Yale his teachers were the leaders of high-powered, fast-paced, and lucrative business which had its finger directly on the pulse of American capitalism. Fletcher's enthusiastic response to the 'uptown pop' of American graphic design appeared in his 'Letter from America', mailed from New York to *ARK* editor Roger Coleman and published in *ARK* 19 (Spring 1957) (Plates 72–3):

At rush hour commuting New Yorkers drive out of Manhattan at sixty miles an hour . . . By day the streets of New York are a kaleidoscope of colour. The dazzling hues of automobiles form constantly changing and dazzling patterns within the rigid design of the gridded streets and vertical buildings. The flat areas of pink, blue, chocolate, and red are punctuated with the chequered squares of taxis . . . the garish colours and tinsel ads lie haphazardly across the faces of buildings. By night the city is transformed. The skyscrapers blend into the night sky and glittering neons write across a drop of twinkling stars . . . The moving lights of Coca-Cola reflect from a waterfall which cascades down to the brightly lit street.[24]

The layout of *ARK* 19, designed by Fletcher's Central School contemporary Gordon Moore (who would work in America as the Photography Editor of

| 72 Photograph by Alan Fletcher in *ARK* 19 (Spring 1957)
| 73 Poster for *ARK* 19 (Spring 1957) by Gordon Moore

Playboy and *Oui* in the 1960s), features collages of photographs of contemporary American magazines sent from America by Fletcher:

The inevitable magazine rack, in addition to screen lovelies can assuage the curious (Sci. Fi.), the salacious (*Confidential*), the sportsman (female wrestling) . . . For those with other tastes there are the multi-page (100 or more) Sunday newspapers, or the attractions of the bookshop. Outstanding among the bright galaxy of dustjackets are the vigorously-designed paper-backed editions published by a few enterprising firms, who see no reason why cheap prices should be matched by cheap design. Employing such designers as Paul Rand, Leo Lionni, Roy Kuhlmann, and the late Alvin Lustig, these editions should easily be sold on the merits of their attractive covers alone.[25]

Just as Ray Hawkey's early interest in American graphics had an important influence on his career and on the subsequent visual evolution of British newspapers and magazines, so Alan Fletcher's American experience had a direct bearing on the evolution of the profession of graphic design in Britain during the 1960s. At a time when most British graphic designers were still producing work in one or two colours, Fletcher returned to London in 1957 with a portfolio bulging with the full-colour layouts he had executed for *Fortune* magazine under Leo Lionni. As he says: 'The American experience changed my career completely . . . a total change.' Fletcher's American portfolio gave him a flying start into the rapidly changing world of commercial graphics. By 1958 he was working for Time-Life as Consultant European Art Editor, before helping to form the Fletcher, Forbes, Gill partnership in 1962, the year which saw the formation of the influential Designers and Art Directors' Association in which Fletcher played a leading role.[26]

The trends in American and Continental graphic design which influenced Fletcher during his student days at the Central, the RCA, and Yale represent some of the major forces which helped transform British graphic design during the following decade. Although the relationship between the devotees of Continental modernist graphic design and American styles of advertising would sometimes become strained during the 1960s, in the School of Graphic Design at the RCA during the mid- to late 1960s both approaches to graphic design were seized upon enthusiastically by a generation of young designers eager to shrug off the heritage of Victorian revivalism.

Apart from the American magazines and New York *Art Directors' Annual*s which so impressed Ray Hawkey and Len Deighton, the major source of innovation in British graphics during the early 1950s was the graphic design course organized by Jesse Collins at the Central School of Arts and Crafts. Collins initiated the Central's graphics course in 1945 and he was virtually unique

amongst heads of British graphic design departments during the late 1940s because he was not an illustrator, a wood engraver, a calligrapher, or a printmaker, but a professional commercial graphic designer, one of the co-founders, with Misha Black and Milner Grey, of the Design Research Unit. Collins was also unusual amongst contemporary British graphic designers in his appreciation of the modern movement in architecture, painting, and design. During the late 1940s and early 1950s he taught a course in Basic Design at the Central School which stressed modernist ideas, augmented in 1950 by Victor Pasmore's Basic Design class for graphics students which stressed objective constructed composition and theories of colour, proportion, and pictorial construction.[27]

In 1948 Anthony Froshaug and Herbert Spencer joined Collins's department as part-time teachers. They were amongst the few British designers at that time who were practising the 'New Typography' pioneered on the Continent in the 1930s and described in Jan Tschichold's books *Die neue Typographie* (1928) and *Typographische Gestaltung* (1935). In his attempt to free design from restrictive rules and give designers greater freedom and flexibility, Tschichold argued in favour of the asymmetric arrangement of design elements, the preference for sanserif over serif typefaces, and the creative use of white space. In addition to Froshaug and Spencer, Collins hired Edward Wright, George Mayhew, and Ian Bradbury to create the first British department thoroughly committed to modern principles of graphic design.

Whereas the graphics departments of most other British art schools tended to focus upon the traditional 'fine art' end of the graphics spectrum, stressing illustration, calligraphy, wood engraving, or lithography, graphics students who attended the Central were taught 'functional typography' with a direct commercial application in addition to courses in the history of the modern movement which introduced them to the work of the Bauhaus and the pioneers of modern typography such as Moholy-Nagy, Tschichold, Werkman, Lissitsky, Léger, and Zwart. In addition to theoretical and historical studies, between 1952 and 1953 Edward Wright ran an evening typography workshop in which students used an Albion Press to experiment in a Dadaist spirit with the structural pattern of letters and the quality of sound.[28] This combination of progressive theory and experimental practice produced an extremely talented crop of young designers, including Peter Wildbur, George Daulby, Derek Birdsall, Colin Forbes, Alan Fletcher, Ken Garland, William Slack, Harold Bartram, and Gordon Moore, all of whom graduated from the Central between 1950 and 1954.[29]

From 1954 onwards some of the energy and innovation of the Central began to enter the RCA in the person of students such as Alan Fletcher and Gordon Moore

and members of staff such as Edward Wright (1956–9) and Anthony Froshaug (1961–4). When they arrived at the College Fletcher and Moore came into contact with like-minded students such as June Fraser, Douglas Merritt, Alan Bartram (brother of Harold), David Collins, Romek Marbur, and George Cayford. With the exception of Marbur and Cayford (who designed advertisements for *ARK*) all these students were art editors of the magazine between 1955 and 1957 and were instrumental in turning the magazine away from the decorative whimsy of the early 1950s. Although most of these students were interested in American graphics, they tended to be more interested in Continental modernism and attempted to introduce a modern look to *ARK* as far as the staff and the financial resources allocated to the magazine allowed. Before leaving for Yale, Alan Fletcher handed the baton of *ARK*'s art editorship on to June Fraser, who also 'felt that she wanted to do something completely modern' with the magazine as a reaction against the stylistic conservatism of much of the work being produced by the School of Graphic Design. She remembers that:

The College was terribly twee when I was there (1954–7) . . . it was such a contrast to Beckenham School of Art where I was taught by Peter Werner, a Bauhaus man. I really loathed all that Victorian stuff . . . the person I really revolted against was Edward Bawden, who was teaching us pattern design, and unless you put little boxes around your patterns you were out, you had to do it exactly like he did . . . I couldn't stand all that. I was very much into modern architecture and modern product design, the kind of Scandinavian products we were beginning to see in shops like Woollens and Finmar . . . apart from Henrion and Cliff Hatts, who was a particularly good tutor, I didn't have anything in common with the staff at all.[30]

Like those students in the Painting School who were rebelling against the styles favoured by the Staff by turning towards *tachisme*, Fraser was far more influenced by other students' work. She recalls that for her Alan Fletcher's work set the pace: 'I remember Alan doing a fantastic poster for suntan lotion of a woman on a beach with all the highlights disappearing into the sand. I looked to his work as an example much more than to the staff, it was really stunning.'[31] The television designer Douglas Merritt (now Head of Graphic Design at Thames Television), art editor of *ARK* 16 (Spring 1956), was encouraged to apply for the College by the example of his contemporary at Hornsey College of Art, John Sewell. He recalls that although Richard Guyatt was beginning to realize that fewer and fewer students 'wanted to do vignettes for limited editions', the 'fine art' side of graphics continued to maintain its status over commercial applications:

When Guyatt brought in Henrion and he began to give us projects which were hard edge advertising, many of us began to think that we would like to start working for advertising

agencies . . . but that was still considered to be very *infra dig*. I remember that there were people nearby us in the Engraving Department—Robert Austin and Edwin La Dell. They were very nice and friendly but they definitely gave us the feeling that we were the 'commercial boys' . . . I got my Diploma from Hornsey in 'Commercial Design' and that seemed very inferior at the time![32]

Merritt's response was to turn to both American graphics ('Like the Americans I designed using photographs, again, photos were considered to be *infra dig*. You'd copped out, you hadn't done it yourself.') and Continental graphic influences, especially Dutch typography. ('The Stedelijk Museum catalogues were very influential, especially the work of Werkman and Sandberg.')[33]

ARK's format change to A4 from issue 18 onwards gave editors and art editors more scope to experiment with the integration of contents and layout. In the most successful issues of the magazine a harmony exists between the two. Gordon Moore's memorable Duchamp-inspired cover for *ARK* 19, for example, provides an excellent symbolic introduction to contents of an issue dominated by the concerns of the Independent Group. Moore's cover design for *ARK* 19 is complemented by a photo-collage on Americana which provides an interesting example of the rather naïve fusion of Dadaism and American pop which characterized contemporary British images of a 'fantasy America'. As Bernard Myers has written, '*ARK* 19 looked anxiously and enviously across the Atlantic, and seized on the American way of life with all the enthusiasm and inside expertise of someone watching a football match through a knot hole in the fence at the back of the crowd.'[34] Perhaps the most successful of Coleman's *ARK*s in terms of integration of content and layout is *ARK* 20 (Autumn 1957) (Plate 74). It is interesting to examine the ideas which underpinned the layout of the magazine because they reveal how what at first appears to be a calculated attempt to produce a magazine which expresses a new sensibility was actually the product of an intuitive, chance interaction between an editor interested in the more sophisticated aspects of American pop and art editors interested in the more 'serious' applications of Continental graphic design.

ARK 20 was co-art edited by David Collins and Alan Bartram. Before he joined the RCA, Collins had attended the London School of Printing (later renamed the London College of Printing and the Graphic Arts), an institution which, under the leadership of William Stobbs and due to the teaching of George Adams and Harold Bartram, was strongly biased in favour of modern Continental graphic design. Alan Bartram had studied painting at Kingston and was taught typography by his brother Harold, who had been a pupil of Froshaug and Spencer at the Central School. While designing *ARK* 20, Bartram concentrated on the typography while Collins worked on the layout. Although both art editors

74 Cover for *ARK* 20 (Autumn 1957) by A. J. Bisley

knew that Roger Coleman was interested in pop Americana, neither of them really shared his interests. Interestingly enough, however, this produced no real clash between them because of their common concern to reject the graphic status quo and explore the dynamics of communication in an urban environment.

Based upon a modernist grid, the layout of *ARK* 20 reflected the interest of the Continental masters of typography in exploiting every element of the graphic process in the search for vehicles of communication, including a photographic cover, the use of gatefold pull-outs, pages of brown wrapping paper derived from Willem Sandberg's Stedelijk Museum catalogues, and an image of a girl in red printed on yellow tracing paper superimposed over an asymmetric photomontage of an urban street for an article on feminine consumer behaviour by Toni del Renzio (Colour Plate 7).[35]

Alan Bartram also had very little interest in American graphic design or pop culture. Throughout his first year at the College, before designing *ARK*, he, like David Collins, had been working for Herbert Spencer and was deeply influenced by the principles of modern typography. Finding the tuition at the RCA largely irrelevant to his interests, he worked on *ARK* during his second year and then left the College in order to work for Spencer on a full-time basis. Reflecting on the ambience of the College in the mid- to late 1950s and his attitudes towards the staff, Bartram writes:

As I remember it we (the Central School of Designers, if I may put it like that) believed that there were basic certainties about what was 'Good Design' practice. I'm thinking particularly of typography. There was no such thing as fashion. Fashion was something we would have deplored—if we had ever thought about it. As we saw it, there were the old gentlemen in their Harris tweed suits and knobbly ties carrying on the English tradition of the 1920s and the 1930s, and there was us, looking at Continental work (which was so obviously so much better) and trying to do work that looked as if it belonged to the mid-twentieth century . . . We saw it as dilettante versus professional.[36]

Before the full flowering of English pop culture in the 1960s, it was possible for the modernist ideals of Bartram and Collins to coexist with pop Americana because both approaches to design were defined as being in opposition to what were perceived to be the anachronistic and effete aesthetic preferences of the Establishment, who continued, in Bartram's phrase, 'to pick away at their woodcuts of roses':

I think our certainties derived from our belief that Good Design was a Good Thing for society in general. We were still (just) living in a post-war atmosphere of altruism, the Welfare State, 'We are making a new world', a decent life for everyone, etc . . . We

weren't quite as arrogant as the architects . . . but we felt we knew what was good for people.[37]

ARK, the RCA, and the ICA

Under Roger Coleman's editorship between the autumn of 1956 and the summer of 1957 *ARK* blossomed into an attractive, lively, and sophisticated magazine. Several commentators have mentioned that Coleman's friendship with Lawrence Alloway and involvement in the ICA led to *ARK* becoming a mouthpiece for the ideas of the Independent Group. In the film *The Fathers of Pop*, for example, Reyner Banham states that *ARK* provided a 'second run' for the ideas of the Independent Group after the informal discussion group ceased to meet in 1955: '*ARK* made us the "Father of Pop" by asking us to write for the magazine. They were the first people to take us seriously.'[38] These claims have to be examined carefully, however, for the cultural politics of the period were more complex than most critics allow.

While Coleman's *ARK*s do contain many articles on pop concerns his own interests were eclectic. When he arrived at the RCA from Leicester College of Art in 1953 he was fascinated by Constructivism, especially the work of Victor Pasmore. The first article to appear in *ARK* 18 (Autumn 1956), published two months after the close of the 'This is Tomorrow' exhibition, was 'The Constructionist Idea and Architecture' by Anthony Hill, one of the artists featured in Lawrence Alloway's first book *Nine Abstract Artists* (1954) and an exhibitor at the exhibition of the same name at the Redfern Gallery in 1955 and the ICA's 'Collages and Objects' exhibition of the previous year. Like many of the articles in Coleman's *ARK*s, the Hill piece was the result of a chance encounter rather than any coherent plan. Ian MacKenzie-Kerr, art editor of *ARK* 17, had been a schoolfriend of Hill's at Bryanston and, recognizing that *ARK*'s new editor was interested in constructivism, introduced Coleman to Hill, who agreed to contribute an article to the magazine. One of the main reasons Coleman was invited by Richard Guyatt to edit *ARK* was the high standard of an essay Coleman had written on abstract art, an interest which is equally as important as pop in his *ARK*s. *ARK*s 18–20 contain articles by Ivon Hitchens, Robert Adams, Robert Melville on action painting, an article by Mathieu on his 'history action painting', and a piece by Coleman himself on the work of his friends Robyn Denny and Richard Smith.[39] If anything, therefore, Coleman was just as interested in aspects of modernism as he was in aspects of pop. As we have seen in our discussion of the layouts of Coleman's *ARK*s, during the 1950s in an English cultural context

clear distinctions between the intentions of some aspects of modernism and pop were difficult to draw because protagonists of both cultural tendencies regarded themselves as hostile to Establishment culture. In fact it was this relaxed eclecticism and breadth of interest across a 'long front of culture' which enabled Coleman to participate in ICA discussions, helped him to become friendly with Lawrence Alloway, and which facilitated his election on to the ICA Exhibitions Committee in February 1957 after David Sylvester's resignation.

As far as *ARK* was concerned, Coleman did not set out to follow a pop manifesto, but was simply keen to do anything to liven up the magazine and link it with interesting developments in the world outside the Royal College.[40] Apart from features on abstract painting and pop culture, he included several articles on subjects which had only marginal connections with IG concerns, including an article by Basil Taylor about watching cricket on television, a photo-essay by A. J. Bisley on wrestling at Lime Grove ('I liked the idea of including articles on sport in what should have been an art magazine'[41]), Victorian railway termini, Hawksmoor's City churches, and a series of poems by some of the leading 'Movement Poets' of 1956 including trad jazz fan Philip Larkin's poem 'For Sidney Bechet', and poems by D. J. Enright and Kingsley Amis, whose *Lucky Jim* had been published in 1954. Indeed, *Lucky Jim*, the story of a bright young man of humble origins who lectures at a provincial university where he detests the 'phoney' cultural posturings of the university Establishment, seemed particularly relevant to RCA students from working- or lower middle-class provincial backgrounds like Coleman and his friend Richard Smith:

I remember in 1954 or 1955 *Lucky Jim* came out and that really focused things. That's why I asked some of the so-called Angry Young Men to contribute to *ARK* . . . I went to a grammar school in Leicestershire. My father worked in a factory and I was the first person in my family to go on to further education. People like me immediately related to *Lucky Jim*.[42]

Like most of the other memorable issues of the magazine, Coleman's *ARK*s were motivated by a healthily anarchic desire to challenge the status quo and shake up what seemed to be the rather smug, stuffy, and self-satisfied attitudes of the inhabitants of the RCA's Senior Common Room by focusing on the energy of pop and the challenging abstraction of the avant-garde rather than on the familiar English obsessions with country life, decoration, narrative, and nostalgia. A detailed analysis of the 'little narratives' which comprise the cultural history of the relationship between the RCA and the ICA during the late 1950s reveals that the influence of the IG, although of crucial importance, was rather less direct and unalloyed than some have suggested. In order to understand this

relationship it is necessary to disentangle the network of personal friendships, chance encounters, and cultural influences which are reflected in *ARK*s 18–20, published between early 1956 and late 1957.

The history of the Independent Group has been documented in great detail.[43] However, the relationships which existed between the RCA and the ICA during the 1950s remain unclear. On a formal level there were few connections between the two institutions. Herbert Read, the modernist president of the ICA, represented a style of moral and ethical intellectualism for which a pragmatic administrator such as Robin Darwin had very little time. On an informal level, however, there were several connections between the ICA and the RCA which became more important as the decade progressed.

Under the professorship of Basil Ward, the School of Architecture organized compulsory lectures on the history of architecture which all RCA students were obliged to attend in an attempt to make a basic grounding in the principles of the modern movement an essential facet of RCA training. In the early 1950s Basil Taylor was appointed lecturer in the History of Art in the School of Architecture and subsequently became the College's first librarian and founder of the School of General Studies. A deeply cultured man, Taylor's interests ranged from book illustration to contemporary Hollywood movies and sport to the painting of George Stubbs (his book on the artist remains a standard work). He broadcast regularly for the BBC and retained a wide network of contacts in intellectual and artistic circles. Many of the more interesting articles which appeared in *ARK* during the 1950s were directly connected to Taylor's policy of inviting artists and scholars of his acquaintance to speak at the College. As the editor and book designer Ian MacKenzie-Kerr recalls:

The fact that *ARK* became more in touch with artistic trends in the world outside the College had a lot to do with Basil Taylor. He was called the librarian but he was much more than that. He was something of a cultural guru at the time. He was a very remarkable man . . . He was extremely good at getting people to come along to speak at the College and a lot of these articles in *ARK* stemmed from that, from the lunchtime seminars he initiated which featured, for example, people like Herbert Read, Henry Russell Hitchcock, and Reyner Banham.[44]

The contents of the *ARK*s edited by Roger Coleman's predecessor John Hodges during 1955–6 were often direct transcripts of these lunchtime seminars, including a 'Question and Answer' session with Herbert Read discussing his own poems and warning students of the perils of pop culture:

The modern poet . . . is living in a world where words have become so debased, chiefly through journalism and advertisements . . . that there is a stream of clichés passing

through our minds all the time . . . The painter also has a difficult time because there are so many visual clichés about and it is difficult not to be influenced by these clichés, by advertisements, illustrated papers and the rest of it.[45]

Although all students were supposed to attend the lectures Taylor organized, Roger Coleman recalls that 'some of the painters were really quite bolshie and seldom turned up'. Coleman enjoyed the lectures however and became great friends with Taylor. The original tentative links between the Independent Group and the RCA also came about through Taylor's ICA contacts. Towards the end of 1955 he asked Reyner Banham, the original convenor of the IG discussions, to give a lunchtime lecture at the College, after which Banham contributed an article to *ARK* 16 (Spring 1956) on the aesthetics of contemporary motorcycle design entitled 'A New Look in Cruiserweights'. Describing Banham as 'an aero-engine mechanic turned art historian', *ARK*'s editor John Hodges pointed out that it was the 'radical aesthetic researches' of the Independent Group which underlay 'his irregular attitude to Industrial Design'. In a passage which might have proved extremely irritating to the Russell brothers, Banham wrote that:

One has only to look at this year's crop of small and middling English motor-cycles to see that there is more than a 'new look' in circulation; a new norm has emerged . . . that would pass as good industrial design in even the most particular circles, and yet the improvement in design has gone undocumented and uncommented . . . this is not surprising, for motor-cycling is the sport of a section of the population—Wild Ones and Mittyesque emulators of Geoff Duke—with which the essentially middle-class concern for 'good design' can never make contact.[46]

Banham's article was closely linked to the 'Man, Machine and Motion' exhibition which followed the second session of IG seminars in July 1955. A collection of 200 photographs tracing man's relationship with the machines he had invented to increase movement and travel, 'Man, Machine and Motion' was a development from and reaction against the ICA's 'Growth and Form' exhibition of 1951, which had been concerned with the normally invisible forms of nature revealed by the microscope in order to draw attention to similarities in natural structures. The catalogue introduction to 'Growth and Form' by Herbert Read had emphasized the modernist overtones of the exhibition which were challenged by the Futurist imagery of 'Man, Machine and Motion', for which Banham wrote the catalogue notes. Banham's *ARK* article celebrates the 'scooped and sculptured fuel tank' of the Italian Gilera-Sport motorcycle as a direct example of 'Design-as-Symbolism' which 'confers on the rider the prestige of a Masetti or Duke'. Banham applauds the verve and imagination of the new pop motorcycle styling which 'comes from the natural operation of the popular market' and throws down the gauntlet to

'the Councils, the Institutes, the Royal Colleges of this and that' by suggesting that 'we should at least be careful before we suppose, again, that popular taste is automatically squalid, amorphous and capable of being indefinitely bamboozled by unscrupulous manufacturers'.[47]

Banham's attack on the aesthetics of the CoID and spirited defence of pop principles was followed in *ARK* 17 (Summer 1956) by Lawrence Alloway's 'Technology and Sex in Science Fiction: A Note on Cover Art', which begins by stating that:

The iconography of the twentieth century is not in the hands of fine artists alone. The futurists, dadaists and purists have, of course, symbolised aspects of the machine and industrial life, but so have a mass of popular artists and acknowledgement of their contribution is overdue. Advertisements cannot be left out of an appraisal of man and machines and nor can movies . . . nor can science fiction.[48]

Like Banham's article on motorcycle styling, Alloway's article was guaranteed to rile the RCA Establishment and, one suspects, Basil Taylor in particular: 'What is needed at the present time is a descriptive study of particular aspects of the popular arts. Only after this has been done can we assess the status and role of the mass arts in our lives in the way that trigger-happy aesthetes and arm-chair educationalists are prematurely attempting.'[49] There was a degree of rivalry between Alloway and Taylor and the two locked horns on several occasions over the years. The parameters of this conflict can be surmised by reading a passage in Alloway's 'Personal Statement' in *ARK* 19 in which he writes:

I have been accused (by Basil Taylor among others) of being Americanized and, since I am English, thus becoming a decadent islander, half-way between two cultures. I doubt that I have lost more by my taste for the American mass media (which are better than anyone else's) than have those older writers who look to the Mediterranean as 'the cradle of civilization'.[50]

This conflict flared up again in a radio programme broadcast on the Third Programme in March 1960. Part of the Third Programme's 'Art and Anti Art' series, the programme, entitled *Artists as Consumers: The Splendid Bargain* was a discussion between Lawrence Alloway, Richard Hamilton, Eduardo Paolozzi, and Basil Taylor in which Taylor wryly dismissed the others' interests 'in all things American' as 'the latest form of English romance. The English yearning for another place and another culture.'[51] By this time the clash between Alloway and Taylor had become rather more bitter, especially after a particularly vicious review the former had written about an exhibition of paintings by the latter's friend Edward Wright.[52]

Roger Coleman, however, remained friendly with both Lawrence Alloway and Basil Taylor. When he took over the editorship of *ARK* from John Hodges in the summer of 1956 he had been attending discussions and exhibitions at the ICA in the company of his friends Richard Smith, Robyn Denny, and, occasionally, Peter Blake. While the RCA students were interested in the activities of the ICA they did not participate in the second series of IG discussions and remained outside the inner circle of Independent Group members. Interviewed on the back seat of Reyner Banham's Cadillac in the film *The Fathers of Pop*, Richard Smith (to whom Banham incorrectly refers as '*ARK*'s art editor') summarizes the relationship between the IG clique and his friends: 'I was conscious of it as more of a social scene. People were cracking jokes which you had no possibility of entering into. Everybody seemed to have known each other for so long . . . It was more of an attitude rather than a work of art one was admiring.'[53] Roger Coleman also stresses the considerable difference in age between the IG and the RCA painting students: 'The ICA people were much older than us . . . Dick and I were about 26 then . . . I think Alloway was 34, closer to our age, but Banham was about 38 and Toni del Renzio was much older.'[54] *ARK* 18 (Autumn 1956) was devised almost a year after the IG had ceased to exist as a regular discussion group and appeared in the wake of the 'Modern Art in the United States' exhibition at the Tate (January 1956) and the 'This is Tomorrow' exhibition at the Whitechapel Gallery (August–September 1956). Out of a total of sixteen articles, *ARK* 18 only contains one article written by members of the IG inner circle. Coleman visited Peter and Alison Smithson, famous for their 'New Brutalist'-style school at Hunstanton (completed in 1954), at their home in Chelsea to ask them to contribute an article to the magazine. The Smithsons' article 'But Today we Collect Ads' is an articulation of ideas that were of immediate relevance to a generation of RCA graphic designers more interested in the New York *Art Directors' Annual of Advertising* (according to Gordon Moore, art editor of *ARK* 19, the walls of the graphic design studios were 'plastered' with American ads by this time) than the work of the Lion and the Unicorn Press:

Traditionally the fine arts depend upon the popular arts for their vitality, and the popular arts depend upon the fine arts for their respectability. It has been said that things hardly 'exist' before the fine artist has made use of them, they are simply part of the unclassified background material against which we pass our lives . . . Why certain folk art objects, historical styles or industrial artefacts and methods become important cannot be easily explained.
Gropius wrote a book on grain silos
Le Corbusier one on aeroplanes

And Charlotte Periand brought a new object into the office each morning;
But today we collect ads.[55]

As David Robbins has pointed out,[56] the Smithsons' position on advertising was
rather more guarded than that of other members of the IG. Although they
regarded ads as possessing 'an almost magical technical virtuosity' they retained
the characteristic modernist disdain towards purely commercial art. They
regarded advertisements as a threat to modernist principles but gloomily
predicted a future in which the ad man would challenge the architect's position
as the most socially influential of artists:

Advertising has caused a revolution in the popular arts field. Advertising has become
respectable in its own right and is beating the fine arts at their own game . . . Mass
production advertising is establishing our whole pattern of life-principles, morals, aims,
aspirations and standards of living. We must somehow get the measure of this
intervention if we are to match its powerful and exciting impulses with our own.[57]

The Smithsons' article, together with pieces on action painting (by Robert
Melville), glossy magazines (by John Hodges), aircraft design (by Bernard Myers),
and the first of a series entitled 'Film Backgrounds' by Coleman and Richard

75 Design by David
Collins for Richard
Smith's article 'Man and
He-Man' in *ARK* 20
(Autumn 1957)

Smith, were warmly welcomed by Lawrence Alloway, who had been appointed assistant director of the ICA in July 1955. Impressed by *ARK* 18 and seeing the magazine's potential as a platform for IG interests, Alloway invited Coleman and Smith to talk at the ICA in February 1957. Their dialogue 'Man about Mid-Century', on men's fashion in the 1950s, provided the basis for an article in *ARK* 20 (Summer 1957) entitled 'Man and He-Man' (Plate 75). Written by Richard Smith and featuring a layout designed by David Collins, the article provides a fine example of the sophisticated 'uptown pop' approach which distinguished this generation of Independent Group-influenced RCA students from the less intellectual approach of the RCA Pop painters. Although Richard Smith had received little formal academic training, his acute, but purely instinctive, approach to cultural analysis parallels, and may even have preceded, the publication of Roland Barthes's seminal collection of semiological essays *Mythologies* (first published in France in 1957, but not translated into English until 1970). Describing his personal view of 'the male image at mid-century', Smith writes that:

For the customer at a modern menswear shop, the choice is wide and the influences cosmopolitan. The English element, being Debrett-angled with shirts named 'St. James', 'Marlborough' and 'Eden'. In casual jackets, names like 'Montana' or 'Oregon' denote the background of a more rural America. Urban America appears in shirts called 'Manhattan', or with the use of 'New Yorker' . . . Continental influence these days is very strong. Sometimes the influences get mixed up, like a sweater called 'Monaco Tyrol'.[58]

The subtly ironic tone is extended to the relationship between fashion and contemporary pop music:

A recent pop song details 'A white sport coat and a pink carnation, I'm all dressed up for the dance' but here the pink carnation does not really fit the average palais milieu. Today when dance bands no longer dress like the RPO and vie in the cut and colour of their jackets with the patrons on the floor, they typify the breakdown of formal social behaviour which is carried to an extreme by the trad. jazz clubs where the particular informality is almost as recognizable as a dinner jacket.[59]

The relaxed sophistication of Smith's article recurs once more in the 'Film Backgrounds' series which runs throughout Coleman's *ARK*s:

Both Dick and I were interested in movies, of course, because we were both brought up on them, they were the earliest things I could remember. What I wanted to do was to get away from the kind of thing you saw in other student journals, you know, if they were about film they had to be about Jean Gabin or something. I wanted our articles to be about things we were actually interested in—Gene Kelly, that sort of thing.[60]

The 'Film Backgrounds' series includes articles by Coleman and Smith on 'Images of the City' in film, 'Film Noir', 'Musicals', a piece by Lawrence Alloway on 'Film and Communications Theory', and an article by Richard Smith entitled 'Sitting in the Middle of Today' about interior design in the movies, another example of the intuitive 'proto-semiology' which characterized the 'cool', 'uptown pop' attitude:

The feathering of Hollywood nests is a complex business, for interior furnishings are one of the expendable consumer products in a society where not to have something new is not only downgrading on the Jones' scale, but also a rank attack on the fabric of the community . . . Hollywood styling lags behind specialist magazines because these magazines reflect the dream world of a minority, while Hollywood has to find the key to the 'hope chests' of the larger public.[61]

Like Alloway and the older IG generation at the ICA, Coleman and Smith were dedicated movie fans, but Coleman displayed relatively little enthusiasm for the science fiction B movies which Alloway enjoyed so much. Coleman and Smith tended to focus their attention on the 'classier' end of Hollywood, Detroit, and Madison Avenue, an attitude captured in an *ARK* 19 article by Coleman entitled 'Dream Worlds, Assorted'. Noting, in the language of Canadian media guru Marshall McLuhan, that 'a large part of the function of the modern urbanized human is to be communicated to', and that 'saturation by information-bearing matter is one of the delights or hazards of modern life', Coleman explores the effects of the seductive 'dream worlds' created by Hollywood movies and the layouts and photographs in up-market American fashion magazines so admired by RCA graphic design students:

Thumbing through the pages of expensive fashion magazines like *Vogue* and *Harpers* is like entering another world. The succession of images accumulate into creating a compelling world of glossy excitement that has no extension into reality. In this way their effect is not unlike that of a certain kind of movie, not so much in the similarity of image, but in the after-atmosphere they both create . . . In a recent copy of *Vogue* a model was seen posed in front of a large de Staël canvas . . . the painting providing a coloured impastoed background for the model, a textured contrast to the rise and fold of tweed.[62]

A contemporary Hollywood movie which epitomized the 'dream world' effect described by Coleman was Douglas Sirk's *Written on the Wind* (1957). According to Coleman *Written on the Wind* was 'a key film often mentioned in our discussions at the ICA'. Starring Rock Hudson, Dorothy Malone, Lauren Bacall, Robert Stack, and Robert Keith, the special appeal of *Written on the Wind* derived from its

dreamworld inventory of images of all the super mod cons . . . a low red sportscar from the Detroit atelier . . . attractively driven by Miss Dorothy Malone across derrick-spiked wastes, private aeroplane trips to Miami (no change of clothes—what a story that tells) for an afternoon's diversion . . . Country clubs and marbled hotels. These were its real attractions.[63]

Coleman and Smith were fascinated by the way in which Sirk managed to use the imagery of consumerism to signify 'the kind of lack of moral fibre that, in the cinema, seems a natural consequence for the children of abstemious oil well owners tempered with nymphomania, dipsomania, psychiatry, suspected impotence and a good many other things thrown in for good measure'.[64] Coleman and Smith's writing for *ARK* 1956–7 represents the emergence of a distinct sensibility at the RCA which can accurately be described as 'postmodern' because they predict and prophesy new cultural developments across 'the long front of culture' which would become a part of everyday life during subsequent decades. 'Dream Worlds, Assorted', for example, anticipates the increase in the 'two-way traffic' between fine art, advertising, and photography which would become the stock-in-trade of the Sunday colour supplements from 1962 onwards:

In the glossy magazines popular images are themselves affected to a great degree by a superficial assimilation of the fine art avant garde . . . within the wider context of a mass audience, it is probably true to say that the fine arts can have little or no effect until they have become popularized in terms of magazine (and advertising) images.[65]

This 'uptown' approach to pop mass media imagery began to characterize Richard Smith's work during his prolonged stay in New York between 1959 and 1961 on a Harkness Fellowship. Inspired by the atmosphere of the metropolis, the professionalism of the art community, and by the sheer scale of American billboards and American Abstract Expressionist canvases, he began to emulate the simulated, 'dreamworld' atmosphere and colour of advertising photography and technicolour wide-screen movies in large abstract-pop canvases with titles such as *Salem, Kent, Flip Top,* and *Fleetwood.* Commenting on his work in the early 1960s Smith explained that his sense of colour was not derived from nature but from

Colour photography . . . When I see real things, other things get in the way of them . . . but in a photograph you only have one image on one plane . . . There is a kind of colour I find especially attractive: pale green with pale yellow, which makes a reference to something cool, a 'hint of mint'—as in menthol-cool. I like this artificiality.[66]

By the time *ARK* 19 appeared in March 1957 Coleman was a member of the

ICA's Exhibitions Committee, an appointment reflected in *ARK*s 19 and 20, which contain a number of articles by ex-IG spokesmen some of which were based on papers delivered at IG seminars during 1955,[67] including 'Gold Pan Alley: A Survey of the Popular Song Field' by Frank Cordell, 'Technology and the Home' by John McHale, 'Shoes, Hair, and Coffee' by Toni del Renzio, and Lawrence Alloway's 'Personal Statement', which, alongside 'The Long Front of Culture', remains one of the clearest descriptions of an emerging British postmodern sensibility and is worth quoting at length:

I think there are two problems common to many people of my age (I was born in 1926) who are interested in the visual arts.

(1) We grew up with the mass media. Unlike our parents and teachers we did not experience the *impact* of movies, the radio, the illustrated magazines. The mass media were established as a natural environment by the time we could see them.

(2) We were born too late to be adopted into the system of taste that had given aesthetic certainty to our parents and teachers. Roger Fry and Herbert Read were not my culture heroes . . . the collapse of their old hat aesthetics has hastened for me the discovery of action painting which showed me that art was possible without the usual elaborate conventions.

The popular arts reached soon after the war a new level of skill and imagination. Berenson, Fry, Read and the others gave me no guidance on how to read, or to see, the mass media . . . The pressure of mass media and the failure of traditional aesthetics combined to unsettle fixed opinion and hint at new pleasures. I tried in various ways to hold the experiences of fine and popular art together . . . What is needed is an approach which does not depend for its existence on the exclusion of symbols which most people live by . . . when I write about art and movies I assume that both are part of a general field of communication. All kinds of messages are transmitted to every kind of audience along a multitude of channels.[68]

The influence of Marshall McLuhan is very strong here, for his theories of the social and cultural effects of mass media as expounded in books such as *The Mechanical Bride* (1951) seemed to Alloway to provide a key to a new interpretation of the cultural role of the arts. McLuhan's positive attitude towards the electronic media stood in stark contrast to the uniformly negative outlook of the majority of university-based British cultural critics. His argument that mass culture and avant-garde culture were not diametrically opposed was not confined to the arts; McLuhan argued, for example, that avant-garde science in the shape of Einstein's Theory of Relativity discarded the same fixed three-dimensional world whose illusory solidity Cubism had also helped to expose. McLuhan's vision was of a synthesis of avant-garde art and science fundamentally altering

anachronistic perceptions of culture and society in a post-industrial 'Global Village' unified by the channels of electronic media.[69]

Both Alloway and McLuhan rejected the liberal-humanist academic orthodoxy of the 1950s by implying that mass and avant-garde modernist culture were not and should never be in opposition. On the contrary, both argued that the cultural potential of television, film, and computer technology offered exciting and radical possibilities for artistic intervention. Like McLuhan, Alloway was enthusiastic about a new cultural continuum in which computer technology, Hollywood B movies, popular graphics, Futurism, Cubism, and the latest advances in physics could occupy the same cultural space and cross-fertilize. In an *ARK* 20 article entitled 'Communications Comedy and the Small World', for example, Alloway suggested that 'the topic of communications . . . may be compared to a commonplace in Elizabethan literature—the Great Chain of Being . . . the Chain gave an effect of order to an otherwise untidy world'.[70] Ideas like these struck a resonant chord among those RCA students interested in rejecting what they regarded as English parochialism by exploring the possibilities of working across the 'long front of culture' Alloway recognized and celebrated. Mutual interests in what was loosely referred to as 'communications theory' provided a point of contact for a number of specialisms during the late 1950s. Roger Coleman was in a particularly interesting position *vis-à-vis* these concerns, because after leaving the RCA he began to pursue a career which straddled the worlds of art criticism and design journalism.

Coleman's links with design journalism began with the publication in *ARK* 19 of an article by John Christopher Jones entitled 'Traditional and Modern Design Methods', later to become part of the first chapter of his book *Design Methods*— the basic textbook of the Design Methods movement. Explaining the milieu within which Jones's ideas developed, his colleague L. Bruce Archer recalls:

There was something very interesting happening right across culture at that time . . . trying to bring an underpinning knowledge to design right across the board. It was very much an interdisciplinary movement and sprung from a number of origins but especially operational research—a combination of scientific disciplines which had been co-ordinated during the War to support the allied war effort. After the War during rearmament the operational research methods were used by the defence industries in the USA and that gave a tremendous boost to lots of fringe scientific activities like ergonomics and management science. The Design Methods movement was contemporary with that, so was systems, or communications theory, which was invented at the same time.[71]

In the late 1940s Jones began to work towards what he has described as a 'human functionalism' ('making design thoughts public so they are not limited to the

experience of the designer and can incorporate scientific knowledge of human liabilities and limitations').[72] In the 1950s he applied his research in what came to be called ergonomics to the electrical industry, 'trying to fit dials, controls, seats, etc . . . to the human operators'. Jones's ideas were particularly appealing to the RCA's cultural radicals because, unlike traditional academic disciplines, operations research, systems theory, and ergonomics were essentially interdisciplinary and international in scope. Lawrence Alloway, Roger Coleman, and their circle encountered many of these ideas for the first time in the pages of *Scientific American* and in conversations at the ICA with their colleagues who taught at the Central School. William Johnstone, Principal of the Central School, was very responsive to these developments in the applied sciences and was quick to hire staff sympathetic to them. Several ex-members of the Independent Group, including Reyner Banham (an ex-aero engineer) and Richard Hamilton (an ex-jig and tool engineering draughtsman), worked alongside L. Bruce Archer at the Central in the early to mid-1950s.[73] There were obvious philosophical links between systems-communications theory, Marshall McLuhan's 'Global Village' concept, and Alloway's idea of a new 'long front of culture'. Alloway and Coleman's interest in communications theory was augmented by the lectures and seminars delivered at the ICA and elsewhere by Dr Colin Cherry, Reader in Telecommunications at Imperial College (Plate 76). Cherry's book *On Human Communication* (1957) became a revered text amongst the ICA–Central School circle, as Coleman recalls: 'Colin Cherry was one of our heroes . . . I was the first one to get a copy of his book and I lent it to everyone else. I had come across him through John Christopher Jones.'[74] Cherry spoke at the ICA in January 1960 and articles of his on the topic of language and electronic communication appeared in *ARK* 24 (Spring 1959) and *Cambridge Opinion*, 17 (December 1959).[75]

Although 'communications theory', 'systems theory', and 'cybernetics' were *de rigueur* amongst members of London's avant-garde art and design community during the late 1950s, interpretations and applications of these ideas varied greatly. In contrast to trained engineers such as J. Christopher Jones and L. Bruce Archer, art critics such as Lawrence Alloway, Roger Coleman, and the ex-Cambridge University student Robert Freeman embraced a loose, open, 'pop' interpretation of communications theory described by Freeman in an editorial to *Cambridge Opinion*, 17, entitled 'Living with the 60s':

The hypnotic impact of popular iconography . . . filters into a widening range of experiences . . . a recent *New Yorker* ad. with coloured stockings draped over the imitation arm of the Venus de Milo bearing the caption—'The Newest Classic is Nylons in Colour' . . No adaptation to this cultural situation is possible if we still adhere to antiquated aesthetics . . . We need through an enlarging of our values the kind of mental agility that

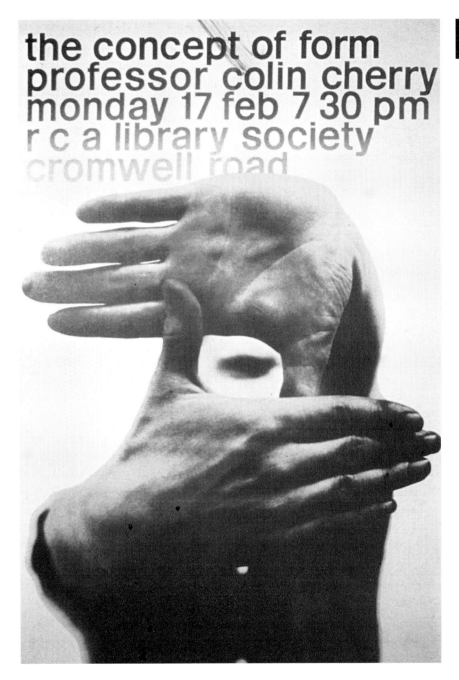

the concept of form
professor colin cherry
monday 17 feb 7 30 pm
r c a library society
cromwell road

76 Poster by Peter Smith for a lecture by Colin Cherry (*c.*1959)

will appreciate the elastic variety of ads., films, jazz, science fiction, and pop music . . . the environment is a complex conditioner . . . and in this issue we look at certain aspects of our cultural SITUATION in terms of COMMUNICATION.[76]

This loose interpretation of 'communication' lay behind the 'Place' exhibition staged at the ICA in September 1959. This 'environmental' exhibition, featuring a maze of large abstract paintings by Ralph Rumney, Robyn Denny, and Richard Smith with a 'Guide' written by Roger Coleman, was (albeit rather vaguely) informed by what Denny termed 'the urbanism–mass media–games theory syndrome'.[77] Like much of the writing in the *ARK*s of the late 1950s, the approach of these abstract artists was essentially intuitive rather than logical and rigorously analytical. As Coleman recalls:

Communications theory was supposed to be a link between all this new stuff . . . but it was a relaxed, intuitive approach . . . the approach was like a science fiction film I can remember seeing with Lawrence Alloway in which a chap picked up a book and on the front of the book was written SIBERNETICS! It was all a bit on that level.[78]

The *ARK*s edited by Roger Coleman's successor Derek Hyatt were also heavily influenced by Marshall McLuhan's ideas as well as by contemporary developments in the applied sciences and the layouts and contents of *Scientific American*. As Hyatt recalls: 'Even if you didn't really understand it, you could still use phrases like "lots of noise in the channel". I found that useful.'[79] The layouts of *ARK*s 21, 22, and 23 (late 1957–8) edited by Hyatt often owe a debt to the format of McLuhan's book *The Mechanical Bride*, in which pages of newspapers, advertising copy, film posters, cartoons, and illustrated covers of pulp fiction complement McLuhan's written analysis of the artistic and social messages conveyed by popular, commercial art. The layouts of mass circulation newspapers such as the *New York Times*, McLuhan argued, juxtapose a mass of disconnected features, photographs, and news stories all vying simultaneously for the reader's attention and creating a similar landscape to that envisioned by avant-garde painting and science. In both mass and avant-garde culture, McLuhan argued, 'The Medium is the Message', a phrase seized upon with relish, if not very deep comprehension, in the offices of *ARK*.

While Alloway and Coleman organized several discussions on ergonomics and communications theory at the ICA during 1959–60,[80] their grasp of these subjects was certainly far less developed than that of trained engineers such as Jones and Archer and their contemporaries at the new Hochschule für Gestaltung in Ulm which had opened in 1955 under the leadership of Max Bill and was, by 1957, under the control of Tomás Maldonado. There was a direct link between *ARK*, the ICA, *Design* magazine, the Design Methods movement, and the HfG, however.

The opening of the HfG had been celebrated in *ARK* 14 (Summer 1955) by Margaret Leischner of the RCA Textiles Department. ('Some of the ideas the

School will introduce will seem strange . . . but the principles and methods of the Bauhaus were arresting in 1919.'[81]) When *ARK* 19 appeared in the spring of 1957, the Design Methods article by J. Christopher Jones came to the attention of Michael Farr, editor of *Design* magazine, the mouthpiece of the CoID. John Blake, ex-*ARK* editor and deputy editor of *Design*, telephoned Roger Coleman in the *ARK* office and offered him a job as an editorial assistant on *Design* when he left the College that summer. Although Coleman's pro-pop attitudes made him less than enthusiastic about the modernist stance of the CoID, he accepted the job and worked for *Design* from September 1957 until April 1959, contributing free-lance articles to the magazine until 1962, the year in which he also resigned from the ICA's Exhibition Committee and 'started to draw again' as a free-lance illustrator. Coleman's appointment to *Design* was the cause of some hilarity amongst his friends at the ICA. In the summer of 1957 Reyner Banham wrote an article intended to be published in the *Architectural Review* entitled 'The Coleman Cometh', speculating upon the turmoil which would be caused in the rather strait-laced bastion of modernism by Coleman's pop punditry. (The article, not surprisingly, was rejected by the editorial board of the *Architectural Review*.)

One of Coleman's first assignments for *Design* was the co-ordination of a series of articles by the Design Methods team of J. Christopher Jones and L. Bruce Archer entitled 'Automation and Design' and 'Design Analysis and Consumer Needs' which aimed to assist consumers in selecting well-designed products and to help designers in making their decisions in designing products by undertaking scientific and consumer tests. This series of articles came to the attention of Tomás Maldonado at Ulm and in 1960, after meeting L. Bruce Archer at a party in Richard Hamilton's house, Maldonado invited Archer to teach at Ulm, a post he took up in September 1960.[82] Archer's logical, analytical methodology was particularly appropriate to the HfG where science, and in particular science applied to industrial production, provided the pedagogical core.

Much of Maldonado's own research was focused in the field of semiotic analysis, an approach to communication explained in English for the first time in Theo Crosby's little magazine *Uppercase* (issue 5 (1961)), which was devoted to the work of Ulm's School of Visual Communication. As Crosby has explained:

I was a friend of the chaps who ran Ulm and I went over there and gave them this issue to do anything they wanted with . . . It was the only thing that had been written about Ulm in English that was clear. The ICA people chatted about all this and managed to get it all wonderfully mixed up. No one could really understand a word of what they were going on about and neither could they! . . . They were all very good at giving the impression that they understood it, though![83]

While Roger Coleman was interested in ergonomics, systems theory, and Design Methods, he was far less committed to the 'hard', scientific approach to design than some of his colleagues on *Design*. Coleman's 'cool', inclusive approach to contemporary developments in art and design could incorporate an interest in aspects of pop Americana alongside aspects of Ulm-modernism. His relaxed stance contrasted with the commitment to the principles of modernist design displayed by *Design* magazine's art editor Ken Garland, who had been trained by Herbert Spencer, Edward Wright, and Anthony Froshaug (Professor of Graphic Design and Visual Communication at Ulm 1957–61 before returning to teach typography at the RCA) at the Central during the early 1950s. Coleman recalls these differences in attitude:

Communications theory gave you a new way of looking at things and the Ulm thing . . . was interesting, but you see there wasn't a real marriage between it and our interests at the ICA. When I was on *Design* magazine there was a meeting, a confrontation really, between Lawrence Alloway and Ken Garland . . . because I had criticized the layout of *Design*. I thought it was sterile and it wasn't interesting enough. It wasn't *fun*. People who were interested in design would buy it anyway, but anyone else would pick it up and close it immediately because it was serious, austere, and dominated by grids.[84]

There was an ideological twist to this conflict also. Largely because of their American interests, Alloway and Coleman inclined to the right of the political spectrum whereas the modernists, and Garland in particular, were committed left- wingers. Although the implicit ideological differences between modernist and pop design did not manifest themselves during the planning of *ARK* (because both modernism and pop were anti-Establishment styles in an English context), by the late 1950s and early 1960s these political differences were beginning to emerge. A similar clash was later to characterize the internal politics of the Designers and Art Directors' Association during the early 1960s when a rift emerged between the 'socially committed' modernist graphic designers and the essentially amoral Madison Avenue-oriented advertising men. David Collins, co-art editor of *ARK* 20, recalls the scenario:

Ken Garland once put an advert into *Design* saying that we should use our abilities for worthy causes. When the D. & AD was set up in 1962 there was a meeting at which the designers and the advertising people got together . . . The designers were saying that they were concerned with improving people's lives and one of the advertising guys stood up and said, 'Sod all that! What we're interested in is improving *our* lives and getting more money!'[85]

Despite the efforts of the designer and design critic Ken Baynes, who attempted to introduce a sense of social awareness and political commitment into

ARK during his period of editorship 1960–1, the *ARK*s of the late 1950s and early 1960s are also largely amoral and apolitical in their enthusiasms. What these magazines do represent, however, is an attempt to understand and appreciate aspects of contemporary cultural change in a high-technological, urban environment. When compared to their predecessors, for example, one of the most striking features of Coleman's *ARK*s is the whole-hearted acceptance of technology and urban life and an appreciation of metropolitan culture as essentially pleasurable (Plate 77). As Robyn Denny has commented:

We were looking for images that weren't the accustomed ones . . . trying to give legitimacy to things which up until that time had been illegitimate . . . For example, I had

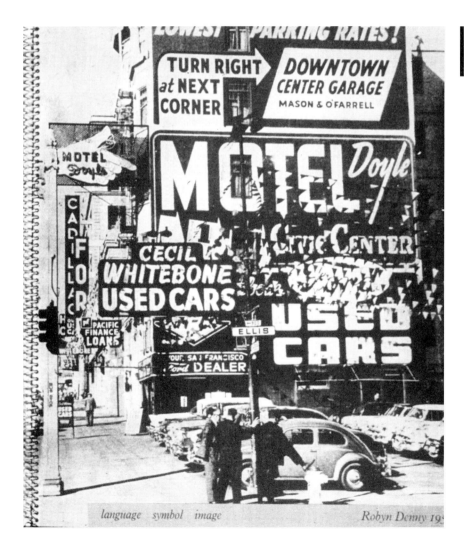

77 Cover of Robyn Denny's thesis 'Language, Symbol, Image' (1957)

a huge collection of postcards of Piccadilly Circus, which I took to be a sort of urban hub . . . People in the College used to say, 'It's so awful, so garish!' Well on the contrary, I thought the city was a very beautiful place. I love the city . . . my pleasures are things like the smell of carbon monoxide and to go out on the street at night. I love waking up to the thunder of traffic.[86]

While Coleman's *ARK*s are characterized by their embrace of urban life, their response to pop culture is always sophisticated, ironic, and knowing. While Coleman enjoyed the 'classier' type of Hollywood movie and listened to modern jazz he 'always had . . . reservations about science fiction' and found rock 'n' roll 'quite repellent'. In May 1959 Coleman took part in a discussion at the ICA with Toni del Renzio entitled 'Minority Pop', in which the two critics attempted to differentiate between the 'uptown' and 'downtown' elements in pop culture. 'We were attempting', Coleman recalls, 'to explain why we were repelled by Elvis Presley but liked musicians like Jerry Mulligan. His music involved real technique, not just two chords on the guitar.'[87]

Coleman's *ARK*s helped to provide a bridge between the theories of the IG and studios of the RCA but the true pioneer of RCA Pop Art was Peter Blake, an artist with a distinctly 'downtown' pop sensibility.

Downtown Pop

Unlike Roger Coleman, Peter Blake was not repelled by Elvis (Plate 78). Born in Dartford, Kent, in 1932, the son of a skilled factory worker, 'at the upper end of the working class', he attended Gravesend School of Art from the age of 14 and passed the old Intermediate Exam in 1949. He then took a year's course in commercial art 'because the tutors advised me to be a commercial artist rather than a painter because they said I'd never make a living as a painter'.[1] In 1950 he tried to gain admission to the RCA School of Graphic Design but was accepted as a painter instead. In the early 1950s students were obliged to complete their National Service before entering the College, so between 1951 and 1953 he 'was in Signals . . . it wasn't so bad. I travelled all around the country . . . met lots of people, drew a lot . . .'[2]

In 1953, at the age of 21, he began his first year in the Painting School, a year behind Joe Tilson and the year before the arrival of Robyn Denny and Richard Smith. Like the vast majority of RCA students he had virtually no contact with the Independent Group who were meeting at the ICA during his years as a student at the College. They were much older than he was and far more cerebral in their approach to contemporary culture: 'Paolozzi, McHale, Hamilton, Henderson, and Co. . . . were a generation, perhaps ten to fifteen years, older than me. They were established by then. They were Fine Artists researching into popular culture like sociologists.'[3]

As a boy in Gravesend during and immediately after the War Blake had grown up steeped in the English street-level pop culture which permeated his art at an instinctive, intuitive level:

The difference between the ICA people and myself was that all my life until then had been working class. I'd been going to jazz clubs since I was 14 when I first went to Gravesend School of Art. I'd gone to wrestling with my mother since the age of 14 or 15. Down at Gravesend I'd drawn the fairgrounds. That was totally different from the Independent Group. Pop culture was the life I actually led.[4]

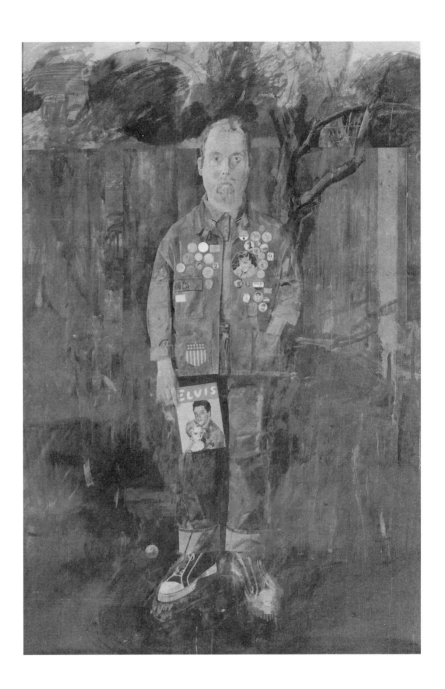

78 Peter Blake, *Self Portrait with Badges* (1961) 173 x 122cm

Blake's treatment of pop culture was based on personal involvement as an *aficionado*. Essentially English, albeit a very different variety of 'Englishness' from that favoured by Robin Darwin or Richard Guyatt, Blake worked from the subjective perspective of a true fan, a receiver rather than a producer of pop

culture. The images in his painting were personal to Blake's own culture and history. The circus and fairground paintings of 1955–8, for example, with titles such as *Siriol, She-Devil of Naked Madness* and *Cherie: Only Bearded and Tattooed Lady* belong to a level of pop culture far removed from the elegance of Douglas Sirk's *Written on the Wind*, *Vogue* fashion photography, or even the simulated splendour of New York City's giant billboards. As Roger Coleman has remarked:

Peter is a fan. For instance, I went to wrestling once or twice but I couldn't get on with it like I could with boxing and I suspect for the same reason, that boxing is more professional . . . I've always disliked the fairground and circus style of popular culture. There's something deeply phoney about it.[5]

Despite their different approaches to pop culture, Coleman (unlike most members of staff in the Painting School) appreciated Blake's painting and contributed a characteristically incisive critical article about Blake's work in the first issue of *ARK* he edited. In 'A Romantic Naturalist: Some Notes on the Painting of Peter Blake' he wrote:

For so young a painter Blake seems surprisingly 'up to the minute'. I say surprisingly for, on the whole, students and young artists tend to be a great deal less adventurous than they are often made out to be . . . His 'up to the minuteness' does not constitute any particular currently fashionable style, rather it lies in his uncomplicated response to the climate of the time and his ready ability to use, as materials for his pictures, the ordinary objects of everyday life and the mythologies of modern urban existence.[6]

Coleman stressed the originality of Blake's work by distinguishing it from the then still fashionable Kitchen Sink School 'of realism which gets all steamed up about the hell of the back streets'. Blake, Coleman argued, 'was not interested in those values'. Instead he uses 'kids' as kinds of props 'upon which he hangs the stuff that interests him' like: 'a coat emblazoned with badges, meticulously painted, that proclaims him to be everything from an ABC Minor to a member of the Dog Spotters' Club . . . fringed shirts, multicoloured satin ties (one knows they are satin) and Tony Curtis haircuts'.[7] Partly because he came from a very similar social background to Blake, Coleman was quick to appreciate the significance of the pop cultural references in Blake's work and how his use of them differed from the artists of the Independent Group:

Blake's attitude to the material from which he fashions his work is an uncomplicated one, by that I mean he is prepared to accept it for what it is, for its appearance and for the enjoyment it gives him in recreating it on the canvas. He does not turn these things, as is the current tendency, into the grounds for an ideological argument on the 'pointlessness of traditional form worlds'; indeed it would be true to say that he is quietly disinterested in the politics and ideologies of art criticism. He enjoys himself too much.[8]

177

As a member of the ICA's Exhibition Committee, Coleman organized 'Five Young Painters' (January–February 1958), one of the first London shows to feature Blake's work and enthusiastically reviewed by Robert Melville in the March 1958 issue of *Architectural Review*.[9]

The 'downtown', subjective approach to pop pioneered by Blake was much closer to the sensibility of the 1959–62 generation of Royal College Pop painters than the intellectual, self-conscious approach of the 1954–7 generation. While Smith and Denny were genuinely interested in street-level pop, there is little evidence of this influence in their work. Denny, for example, remembers

hearing my first rock 'n' roll record walking up Kensington Church Street. The sound was absolutely amazing, like forbidden fruit. Suddenly something was happening which had nothing to do with received values . . . which was our property, that wasn't something we'd been told or learned about.[10]

Denny embraced rock intellectually, as an anti-Establishment icon, whereas Blake, like Peter Phillips and Derek Boshier who followed in his footsteps, was a devoted pop fan. An understanding of his work is inseparable from an appreciation of the milieu in which he grew up.

Blake's geographical roots are in north-west Kent, 'along the river from Eltham to the Medway towns, taking in Dartford', an area which played a leading role in the birth of post-war English pop culture. The first British traditional jazz band, George Webb's Dixielanders, whose original members were munitions workers at the Vickers Armstrong factory in Crayford, played their first gig from the back of a coal cart as it trundled between Bexley Heath Broadway and Welling to drum up support for Aid a Prisoner of War Week in May 1942. One of the first Rhythm Clubs in Britain to feature regular live trad jazz met on Monday nights in the garden bar of the Red Barn pub in Barnehurst, Kent. In 1947 George Webb's Dixielanders were joined by the cartoonist Wally 'Trog' Fawkes and an Old Etonian ex-Brigade of Guards officer, Humphrey Lyttelton. By 1948, when the Dixielanders split up, Fawkes and Lyttelton had enrolled at Camberwell School of Art (where they were taught by John Minton), cementing the strong links between traditional jazz and the London art school scene which continued throughout the 1950s. By the early 1950s the north-west Kent area had several other jazz clubs including the Bop House, a club devoted to modern jazz which met at the Woodman pub in Blackfen and was frequented by local art students including Peter Blake.

Apart from the lively jazz scene, another source of pop iconography was sport, and Blake was a keen amateur racing cyclist:

Cycling was the other style thing. We almost all cycled and were involved in the style, whether you wore socks or not, whether you were in the League or the Union. You see I came from Dartford and Bromley and Beckenham were much posher. All the people with the posh bikes came from there and the poorer ones came from our area. It seems trivial now, but those things make a really deep impression on you when you're a kid.[11]

When Blake arrived at the RCA in 1953 after completing his National Service he entered the London art school/Soho jazz milieu, a scene in which students from St Martin's College of Art played a central role in an era of transition between the old bohemianism of the Caves de France, the Colony Club, the Gargoyle, and the French pub (as described by Daniel Farson in his *Soho in the Fifties*[12]) and the newer Soho scene of modern jazz, Italian fashion, and West Indian and African music clubs (as described by Colin MacInnes in *Absolute Beginners*[13]).

Alongside the RCA graphic designers' interest in American photography and illustration, the 'St Martin's connection' was an original source of the infiltration of pop culture into the RCA during the 1952–4 period. As fashion photographer and ex-St Martin's fashion student Brian Duffy points out, 'the Royal College was very slow to pick up on the pop thing compared to St Martin's'.[14] Joe Tilson and Len Deighton had been friends from their first year at St Martin's in 1949–50 and St Martin's was also Robyn Denny's art school between 1951 and 1954. Like Peter Blake, Tilson and Deighton had a keen interest in American culture, especially jazz and film, which they had cultivated during their period of National Service in the RAF. As Tilson points out: 'I was interested in jazz long before I went to the Royal College. Back in 1949 in the RAF I listened to lots of jazz in the camps — trad mainly. We left the RAF, went to St Martin's, and were immediately in on the Soho jazz scene.'[15] By the time Tilson, Deighton, and Denny were attending St Martin's, the young dance band musicians who worked the transatlantic liners (or 'Geraldo's Navy', as they were known) were beginning to discover the delights of bebop in the clubs of New York's Fifty-Second Street. Musicians like Ronnie Scott, Stan Tracey, Tubby Hayes, and John Dankworth were starting to imitate the sounds of Charlie Parker, Dizzy Gillespie, and the other New York beboppers in Soho. The 51 Club and Club 11 were irresistible lures to street-wise young art school hipsters like Tilson and Blake as was the calypso music which could be heard in the African and West Indian night-clubs like the Abalabi in Maidenhead Passage off Berwick Street and the Sugar Hill Club in Mason's Yard, scenes from which Tilson illustrates in an *ARK* 11 (1954) article 'Glances in the Slanting Rain' (Plate 79).

Len Deighton was a key figure in bringing the Soho scene to the RCA. In 'Down Past Compton on Frith, Food Makes Wonderful Music', the article which he wrote and illustrated for *ARK* 10 (1954) (Plate 80), he describes the lure of Soho in the snappy, street-wise Raymond Chandler-style prose which would make him a best-selling novelist and popular columnist. As it is probably the most skilfully written article ever to appear in *ARK*, it is worth quoting at length:

Gashed across the face of London's West End, Old Compton Street, the High Street of London's largest foreign section, is constantly busy with the hustle of day, evening and night. Dribbling across newly swept pavements, ice blocks rest outside restaurant and shops by 8.30am. A rambling monster lumbers slowly along clanging its sanitary progress—the Westminster Council dustcart is one of the few English intrusions. A thousand empty bottles—dusty and vintage laden the previous evening—join garbage and broken furniture in a jostling to the incinerator . . . Chairs are swept under as lunch menus are written. The Continental butcher is receiving this week's horse sections, while on the corner of Frith, horses of another colour are the only topic of conversation. The broad benevolent bookie, one of the best known local characters, stands outside Bianchi's as the girls from the casino go in to buy the biggest and cheapest spaghetti in town . . . Tomorrow, Friday, the girls are paid and perhaps they'll lunch at Salusolias, where the sound of musicians rehearsing downstairs vibrates . . . Food is one of the main occupations; dried fish, lychees, aubergines, pastas, vine leaves are all easily obtained . . . The French [café] is arty, no one tries to pretend different, but you can drink a small black and skim through *Elle, Arts, Figaro* or *The New York Herald Tribune* . . . Outside Torino's a couple of 'the girls' are talking to barrow boys; next door machines bulldoze the sweet smell of fresh coffee onto a smell laden pavement. On the end of a ten foot pole, steel fingers grip the neck of a Chianti bottle and pluck it from a

79 'Glances in the Slanting Rain' illustration by Joe Tilson in *ARK* 14 (Summer 1955)

80 'Down Past Compton on Frith, Food Makes Wonderful Music' illustration by Len Deighton in *ARK* 10 (Spring 1954)

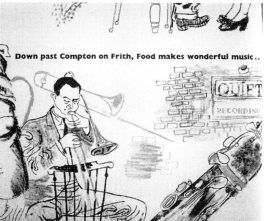

bedecked ceiling. A thousand foreign banknotes glare from the wall as Toni serves another chopped herring with dill . . . A mandolin tings in the 'Minster', accordians play in the 'Bleu'. High heels click slowly on the dark pavement, while the rest of Soho hides from its visitors.[16]

This intimate knowledge of Soho, for which Deighton would become nationally famous during the 1960s, originated during his student days at St Martin's and his connections with the West End world of advertising agencies and commercial photographers, which sprang directly from personal contacts and practical experience gained during his period of National Service as a photographer in the RAF.

After graduating from the RCA in 1955, Deighton earned his living as an illustrator and, in common with several other free-lance artists working in London during that period, was registered with the Artist's Partners agency. John Barker, an advertising man who was a senior partner at Artist's Partners, would often take his illustrators and designers and their clients to lunch at the Trattoria Terrazza, an Italian restaurant on Romilly Street owned by two Neapolitans, Mario Cassandra and Franco Lagotelli. Once this connection between Artist's Partners and Trattoria Terrazza had become established, the illustrators and designers began to bring other members of the London artistic community to the 'Trat' and the restaurant quickly became one of the focal points of the 'Swinging London' legend, both for its reputation as a 'trendy' artistic venue and for the high quality of its 'cool' Soho-Italianate interior, designed by Artist's Partners' illustrator and fellow Neapolitan Enzo Apichella. By the time Deighton's very successful first novel *The Ipcress File* was published in 1962, its ruthless, ambitious, working-class hero Harry Palmer (played by Michael Caine in the 1966 film of the book) had come to inhabit a similar world:

I walked down Charlotte Street towards Soho. It was that sort of January morning that had enough sunshine to point up the dirt without raising the temperature. I was probably seeking excuses to delay; I bought two packets of Gauloises, sank a quick grappa with Mario and Franco at the Terrazza, bought a *Statesman*, some Normandy butter and garlic sausage. The girl in the delicatessen was small, dark and rather delicious. We had been flirting across the mozzarella for years . . . In spite of my dawdling I was still in Lederer's coffee house by 12.55. Led's is one of those continental-style coffee houses where coffee comes in a glass. The customers, who mostly think of themselves as clientele, are those smooth-rugged characters with sun-lamp complexions, half a dozen 10″ by 8″ glossies, an agent and more time than money on their hands.[17]

The 'Trat' was also to become one of the focal points of the best-selling *Len Deighton's London Dossier* (1964), the ex-RCA illustration student's hepcat guide to

the delights of the metropolis. By the early 1960s the modern 'Continental' look which had been nurtured in London art schools during the 1950s was becoming synonymous with pop culture, anti-Establishment attitudes, and a 'hip life-style'.

There were other direct links between Royal College painting and graphics students and the interior design of London's trendier restaurants. Ex-Central School student Terence Conran, who opened his first 'Soup Kitchen' in Knightsbridge in the late 1950s, commissioned fellow ex-Central School students Alan Fletcher and Gordon Moore to design murals for the interior. When the next Soup Kitchen opened on Fleet Street, it featured a letter-collage mural painted by Peter Blake and Richard Smith. The restaurateur Michael Chow, who as Chow Ying Wha had exhibited his abstract work at the New Vision Centre Gallery in 1958, would later commission his friend Richard Smith to design installations for his restaurant in Los Angeles.[18]

The post-war Italian styling seen for the first time in England in Soho and its environs was first mentioned by *ARK* in 1955 when the editor, Anthony Atkinson, commented that:

People never seem to have been so aware of Italian industrial design as they are today, particularly in London and the environs of the *ARK* office. Small Italian motor scooters snake their way cheekily through the traffic jams. Well-known stores have prominent displays of Italian dresses, textiles and furniture. Here, probably more than anywhere, people drink espresso coffee, which could not be more Italian, in spite of the fact that it is usually served in the midst of bamboo and buffalo hide, in bars with names like fictitious South American states.[19]

In the same issue Joseph Rykwert praises the progressive design policies of the Olivetti company, which by 1955 was commissioning the British designers F. H. K. Henrion and Gordon Andrews to design their first British showroom on Kingsway. 'Shoes, Hair, and Coffee' by Toni del Renzio in *ARK* 20 (1957) features photographs of the 'Soho-Italianate' interiors of the Las Vegas and the Sombrero (Plate 81), some of the earliest espresso bars to appear in the South Kensington and Knightsbridge area.

An interest in 'cool', 'Continental' styling and modern jazz distinguished the 'St Martin's crowd' from their RCA contemporaries and especially from their 'Royal College Realist' predecessors, who favoured a combination of beards, duffel coats, left-wing politics, and trad jazz. In his autobiographical novel *Breakdown* (1960) the Royal College Realist painter John Bratby caustically describes an RCA dance where a 'duffel coated girl' is talking to

a man in an Italian style short coat, a pair of pointed, elegant shoes, a thinly striped Italian shirt and a very narrow neck to belly tie. He was the new Italian-derivative arty type, the

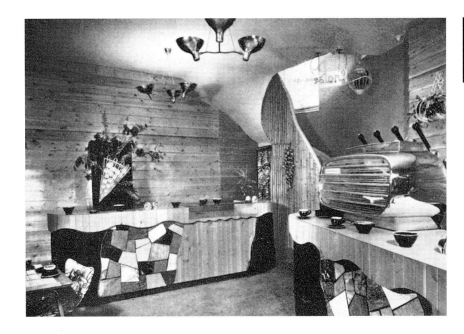

type that has been to Italy and never recovered . . . he had a Lambretta of course and . . . when he could afford it he drank *espresso* coffee and lived in the Italian-style coffee bars that have sprung up all over London.[20]

The subject of Bratby's scorn could have been any of those RCA students of the late 1950s who bought their clothes from Vince Man's Shop in Foubert's Place (promoted in *ARK*s 18–20 in advertisements designed by Gordon Moore (Plate 82)) and, like Joe Tilson, rode Lambretta or Vespa motor scooters. Terry Green, who since his pre-National Service days as an art student at Twickenham had made 'regular weekly runs down to Soho . . . to the 51 Club, Club 11, and later the Flamingo Club', recalls that the style of the RCA hipsters was 'crew cuts and Italian clothes', while Roger Coleman remembers:

Italian gear was very in then . . . What was interesting was that we all tended to have our hair cut rather short at that time in the Perry Como 'college boy' hairstyle. I remember that after I did those *ARK*s I was smitten by appendicitis and after I'd been visited in hospital by Dick Smith, Robyn Denny, and Pete Blake an old Austrian guy in the bed next to me asked: 'What is this? Some club mit the hair?'[21]

These styles immediately distinguished the urban hipsters from their 'squarer', more provincial contemporaries, as Dennis Bailey, fresh up from Worthing to study illustration in the early 1950s, remembers: 'I first met Len Deighton in Dover Street. I was very impressed by this guy in a leather flying jacket, looking

82 Advertisement for
Vince Man's Shop by
Gordon Moore in *ARK* 20
(Autumn 1957)

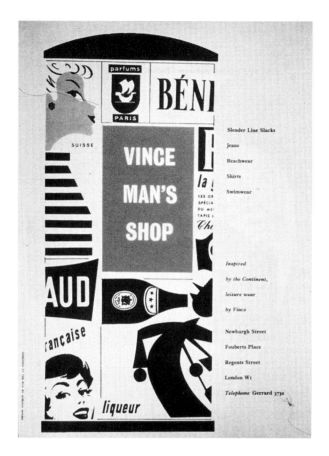

like a cross between Philip Marlowe and Groucho Marx. The St Martin's crowd were the stylists of the London art school scene. Rather suspiciously so, actually!'[22] Not only did St Martin's have a progressive fashion school (run by Muriel Pemberton) but also the students were close to the first shops in London which were selling American and Italian styles for men. The fashion photographer Brian Duffy, who transferred from the Painting Department to the Fashion School at St Martin's in the early 1950s, recalls the milieu within which London's post-war street styles developed:

The Italian look came in at that time because there were a bunch of Italian gangsters from Clerkenwell who were running villainy in Soho. There was also a strong link with gay subculture at that time, because what you had in the early 1950s was this group of ex-Guards' officers, psychotic high camp military men. They were very effete. They dressed in particular shops and they met at particular French restaurants. The Saville Row Edwardian look of 1951–2 began with them. One of their shops was called Dale Cavanagh

in Mayfair, which sold things like French pink knitted ties you couldn't get anywhere else. There were several other shops which are seminal to understanding American influences in London during that period. Austin's in Shaftesbury Avenue, Cecil Gee in Charing Cross Road, opposite St Martin's, and David, which was next door. These shops stocked American clothes brought in by the members of Ted Heath's and Geraldo's bands, 'Geraldo's Navy', which played the liners. Ronnie Scott, for example, used to bring back a pile of twenty shirts from New York after each trip. That was the beginning of the link between Italian-American clothes and modern jazz in Soho. 'Cool' was the word and 'cool' modern jazz could be heard just round the corner from St Martin's at the 51 Club in Great Newport Street.[23]

Pop Photography in *ARK*

Most of the evidence of the growing awareness of 'downtown pop' in *ARK* from 1956 onwards appears in the form of photographs rather than articles. As we have seen in the case of Jack Stafford's writing for *ARK* 1 and in the quotes from *ARK* art editors Ray Hawkey, Len Deighton, and Douglas Merritt, during the 1950s photography tended to be regarded as a distinctly inferior pursuit by the RCA Establishment, an attitude summarized by Darwin, who once said that 'only when allied to another discipline does photography have a proper function in life'.[24] One of the distinguishing characteristics of the developing postmodern sensibility at the RCA was a resistance to this anachronistic attitude, for, as Len Deighton has commented, his attitude towards photography was that although it was neither superior nor inferior to illustration, 'it was part of the real modern world, and we had to come to terms with it, rather than pretend it had never happened'.[25]

Although the RCA did not have a separate Department of Photography until 1968, from 1956 onwards Geoffrey Ireland served as Tutor in Charge of Photography within the School of Graphic Design. Despite Ireland's appointment, however, there seems to have been little enthusiasm for the more creative aspects of photography on the part of the staff and, as Brian Duffy has pointed out, 'photography at the College was still really just a tool for getting a black and white print done'.[26] The impetus behind creative photography at the College came, like so many other aspects of RCA life during the 1950s and early 1960s, not from the staff but from the students.

There were two major sources of photographic inspiration for the RCA students of the 1950s. In the case of graphic designers like Ray Hawkey, the work of American photographers such as Irving Penn and Richard Avedon was extremely influential. Richard Smith was also deeply affected by the photographs

in American magazines such as *Harper's Bazaar* and *Redbook* by Bert Stern and Art Kane.[27] Apart from the Americans, RCA students were influenced by the modernist photographic tradition represented in two key texts of the 1940s, Gyorgy Kepes's *The Language of Vision* (1944) and László Moholy-Nagy's *Vision in Motion* (1947), both of which had been of great interest to key Independent Group figures such as Eduardo Paolozzi and Nigel Henderson, who taught at the Central School during the early 1950s. Ken Garland, who was a student at the Central during the crucial 1950–4 period, recalls the impact of Moholy-Nagy's and Kepes's books:

The Language of Vision and *Vision in Motion* were Bibles to us. Nigel Henderson, who was part of the ICA group, taught photography at the Central, which at the time was a kind of an orphan subject, tucked away in the basement. We all used to gather down there and he'd say, 'You're in graphic design and you don't even know about Moholy-Nagy?' And when I said, 'What is it?' he replied, 'He's a person and he wrote a book called *Vision in Motion* and you should get it!' I wasn't put on to that by a graphic design teacher but by Nigel.[28]

The artist Derek Hyatt, editor of *ARK*s 21, 22, and 23 (Winter 1957–Autumn 1958), recalls that these books were a major influence on his contemporaries at the RCA because

Anyone looking at those books was shown that photography was a tool for design. As soon as students saw that, they saw a history to back up their own inclinations . . . that it wasn't just based on magazine images from America, but that European modernist tradition which went right back to the 1920s.[29]

The photographic layouts of Hyatt's *ARK* 23 (featuring work by Roger Mayne, A. J. Bisley, Dermot Goulding, and Janet Allen) betray the influence of Kepes and Moholy-Nagy in their reliance upon the dramatic effects of chance juxtaposition.

Several exhibitions were also important in establishing photography as a dynamic element in the visual arts during the 1950s. The ICA exhibitions 'Parallel of Life and Art' (1953) and 'Man, Machine and Motion' (1955) were both entirely photographic, while the major 'Family of Man' exhibition, organized by Edward Steichen and displayed in 1953 at the Festival Hall, had a major public impact. As Brian Duffy recalls: 'That was a real turning-point in British creative photography. "Family of Man" was one of the biggest and most influential photography exhibitions ever.'[30]

The first photographs to feature in *ARK* appeared in the style of *Vogue* fashion photography in *ARK* 5 (art edited by Raymond Hawkey) and photographic imagery becomes progressively more important in the magazine from 1956 onwards. *ARK* 17 contains examples of Nigel Henderson's photograms, while

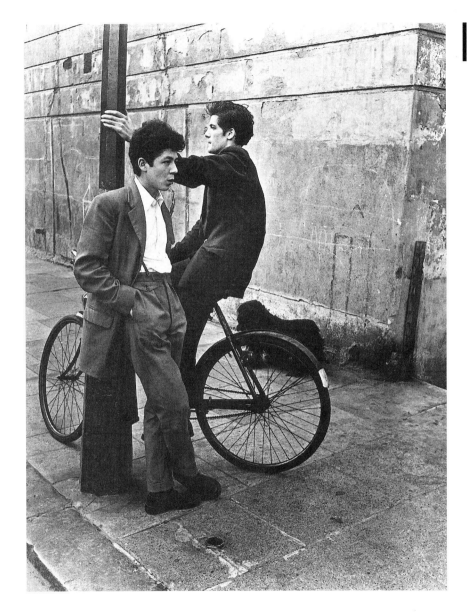

83 Roger Mayne,
Southam St., photograph
in *Uppercase* (1958)

ARK 23 (Autumn 1958) contains photographs by Roger Mayne, whose famous
Notting Hill street photographs also featured in Theo Crosby's magazine
Uppercase (Plate 83). Mayne's social documentary photographic style retained
strong links with Henderson's Bethnal Green photographs, continuing a British
tradition of social anthropology with roots in the Mass Observation movement
of the 1930s, discussed by Humphrey Spender in Derek Hyatt's *ARK* 23.

The first two graphic design students to concentrate whole-heartedly upon

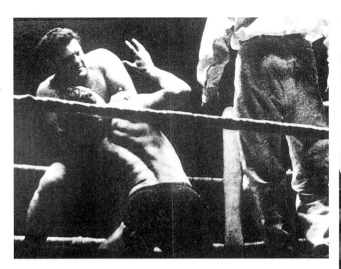

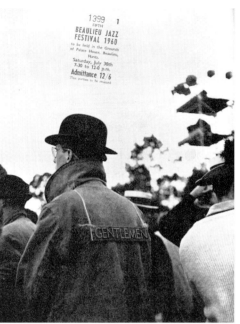

84 *On the Mat at Lime Grove*, photograph by A. J. Bisley in *ARK*
20 (Autumn 1957)

85 *Beaulieu Jazz Festival 1960*, photograph by Allan Marshall in
ARK 28 (Spring 1961)

photography were Gordon Moore, art editor of *ARK* 19, and A. J. Bisley, art editor
of *ARK* 21. Bisley's cover photograph and photo-essay about wrestling, 'On the
Mat at Lime Grove' (Plate 84), in *ARK* 20 is an early example of the grainy black
and white style which would become very fashionable during the 1960s and begins
to recur with increasing frequency in subsequent issues, as in Allan Marshall's
photographs of London rocker 'ton-up' boys and the 1960 Beaulieu jazz festival in
ARK 28 (Spring 1961) (Plate 85). By 1959–60, photography had become a central
element in pop graphics at the RCA—a development which filtered very quickly
into the mainstream of mass media during the early 1960s.

A major influence on *ARK*'s student photographers was the 'hard edge' graphic
style of *Twen* magazine, established in Cologne in 1959 by Willy Fleckhaus (Plates
86–7). Aimed at the *Halbstarker*, the first post-war generation of German
teenagers, *Twen* combined the rational typographic aesthetics of the Ulm HfG
with pop subject-matter. The magazine defied conventional relationships between
text and image, an outstanding feature being its unusual use of photography
around which layouts and storylines were constructed. The impact of *Twen* on
many young English graphic designers of the early 1960s should not be
underestimated, for example Keith Branscombe's 'Twist Drunk' (Plates 89, 92), a
photo-essay in *ARK* 33 (December 1962) about a cross-Channel 'rave-up', clearly
reflects the influence of *Twen* and also the layouts of the new *Twen*-influenced
English magazines of the early 1960s such as *Town* and *Queen* (Plates 86-7).[31]

Pop Art and Pop Art-Influenced Graphic Design in *ARK*

In 1956, after graduating from the College with a First Class Diploma, Peter Blake travelled through Holland, Belgium, France, Italy, and Spain on a Leverhulme Research Award studying popular arts. By 1961 Blake was teaching part time at St Martin's, Harrow, and Walthamstow Schools of Art, where he advised his students (including rock star-to-be Ian Dury) 'to convert their . . . private obsessions into artistic energy'.[32]

It is well known that in 1959 a new generation of painters entered the Royal College who were to achieve fame in the wake of the 1961 'Young Contemporaries' exhibition. The major retrospective of Pop Art exhibited at the Royal Academy in 1991 has meant that the history of this generation has already been studied in great depth.[33] Although this group, which included R. B. Kitaj, David Hockney, Allen Jones, Derek Boshier, Peter Phillips, and (by 1960) Patrick Caulfield (Plate 90), are often categorized as 'Pop Artists', the term obscures the considerable differences of attitude and subject-matter employed by this generation and is vehemently rejected by several of the artists concerned, who, one suspects, are eager to dissociate themselves from the anti-intellectualism of street-level pop culture. When interviewed by Peter Webb, for example, R. B. Kitaj was at pains to point out that 'Pop Art was a figment of the critics' imaginations. It was not a group at all. I've always despised the idea of pop. I have no interest in popular music or popular culture and never have had.'[34] Kitaj's influences were drawn from high culture rather than pop. His serious, dedicated, intellectual approach to painting made a profound impression on David Hockney, who is also eager to dissociate himself from the Pop Art label: 'I saw no connection between packaging, advertisements and things like that and my art. Neither the pop world nor the subject matter of pop art interested me much . . . I never thought I had much connection with Pop Art myself.'[35] If the term 'Royal College Pop Art' has any meaning, it is in connection with the work of Peter Phillips and Derek Boshier, who, alongside Peter Blake and Pauline Boty (a student who concentrated primarily upon stained glass as well as being a gifted *collagiste*, painter, and a talented actress), appeared in Ken Russell's film *Pop Goes the Easel*, broadcast for the *Monitor* programme by the BBC in February 1962 (Colour Plate **8**). The approach to pop of Phillips and Boshier had a good deal in common with Peter Blake's 'downtown' stance and shared little of the rather self-conscious intellectualizing characteristic of the IG's approach to pop subject-matter. As Marco Livingstone has pointed out: 'For Alloway's generation, "Pop" identified not an artistic movement, but the popular end of a spectrum of visual production—Hollywood films, Sci. Fi., magazines, car styling.'[36] Alloway disliked

DALI

"Buenos Dias, Señor Dali!"
"Muh!"
Der Mann mit dem abenteuerlich gezwirbelten Schnurrbart grinst nicht einmal. Er schaut uns ernst an mit weitaufgerissenen Augen. Voller Stolz zeigt der Spanier uns dann im Atelier seine Kollektion bekannter Schnurrbartträger: Wilhelm II. mit seinem "Es-ist-Erreicht", Josef Stalin, der braune Brotschnäuzer; daneben einen Druck der Mona Lisa. "Ist sie mir nicht ähnlich?" fragt Salvadore und zeigt auf die geheimnisvoll Lächelnde. Ihr hat er einen Bart aufgemalt, wie er ihn zu tragen pflegt. Die Ähnlichkeit ist da. Frappant!
Aus einem offenen Kamin holt Dali Blitzlichtbirnchen und demonstriert uns, wie er Gemälde für Amerikaner herstellt: Er füllt die angebohrten Blitzlichtbirnchen mit Tinte und wirft sie gegen eine Leinwand. Die Birne zerspittert, die Tinte verspritzt explosionsartig. Einige Pinselstriche geben dem zerfledderten Fleck auf der Leinwand einen Sinn, von dessen Verständlichkeit nur er überzeugt ist. Er nennt das: "Kunst schießen!"
"Dieses Bild ist bestellt", sagt Dali zu uns und deutet auf eine blütenweiße Leinwand. Drei mal vier Meter. "Von einem amerikanischen Industriellen: 20000 Dollar."
Wir fragen höflich: "Was wollen Sie mit diesem Bild sagen?"
Die Frage scheint uns wichtig. Denn es ist noch kein Pinselstrich auf der Leinwand. Pfiffig antwortet der Meister:
"Wie Sie sehen, ist es noch nicht ganz fertig. Aber jetzt muß ich meine Frau abholen. Sie ist auf dem See. Fischen."
Eine hübsche Frau. Sie wirkt wie 35. Wir wissen aber, daß sie zehn Jahre älter ist als Dali, Mitte 50.
Wir sehen noch, wie er ins Motorboot springt, sie zärtlich in die Arme nimmt und küßt.

▌86 Layout from *Twen* (1959) *see facing page*

▌87 Layout from *Twen* (1960)

DER
AUSTIN
HEALEY
SPRITE

JAZZ TOWN: PARIS

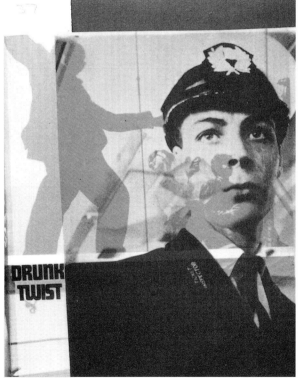

88 Layout from *Town* (1960)

89 'Twist Drunk' picture story by Keith Branscombe in *ARK* 33 (Autumn 1962)

90 Poster for 'British Paintings at the Paris Biennale 1963' featuring Derek Boshier, Peter Phillips, Joe Tilson, David Hockney, and Peter Blake by Stephen Abis (1963)

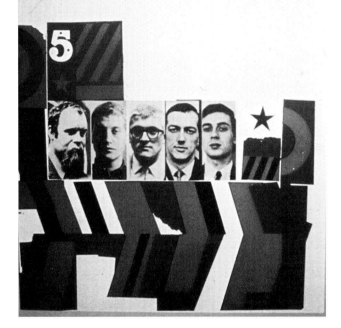

British Paintings from the Paris Biennale 1963
Peter Blake Derek Boshier David Hockney Allen Jones
Peter Phillips RCA Galleries Kensington Gore SW7
Thursday 9th January to Wednesday 29th January
Open weekdays 10 am to 5.30 pm and 8 pm Thursdays
Saturdays 10 am to 4 pm Admission 1/6 students 1/-

much of the work of this younger generation, criticizing Phillips's work in particular for

taking pop literally, believing in it as teenagers believe in the 'top twenty' . . . one of the strongest motives for using pop art has been lost. The new pop art painters use the mass media in the way that teenagers do, to assert, by their style and goods their differences from their elders & others.[37]

ARK provided a very important link between the first generation of Independent Group-influenced RCA painters and their younger successors. ARK 32 (Summer 1962) contains a section entitled 'New Readers Start Here' by Richard Smith, recently returned from New York after his first one-man show at

the Green Gallery (Plate 91). Featuring black and white photographs of David Hockney's *Typhoo Tea* (spelled 'TAE') and *I will Love you at 8p.m. Next Wednesday* (beneath a photograph of the artist in drag), Peter Phillips's *Game Paintings*, and Derek Boshier's *So Ad Men Became Depth Men*, Smith's article was one of the first to be written about the new breed of RCA painters. Understanding the younger painter's terms of reference, Richard Smith distinguished Hockney's 'highly successful, personalized statements' from Phillips's 'dark side of popular art . . . Ray Charles rather than Bobby Vee . . . leather jackets rather than après ski',[38] and was astute enough to recognize their influences while avoiding collective categorization of their work as 'Pop Art':

Three painters in their last year at the RCA, Derek Boshier, David Hockney, and Peter Phillips are linked in their use of mass media imagery but separated by the uses to which they put it. Hockney's space, for instance, is a thin wafer, Boshier's scattered and fragmented, Phillips' battened to the canvas surface. They share, importantly, the style-making influence of Peter Blake and R. B. Kitaj.[39]

Smith was also quick to recognize the differences between the 1959–62 generation's unintellectual approach to pop subject-matter and his own:

The field of popular imagery is wide, full of kicks and possibly loaded with pitfalls . . . A friend met a teenager who was dissatisfied with a pop record because there were too many cymbals. 'Too many symbols?' said my ICA-attuned friend. 'Yes, too many cymbals. They make too much noise'. Our attention is riveted on pop music in a more

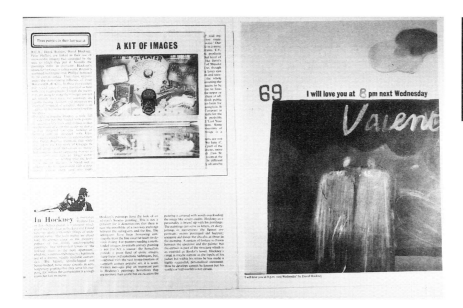

91 Layout for Richard Smith's 'New Readers Start Here' by Brian Haynes (featuring cover of the 'Kit of Images' and photograph of *I will Love you* by David Hockney) in *ARK* 32 (Summer 1962)

critical way than maybe it warrants . . . In using this material they are not either saying 'We love it' or 'We hate it'. They accept it for what it is.[40]

Under the editorship of Bill James (Spring–Winter 1962), *ARK* moved away from the rather lofty 'socially concerned' tone its articles had assumed during 1960–1 under the editorship of Ken Baynes and Stephen Cohn, resuming the integration of subject-matter and layout first seen in Roger Coleman's 'uptown pop' *ARK*s 19 and 20 of 1957 and in Roddy Maude-Roxby's 'Dadaist' *ARK*s 24 and 25 of 1959. As Brian Haynes, art editor of *ARK* 32, remembers, by the time Bill James took over the editorship the need to be 'different' from its predecessors had become the most salient characteristic of the magazine: 'The problem you had at the College at this time was that it became a recognized thing that each year in graphics and painting had to "progress" from the last. So that if last year it was ripped covers and day-glo inks or whatever, the next year you had to do something else.'[41] The need to set trends and pioneer a new style, whether or not it had any real *raison d'être*, made James's *ARK*s pure pop in the sense outlined by Richard Hamilton when, in his oft-quoted 1957 letter to the Smithsons, he included in his list of the components of American popular culture the necessity to be 'Young (aimed at Youth), Witty, Sexy, Gimmicky, [and] Glamourous'.[42] In *ARK* 33, dedicated to teenage culture, 'an oblique exposée of the Young Ones', grainy black and white photographs predominate, indicating that by the end of 1962 photography was becoming the most fashionable medium in graphic design (Plate 92). *ARK* 32, focusing on 'The Crowd', bulges with pop imagery collected by art editor Brian Haynes (Colour Plate **10**).

Following in the footsteps of a succession of *ARK* art editors, including Len Deighton, Alan Fletcher, David Gillespie, and Denis Postle, Brian Haynes seized the first opportunity he could find to cross the Atlantic. 'America: Photographs Taken Last Year while on Tour of America' record the wide-eyed amazement and culture shock of a young English art student visiting America for the first time (Plate 93):

We'd heard of America being the promised land . . . we discovered that the London School of Economics did these £40 charter flights to America and then we discovered a $99 Greyhound Bus Pass which lasted two months, so for about £90 you could spend two months in America, sleeping on buses . . . A whole gang of us went, including David Hockney . . . these photos are a wide-eyed result of what we found. They were so much more developed than us. It was like arriving from a Third World country . . . The billboards were amazing . . . It was before the Civil Rights thing, so you got off the bus in the South and all the blacks would go through one door of the café and all the whites would go through another . . . So this was also the beginning of a naïve sort of social awareness on my part.[43]

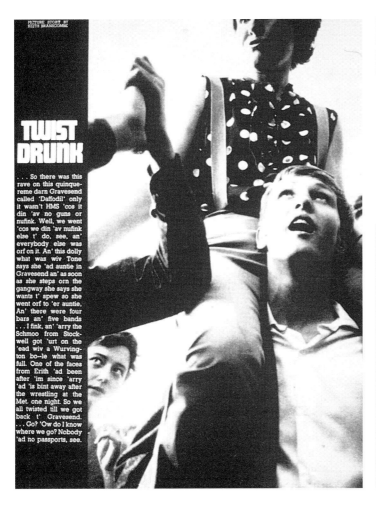

PICTURE STORY BY
KEITH BRANSCOMBE

TWIST DRUNK

... So there was this
rave on this quinque-
reme darn Gravesend
called 'Daffodil' only
it wasn't HMS 'cos it
din 'av no guns or
nufink. Well, we went
'cos we din 'av nufink
else t' do, see, an'
everybody else was
orf on it. An' this dolly
what was wiv Tone
says she 'ad auntie in
Gravesend an' as soon
as she steps orn the
gangway she says she
wants t' spew so she
went orf to 'er auntie.
An' there were four
bars an' five bands
... I fink, an' 'arry the
Schmoo from Stock-
well got 'urt on the
'ead wiv a Wurving-
ton bo--le what was
full. One of the faces
from Erith 'ad been
after 'im since 'arry
'ad 'is bint away after
the wrestling at the
Met. one night. So we
all twisted till we got
back t' Gravesend.
... Go? 'Ow do I know
where we go? Nobody
'ad no passports, see.

92 'Twist Drunk' by Keith Branscombe in *ARK* 33 (Autumn 1962)

93 *Bowery* photograph by Brian Haynes in *ARK* 32 (Summer 1962)

The transatlantic culture shock Haynes captured in *ARK* 32 was also echoed in David Hockney's *A Rake's Progress* (1963), which began life in the form of sketches brought back from New York in the autumn of 1961 at the end of his first Stateside trip.[44]

Haynes's pop graphic work for *ARK* 32 anticipated and influenced many developments in British pop design later in the 1960s. He included a section in which the readers were invited to cut out and make their own 'Top Crowd' political leader from a selection of Fidel Castro, John F. Kennedy, Harold Macmillan, and Nikita Khrushchev, a random selection of American trademark logos, and a 'free pull-out' 'Kit of Images' whose iconography included targets (a reference to Jasper Johns and Peter Blake), tin cars, robots, and a packet of 'Kellogg's Special K' breakfast cereal, which had formed a background prop to the interview with Derek Boshier in Ken Russell's *Pop Goes the Easel* in 1962. According to Brian Haynes: 'The "Kit of Images" wasn't based on any plan. I

simply selected them because they looked interesting . . . That Kellogg's "Special K" thing came from my fascination with the American hard sell—no jokes, no subtlety, just big "K" (Colour Plate **12**).[45]

Haynes explains that by 1962 there was a very busy 'two way traffic' of images between the School of Graphic Design and the Painting School down the corridor. For Haynes and other pop graphic designers such as Barrie Bates (who was known later as Billy Apple) the important thing about Pop Art was its visual impact, stylistic inventiveness, and the sheer speed of its obsolescence. *ARK 32* pioneered the pop graphic aesthetic which became a distinguishing characteristic of English pop culture during the mid-1960s (Colour Plates **9, 11-13**):

The thing that amused us about the Pop paintings was that we thought that as soon as they were done they were stacked up against the wall, dead. The exciting thing was watching people doing them, the process . . . Our aim in *ARK* was, firstly, to have a bit of fun like that and, secondly, to try not to do what they did last year, to get a new style which was still easy then because there was so much material still to process.[46]

These cross-overs of imagery were not confined to painting and graphics. By 1959 a close network of friendships was developing between students in the various schools and departments of the College which would help to blur thoroughly the distinction between what Richard Guyatt had once referred to as the 'useful' applied arts and the 'useless' fine arts. This 'two-way traffic', greatly facilitated by over a decade of effort by Darwin to place design for industry on a par with fine art, was to have profound effects upon the cultural development of Britain during subsequent decades. Many of these cross-overs between fine art and design at the College have already been documented,[47] as have the subsequent careers of some of the most successful RCA graduates of this period. Despite the accolades, however, it is worth remembering that several members of the 1959–62 generation were very unpopular with the staff. Allen Jones was expelled from the Painting School at the end of his first year 'for setting a bad example',[48] Peter Phillips was forced to transfer from the 'élite' Painting School into the Television School in his third year, while textile student Geoff Reeve, who painted fellow student and Temperance Seven saxophonist Philip Harrison's spectacles with the Union Jack before transferring the design on to cloth, thereby creating one of the dominant motifs of the 'Swinging Sixties', so horrified his professor, Roger Nicholson, that he was threatened with expulsion from the college for 'defiling the flag'.[49]

The previous two chapters have examined responses to pop culture in *ARK* between 1950 and 1962. Emphasis has been placed upon the ways in which the

sophistication of American graphic design exerted a powerful influence over a group of ambitious graphic design students during the early 1950s, how the intellectual influence of the Independent Group and the modern Continental graphics promoted by the Central School helped shape the 'uptown pop' sensibility of Roger Coleman's *ARK*s, and how, beginning with the influence of students from working-class backgrounds such as Peter Blake, Joe Tilson, and Len Deighton, direct links developed between the 'downtown pop' world and the contents and increasingly photographic layouts of the *ARK*s art edited by Terry Green and Brian Haynes during the early 1960s. The next and final chapter will examine the links between *ARK* and the mass media of the 1960s while reassessing the attempt to discover the origins of an English postmodern sensibility.

7 *ARK* and an English Postmodern Sensibility

In an essay written for the catalogue of 'Graphics RCA', an exhibition held in the spring of 1963 reviewing work of the RCA School of Graphic Design over the previous fifteen years, Mark Boxer, art editor of the new *Sunday Times Colour Section*, was full of praise for the pop graphics of the latest issues of *ARK*:

At best *ARK* is the flowering of certain intelligent enthusiasms expressed with considerable professional ability . . . the last issue [art edited by Brian Haynes] seems to me quite outstanding, a controlled and distinguished number . . . The reason for this must surely not be unconnected with the Painting School. The Pop Art movement owes a great deal to graphics. But in its turn it has enriched graphics and *ARK* in particular. There is no arid puritanism here, design at last seems to have found other inspirations besides Mondrian and the Bauhaus . . . The pop-graphic movement may be instant nostalgia, but this is the very guts of visual magazines.[1]

In applauding the 'instant nostalgia' and superficial impact of *ARK*'s pop graphics, Boxer was unwittingly writing the magazine's obituary, for although *ARK* would continue to be published until the mid-1970s, it was never to regain the verve of its 'moment' between 1956 and 1962. During that period *ARK* successfully fulfilled the intentions of Jack Stafford, its founder and first editor, to 'explore the necessary but elusive relationships between the arts and their social context'[2] in a manner that was at once original and challenging in both form and content. As graphic design historian William Owen has pointed out, it is important to recall the drabness of English magazine design during *ARK*'s heyday in the 1950s when, after the closure of the lively and innovative *Picture Post* in 1950, all that Britain could boast was 'a ragbag of titillating weeklies, purveyors of handy hints for hobbyists, country magazines for the upper classes, and anaemic and elitist fashion books'.[3] Rationing and post-war austerity had lengthy repercussions in the parochial world of British magazine design, a fact thrown into focus with the realization that the *Radio Times*, Britain's biggest selling magazine, did not resume colour printing of its covers until 1964!

By the early 1960s, however, a new crop of far more professionally produced magazines had blossomed from the ground that *ARK* had helped cultivate. *Queen* (bought by Jocelyn Stevens in 1957) (Plate 94), *Town* (acquired by Clive Labovitch and Michael Heseltine in 1959) (Plate 95), and the Sunday colour magazines (beginning with the *Sunday Times Colour Section* in February 1962 and followed by the *Telegraph Colour Supplement* in 1964, and the *Observer Magazine* in 1965) all followed a formula of combining features about art, design, and 'life-styles' which complemented their highly professional, witty, sexy, and glamorous advertising copy (Plate 96).

Not surprisingly, there was a direct connection between ex-*ARK* personnel and these new magazines. Raymond Hawkey, art editor of *ARK 5*, went on to become art director of *Vogue* before graduating to design director of the *Daily Express* in 1959 and presentation director of both the *Observer* and the *Observer Colour Magazine* by 1964. Working alongside Hawkey on the art direction of the *Observer Colour Magazine* from 1965 was Romek Marbur, a contemporary of Alan Bartram and David Collins and a designer of advertisements for the *ARK*s they art edited. Gordon Moore, art editor of *ARK 19*, worked for the IPC magazine *Woman's Own* for a year before working as art editor for *Queen* and, very briefly, art editing the new *Sunday Times Colour Section* before the arrival of Mark Boxer from *Queen*. Brian Haynes, art editor of *ARK 33*, followed a similar career path, working as art editor for both the *Sunday Times Magazine* and *Queen* during the mid-1960s. Dennis Bailey, who studied illustration at the College 1951–3 and contributed to *ARK*s 6 and 14, worked as art editor for the influential Swiss magazine *Graphis* in the mid-1950s before becoming art editor of *Town* after the departure of Tom

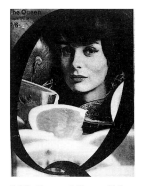

94 Cover of *Queen* (16 Aug. 1961), photographer Peter Williams, art editor Gordon Moore

95 Cover of *Town* (Sept. 1962), photographer Horst Baumann

96 'A Clown with Vision' by Emma Yorke: article on David Hockney in *Town* (Sept. 1962)

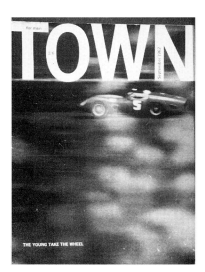

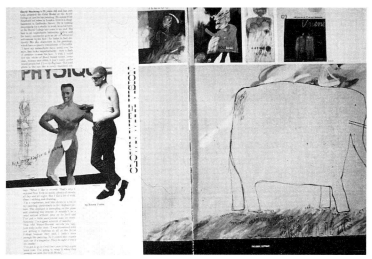

Wolsey in 1965. The story of Bailey's involvement in the world of British magazine publishing provides an interesting insight both into change in graphic design during this period and also into some of the complex 'little narratives' which underlie the history of contemporary British graphic design.

When Bailey graduated from the RCA in 1953 he regarded himself as a 'fine art illustrator' rather than a commercial artist and, in common with many young fine artists at the time, saw his future in terms of 'illustration with a bit of teaching thrown in'.[4] Following the line that was encouraged by the College at that time, he looked to businessmen like Colin Anderson (owner of the Orient Line of ships) or Shell's Jack Beddington for patronage and also 'did book-jackets for Jonathan Cape . . . which paid £15 each' while teaching part time at Walthamstow and Croydon art schools. Disillusioned by Jack Beddington's rather haughty attitude to his work, he met fellow student Bernard Myers one evening in 1955 and was informed that *Graphis* were looking for a new art editor:

So somehow, about three months later, I was getting off the train in Zürich . . . That completely changed my whole view of things . . . I started to get very interested in Swiss typographic design, Müller-Brockmann, Karl Gerstner, and Max Bill . . . they were the first people in graphics that I had real enthusiasm for.[5]

For Bailey, Swiss graphic design appeared to reconcile fine art and commercial design because 'it was based on rational structures, it was abstract . . . it didn't undermine my personal work and it enabled me to combine art and graphics'. Abstract art seemed to complement Swiss typography and, in contrast to England, there seemed to be none of the snobbery which deemed graphic design to be somehow inferior to painting. The reputation of Swiss master Max Bill, for example, was based upon both his graphic work and his abstract painting. After a period working as a free-lance designer back in London during the late 1950s when he made connections with Mark Boxer and the new breed of fashion photographers, including Brian Duffy and Terence Donovan, Bailey became very disillusioned at the prospect of a trendy life 'of tan carpets, Italian glass and Japanese lamps' and left for Paris to study and make experimental films. Only half believing the stories of 'Swinging London' recounted to him by visiting friends, he was finally coaxed back home after hearing that *Town* was looking for an art editor. Offered the job by Clive Labovitch, Bailey continued the magazine's connection with the hard edge Swiss style pioneered on the Continent by *Twen* ('the only magazine that had really well-set type') until the magazine ceased publication in 1967 due to a combination of factors including the changing face of 'men's magazines' during the late 1960s.[6]

Between the mid-1950s, when Bailey went to Zürich, and the mid-1960s, when

he took over the art editorship of *Town*, the world of British graphic design had changed beyond recognition, a change that was paralleled and complemented by the transformation of the British advertising industry and the rise of new design consultancy groups. This development enhanced the status of individual graphic designers within the advertising industry, led by Tom Wolsey of Crawfords (later art editor of *Town*), Colin Milward of Collett, Dickenson, and Pearce, Michael Hart of Bensons, and Ruth Gill of Mather and Crowther. The rise of the 'Creative Director' was greatly strengthened by the arrival in London during the early 1960s of a group of highly talented American advertising men, including Robert Brooks and Robert Geers (who worked for Benton and Bowles), Robert Brownjohn (McCann-Erikson), and Bob Gill (Charles W. Hobson). A symbol of the new self-confidence of British graphic designers was the 'Twelve Graphic Designers' exhibition at the Time-Life Building on Bond Street in 1960. The young designers whose work was on show, including ex-RCA and Central School students Alan Fletcher, David Collins, John Sewell, Romek Marbur, Colin Forbes, and Derek Birdsall, exhibited under the aegis of the London Association of Graphic Designers and their work, which was displayed in a gallery environment, emphasized the creativity and originality of the new kind of British advertising art.

The growth in creativity of British advertisements was complemented by the simultaneous birth of a new breed of design consultancy groups led by Fletcher, Forbes, Gill (1962) (later Crosby, Fletcher, Forbes, and then Pentagram), Main Wolff (1963) (later Wolff Olins), Minale Tatterfield (1964), and Omnific (1965). The new graphics scene was represented by the Designers and Art Directors' Association, established in 1962, in which ex-*ARK* art editor Alan Fletcher played a central role. Remembering the impact of the D. & AD on the contemporary design scene from the perspective of the late 1960s, ex-*ARK* editor Ken Baynes wrote that:

It is hard now to remember just what a big gap the D&AD exhibitions filled when they began, at last giving London an annual forum comparable to the famous show sponsored by the New York Art Directors' Club . . . there was a genuine feeling of newness and exuberance. The real core of graphic inventiveness in the mass media successfully asserted its own validity.[7]

By the time of the 'Graphics RCA' exhibition in 1963, therefore, many of the interests and obsessions which had seemed so exciting and subversive in the *ARK*s of the 1950s had filtered into the mainstream mass media. Not only were ex-*ARK* personnel playing key roles in the worlds of magazine and newspaper design, advertising, television, and film but also the media were filled with features about

and work by ex-RCA students (Plates 97 and 98). The first (February 1962) issue of the *Sunday Times Colour Section*, for example, featured an article by John Russell entitled 'The Pioneer of Pop Art' about Peter Blake, 'a quiet red bearded young man with the looks of an intellectual gardener'. A *Sunday Times Colour Section* of July 1962 was entirely devoted to an exposé of British art schools, featuring an extensive section on the RCA entitled 'The Royal Road to Success', which included an interview in which Robin Darwin restated his opinion that 'the art student of today is less easy to teach because the chips on his shoulder . . . are virtually professional epaulettes'.[8] The feature also praised 'the highly professional' *ARK* magazine, and quoted Richard Guyatt as saying, 'My students are with it and frisky. They all get jobs.'[9] Ken Baynes's Anti-Ugly Society was applauded for fighting 'in a very practical way against the ugliness of public buildings'.[10] In April 1963 the same magazine asked, 'How American are we?' and provided a glossier rerun of many of the issues covered in Roger Coleman's *ARK*s of 1956–7. A later issue featured 'Art in a Coke Climate' by the critic David Sylvester, contrasting the 'coke culture' celebrated by pop artists to the 'wine culture' which was the province of the more traditional fine artist. Sylvester's article also featured photographs of work by Eduardo Paolozzi, Peter Blake, R. B. Kitaj, and Richard Smith (Plate 99).[11]

The culmination of the new magazines' obsession with the RCA came in June 1967, when Jocelyn Stevens (who would become an energetic and formidable Rector of the RCA between 1984 and 1992), devoted an entire issue of *Queen* to the College, allowing the whole magazine to be designed by the School of Graphic Design with an editorial by Richard Guyatt (Plate 100):

97 Cover of *Sunday Times Magazine* (30 Aug. 1964) featuring RCA industrial design student Vic Roberts

98 *Sunday Times Magazine* feature on young designers, including Zandra Rhodes, George Ingham, Nick Jensen, Roger Wilkes, and Richard Lord

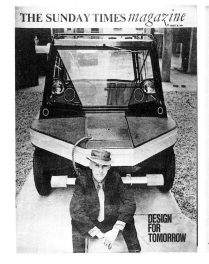
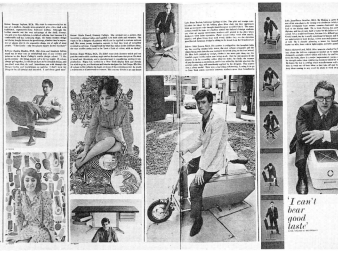

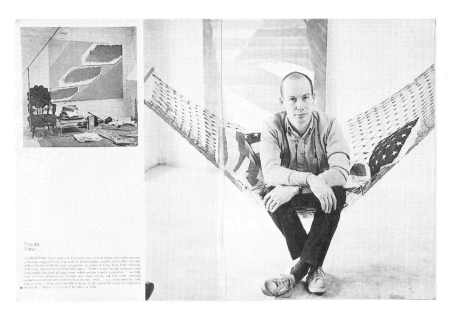

99 'Private View' feature on Richard Smith in the *Sunday Times Magazine* (3 Oct. 1965), photograph by Lord Snowdon

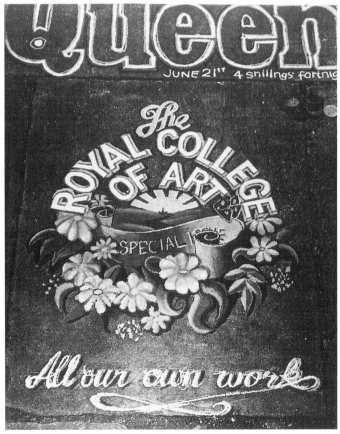

100 *Queen* (21 June 1967)

When Jocelyn Stevens proposed that a whole issue of his magazine should be devoted to the RCA . . . It showed yet again his brilliant flair as an innovator . . . One thing stood out a mile . . . the project would form a superbly realistic training exercise for those graphic designers involved in designing the issue. Here was a glittering opportunity for them to show their professional paces.[12]

Summing up the attraction of the RCA and its central role in British culture during the 1960s, Guyatt, who now seemed to have forgotten his hostility to pop, noted that:

in this youth-conscious age the College finds itself the centre of a cross-current of young talent attracted from all over Britain and indeed the world, which wants to come and swing in London for a three year postgraduate course . . . in a period when the guide lines of tradition have burnt themselves out in the fine arts while in the applied arts the problem switches to one of keeping pace with galloping technology.[13]

In a May 1963 review of the 'Graphics RCA' show (Plate 101), Reyner Banham criticized Lawrence Alloway's dismissal[14] of the new wave of Royal College Pop

101 Poster for 'Graphics RCA' (1963)

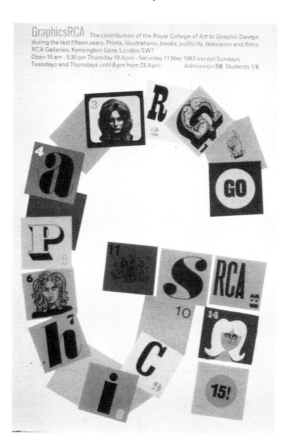

Art but pointed out that the old anti-Establishment spirit that had fuelled the original IG-influenced artists and the *ARK*s of the previous decade seemed to have run out of steam:

Surveying, from his new American eminence at the Guggenheim Museum, the present state of the English (or senior) branch of Pop Art, Lawrence Alloway complained that it was too much under the influence of graphics. This 'too much' I do not dig—Pop was largely created out of graphics . . . but the connection is very real and precise. The point of connection is the RCA's pseudo-student magazine *ARK*, the time of the connection the first of the issues edited by Roger Coleman in 1955 [*sic*] . . . This link up between nascent pop fancy and the graphics department was to have portentous consequences for the College—as is only too clear when one visits the current graphics exhibition . . . behind its obvious impact lies a good deal of 'how' and 'why' not all of it very reassuring.[15]

Whereas Coleman's *ARK*s had been witty, ironic, subversive, and intellectually engaging, the latest issues appeared to Banham to be simply obsessed by rapid stylistic turnover and technical slickness facilitated by the introduction of high-speed web offset printing technology during the early 1960s:

Over it all there reigns an air of theatrical brilliance . . . The demands of newspaper and magazine printing, of advertising and packaging, have forced techniques to a level of sophistication that is bewildering . . . for while inevitably painstaking and slow moving departments, from painting to industrial design were being revolutionized (or not) at their own lumbering speeds, graphics could have a revolution with every issue of *ARK* that appeared . . . Since the graphics boys had control of *ARK* and most other public manifestations of the College . . . they have contrived to give the impression that the RCA is madly with-it, never misses a trick and is preoccupied with fashion.[16]

For Banham, the 1962–3 issues of *ARK* gave the impression of being 'flashy and footloose', producing 'quick and showy aesthetic returns on a minimum outlay of talent and intellect', an opinion which seems to be supported by Brian Haynes, art editor of *ARK* 32, who recalls that his main preoccupations at the time were 'trying to have a bit of fun . . . and not doing what had been done before . . . searching for a new style'.[17] According to Banham, *ARK*'s superficial obsession with pop style had caused its art editors to miss the most significant contemporary development in modern typography 'exemplified in Britain by *Town* and in its most extreme form on the Continent by *Twen* . . . optical communication by means of patterns of black and white on the page'[18]—an interesting and apparently paradoxical condemnation of pop aesthetics by one of the Independent Group's 'Fathers of Pop'.

The reason for the vacuousness of *ARK*'s pop graphics was, according to Banham, a characteristically British indifference to theory and lack of research

into 'the techniques and skills of communication', lacunae which made the RCA's School of Graphic Design comparable to a 'university department where no one is doing any research'. Comparing the 'intellectual vacuum' behind contemporary British graphics to the 'long and gruelling seminars' in semiotics which were a compulsory requirement for Tomás Maldonado's graphic design students at the HfG in Ulm, Banham advised the RCA to take a leaf out of Ulm's book, to relinquish some of their 'surface brilliance' for 'an intellectual discipline which entitled [the HfG] to be considered seriously as a post-graduate school'.[19]

The main thrust of Banham's criticism was repeated once again in *ARK 35* (May 1964), an issue heavily influenced by Anthony Froshaug (who had been teaching in the School of Graphic Design since returning from Ulm in 1961). Featuring an article by Froshaug on cybernetics, a reprint of Ken Garland's 'Manifesto' for *Design* magazine,[20] exhorting graphic designers not to prostitute themselves to 'gimmick merchants, status salesmen, and hidden persuaders' but to use their skills for 'worthwhile purposes' instead, Michael Myers, the editor of *ARK*s 35 and 36, cast a critical eye over the *ARK*s of the past decade:

In any analysis of *ARK* much is made of the way in which, if nothing else, it has a visual ability which is both stimulating and fresh. However, it seems to me that it is in its overall use of graphics that *ARK* is often at its weakest. Looking through the past *ARK*s one is almost overwhelmed by the proliferation of slick sharp bizarre type of imagery which seems to have been lifted carte-blanche from the ad. man. The images are 'now' images whose only relevance is to today.[21]

Like Banham's review of the previous year's 'Graphics RCA' exhibition, the essential message of Myers's editorial was that although pop had been an interesting and challenging subject for bright students during the 1950s ('largely because the established staff were too snobby to dirty their hands with it'[22]), by the pop-glutted mid-1960s it had become jaded. Myers's solution was to propose a return to the discipline and integrity of modernism:

To indulge in the indiscriminate use of detergent graphics or pop imagery . . . is evidence of nothing more than a totally misinformed and misguided approach to the whole problem of visual communications, the very essence of which surely is that the manner of communication must be appropriate to that which is being communicated. Some ideas are not necessarily marketable commodities to be foisted upon the public in the shortest possible time by some graphic sleight-of-hand.[23]

The implication of Myers's editorial was that by 1964 pop had lost the subversive qualities it had once possessed and had become the latest, and most insidious, component of capitalist culture. While the mid-1950s generation had

embraced urban pop as an alternative to the cosy images of 'Englishness' favoured by the Establishment, by the mid-1960s pop had become a central element in a new version of 'swinging' Englishness promoted by glossy magazines and commercial television and cynically encouraged by those who were profiting from the new consumerism. The English postmodern sensibility originally nurtured in the art schools during the 1950s had become incorporated into the mainstream of English culture and, both Banham and Myers argued, as a new orthodoxy it deserved to be subjected to criticism.

Others, while recognizing pop's incorporation into the cultural mainstream, adopted a rather different line. Writing in *ARK* 35, a group of painting students from the Slade who called themselves the Fine Artz Associates captured the feeling of ennui but blamed it squarely upon an anachronistic art Establishment and an art education system out of touch with current technological and cultural trends:

We've had the push-button revolution and the technological take-over. We've been presented with conveyor belt production, cybernetics, depth psychology, mass-communication, instant packs, supermarkets, glam admanship . . . neon, nylon, perspex, plastic . . . miraculous materials, magical machines, communications techniques and more leisure . . . The scandal of the great Art Racket is about to break any day now . . . the masses have begun to see through this confidence trick and the new generations . . . are rejecting all claims of the old culture and are producing a new culture of their own—Pop Culture. The art world's reaction to this new culture has taken the form of 'Pop Art' . . . but Rauschenberg mania doesn't sound right somehow . . . the 'hipsters' of the New York and London art scenes are really playing an old-fashioned game.[24]

Rejecting the approach to contemporary culture adopted by the Independent Group and their followers, the Fine Artz Associates were particularly unimpressed by the 'pose' of 'scientific artists' adopted by the 'Fathers of Pop':

Throwing around phrases like cybernetics, elaborate and restricted code communications (and other imposing phrases gleaned from magazines like *Scientific American*) they are trying to give the impression that they have revised the status of the artist and we are expanding the universe of visual communication . . . they are obviously deluded . . . *The artist has no relevant role in the new society if all he can do is play with the achievements of his more serious minded and socially functioning fellow citizens.*[25]

Proclaiming that the 'clues to tomorrow's culture lie in the [youth] cults of today', the Fine Artz Associates demanded a 'radically revised concept of art education' not based upon modernist precepts but upon 'mod' aesthetics of desire, featuring 'forward looking courses geared to utilizing modern technological discoveries and aware of the new social needs for romance and

built-in desirability. So brake with boredom—forget your Tate date and follow that tangerine-flake baby!'[26]

The Fine Artz Associates' rejection of the 'confidence trick' of Pop Art (a style often sneered at by Slade students jealous of the fame of RCA Pop painters), Michael Myers's irritation about the superficiality of *ARK*'s pop graphics, and Reyner Banham's suggestion that the RCA School of Graphic Design follow the example of the HfG's 'extended studies of the legibility of a trademark' and 'systematic analyses of the visual rhetoric of advertising' rather than simply 'playing graphic design for kicks'[27] help highlight the problem of assessing *ARK* in terms of contemporary theories of the postmodern. For the concept of an English postmodernism is rendered particularly problematic by the fact that modernism was never elevated to the status of 'official' culture in this country as it was during the 1950s in Switzerland, Germany, and the United States. A clear concept of the term is also blurred by the plethora of meanings which it has acquired over the past decade, when, as David Robbins has pointed out:

Following Jürgen Habermas's 1980 attack on both architectural postmodernism and post-structuralism as opposite threats to the 'uncompleted modernist project' an international, politically charged cultural debate emerged that gathered theorists as different as Jean Baudrillard, Frederic Jameson and Jean-François Lyotard under the rubric of postmodernism. Discipline-specific uses of the term became secondary to a periodizing usage that defined media-saturated postwar culture as 'a new type of social life and a new economic order'. Consumer culture was interpreted as a historic displacement of the Industrial Age labor-based categories of production and its meanings (if any) were seen as systematically destabilized and aestheticized by the mass media.[28]

This vagueness does not necessarily mean that the term 'postmodern' is meaningless, however. As Dick Hebdige has argued,[29] the degree of semantic complexity surrounding the term signals the fact that a large number of people with conflicting interests and opinions feel that there is something sufficiently important at stake to be worth struggling and arguing over. Loosely speaking, therefore, the term postmodernism has become a catch-all phrase used promiscuously to describe fundamental changes in the social and cultural life of the advanced capitalist societies since the Second World War. In England, at least, pop in its broadest sense was the context within which the notion of the postmodern first took shape and a specifically English 'structure of feeling' which could be termed a 'postmodern sensibility' necessarily involved the awareness, appreciation, and, most importantly, the acceptance of the collapse of the traditional boundaries separating high culture from mass culture.

Although it seems irrefutable that issues of *ARK* published between 1950 and

1963 reflect the emergence of a distinct *mentalité* at the RCA (compare, for example, the layouts of *ARK*s 35 and 36 (1964) with those of that postmodernist 'ur-text' *The Face* during the mid-1980s), it is equally obvious that during the 1950s and early 1960s an appreciation and acceptance of the postmodern did not necessarily imply a rejection of modernism (Plates 102–6). Indeed, as we have seen in the cases of Roger Coleman, Alan Fletcher, Roddy Maude-Roxby, and Terry Green, several of the *ARK* editors and art editors who most clearly exhibit a postmodern sensibility were also equally enthusiastic about aspects of the modernist avant-garde. As the cultural historian David Mellor has pointed out,[30] generalized statements about cultural change during the 1950s are notoriously inaccurate. A true picture of the cultural history of the period can only be recreated by analysing its 'little narratives', via 'a patient remapping of the textual sites of the period', as Mellor so succinctly describes it.

What a patient remapping of 'the textual site' of *ARK* does reveal is that a postmodern sensibility at the RCA did not emerge as a reaction against

102 'It Lasts Only a Second but we Know we're Really Alive', surfing feature by Roy Giles and Stephen Hiett in *ARK* 36 (Summer 1964)

103 Introduction to 'New England' photo-essay in *The Face* (August 1986), art direction by Robin Derrick, photography by Nick Knight

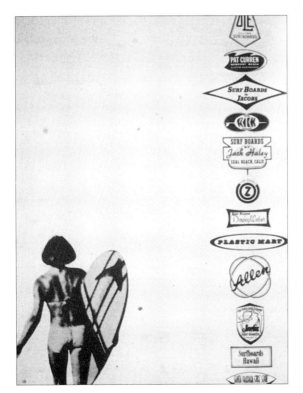

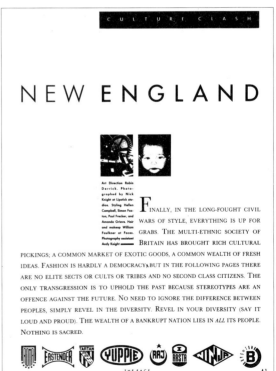

104 *New England*
photograph by Nick
Knight, art direction by
Robin Derrick in *The Face*
(August 1986)

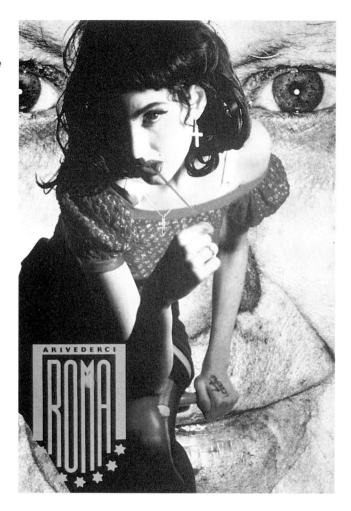

modernism but rather out of a rejection of what Robert Hewison[31] has described
as the 'mandarin values' of the English cultural and political establishment and
the drab, snobbish parochialism of much English cultural life during the 1950s, a
rebellion elegantly summarized by the critic John Russell as

a resistance movement: a classless commando which was directed against the
Establishment in general and the art-Establishment in particular . . . a cultural break,
signifying the firing squad, without mercy or reprieve, for the kind of people who
believed in Loeb classics, holidays in Tuscany, drawings by Augustus John, signed pieces
of French furniture, leading articles in *The Daily Telegraph* and very good clothes that
lasted forever.[32]

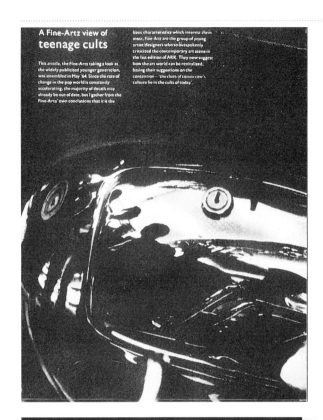

A Fine-Artz view of
teenage cults

This article, the Fine-Artz taking a look at the widely publicised younger generation, was assembled in May '64. Since the rate of change in the pop world is constantly accelerating, the majority of details may already be out of date, but I gather from the Fine-Artz' own conclusions that it is the basic characteristics which interest them most. Fine-Artz are the group of young artist/designers who so outspokenly criticized the contemporary art scene in the last edition of ARK. They now suggest how the art world can be revitalized, basing their suggestions on the contention—'the clues of tomorrow's culture lie in the cults of today'.

105 'A Fine-Artz view of teenage cults' in *ARK* 36 (Summer 1964)

106 'Was Freddy Kreuger a Mod?' photographs by Christian Thompson, *The Face* (November 1988) (Courtesy Camilla Arthur Representation Europe)

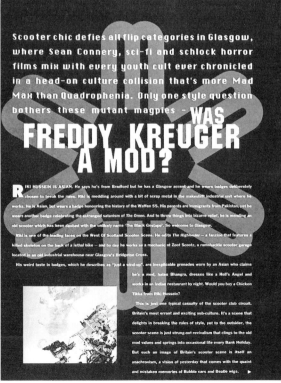

Scooter chic defies all flip categories in Glasgow, where Sean Connery, sci-fi and schlock horror films mix with every youth cult ever chronicled in a head-on culture collision that's more Mad Max than Quadrophenia. Only one style question bothers these mutant magpies – WAS FREDDY KREUGER A MOD?

RIKI HUSSEIN IS ASIAN. He says he's from Bradford but he has a Glasgow accent and he wears badges deliberately chosen to break the rules. Riki is meddling around with a bit of scrap metal in the makeshift industrial unit where he works. He is Asian, but wears a badge honouring the history of the Waffen SS. His parents are immigrants from Pakistan, yet he wears another badge celebrating the estranged satanism of The Omen. And to throw things into bizarre relief, he is mending an old scooter which has been daubed with the unlikely name 'The Black Gestapo'. So welcome to Glasgow.

Riki is one of the leading faces on the West Of Scotland Scooter Scene. He edits The Highlander – a fanzine that features a killed skeleton on the back of a lethal bike – and by day he works as a mechanic at Zoot Scootz, a ramshackle scooter garage located in an old industrial warehouse near Glasgow's Bridgeton Cross.

His weird taste in badges, which he describes as "just a wind-up", are inexplicable grenades worn by an Asian who claims he's a mod, hates Bhangra, dresses like a Hell's Angel and works in an Indian restaurant by night. Would you buy a Chicken Tikka from Riki Hussein?

This is just one typical casualty of the scooter club circuit, Britain's most errant and exciting sub-culture. It's a scene that delights in breaking the rules of style, yet to the outsider, the scooter scene is just strung-out revivalism that clings to the old mod values and springs into occasional life every Bank Holiday. But such an image of Britain's scooter scene is itself an anachronism, a vision of yesterday that comes with the quaint and mistaken memories of Bubble cars and Beatle wigs. ▶

Paradoxically, Robin Darwin's leadership of the RCA helped to inspire, focus, and promote this cultural rebellion. On the one hand Darwin's upper-class 'English Good Taste' and determination to recreate the RCA in the image of a Cambridge college provided unwavering symbols of Establishment culture for a generation of 'bolshie' RCA students to thumb their noses at. On the other hand, his progressive drive to elevate the status of design for industry was largely responsible for helping to break down the traditional snobbery which in England had tended to separate the 'useful' applied arts from the 'useless' fine arts. While the irascible Old Etonian Principal, with his connoisseurship and deep love of English tradition, seemed to epitomize the culture of the Establishment, his reforms actively encouraged the blurring of the boundaries between high and mass culture, fine art and the mass media. As Clifford Hatts, who both studied and taught in the School of Design during the late 1940s and 1950s, has pointed out: 'Despite all the lampooning by students . . . Darwin, in the School of Design at least, was seen to throw out the faded remnants of the old Arts and Craft curriculum and drag us cheering into the realities of a new post-war world.'[33]

ARK is a symbol of this paradox. Promoted by Darwin and Guyatt as the public face of the RCA from 1951 onwards, by the mid-1950s the magazine had changed from a semi-official mouthpiece promoting the aesthetic preferences of the RCA Establishment to an iconoclastic and often deliberately subversive platform for the anti-Establishment strategies of the most rebellious sections of the student body. Between the mid-1950s and the early 1960s, before the Coldstream reforms institutionalized aspects of the avant-garde into the curricula of British art and design education, the more adventurous RCA students ranged across the 'long front of culture', creating new meanings by collaging images and ideas together with a cargo-cultish devotion. This promiscuous combination of pre-war Dada, 'uptown' American graphics and movie imagery, 'downtown' London pop culture, the modernism of Kepes and Moholy-Nagy, Situationism, the jazz and poetry of the American Beats, the *tachisme* of Mathieu, the rock 'n' roll of Elvis, and the Abstract Expressionism of Jackson Pollock widened these students' scope of inspiration and evaded traditional categories of value. It was a stimulating and exciting period in which to be an art student, for, as Robyn Denny recalls:

It was a time for trying to think differently, radically, a time for 'busting out' and laying down the roots of a profound cultural change . . . that dynamic was sustained from 1956 until about 1961 . . . by the mid-1960s people were getting much more professional, much more conscious of image, identity and presentation, and the edge was missing . . . the RCA in the late 1950s was raw, vigorous, experimental, often coarse and often very funny, sparky and bright.[34]

As a reflection of this cultural 'moment' *ARK* was most successful when it was intuitive rather than intellectual, semi-coherent rather than didactic. In the most memorable issues of the magazine the layouts complement the contents to produce distillations of the energy and enthusiasm of the period, an achievement recognized in 1960 by a bemused Robin Darwin, who commented that: 'what is significant is that the more generally unintelligible *ARK* becomes . . . the better it sells. Vitality is indeed an attraction in itself!'[35]

Bibliography

Adams, H., *Art of the Sixties* (Oxford, 1978).

Alloway, L., *Nine Abstract Painters* (London, 1954).

—— 'The Long Front of Culture', *Cambridge Opinion*, 17 (1959).

—— 'Pop Art since 1949', *Listener*, 68 (27 Dec. 1962).

—— 'The Development of British Pop', in L. Lippard, *Pop Art* (London, 1966).

—— 'The Independent Group and the Aesthetics of Plenty', in D. Robbins (ed.), *The Independent Group: Postwar Britain and the Aesthetics of Plenty* (Cambridge, Mass., 1990).

Appignanesi, L. (ed.), *Postmodernism* (Institute of Contemporary Art, London, 1986).

Appleyard, B. (1989), *The Pleasures of Peace: Art and Imagination in Postwar Britain* (London, 1989).

Archer, L. B., *Systematic Method for Designers* (London, 1965).

Architectural Design (1958–62).

Architectural Review (1950–64).

ARK: The Journal of the Royal College of Art (1950–64).

Art Directors' Club of New York, *27th Annual of Advertising and Editorial Art* (New York, 1948).

Banham, M., and **Hillier, B.** (eds.), *A Tonic to the Nation* (London, 1976).

Banham, R., 'The City as Scrambled Egg', *Cambridge Opinion*, 17 (1959).

—— 'Department of Visual Uproar', *New Statesman* (3 May 1963).

Benjamin, W., *Illuminations* (London, 1973).

Bergonzi, B., *Innovations: Essays on Art and Ideas* (London, 1968).

Bernstein, D. (ed.), *That's Shell—That Is! An Exhibition of Shell Advertising Art* (Barbican Art Gallery, London, 1983).

Bingham, J., 'The Designers and Art Directors' Association in the 1960s: A Reflection of Changes in Graphic Design and Advertising', MA thesis (Royal College of Art, London, 1989).

Birch, N., *The Advertising we Deserve?* (London, 1962).

Bliss, D. P., *Edward Bawden* (London, 1979).

Booker, C., *The Neophiliacs: A Study of the Revolution in English Life in the Fifties and Sixties* (London, 1969).

Bratby, J., *Breakdown* (London, 1960).

Button, V. M., 'The Aesthetic of Decline: English Neo-Romanticism *c*. 1935–1956', Ph.D. thesis (Courtauld Institute of Art, University of London, 1991).

Campbell, C., *The Romantic Ethic and the Spirit of Modern Consumerism* (Oxford, 1987).

Chambers, I., *Urban Rhythms: Pop Music and Popular Culture* (London, 1985).

—— *Popular Culture: The Metropolitan Experience* (London, 1986).

Cherry, C., *On Human Communication* (London, 1957).

—— 'Communication and the Growth of Societies', *Cambridge Opinion*, 17 (1959).

Craig, J., and **Barton, B.**, *Thirty Centuries of Graphic Design* (New York, 1987).

Crosby, T., 'Night Thoughts of a Faded Utopia', in D. Robbins (ed.), *The Independent Group: Postwar Britain and the Aesthetics of Plenty* (Cambridge, Mass., 1990).

Curtis, B., 'From Ivory Tower to Control Tower', in D. Robbins (ed.), *The Independent Group: Postwar Britain and the Aesthetics of Plenty* (Cambridge, Mass., 1990).

Darwin, R., 'The Dodo and the Phoenix', *Journal of the Royal Society of Arts* (Feb. 1954).

David, E., *French Country Cooking* (London, 1951).

Deighton, L., *The Ipcress File* (London, 1962).

Design (1949–64).

Eagleton, T., 'Capitalism, Modernism and Postmodernism', *New Left Review*, 152 (July–Aug. 1985).

Elderfield, J., *Kurt Schwitters* (London, 1985).

England, J., *et al.*, *William Green: The Susan Hayward Exhibition* (London, 1993).

Farson, D., *Soho in the Fifties* (London, 1987).

Frayling, C., *The Royal College of Art: One Hundred and Fifty Years of Art and Design* (London, 1987).

Freeman, R., 'Living with the 60's', *Cambridge Opinion*, 17 (1959).

Frith, S., and **Horne, H.**, *Art into Pop* (London, 1987).

Fuller, P., *Beyond the Crisis in Art* (London, 1980).

Garlake, M., *New Vision 56–66* (Bede Gallery, Jarrow, 1984).

Garland, K., 'Graphic Design 1951–1961: A Personal Memoir', unpublished paper (1983).

Gilliatt, M., *English Style* (London, 1967).

Godbolt, J., *A History of Jazz in Britain 1919–1950* (London, 1984).

Grey, N., *Nineteenth Century Ornamented Typefaces* (London, 1976).

Guyatt, R., 'Head, Heart and Hand', in Royal College of Art, *Anatomy of Design: RCA Inaugural Lectures* (London, 1951).

—— 'Graphic Design at the Royal College of Art', in *Graphics RCA: Fifteen Years' Work of the School of Graphic Design, Royal College of Art* (London, 1963).

—— (ed.), *Queen: The Royal College of Art Special Issue* (June 1967).

—— *et al.*, *The Lion and the Unicorn Press: Short History and List of Publications 1953–1978* (London, 1978).

Hall, S., and **Jefferson, T.** (eds.), *Resistance through Rituals: Youth Subcultures in Postwar Britain* (London, 1975).

—— and **Whannel, P.**, *The Popular Arts* (London, 1964).

Hamilton, R., *Collected Words* (London, 1982).

Harrison, C., *English Art and Modernism 1900–39* (London, 1981).

Hebdige, D., *Subculture: The Meaning of Style* (London, 1979).

—— *Hiding in the Light: On Images and Things* (London, 1988).

Hewison, R., *Under Siege: Literary Life in London 1939–45* (London, 1977).

—— *In Anger: Culture in the Cold War 1945–60* (London, 1981).

—— *Too Much: Art and Society in the Sixties 1960–1975* (London, 1986).

Hillier, B., *Austerity/Binge* (London, 1975).

Hoggart, R., *The Uses of Literacy* (London, 1957).

Horne, H., 'Hippies: A Study in the Sociology of Knowledge', Ph.D. thesis (University of Warwick, 1982).

Huizinga, J., *Homo Ludens: A Study of the Play-Element in Culture* (London, 1949).

Huxley, P. (ed.), *Exhibition Road: Painters at the Royal College of Art* (London, 1988).

Huygen, F., *British Design: Image and Identity* (London, 1989).

Huyssen, A., *After the Great Divide: Modernism, Mass Culture and Postmodernism* (Basingstoke, 1986).

—— 'The Cultural Politics of Pop', *New German Critique*, 4 (Winter 1975).

—— 'Mapping the Postmodern', *New German Critique*, 33 (Fall 1984).

Ironside, J., *Janey* (London, 1973).

Jameson, F., 'Postmodernism or the Cultural Logic of Late Capitalism', *New Left Review*, 146 (July–Aug. 1984).

Janello, A., and **Jones, B.**, *The American Magazine* (New York, 1991).

Jencks, C., *The Language of Postmodern Architecture* (London, 1991).

—— *What is Postmodernism?* (London, 1985).

Johnson, L., *The Cultural Critics* (London, 1979).

Johnstone, W., *Points in Time: An Autobiography* (London, 1980).

Jones, B., *Black Eyes and Lemonade* (Whitechapel Gallery, London, 1951).

—— *The Unsophisticated Arts* (London, 1951).

Jones, J. C., *Design Methods* (London, 1970).

—— *Essays in Design* (London, 1984).

Kepes, G., *The Language of Vision* (Chicago, 1944).

Kozloff, M., 'Pop Culture, Metaphysical Disgust and the New Vulgarians', *Art International*, 6 (Feb. 1962).

Kudielka, R., *Robyn Denny* (Tate Gallery, London, 1973).

Lambert, M., and **Marx, E.**, *English Popular and Traditional Art* (London, 1946).

Leffingwell, E., and **Marta, K.** (eds.), *Modern Dreams: The Rise and Fall and Rise of Pop* (New York, 1988).

Levy, M., *Ruskin Spear* (London, 1985).

Lewis, P., *The Fifties* (London, 1978).

Lippard, L., *Pop Art* (London, 1966).

Livingstone, M., 'Prototypes of Pop', in P. Huxley (ed.), *Exhibition Road: Painters at the Royal College of Art* (London, 1988).

—— *Pop Art: A Continuing History* (London, 1990).

MacDonald, S., *The History and Philosophy of Art Education* (London, 1970).

MacInnes, C., *Absolute Beginners* (London, 1959).

McLuhan, M., *The Mechanical Bride* (Chicago, 1951).

McRobbie, A., 'Postmodernism and Popular Culture', in L. Appignanesi (ed.), *Postmodernism* (London, 1986).

Marcus, G., *Lipstick Traces: A Secret History of the Twentieth Century* (London, 1989).

Martin, B., *A Sociology of Contemporary Cultural Change* (Oxford, 1981).

Marwick, A., *British Culture since 1945* (Oxford, 1991).

Massey, A., 'The Independent Group and Modernism in Britain 1951–56', *Association of Art Historians Bulletin* (July 1984).

—— 'The Independent Group: Towards a Redefinition', *Burlington Magazine*, 129 (Apr. 1987).

—— and **Sparke, P.**, 'The Myth of the Independent Group', *Block*, 10 (1985).

Mellor, D., 'The Pleasures and Sorrows of Modernity: Vision, Space and the Social Body in Richard Hamilton', in Tate Gallery, *Richard Hamilton* (London, 1992).

—— 'A "Glorious Techniculture" in 1950s Britain: The Many Cultural Contexts of the

Independent Group', in D. Robbins (ed.), *The Independent Group: Postwar Britain and the Aesthetics of Plenty* (Cambridge, Mass., 1990).

—— *Paradise Lost: The Neo-Romantic Imagination in Britain 1935–1955* (Barbican Art Gallery, London, 1987).

—— *The Sixties Art Scene in London* (Barbican Art Gallery, London, 1993).

Melville, R., 'Review of Five Young Painters', *Architectural Review* (Apr. 1958).

Moholy-Nagy, L., *The New Vision* (London, 1939).

Morris, L., 'The Beaux Arts Years 1948–57', in P. Huxley (ed.), *Exhibition Road: Painters at the Royal College of Art* (London, 1988).

Nevett, T. R., *Advertising in Britain: A History* (London, 1982).

Nuttall, J., *Bomb Culture* (London, 1970).

Owen, W., *Magazine Design* (London, 1991).

Pevsner, N., *The Englishness of English Art* (London, 1955).

—— *Studies in Art, Architecture and Design*, ii: *Victorian and After* (London, 1968).

Plant, S., *The Most Radical Gesture: The Situationist International in a Postmodern Age* (London, 1992).

Price, C., *Works II* (London, 1978).

Quant, M., *Quant by Quant* (London, 1966).

Read, H., *Art and Industry* (London, 1934).

Reichardt, J., 'Pop Art and After', *Art International* (7 Feb. 1963).

Robbins, D., *The Independent Group: Postwar Britain and the Aesthetics of Plenty* (Cambridge, Mass., 1990).

——'The Independent Group: Forerunners of Postmodernism?', in D. Robbins (ed.), *The Independent Group: Postwar Britain and the Aesthetics of Plenty* (Cambridge, Mass., 1990).

Robertson, B., 'Abstract Painters at the RCA', in P. Huxley (ed.), *Exhibition Road: Painters at the Royal College of Art* (London, 1988).

—— et al., *Private View: The Lively World of British Art* (London, 1966).

Royal College of Art, *Annual Reports* (1950–64).

—— 'Prospectuses' (1950–64).

—— 'Minutes of College Council' (1950–64).

Russell, G., *Designer's Trade: An Autobiography* (London, 1968).

Russell, J., and **Gablik, S.** (eds.), *Pop Art Redefined* (London, 1969).

Rykwert, J., et al., 'Tribute to Edward Joseph Wright', in *Typographic*, 37 (Winter 1988–9).

Seago, A., 'Burning the Box of Beautiful Things: *ARK* Magazine and the Development of a "Postmodern Sensibility" at the Royal College of Art: 1950–1962', Ph.D. thesis (Royal College of Art, London, 1990).

Smith, R., *Paintings 1958–1966* (London, 1966).

—— *Seven Exhibitions 1961–1975* (Tate Gallery, London, 1975).

Spalding, F., *Dance till the Stars come down: A Biography of John Minton* (London, 1991).

Sparke, P., 'Theory and Design in the Age of Pop', Ph.D. thesis (Brighton Polytechnic, 1975).

Spencer, H., *Pioneers of Modern Typography* (London, 1969).

Stangos, N. (ed.), *David Hockney by David Hockney* (London, 1976).

Sunday Times Colour Magazine (1962–5).

Sutton, J., and **Bartram, A.**, *An Atlas of Typeforms* (London, 1988).

Tate Gallery, *Richard Hamilton* (London, 1992).

—— *Peter Blake* (London, 1983).

Thompson, D. (ed.), *Discrimination and Popular Culture* (Harmondsworth, 1964).

Thompson, P., *Voice of the Past: Oral History* (Oxford, 1988).

Typographica (1950–66).

Ullstein, G., 'Patrons of Design: Jack Beddington', *Design*, 31 (July 1951).

Uppercase (1958–61).

Varley, W., 'Art is Art is Art', in B. Bergonzi (ed.), *Innovations* (London, 1968).

Venturi, R., et al., *Learning from Las Vegas* (New York, 1972).

Walker, J. A., *Art in the Age of the Mass Media* (London, 1983).

—— *Crossovers: Art into Pop; Pop into Art* (London, 1987).

Webb, P., *Portrait of David Hockney* (London, 1988).

Whiteley, N., *Pop Design: Modernism to Mod* (London, 1987).

Whitford, F., *Eduardo Paolozzi* (Tate Gallery, London, 1971).

Whitham, G., 'The Independent Group at the ICA: Its Origins, Development and Influences 1951–1961', Ph.D. thesis (University of Kent, Canterbury, 1986).

—— 'Chronology', in D. Robbins (ed.), *The Independent Group: Postwar Britain and the Aesthetics of Plenty* (Cambridge, Mass., 1990).

Wiener, M., *English Culture and the Decline of the Industrial Spirit: 1850–1980* (Harmondsworth, 1985).

Williams, C., 'A Survey of the Relationship between Pop Art, Pop Music and Pop Films in Britain from 1956–76', MA thesis (Royal College of Art, London, 1976).

Williams, R., *Culture and Society: 1780–1950* (London, 1958).

—— *The Long Revolution* (Harmondsworth, 1961).

Wilson, D., *Projecting Britain: Ealing Studios Film Posters* (London, 1982).

Wright, E., *Graphic Work and Painting* (London, 1985).

Notes

Introduction

1 Dick Hebdige, 'A Report from the Western Front', *Block*, 12 (1986–7), 7.
2 Andreas Huyssen, 'Mapping the Postmodern', *New German Critique*, 33 (Fall 1984), 8. This essay also appears in Andreas Huyssen, *After the Great Divide: Modernism, Mass Culture and Postmodernism* (Basingstoke, 1986).
3 Ibid. 16.
4 Ibid. 19.
5 Ibid. 21.
6 Ibid. 20.
7 Ibid. 23.
8 Ibid. 24.

Chapter 1

1 Pete Brown and Piblokto!, *Years may come, years may go, but the Art School Dance goes on forever* (EMI/Harvest, 1970).
2 Jeff Nuttall, *Bomb Culture* (London, 1970), 114.
3 Ibid. 116.
4 Ibid.
5 Ibid. 120.
6 Christopher Booker, *The Neophiliacs: A Study of the Revolution in English Life in the Fifties and Sixties* (London, 1969), 42.
7 Ibid. 42–3.
8 See e.g. Peter Fuller, 'Art Education: Some Observations', *Aspects*, 18 (Spring 1982).
9 Robert Hewison, *Too Much: Art and Society in the Sixties 1960–1975* (London, 1986), p. xii.
10 Ibid.
11 Ibid.
12 Robert Hewison, *In Anger: Culture in the Cold War 1945–60* (London, 1981), 64.
13 Ibid. 64–5.
14 Hewison, *Too Much*, 63–4.
15 Bryan Appleyard, *The Pleasures of Peace: Art and Imagination in Postwar Britain* (London, 1989), 129.
16 Ibid. 130.
17 Ibid. This is a questionable statement. The Euston Road style of Sickert was more of an 'orthodoxy' in pre-war Britain than the work of Picasso or Matisse.
18 Ibid. 131.
19 Ibid.
20 Ibid. 190.
21 Ibid. 192.
22 Bernice Martin, *A Sociology of Contemporary Cultural Change* (Oxford, 1981), 1.
23 Ibid. 138.
24 Ibid. 2.
25 Ibid.
26 Ibid. 15.
27 Ibid. 112.
28 Ibid. 94.
29 Ibid.
30 Martin was associated with the group which produced the 'Black Papers on Education' between 1969 and 1970. This group, which included Kingsley Amis, Robert Conquest, Rhodes Boyson, and Philip Larkin, attacked the growing influence of progressive education in British schools. See Hewison, *Too Much*, 295–6.

Notes

31 Howard Horne, 'Hippies: A Study in the Sociology of Knowledge', Ph.D. thesis (University of Warwick, 1982), 4.

32 Ibid. 5.

33 Ibid. 305–6.

34 Ibid. 345.

35 Ibid. 412.

36 Simon Frith and Howard Horne, *Art into Pop* (London, 1987), 1.

37 Ibid. 29–30.

38 Ibid. 30.

39 Ibid. 55.

40 Ibid. 180.

41 Ibid. 164.

42 Colin Campbell, *The Romantic Ethic and the Spirit of Modern Consumerism* (Oxford, 1987), 206.

43 Ibid.

44 Frith and Horne, *Art into Pop*, 21.

45 Ibid. 169.

46 Ibid.

47 Richard Smith, 'Man and He-Man', *ARK* 20 (Autumn 1957).

48 Terry Atkinson *et al.*, 'A Fine Artz View of Teenage Cults', *ARK* 36 (Summer 1964).

49 William Varley, 'Art is Art is Art', in Bernard Bergonzi (ed.), *Innovations: Essays on Art and Ideas* (London, 1968), 226–37.

50 Penny Sparke, 'Theory and Design in the Age of Pop', Ph.D. thesis (Brighton Polytechnic, 1975).

51 See Graham Whitham, 'The Independent Group at the Institute of Contemporary Arts: Its Origins, Development, and Influences, 1951–1961', Ph.D. thesis (University of Kent at Canterbury, 1986); Anne Massey, 'The Independent Group: Towards a Redefinition', *Burlington Magazine*, 129 (Apr. 1987), 232–42; Anne Massey and Penny Sparke, 'The Myth of the Independent Group', *Block*, 10 (1985), 48–56; Nigel Whiteley, *Pop Design: Modernism to Mod* (London, 1987), ch. 3; David Robbins (ed.), *The Independent Group: Postwar Britain and the Aesthetics of Plenty* (Cambridge, Mass. 1990); Edward Leffingwell and Karen Marta (eds.), *Modern Dreams: The Rise and Fall and Rise of Pop* (New York, 1988).

52 Christopher Williams, 'A Survey of the Relationship between Pop Art, Pop Music and Pop Films in Britain from 1956–76', MA thesis (Royal College of Art, 1976), 18.

53 Ibid. 22.

54 Ibid. 54.

55 Ibid. 49.

56 Ibid. 101.

57 Whiteley, *Pop Design*, 8.

58 Ibid. 90.

59 John A. Walker, *Crossovers: Art into Pop; Pop into Art* (London, 1987), 8–9.

60 Ibid.

61 Ibid. 16.

62 Ibid. 17.

63 Ibid. 19.

Chapter 2

1 Richard Guyatt, 'Graphic Design at the Royal College of Art', in *Graphics RCA: Fifteen Years' Work of the School of Graphic Design, Royal College of Art* (London, 1963), 22.

2 Richard Guyatt interviewed by the author, 10 Jan. 1989.

3 Richard Guyatt, 'Head, Heart and Hand', in *Anatomy of Design: RCA Inaugural Lectures* (London, 1951), 38.

4 Ibid. 40.

5 Robin Darwin quoted in Christopher Frayling, *The Royal College of Art: One Hundred and Fifty Years of Art and Design* (London, 1987), 131.

6 Richard Guyatt interviewed by the author, 10 Jan. 1989.

7 Ibid.

8 An example of this was *The Compleat Imbiber*, a magazine promoting the inebriate benefits of Gilbey's gin, produced between 1956 and 1957 with the assistance of Henrion's students in the School of Design. See William Owen, *Magazine Design* (London, 1991), 84.

9 Richard Guyatt, 'Prospectus: Royal College of Art: 1959', 5.

10 Richard Guyatt *et al.*, *The Lion and the Unicorn Press: Short History and List of Publications 1953–1978* (London, 1978).

11 Jack Stafford, 'Editorial', *ARK* 1 (Autumn 1950).

12 Ibid.

13 Len Deighton interviewed by the author, 4 Jan. 1989.

14 For example, an unsigned review in *Typographica*, 2 (1950) reads: 'The only reasonable reaction on seeing the first issue of *ARK* . . . must surely be one of warm welcome . . . something really worthwhile has been started, and it seems evident that there is sufficient impetus here to carry future issues along with the same zest . . . It is good that such a journal should be an arena and not just a jolly gymnasium or, worse still, a wailing wall . . . We look forward to future issues.'

15 Bernard Myers, 'The First Twenty Five Years: The First Fifty Issues', *ARK* 50 (Autumn 1975).

16 Kenneth Garland interviewed by the author, 16 June 1989.

17 See *Gebrauchsgraphik: International Journal of Advertising Art*, 4 (1960), 36–43.

18 Tony Evora interviewed by the author, 16 Sept. 1989.

19 *RCA Annual Report* (1951–2).

20 See Ch. 5.

21 Denis Bowen, 'To "What is it?" Questioners', *ARK* 30 (Winter 1961), 24.

22 Richard Smith, 'New Readers Start Here', *ARK* 32 (Summer 1962), 38.

23 Bill James, 'Editorial', *ARK* 33 (Winter 1962), 1.

24 *RCA Annual Report* (1960).

25 'Minutes of RCA Financial and General Purposes Subcommittee' (May 1963).

26 Terry Atkinson *et al.*, 'Fine Artz View of Teenage Cults', *ARK* 35 (Spring 1964), 40.

27 Ibid. 45.

28 Derek Boshier writes: 'I remember a group of Royal College painters going to a Slade School of Art party, and a Slade student saying: "There's those Pop Art boys—let's get 'em!" ' (letter to the author, June 1992).

29 Mark Boxer, '*ARK*: The Journal of the Royal College of Art', in *Graphics RCA*.

30 Michael Myers, 'Editorial', *ARK* 35 (Spring 1964), 10.

Chapter 3

1 Theo Crosby interviewed by the author, 20 June 1989.

2 Robin Darwin, quoted in Frayling, *The Royal College of Art*, 128–9.

3 Richard Guyatt interviewed by the author, 10 Jan. 1989.

4 Nigel Chapman interviewed by the author, 24 Jan. 1989.

5 Clifford Hatts interviewed by the author, 6 May 1989.

6 Frayling, *The Royal College of Art*, 147.

7 Ibid.

8 Richard Guyatt interviewed by the author, 10 Jan. 1989.

9 For an elaboration of this theme see Virginia Button, 'The Aesthetic of Decline: English Neo-Romanticism *c.* 1935–1956', Ph.D. thesis (University of London, Courtauld Institute of Art, 1991).

10 Raymond Hawkey interviewed by the author, 19 Jan. 1989.

11 Nikolaus Pevsner, 'The Return of Historicism', in *Studies in Art, Architecture and Design,* ii: *Victorian and After* (London, 1968), 243.

12 Ibid. 255.

13 Ibid.

14 Charles Hasler, 'Festival Lettering: A Specimen of Display Letters Designed for the Festival of Britain', in Mary Banham and Bevis Hillier (eds.), *A Tonic to the Nation* (London, 1976), 114.

15 Robyn Denny interviewed by the author, 5 June 1989.

16 David Mellor (ed.), *Paradise Lost: The Neo-Romantic Imagination in Britain 1935–1955* (London, 1987), 76.

17 Peter Blake interviewed by the author, 26 Oct. 1989.

18 Dennis Bailey interviewed by the author, 26 Oct. 1989.

19 Richard Guyatt interviewed by the author, 10 Jan. 1989.

20 Barbara Jones, 'Roundabouts: The Demountable Baroque', *Architectural Review* (1945). Quoted in Bevis Hillier, *Austerity/Binge* (London, 1975), 73.

21 Charles Plouviez in Banham and Hillier (eds.), *A Tonic to the Nation*, 165–6.

22 George McGowan, 'Black Eyes and Lemonade', *Everybody's* (21 Aug. 1951), 14.

23 Sir Gerald Barry, 'Retrospect', *ARK* 4 (Winter 1952), 6.

24 Jim Lovegrove, 'The Spritsail Sailing Barge', *ARK* 4 (Winter 1952), 12.

25 Ibid. 14.

26 David Weeks, 'Editorial', *ARK* 7 (Spring

1953), 2.

27 David Gentleman, 'Saints and Sardines', *ARK* 7 (Spring 1953), 17.

28 John E. Blake, 'Mainly Concerning Landscape', *ARK* 5 (Summer 1952), 26.

29 Bernard Myers, 'Pictures on the Skin', *ARK* 13 (Spring 1955), 15.

30 Colin Sorensen, 'Up the Line to London', *ARK* 18 (Autumn 1956), 18.

31 Rosalind Dease, 'Mr. Buckett of Brougham St. Battersea', *ARK* 8 (Summer 1953), 24.

32 Frayling, *The Royal College of Art*, 130.

33 Robin Darwin, 'Open Letter to Professor R. D. Russell', *ARK* 2 (Winter 1951), 23.

34 Gordon Russell, *Designer's Trade: An Autobiography* (London, 1968), 263.

35 Ibid. 262.

36 Ibid. 152.

37 Gordon Russell, 'What is Good Design?', *Design* (Jan. 1949), 3.

38 Gordon Russell, 'Kitsch', *Design*, 37 (Jan. 1952), 4.

39 Nigel Chapman interviewed by the author, 24 Jan. 1989.

40 John E. Blake interviewed by the author, 1 Feb. 1989.

41 Joseph Burrows, 'In Defence of Common Vulgarity', *ARK* 6 (Autumn 1952), 26.

42 Jack Stafford, 'Editorial', *ARK* 1 (Autumn 1950), 2.

43 John Minton, 'Doing the Book of the Film, or How I Ruined my Life', *ARK* 1 (Autumn 1950), 18.

44 Ibid.

45 Ibid.

46 Dennis Bailey interviewed by the author, 26 Oct. 1989.

47 Gabrielle Ullstein, 'Patrons of Design: Jack Beddington', *Design*, 31 (July 1951), 5. See also T. R. Nevett, *Advertising in Britain: A History* (London, 1982). See also David Bernstein (ed.), *That's Shell— That Is! An Exhibition of Shell Advertising Art* (Barbican Art Gallery, London, 1983).

48 Nigel Birch, *The Advertising we Deserve?* (London, 1962), 37.

49 Nikolaus Pevsner quoted in Ullstein, 'Patrons of Design'.

50 Dennis Bailey interviewed by the author, 26 Oct. 1989.

51 Raymond Hawkey, 'Advertising: A Skeleton in Whose Cupboard?', *ARK* 5 (Summer 1952), 14.

52 Jack Beddington, 'Advertising: No Skeleton in Anybody's Cupboard', *ARK* 5 (Summer 1952), 17.

53 Hawkey, 'Advertising: A Skeleton in Whose Cupboard?'

54 Frank Height and V. A. Hindley, 'Folly and Design', *ARK* 6 (Autumn 1952), 50.

55 Gordon Russell, 'Industry and the RCA', *ARK* 8 (Summer 1953), 9.

56 Ibid. 10.

57 Alan Fletcher interviewed by the author, 22 May 1989.

58 Brian Duffy interviewed by the author, 25 Oct. 1989.

59 Cyril Ray, 'Londres la nuit', *ARK* 12 (Autumn 1954), 13.

Chapter 4

1 Clifford Hatts interviewed by the author, 6 June 1989.

2 Denis Bowen interviewed by the author, 7 Feb. 1990.

3 Clifford Hatts interviewed by the author, 6 June 1989.

4 Ronald Searle, 'The Survivor', *ARK* 10 (Spring 1954), 34.

5 Ted Dicks interviewed by the author, 4 Jan. 1989.

6 Peter Blake interviewed by the author, 12 June 1989.

7 Robyn Denny interviewed by the author, 5 June 1989.

8 Terry Green interviewed by the author, 31 Aug. 1989.

9 Len Deighton interviewed by the author, 4 Jan. 1989.

10 Joe Tilson interviewed by the author, 8 Oct. 1989.

11 Len Deighton interviewed by the author, 4 Jan. 1989.

12 Denis Bowen interviewed by the author, 7 Feb. 1990.

13 Ted Dicks interviewed by the author, 4 Jan. 1989.

14 Richard Guyatt interviewed by the author, 10 Jan. 1989.

15 Clifford Hatts interviewed by the author, 6 June 1989.

16 Richard Hamilton in conversation at the Institute of Contemporary Arts, 14 Feb. 1990. See also David Mellor, 'The

Pleasures and Sorrows of Modernity: Vision, Space and the Social Body in Richard Hamilton', in Tate Gallery, *Richard Hamilton* (London, 1992), 27–39.

17 Ted Dicks interviewed by the author, 4 Jan. 1989.

18 Bruce Lacey interviewed by the author, 30 Mar. 1989.

19 Bruce Lacey, 'Minutes of the First Dodo Cocktail Party' (July 1954).

20 Ibid.

21 Bruce Lacey interviewed by the author, 30 Mar. 1989.

22 Ibid.

23 Ibid.

24 Bruce Lacey, 'Other People's Attics', *ARK* 10 (Spring 1954), 26.

25 Kenneth Garland interviewed by the author, 16 June 1989.

26 Nuttall, *Bomb Culture*, 117.

27 Ibid. 157.

28 Bruce Lacey interviewed by the author, 30 Mar. 1989.

29 Alan Fletcher interviewed by the author, 22 May 1989.

30 See e.g. Hewison, *In Anger*, pp. xiv–xv, 268.

31 Theo Crosby interviewed by the author, 20 June 1989.

32 John Hodges, 'Collage', *ARK* 17 (Summer 1956), 24.

33 Terry Green interviewed by the author, 31 Aug. 1989.

34 John Minton, 'Three Young Contemporaries', *ARK* 13 (Spring 1955), 13.

35 Denis Bowen, 'A Reply to "What is It?" Questioners', *ARK* 30 (Winter 1961), 24.

36 Ken Baynes, 'Better and Worse Dreams: Some Ideas about Design', *ARK* 30 (Winter 1961), 27–8.

37 Denis Bowen interviewed by the author, 7 Feb. 1990.

38 Robyn Denny interviewed by the author, 5 June 1989.

39 Robyn Denny, 'Mosaic', *ARK* 16 (Spring 1956), 18.

40 Derek Hyatt interviewed by the author, 16 Nov. 1989.

41 Denny, 'Mosaic'.

42 Richard Smith, 'Ideograms', *ARK* 17 (Summer 1956), 14.

43 Graham Whitham, 'Chronology', in Robbins (ed.), *The Independent Group*, 38.

44 Edward Wright, 'Chad, Kilroy, the Cannibal's Footprint and the Mona Lisa', *ARK* 19 (Spring 1957), 5.

45 Robyn Denny interviewed by the author, 5 June 1989.

46 Ibid.

47 Ibid.

48 Ibid.

49 Derek Hyatt interviewed by the author, 16 Nov. 1989.

50 Derek Hyatt, 'Kurt Schwitters, Paul Nash and Mrs. Nevelson', *ARK* 23 (Autumn 1958), 12.

51 Frayling, *The Royal College of Art*, 124–5.

52 Peter Blake interviewed by the author, 12 June 1989.

53 Gordon Moore interviewed by the author, 25 Aug. 1989.

54 Alan Fletcher interviewed by the author, 22 May 1989.

55 Robyn Denny interviewed by the author, 5 June 1989.

56 Guyatt, 'Graphic Design at the RCA'.

57 Brian Haynes interviewed by the author, 18 Feb. 1990.

58 Ibid.

59 Huyssen, 'Mapping the Postmodern', 116.

60 Robyn Denny interviewed by the author, 5 June 1989.

61 Margaret Garlake, *New Vision 56–66* (Bede Gallery, Jarrow, 1984), 13.

62 See Anne Massey, 'The Independent Group and Modernism in Britain 1951–56', *Association of Art Historians Bulletin* (July 1984), 23–4. See also Massey and Sparke, 'The Myth of the Independent Group', 48–56. See also Robbins (ed.), *The Independent Group*, *passim*.

63 Joe Tilson interviewed by the author, 8 Sept. 1989.

64 Robyn Denny interviewed by the author, 5 June 1989.

65 David Collins interviewed by the author, 17 Nov. 1989.

66 Robyn Denny interviewed by the author, 5 June 1989.

67 Roger Coleman interviewed by the author, 26 June 1989.

68 Roger Coleman, 'Editorial', *ARK* 18 (Autumn 1956), 2.

69 Roger Coleman, 'Two Painters', *ARK* 20 (Autumn 1957), 23.

70 See Graham Whitham, 'Chronology', in Robbins (ed.), *The Independent Group*.

71 Roger Colman interviewed by the author, 26 June 1989.

72 Lawrence Alloway, 'Personal Statement', *ARK* 19 (Spring 1957), 28.

73 Lawrence Alloway, 'Marks and Signs', *ARK* 22 (Summer 1958), 18.

74 Roddy Maude-Roxby interviewed by the author, 22 May 1989.

75 Griel Marcus, *Lipstick Traces: A Secret History of the Twentieth Century* (London, 1989), 51–3. See also Sadie Plant, *The Most Radical Gesture: The Situationist International in a Postmodern Age* (London, 1992).

76 See Johan Huizinga, *Homo Ludens: A Study of the Play-Element in Culture* (London, 1949). See also Cedric Price, *Works II* (London, 1978). Cedric Price contributed several articles to *ARK* including a series on the 'Fun Palace' (*ARK*s 35 and 36 (1964)).

77 Reyner Banham, 'The City as Scrambled Egg', *Cambridge Opinion*, 17 (1959), 18–24.

78 Ralph Rumney, 'The Leaning Tower of Venice', *ARK* 24 (Spring 1959), and continued in *ARK*s 25 and 26.

79 Roger Colman interviewed by the author, 26 Aug. 1989.

80 Lawrence Alloway quoted in Hewison, *In Anger*, 188.

81 Garlake, *New Vision 56–66*.

82 Roger Coleman, 'Guide' to 'Place' (23 Sept. 1959), quoted in Robert Kudielka, *Robyn Denny* (Tate Gallery, London, 1973), 27.

83 Roger Coleman interviewed by the author, 26 June 1989.

84 Eric Newton and Lawrence Alloway, quoted in Kudielka, *Robyn Denny*, 28.

85 Denis Bowen interviewed by the author, 7 Feb. 1990.

86 Roger Colman, Introd. to 'Situation' catalogue, quoted in Kudielka, *Robyn Denny*, 28.

87 Roger Colman interviewed by the author, 28 June 1989.

88 Robyn Denny interviewed by the author, 5 June 1989.

89 Robyn Denny and Richard Smith, 'A Stiffy on Whose Easel?', *RCA Newssheet No. III* (1956), quoted in Frances Spalding, *Dance till the Stars come down: A Biography of John Minton* (London, 1991), 230.

90 See Spalding, *Dance till the Stars come down*, 230–2.

91 Robyn Denny interviewed by the author, 5 June 1989.

92 Ruskin Spear, quoted in Mervyn Levy, *Ruskin Spear* (London, 1985), 35.

93 Robin Darwin, *RCA Annual Report* (1960).

94 Roddy Maude-Roxby interviewed by the author, 19 May 1989.

95 Robyn Denny interviewed by the author, 5 June 1989.

96 Denis Bowen interviewed by the author, 7 Feb. 1990.

97 William Green in a letter to the author, 9 Mar. 1993.

98 Ibid.

99 John Bratby, *Breakdown* (London, 1960), 59.

100 *Daily Express*, 19 May 1956. Quoted in Spalding, *Dance till the Stars come down*, 216.

101 David Gillespie interviewed by the author, 15 June 1989.

102 Ibid.

103 Ibid.

104 Ibid.

105 Ibid.

106 Frith and Horne, *Art into Pop*; Walker, *Crossovers*.

107 David Gillespie interviewed by the author, 15 June 1989.

108 Denis Postle interviewed by the author, 31 May 1989.

109 Ibid.

110 Ibid.

111 Ibid.

112 'Minutes of College Council' (May 1959).

113 Denis Postle interviewed by the author, 31 May 1989.

114 Terry Green interviewed by the author, 31 Aug. 1989.

115 Ibid.

116 Ibid.

117 Ibid.

Chapter 5

1 One notable exception was Basil Ward, Professor of Architecture. In his inaugural lecture 'Architecture and the Designer' in *Anatomy of Design* (Royal College of Art, London, 1951), he

declared that 'the modern movement . . . represents a most important grouping . . . now widespread and moving significantly towards a new unity of art and science. In its work the modern movement has, within its techniques and in high degree, developed a new canon of taste, and the principles which it embodies have, in my view, the universal qualities of great art. I believe that this new canon of taste is becoming the dominant one, and that a great art style will develop as its outcome.' Under Basil Ward's leadership the School of Architecture offered courses to all students in an attempt to make a grounding in the modern movement an essential part of the RCA experience. Several interviewees recall the impact of Sergei Kadleigh's lectures in this context. (For example, Roger Coleman recalls that Kadleigh was 'absolutely besotted with proportion'.) Kadleigh's utopian modernist architectural schemes are displayed in an article in *ARK* 16 (Spring 1956) entitled 'Mr. Mansell Visits High Paddington', an account of a visit to a futuristic housing estate built on *pilotis* above Paddington Station.

2 Joe Tilson interviewed by the author, 8 Sept. 1989.

3 Ibid.

4 Ibid.

5 Lawrence Alloway, 'Pop Art since 1949', *Listener*, 68 (27 Dec. 1962), 1085–7.

6 Lawrence Alloway, 'The Development of British Pop', in Lucy Lippard (ed.), *Pop Art* (London, 1966), 43.

7 Ibid. 60.

8 Peter Phillips quoted in Alloway, 'The Development of British Pop', 66.

9 Alan Fletcher interviewed by the author, 22 May 1989.

10 Raymond Hawkey interviewed by the author, 19 June 1989.

11 Ibid.

12 Ibid.

13 Ibid.

14 Len Deighton interviewed by the author, 4 Jan. 1989.

15 Len Deighton in a letter to the author, 1 Mar. 1992.

16 Len Deighton interviewed by the author, 4 Jan. 1989.

17 Jack Stafford, 'Editorial', *ARK* 1 (Autumn 1950), 2.

18 See Dick Hebdige, 'Towards a Cartography of Taste: 1935–1962', in Dick Hebdige, *Hiding in the Light* (London, 1988).

19 Jack Stafford, 'Honesty in Design', *ARK* 2 (Winter 1951), 7.

20 R. D. Russell, 'Reply to Robin Darwin', *ARK* 2 (Winter 1951), 25.

21 Robin Darwin, 'Minutes of College Council' (1955).

22 Ibid.

23 Alan Fletcher interviewed by the author, 22 May 1989.

24 Alan Fletcher, 'Letter from America', *ARK* 19 (Spring 1957), 25.

25 Ibid.

26 For a detailed history of the D. & AD see Julia Bingham, 'The Designers and Art Directors' Association in the 1960s: A Reflection of Changes in Graphic Design and Advertising', MA thesis (Royal College of Art, London, 1989).

27 Geoffrey White interviewed by the author, 23 Sept. 1989.

28 Ken Garland interviewed by the author, 16 June 1989.

29 Ken Garland, 'Graphic Design 1951–1961: A Personal Memoir', unpublished paper delivered at a seminar on 'Postwar Graphic Design History', Kingston Polytechnic (21 Mar. 1983).

30 June Fraser interviewed by the author, 31 Aug. 1989.

31 Ibid.

32 Douglas Merritt interviewed by the author, 26 Mar. 1990.

33 Ibid.

34 Bernard Myers, 'The First Twenty Five Years: The First Fifty Issues', *ARK* 50 (Autumn 1975), 22–3.

35 Toni del Renzio, 'Shoes, Hair, and Coffee', *ARK* 20 (Autumn 1957).

36 Alan Bartram in a letter to the author, 14 Oct. 1989.

37 Ibid.

38 Reyner Banham in the film *Fathers of Pop* (Arts Council, 1979).

39 Ivon Hitchens, 'Notes on Painting', *ARK*

18 (Autumn 1956); Robert Adams, 'Personal Statement', *ARK* 19 (Spring 1957); Robert Melville, 'Action Painting: New York, Paris, London', *ARK* 18 (Autumn 1956); Georges Mathieu, 'La Condamnation de Siger de Brabant', *ARK* 20 (Autumn 1957); Roger Colman, 'Two Painters', *ARK* 20 (Autumn 1957).

40 In an interview with Graham Whitham (18 Apr. 1983) Coleman explained: 'a lot of it was to do anything to keep out the people from the Weaving Department who . . . wanted to do some articles on the decoration of barges, which we were desperately trying to avoid. And so anything was OK as long as it was made of aluminium . . . and went fast, then it was OK and would get in.'

41 Roger Colman interviewed by the author, 26 June 1989.

42 Ibid.

43 See Robbins (ed.), *The Independent Group*.

44 Ian MacKenzie-Kerr interviewed by the author, 13 June 1989.

45 Herbert Read, 'Question and Answer', *ARK* 16 (Spring 1956), 47.

46 Reyner Banham, 'A New Look in Cruiserweights', *ARK* 16 (Spring 1956), 44.

47 Ibid.

48 Lawrence Alloway, 'Technology and Sex in Science Fiction: A Note on Cover Art', *ARK* 17 (Summer 1956), 19.

49 Ibid.

50 Lawrence Alloway, 'Personal Statement', *ARK* 19 (Spring 1957), 15.

51 Basil Taylor in *Artists as Consumers: The Splendid Bargain*, Part of the 'Art and Anti-Art' series (11 Mar. 1960), BBC Third Programme. (See Whitham, 'Chronology', in Robbins (ed.), *The Independent Group*.)

52 Joseph Rykwert interviewed by the author, 20 June 1989. See also Joseph Rykwert, Dennis Bailey, *et al.*, 'Tribute to Edward Joseph Wright', *Typographic*, 37 (Winter 1988–9), *passim*.

53 Richard Smith in the film *Fathers of Pop*.

54 Roger Colman interviewed by the author, 26 June 1989.

55 Peter and Alison Smithson, 'Personal Statement: But Today we Collect Ads.', *ARK* 18 (Autumn 1956), 28.

56 David Robbins, 'American Ads.', in Robbins (ed.), *The Independent Group*, 59.

57 Peter and Alison Smithson, 'Personal Statement: But Today we Collect Ads.'.

58 Richard Smith, 'Man and He-Man', *ARK* 20 (Autumn 1957), 20.

59 Ibid.

60 Roger Coleman interviewed by the author, 28 June 1989.

61 Richard Smith, 'Sitting in the Middle of Today', *ARK* 19 (Spring 1957), 30.

62 Roger Coleman, 'Dream Worlds, Assorted', *ARK* 19 (Spring 1957), 24.

63 Ibid.

64 Ibid.

65 Ibid.

66 Richard Smith, in *Richard Smith: Paintings 1958–1966* (Whitechapel Gallery, London, May 1966).

67 'Advertising 1' with speeches by Peter Smithson, Eduardo Paolozzi, John McHale, Lawrence Alloway (15 Apr. 1955); 'Fashion and Fashion Magazines', by Toni del Renzio (24 June 1955); 'Gold Pan Alley', by Frank Cordell (15 July 1955). See Graham Whitham, 'Appendix: Notes on the Independent Group Session of 1955', in Robbins (ed.), *The Independent Group*, 274.

68 Lawrence Alloway, 'The Long Front of Culture', *Cambridge Opinion*, 17 (1959), 25–6.

69 Marshall McLuhan, *The Mechanical Bride: Folklore of Industrial Man* (Chicago, 1951).

70 Lawrence Alloway, 'Communications Comedy and the Small World', *ARK* 20 (Autumn 1957), 40.

71 L. Bruce Archer interviewed by the author, 20 Dec. 1988.

72 John Christopher Jones, 'How my Thoughts on Design Have Changed during the Years', in John Christopher Jones, *Essays in Design* (London, 1984), 15.

73 See Mellor, 'The Pleasures and Sorrows of Modernity', 27–39.

74 Roger Colman interviewed by the author, 26 June 1989.

75 Colin Cherry, 'Communication and the Growth of Societies', *Cambridge Opinion*, 17 (1959), 12–14.

76 Robert Freeman, 'Living with the 60's', *Cambridge Opinion*, 17 (1959), 2–4.

77 Robyn Denny interviewed by the author, 5 June 1989.
78 Roger Colman interviewed by the author, 26 June 1989.
79 Derek Hyatt interviewed by the author, 16 Nov. 1989.
80 For example, Colin Cherry lectured at the ICA on 'Automation amongst the Artists' (20 Jan. 1959), Roger Coleman arranged a discussion on 'Ergonomics' (21 May 1959), and W. Ross Ashby lectured on 'Art and Communication Theory' (7 Apr. 1960). See Whitham, 'Chronology', in Robbins (ed.), *The Independent Group*.
81 Margaret Leischner, 'The New Bauhaus', *ARK* 14 (Summer 1955).
82 L. Bruce Archer interviewed by the author, 20 Dec. 1988.
83 Theo Crosby interviewed by the author, 20 June 1989.
84 Roger Coleman interviewed by the author, 28 June 1989.
85 David Collins interviewed by the author, 17 Nov. 1989.
86 Robyn Denny interviewed by the author, 5 June 1989.
87 Date for 'Minority Pop' from Whitham, 'Chronology', in Robbins (ed.), *The Independent Group*.

Chapter 6

1 Peter Blake interviewed by the author, 12 June 1989.
2 Ibid.
3 Ibid.
4 Ibid.
5 Roger Colman interviewed by the author, 28 June 1989.
6 Roger Colman, 'A Romantic Naturalist: Some Notes on the Painting of Peter Blake', *ARK* 18 (Autumn 1956), 17.
7 Ibid.
8 Ibid.
9 Robert Melville, 'Review', *Architectural Review* (Mar. 1958), 278.
10 Robyn Denny interviewed by the author, 5 June 1989.
11 Peter Blake interviewed by the author, 12 June 1989.
12 Daniel Farson, *Soho in the Fifties* (London, 1987).
13 Colin MacInnes, *Absolute Beginners* (London, 1959).
14 Brian Duffy interviewed by the author, 25 Oct. 1989.
15 Joe Tilson interviewed by the author, 8 Sept. 1989.
16 Len Deighton, 'Down Past Compton on Frith, Food Makes Wonderful Music', *ARK* 10 (Spring 1954), 15.
17 Len Deighton, *The Ipcress File* (London, 1962).
18 See Richard Smith, *Seven Exhibitions 1961–1975* (Tate Gallery, London, 1975), 109.
19 Anthony Atkinson, 'Editorial', *ARK* 14 (Summer 1955), 2.
20 Bratby, *Breakdown*, 90.
21 Roger Colman interviewed by the author, 28 June 1989.
22 Dennis Bailey interviewed by the author, 26 Mar. 1990.
23 Brian Duffy interviewed by the author, 25 Oct. 1989.
24 Robin Darwin quoted in Frayling, *The Royal College of Art*, 167.
25 Len Deighton in a letter to the author, 1 Mar. 1992.
26 Brian Duffy interviewed by the author, 25 Oct. 1989.
27 See Alloway, 'The Development of British Pop', 47.
28 Ken Garland interviewed by the author, 16 June 1989.
29 Derek Hyatt interviewed by the author, 16 Nov. 1989.
30 Brian Duffy interviewed by the author, 25 Oct. 1989.
31 See William Owen, *Magazine Design* (London, 1991), 89–91.
32 Ian Dury quoted in Frayling, *The Royal College of Art*, 166.
33 See Marco Livingstone, 'Prototypes of Pop', in Paul Huxley (ed.), *Exhibition Road: Painters at the RCA* (London, 1988). See also Marco Livingstone, *Pop Art: A Continuing History* (London, 1990).
34 R. B. Kitaj quoted in Peter Webb, *Portrait of David Hockney* (London, 1988), 33.
35 David Hockney quoted ibid. 32.
36 Livingstone, 'Prototypes of Pop', 41.
37 Alloway, 'Pop Art since 1949', 1087.
38 Richard Smith, 'New Readers Start Here', *ARK* 32 (Summer 1962), 40.
39 Ibid. 42.
40 Ibid. 41.

41 Brian Haynes interviewed by the author, 18 Feb. 1990.

42 Richard Hamilton in letter to the Smithsons (16 Jan. 1957), in Richard Hamilton, *Collected Words* (London, 1982), 28.

43 Brian Haynes interviewed by the author, 18 Feb. 1990.

44 See Webb, *Portrait of David Hockney*, and Nikos Stangos (ed.), *David Hockney by David Hockney* (London, 1976), 74–5.

45 Brian Haynes interviewed by the author, 18 Feb. 1990.

46 Ibid.

47 See Frayling, *The Royal College of Art*, 156–7.

48 Livingstone, 'Prototypes of Pop', 44.

49 Brian Haynes interviewed by the author, 18 Feb. 1990.

Chapter 7

1 Mark Boxer, '*ARK*: The Journal of the Royal College of Art', in *Graphics RCA*.

2 Jack Stafford, 'Editorial', *ARK* 1 (Autumn 1950).

3 Owen, *Magazine Design*, 81.

4 Dennis Bailey interviewed by the author, 26 Mar. 90.

5 Ibid.

6 Ibid.

7 Ken Baynes, 'D&AD '68', *Design*, 235 (1968), 35.

8 *Sunday Times Colour Section* (1 July 1962), 12.

9 Ibid.

10 Ibid.

11 David Sylvester, 'Art in a Coke Climate', *Sunday Times Colour Magazine* (26 Jan. 1964).

12 Richard Guyatt (ed.), 'Royal College of Art Special Issue', *Queen* (June 1967), *passim*.

13 Ibid.

14 Alloway, 'Pop Art since 1949'.

15 Reyner Banham, 'Department of Visual Uproar', *New Statesman* (3 May 1963), 687.

16 Ibid.

17 Brian Haynes interviewed by the author, 18 Feb. 1990.

18 Banham, 'Department of Visual Uproar'.

19 Ibid.

20 'Manifesto', signed by Edward Wright, Geoffrey White, William Slack, Caroline Raulence, Ian McClaren, Jan Lambert, Ivor Kamlish, Gerald Jones, Bernard Higton, Brian Gimbly, John Garner, Ken Garland, Anthony Froshaug, Robin Fior, Germano Facetti, Ivan Dodd, Harriet Crowder, Gerry Cinamon, Robert Chapman, Ray Carpenter, and Ken Briggs, in *ARK* 35 (Spring 1964), 26.

21 Michael Myers, 'Editorial', *ARK* 35 (Spring 1964).

22 Banham, 'Department of Visual Uproar'.

23 Myers, 'Editorial'.

24 Fine Artz Associates, 'Visualizing', *ARK* 35 (Spring 1964), 40–2.

25 Ibid.

26 Ibid.

27 Banham, 'Department of Visual Uproar'.

28 David Robbins, 'The Independent Group: Forerunners of Postmodernism?', in Robbins (ed.), *The Independent Group*, 237.

29 Dick Hebdige, 'A Report on the Western Front: Postmodernism and the Politics of Style', *Block*, 12 (1986–7), 7.

30 David Mellor, 'A "Glorious Techniculture" in 1950s Britain: The Many Cultural Contexts of the Independent Group', in Robbins (ed.), *The Independent Group*, 229.

31 Hewison, *In Anger*, 64–5.

32 John Russell, in John Russell and Suzi Gablik (eds.), *Pop Art Redefined* (London, 1969), 31.

33 Clifford Hatts in a letter to the author, 22 Feb. 1992.

34 Robyn Denny interviewed by the author, 5 June 1989.

35 Robin Darwin, *RCA Annual Report* (1960).

Index

Abis, Stephen *pl. 90*
abstract expressionism 109–11, 119–20, 156, 165
Academie de la Grande Chaumière 93, 111
Adams, George 154
Adams, Robert 156
advertising 71–4, 136, 141–2, 162, 165, 201
advertising agencies 36–8, 72, 154, 172, 181, 201
Alberts 7, 88–9, *pl. 46*
Allen, Janet 186
Alloway, Lawrence 9, 19, 39–40, 94, 114–22, 140, 156,
 160, 164, 166, 168, 204
Alphabet and Image 54
Amis, Kingsley 157
And God Created Woman 40, *Pl. 18*
Anderson, Sir Colin 36
Ansen, Alan 118
Anti-Ugly Society 129, 202
Apichella, Enzo 181
Apple, Billy *see* Bates, Barrie
Appleyard, Bryan 10
Archer, Bruce 167–8, 170–1
Architectural Review 54, 57, 61, 178
Ardizzone, Edward 32, 58, 72
ARK
 advertising 36–8
 editorship 38–47
 Graphic Design in 141–56, 189–97
 and Institute of Contemporary Arts 156–74
 history 25–48
Armstrong-Jones, Anthony 45, *pl. 99*
Art Autre 111
*Art Directors' Annual of Advertising and Editorial
 Art* 142–3
Art News 113
Art News and Review 114
art schools 9–10, 12, 13–24
Arts and Crafts Movements 67
Ascott, Roy 20
Atkinson, Anthony 39
Atkinson, Terry 18, 45
Auerbach, Frank 40
Avedon, Richard 142–3, 185

Bailey, Dennis 59, 66, 71–2, 74, 143, 183, 199–201

Balcon, Michael 55
Ballard, Arthur 20
Banham, Reyner 18, 39–40, 92, 117–8, 156, 159, 161,
 171, 204–6
Bardot, Brigitte 40, 133, *Pls. 18, 61*
Barker, John 181
Barry, Sir Gerald 62
Bartlett, Michael 44
Bartram, Alan 40, 112, 153–5
Bartram, Harold 152, 154
Basic Design 14, 20, 42, 94, 152
Bass, Saul 149
Bassingthwaite, Lewin 71
Bates, Barrie 108, 196, *Pls. 57–8*
Bates, H. E. 60, *Pl. 34*
Bauhaus 152, 170–1
Baumann, Horst *Pl. 95*
Bawden, Edward 32, 52, 54–5, *Pl. 30*
Baynes, Ken 40, 42, 96, 172, 194, 201–2
BBC Design Group 84–5
'beat generation' 42, 118, 124–5
Beatles 11, *Colour Plate 9*
Beaulieu jazz festival 40, 188, *Pl. 85*
Beddington, Jack 36, 38, 72–5, 143, 200
Bensons 201
Betjeman, John 54, 73
Better Books 34, 36, 91
Bill, Max 170, 200
Birch, Nigel 74
Birdsall, Derek 152, 201
Bisley, A. J. 157, 186, *Pls. 74, 84*
Black, Misha 75, 83, 152
Blake, John 38, 62, 65, 69–70, 141, 171
Blake, Peter 39, 42, 46–7, 59, 79, 93, 105, 135, 161,
 174–9, 189, 202, *Pls. 25, 56, 62, 78, 90*
Blayney, Robert 66
Blow, Sandra 119
Bob Kerr's Whoopee Band 89
bohemianism 13–18, 130
Bonzo Dog Doo-Dah Band 88–9, *Pl. 47*
Booker, Christopher 7–8, 25
Boshier, Derek 42, 133, 141, 178, 189, 193, 221 n., *Pl.
 90, Colour Plate 8*
Boty, Pauline 42, 133, 189

Index

Bowen, Denis 42, 78, 81, 96–7, 110, 121, 126–7
Bowstead, John 45
Boxer, Mark 45–6, 198–200
Bradbury, Ian 152
Bradley, Will 52, 54
Brando, Marlon 131, *Pl. 60*
Branscombe, Keith 42, 188, *Pls. 21, 88–9*
Bratby, John 96, 127–8, 182–3
Brinkley, John 32, 38, 52
Brisley, Stuart 127
Britain in Pictures 55
Brodovitch, Alexey 142–3
Brooks, Robert 201
Brown, Arthur 7
Brownjohn, Roberts 201
Buckett, Alf 66–7
Buhler, Robert 66
Burri, Albert 116
Burrows, Joseph 70

Camberwell School of Art 93, 110, 178
Cambridge Opinion 168
Cambridge University 50
Campbell, Colin 17
Carrington, Noel 60
Cassandra, Mario 181
Casson, Sir Hugh 52, 83, 94
Caulfield, Patrick 133, 189
Cayford, George 153
Central School of Art 25, 92–3, 100, 149
Centre for Contemporary Cultural Studies,
 Birmingham University 13, 15
Chalk, Michael 119
Chalker, Jack 78
Chambers, Iain 13
Chapman, Nigel 51, 69
Cherry, Colin 168, *Pl. 76*
Chow, Michael 182
Christiansen, Arthur 144
Cimaise 112
Clarke, G. *Pl. 51*
Clarke, John 13
Cohen, Harold 122
Cohn, Stephen 42, 194
Coldstream Report 14, 18, 22
Coleman, Roger 34, 39–40, 84, 93, 112–13, 120–1,
 140, 156–74, 177, 183
Colman, Prentis, and Varley 36, 141, *Pl. 13*
collage 92–108
Collett, Dickenson, and Pearce 201
Collins, David 40, 112, 153–5, 163, 172, 201, *Pl. 75,*
 Colour Plate 7
Collins, Jesse 25, 92, 149, 151–2
Compleat Imbiber 220 n.
Conran, Terence 182
constructivists 109–10, 114
consumerism 16–17
Cordell, Frank 40, 166
Cordell, Magda 119
Council of Industrial design 36, 67–70, 147
Cowells Ltd. 36
Crawford Snowdon, W. *Pl. 39*
Crawfords 36, 201

Cream 16
Crosby, Theo 49, 171, 187
cubism 100
Cullen, Gordon 54
Curwen Press 54

dadaism 12, 40, 91, 94-5, 116–18, 128–35, 152
Daily Express 144, 199
Dankworth, John 179
Darwin, Robin 25–8, 36, 42–5, 49–51, 67–8, 78, 107,
 124–5, 148–9, 185, 202, 212–13
Daulby, George 152
Davey, Patricia *Pl. 14*
David, Elizabeth 58, *Pl. 33*
Davie, Alan 20, 113
Dease, Rosalind 39, 66
Debord, Guy 117, 131
Deighton, Len 34, 71, 80, 144–5, 151, 179–85, *Pls.*
 67–9, 79–80
Del Renzio, Toni 18, 40, 110, 116, 119, 155, 161, 166,
 174 *Colour Plate 7*
Denny, Robyn 39, 57, 79, 84, 93, 97–8, 101, 103, 107,
 109, 111–12, 116, 119, 122–3, 126, 156, 173,
 178–9, 212, *Pls. 52, 54, 59, 77, Colour Plates 2–14*
Derujinsky *Pl. 66*
Design 69, 170–2, 206
design consultancy groups 201
design methods movement 167, 170
Design Research Unit 36, 152
Designers and Art Directors' Association 151, 172,
 201
Dicks, Ted 81, 85
Dodo Society 85–6
Donovan, Terence 200
Dorfsman, Lou 149
Dubuffet, Jean 111
Duchamp, Marcel 4, 40
Duffy, Brian 76, 179, 184–5, 200

Ealing Studios 55
Elpher, Arpad 36–7
Emmett, Rowland 61
Enright, D. J. 157
Ernst, Max 94
Erwin Wasey 36
espresso bars 76, 182–3, *Pl. 81*
Establishment Club 91
Euston Road School 95, 97
Evening of British Rubbish 89, *Pl. 48*
Everly Brothers 132
exhibitions (in alphabetical order)
 Black Eyes and Lemonade (Whitechapel
 Gallery) 60–1
 Collages and Objects (ICA) 114
 Dimensions (O'Hana Gallery) 119
 Jean Dubuffet (ICA) 112
 Errol Flynn Show (New Vision Centre
 Gallery) 126
 An Exhibit (ICA) 84
 Family of Man (Festival Hall) 186
 Five Young Painters (ICA) 178
 Graphics RCA (RCA) 45, 198–204, *Pl. 101*
 Growth and Form (ICA) 93, 159

Have Image Will Travel! (Oxford University Divinity School) 136,
 Pls. 63–5
Morris Louis (ICA) 121
Man, Machine, and Motion (ICA) 156
Georges Mathieu (ICA) 112
Metavisual, Tachiste, Abstract (Redfern Gallery) 119–20
John Minton (Lefevre Gallery) 123
Modern Art in the United States (Tate Gallery) 109, 112
New American Painting (Tate Gallery) 121
Nine Abstract Artists (ICA) 114
Opposing Forces (ICA) 111
Parallel of Life and Art (ICA) 93–4, 186
Picasso and Matisse (Victoria and Albert Museum) 109
Place (ICA) 84, 120–1, 170
Kurt Schwitters (Lords Gallery) 103–5, *Pl. 55*
Situation 1 and 2 (RBA Galleries and Marlborough Gallery) 122–2
This is Tomorrow (Whitechapel Gallery) 7, 113, 118–19
Mark Tobey (ICA) 112
Twelve Graphic Designers (Time-Life Building) 201
Victorian and Edwardian Decorative Arts (Victoria and Albert
 Museum) 62

The Face Pls. 103–4, 209
Faith, Adam 40, *Pl. 19*
Farr, Michael 171
Farson, Daniel 179
fashion 179, 182–5
Faucheux, Pierre 39
Fawkes, Wally 178
Fenton-Brown, John *Pl. 5*
Festival of Britain 7, 52–4
Fine Artz Associates 18, 45, 207
Fleckhaus, Willy 188
Fletcher, Alan 39, 76, 92, 105, 107, 141, 149–51, 151–3, 182, 201, *Pls. 15,
 72*
Fletcher, Forbes, Gill 151, 201
Fontana, Lucio 116, *Colour Plate* 1
Forbes, Colin 152, 201
Foreman, Michael 44
Fortune 151
Fowler, Derek 78
Francis, Sam 111
Fraser, June 153
Frayling, Christopher 50, 104
Free Painters 110
Freeman, Tobert 136, 168
Frith Simon 15–17, 130
Froshaug, Antony 92, 149, 152–3, 172, 206
Frost, Terry 110

galleries *see* exhibitions
Games, Abram 52
Garlake, Margaret 110–11, 120
Garland, Ken 34, 87, 152, 172, 186, 206
Gebrauchsgraphik 35
Geers, Robert 201
Gentleman, David 62, 64, 66, 82, 143, *Pls. 1, 36, 43*
George Webb's Dixielanders 178
Gerstner, Karl 200
Gilbert and George 127
Gill, Eric 54
Granta 46
Graphis 35, 199

Gilbeys Ltd. 36; *see also Compleat Imbiber*
Giles, Roy *Pls. 23, 102*
Gill, Bob 201
Gill, Melvyn 44, *Pl. 11*
Gill, Ruth 201
Gillespie, David 94, 128–30, 140, *Pl. 50*
Godfrey, N. *Pl. 2*
'Good Design' 68
Goodden, Robert 52
Goon Show 6, 81–2, 86
Goulding, Dermot 186
Grant, Alistair 48
Greaves, Derrick 66, 96
Green, Alan 119
Green, Terry 40 80, 94–5, 116, 128, 135–7, 140, 182, *Pls. 18, 61*
Green, William 125–8
Grey Brothers 88, *Pl. 46*
Grey, Milner 36, 75, 152
Grey, Nicolette 55
Guy, Tony *Pl. 6*
Guyatt, Richard 25–32, 50, 52, 60, 81, 107, 113, 149, 153, 196, 202

Hall, Stuart 13
Hamilton, Richard 10, 14, 20, 84, 93–4, 160, 168, 194
Harling, Robert 54
Harper's Bazaar 142, 186, *Pl. 66*
Harrison, Phillip 88
Hart, Michael 201
Haslam, George 128, 136
Hasler, Charles 57
Hatts, Clifford 51, 77–8, 83, 212
Havingden, Ashley 36
Hawkey, Raymond 38, 55, 71, 74–5, 141-5, 185–6, 199, *Pl. 71*
Haworth, Jann *Colour Plate* 9
Hayes, Tubby 179
Haynes, Brian 42, 47, 107–8, 194–7, 199, *Pls. 91, 93, Colour Plates* 10,
 11,12
Hebdige, Dick 1, 13, 15, 208
Hedgecoe, John 45, 48
Henderson, Nigel 92–3, 110, 186–7
Henrion, F. H. K. 29, 52, 153–4, 220 n.
Hepworth, Barbara 110
Heron, Patrick 110, 119
Heseltine, Michael 45, 199
Hewison, Robert 8, 210
Hiett, Stephen *Pls. 23, 102*
Hill, Anthony 110, 113–4, 156
Hilton, Peter 110
hippies 13–16
Hitchens, Ivon 156
Hochschule für Gestaltung, Ulm 170–1, 206
Hockney, David 11, 42, 133, 189, 193, 195, *Pls. 90–1, 96*
Hodges, John 34, 39, 93, 113, 162
Hofmann, Armin 112
Holly, Buddy 132
Horne, Howard 13–18, 130
Hornsey College of Art 14, 153
Horst, Horst P. 142
Howard, Cephus 88
Huber, Max 39, 112
Hudson, Tom 20
Huizinga, Johan 117
Huyssen, Andreas 1–5, 109

Index

Hyatt, Derek 40, 99, 103, 124, 170, 186

ideograms 100
Independent Group 7, 9–10, 19, 20–1, 39–40, 110–11, 114, 117, 139, 156–75, 186, 193
informal art 110–11
Ingham, George, *Pl. 98*
Ingram, Tom 61
Innes, Brian 88
Innes, Neil 89, *Pl. 47*
Institute of Contemporary Arts 93–4, 109–10, 112, 114, 120, 156–74, 186
International Union of Architects Congress 101, *Pl. 53*
Ireland, Geoffrey 28, 185, *Pls. 7. 9*
Isou, Isidore 117
Italian styling 182–5

Jacobs, Nicholas 35
James, Bill 42, 194
jazz 7, 88–9, 157, 174, 178
Jefferson, Tony 13
Jeffs, Roger 45
Jellicoe, Ann 133
Jennings, Bernard 45
Jensen, Nick *Pl. 98*
Johnstone, William 50, 93, 168
Jones, Allen 189, 196
Jones, Barbara 61
Jones, John Christopher 167–8, 170–1
Jorn, Asger 116–7
Jowett, Percy 25

Kadleigh, Segei 225 n.
Kane, Art 186
Kauffer, McKnight 72
Kelly, Mike 78
Kepes, Gyorgy 186
Kidd, Mike 116, 136
King, David *Colour Plate* **13**
Kitaj, R. B. 11, 140, 189, 202
Kitchen Sink School *see* Royal College Realists
Knight, Nick *Pl. 103*

L'Art d'aujourd' hui 112
La Dell, Edwin 32, 52, 72
Labovitch, Clive 45, 199
Lacey, Bruce 7, 84, 86–91, *Pls. 45–6*
Lagotelli, Franco 181
Lambert, Margaret 60
Lanyon, Peter 110
Larkin, Phillip 157
Latham, John 91, 127
Law, Roger *Colour Plate* **13**
Lee, L. *Pl. 51*
Léger, Fernand 152
Lehmann, John 34
Leicester College of Art 156
Leischner, Margaret 170–1
Lester, Dick 7, 88
Lettrist International 117
Levin, Dick 83–4

Lewis, John 32, 36, 38
Lhôte, André 93
Liberman, Alexander 124, 142–3, *Colour Plate* **3**
Lilliput 143
Lion and the Unicorn Pavilion 52–4, 62 *Pls. 26–9*
Lion and the Unicorn Press 29–33, *Pls. 7–8*
Lionni, Leo 149, 151
Lissitsky, El 152
Livingstone, Marco 189
Lodge, Bernard 84
London Artists' Theatre Productions 82
London Association of Graphic Designers 201
London College of Printing 154
Look Back in Anger 7
Lord, Richard *Pl. 98*
Lovegrove, Jim 63, *Pl. 37*
Lucky Jim see Amis, Kingsley
Lyttelton, Humphrey 178

McCann Erikson 201
McDowell, Paul 88
McHale, John 40, 114, 166
MacInnes, Colin 179
McLuhan, Marshall 115, 164, 166–7, 170
McRobbie, Angela 13
MacKenzie-Kerr, Ian 156, 158
Main Wolff 201
Maldonado, Tomás 170–1, 206
Malkin, Neville *Pl. 3*
Marbur, Romek 47, 144, 153, 199, 201
Marshall, Allan 40, 188, *Pls. 19–20, 85*
Martin, Bernice 11–12
Martin, Kenneth 109, 114
Martin, Mary 110
Marx, Enid 60–1
mass observation 187
Massey, Anne 19
Mather and Crowther 201
Mathieu, Georges 111–13, 125, 156
Maude-Roxby, Roddy 40, 116, 118, 123–4, 126, 128, 131, 133
Mayhew George 152
Mayne, Roger 186–7, *Pl. 83*
Mellor, David 209
Melville, Robert 113, 116, 156, 162, 178
Merritt, Douglas 152–3
Metzger, Gustav 127
Michaux, Jean 111–12
Middleditch, Edward 66, 96
Milward, Colin 201
Minale Tattersfield 201
Minton, John 52, 55, 57–60, 70–1, 82, 93–4, 122–4, 128, *Pls. 32–4*
Moholy-Nagy, Lázló 152, 186
Montgomery, David *Colour Plate* **13**
Moore, Gordon 40, 45, 105, 112, 150–2, 154, 161, 182, 199, *Pls. 16, 73, 82, 94*
Morris, Cedric 72
Morris, William 54, 67
mosaic 98–9, *Pl. 52*
Mottram, Eric 42
Movement for an Imaginist Bauhaus 117

Moynihan, Rodrigo 52, 82, 93–4, 112
Müller-Brockmann, Josef 112, 200
Munsing, Stefan 120
Murphy Ltd. 36, *Pl. 12*
Myers, Bernard 34, 66, 82, 154, 162
Myers, Michael 47, 206

Nalecz, Halima 110
Nash, John 32, 52, 72
Nash, Paul 72, *Pl. 41*
Nason, Gerald 44
national service 6, 77–82, 175, 179
neo-romanticism 9, 95, 97, 139
New, Keith *Pl. 51*
New Vision Centre Gallery 97, 110–11
Newington, Peter 78
Newman, Barnett 124
Newton, Eric 121
Nicholson, Ben 110
Nicholson, Roger 196
Nuttall, Jeff 6, 91

Observer Magazine 144, 199
Omnific 201
Orient Line 36, 132, *Colour Plate* **5**
Oui 151
Owen, William 198
Oxford University Design Society 136

Paolozzi, Eduardo 93-4, 110, 114, 160, 186, 202
Parker, Charlie 179
Pasmore, Victor 14, 20, 84, 94, 109–10, 114, 152, 156
Pemberton, Muriel 184
Penguin New Writing 34
Penn, Irving 142–3, 185
Pentagram 201
performance 82–91
Pevsner, Nikolaus 23, 55–7, *Pl. 31*
Phillips, Peter 42, 133, 141, 178, 189, 192–3, 196, *Pl. 90*
photography 142–6, 165, 185–8
Picasso, Pablo 93–4
Picture Post 198
Pink Floyd 16
Piper, John 58, 72
Playboy 151
Plouviez, Charles 61
Pollock, Jackson 111, 113, 125
pop art 8, 10–11, 14, 133–4, 140–1, 175–9, 189–97, *Pls. 3, 90*
pop culture 8, 15–24, 174–97
pop design 159–60
Pop Goes the Easel 42, 133, 189
pop graphic design 189–98, *Colour Plates* **9, 11–13**
pop music 7, 15–25, 178–9
popular culture (folk art) 60–7
Postle, Denis 40, 94, 128, 130–4, 140, *Pl. 12, Colour Plates* **1, 5**
postmodernism
 and art schools 10, 16–17, 21–4, 165
 and modernism 139, 156, 209
 and national cultures 1–5, 198–213

Powell, Edwards 36
Powell, Roger 52
Presley, Elvis 116, 175–6, *Pl. 78*
Price, Cedric 224 n.
Psychogeographic Society 117
punk 16–17, 44–5, 131, *Pls. 22, 44, Colour Plate* **6**

Queen 45, 188, 199, *Pls. 94, 100*

Radio Times 143, 198
Rand, Michael 144
Rand, Paul 149
Ravilious, Eric 55
Ray, Cyril 76
Read, Herbert 158–9
Redbook 186
Reeve, Geoff 196
Reeves Ltd. 36
Reid, Jamie 132, *Colour Plate* **6**
Reilly, Paul 69
Rhodes, Zandra *Pl. 98*
Richard, Cliff 42, 132
Robbins, David 162, 208
Roberts, Vic *Pl. 97*
rock 'n' roll *see* pop music
romanticism 11–12, 13–17
Rothenstein, William 25
Rothko, Mark 113
Rowneys Ltd. 36
Royal College of Art
 college council 67
 Department of Photography 185
 Department of Stained Glass 98–9
 Department of Television Design 82, 128–37
 Drama Society 29, 82–3, *Pls. 43–4*
 'englishness' of 49–51
 Film Club 29, *Pls. 2, 4, 5, 60, 70*
 history of graphic design at 25–48, 141–56
 Painting School 95–6, 143
 School of Architecture 158, 224 n.
 School of Interior Design 83–4, 94
 School of Wood, Metals, and Plastics 68–70
 student union 78, 131–2
Royal College Realists 96, 177, 182
Rumney, Ralph 84, 116, 118, 131, 133
Russell, Gordon 36, 68–9, 75
Russell, John 210
Russell, Ken 42, 125–6
Russell, R. D. 36, 52, 67–9, 147–8

St. Ives painters 110
St. Martin's School of Art 112, 179, 183–5
Sandberg, Willem 39, 100, 112, 155
satire 78, 85–91
Scandinavian design 68
Schlesinger, John 101, 103
Schweppes Ltd. 36
Schwitters, Kurt 40, 93, 103–5, *Pl. 55*
Scialoja 116
Scientific American 168
Scott, Ridley 136, 140
Scott, Ronnie 179

Searle, Ronald 78
Sequin, Ken *Pl. 60*
Sewell, John 84, 140, 153, 201, *Pls. 48, 70*
Sex Pistols *Colour Plate* **6**
Shahn, Ben 142, 145
Shand, James 54
Shell 36, 54, 71–3, *Pls. 11, 40–2*
Sirk, Douglas 164
situationism 116–18, 124–6, 128–35
Skeaping, John 72, 85, *Pl. 42*
Slack, William 152
Slade School of Art 45
Smith, Jack 96
Smith, Richard 18, 39, 42, 84, 93, 100–1, 105, 112,
 119, 121-2, 156, 161, 163-5, 182, 185, 192–3, 202,
 Pls. 54, 59, 99
Smithson, Peter and Alison 40, 161–2
Snowdon, Lord *Pl. 99*
Soho 179–85
Sorensen, Colin 66
Spalding, Frances 123, 128
Sparke, Penny 18–19
Spear, Roger 89, *Pl. 47*
Spear, Ruskin 52, 93, 96, 122, 124, *Colour Plates*
 3, 4
Spencer, Herbert 39, 149, 152, 172
Spender, Humphrey 187
Stafford, Jack 32–3, 145–6, 198
stained glass 99, *Pl. 51*
Stanshall, Vivian 89, *Pl. 47*
Steichen, Edward 186
Steinberg, Saul 142
Stern, Bert 186
Stetelijk Museum, Amsterdam 112, 154–5
Stevens, Jocelyn 45, 199
sTigma project 91
Stobbs, William 154
Stone, Reynolds 32
Stone Martin, David 142, 145
Sunday Times Colour Section 45, 144, 199, 202, *Pls. 25,*
 97–8
Sunderland School of Art 131
Sutch, Screaming Lord 7
Sutherland, Graham 72
Swiss typography 200
Sylvester, David 157, 202

tachisme 109–14, 119–28
Tapié, Michel 111
Tati, Jacques 131
Tattooist International 133
Taylor, Basil 116, 157–60
teddy boys 7
Telegraph Colour Supplement 199
Temperence Seven 7, 88, 129
Temple, Paul *Pl. 44*
Thames Television 136, 153
Thompson, Christian *Pl. 106*
Thubron, Harry 20
Tilson, Joe 80, 105, 107, 111, 139–40, 179, 182, *Pls. 79,*
 90
Tobey, Mark 112
Tomalin, Nicholas 45

Town 45, 188, 199, 205, *Pls. 24, 88, 95–6*
Townshend, Pete 7, 127, *Colour Plate* **13**
Trattoria Terraza 181
Trevelyan Oman, Julia 84
Tschichold, Jan 54, 152
Tuer, Andrew 54
Turnbull, William 20, 114
Turner, W. J. 55
Twen 188, 200, 205, *Pls. 86–7*
Typographica 149, 221 n.

Uppercase 171, 187

Vadim, Roger 40, 133
Van Doesburg, Theo 100
Varley, David 40, *Pl. 17*
Varley, William 18
Venturi, Robert 2
Vertigan, Norman *Pl. 4*
Vogue 142–3, 186, 199

Wakefield, Annette 42
Walker, Emery 54
Walker, John A. 21–3, 130
Ward, Basil 158, 224–5 n.
Wedgwood Ltd. 36
Weeks, David 63–4
Weight, Carel 52, 66, 126
Werkman, H. N. 100, 152
Whannel, Paddy 13
Whiteley, Nigel 20-1
Whitham, Graham 19
The Who *Colour Plate* **13**
Wildbur, Peter 152
Wilkes, Roger *Pl. 98*
Wilkinson, Barry 78
Williams, Christopher 19–20
Williams, Peter *Pl. 94*
Willis, Paul 13, 15
Wilson, Frank Avray 110
Winsor and Newton Ltd. 36
Wolsey, Tom 45, 200–1
Woman's Own 199
Wright, Edward 92, 94, 100–1, 129, 149, 152–3, 160,
 172, *Pl. 53*
Written on the Wind 164

Yale University 149

Zwart, Piet 100, 152
Zwemmers 34, 36